LAWRENCE

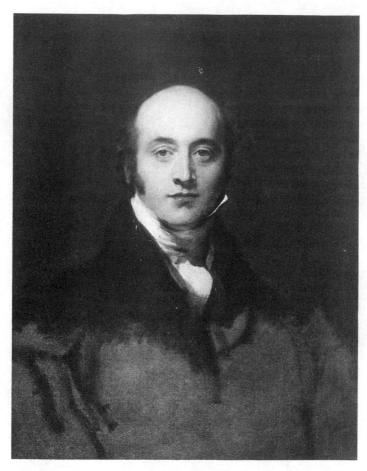

Sir Thomas Lawrence, P.R.A.
from the painting by himself in the Royal Academy of Arts.

LAWRENCE

By

SIR WALTER ARMSTRONG

WITH 41 PLATES

AMS PRESS
NEW YORK

Reprinted from the edition of 1913, New York
First AMS EDITION published 1969
Manufactured in the United States of America

Library of Congress Catalog Card Number: 70-100531
SBN: 404-00385-0

AMS PRESS, INC.
New York, N.Y. 10003

CONTENTS

vii

64943

LIST OF PLATES

ix

SIR THOMAS LAWRENCE, P. R. A.

x

LIST OF PLATES

xi

SIR THOMAS LAWRENCE, P.R.A.

CHAPTER I

BIRTH—PARENTAGE—EARLY PROMISE

IF we mapped the pedigree of a man born in 1800 as we do that of a thoroughbred horse, filling in the whole of his ancestors and therefore doubling their number with each generation backwards, we should find, by the time we reached the Norman Conquest, that we had made more than sixty-six million entries, of which over thirty millions, of course, would be in the first—the initial line. Putting it differently, the entire population of England, in 1066, was insufficient to supply one-sixtieth of the number of forbears required by an individual born in 1800 if his stem were to be kept free from those of other people.

In the light of this simple calculation it seems futile to discuss the breeding of any member of a society not cut up into watertight compartments by some permanent force, such as the difference of religion has been in Ireland. All the generative vitality the country possessed in those remote and scantily peopled days was needed for the production of the great race which has since covered so much of the world's surface. I have heard a genealogist declare that every non-imported Englishman is descended from Edward III ! However that may be, it is pretty certain that every truly English family, whether of high or low degree, is connected by blood with every other, and that arguments based on the hereditary quality of that essential fluid must therefore be employed with some diffidence.

A distinguished ancestry has been claimed for Sir Thomas Lawrence. His first biographer,[1] D. E. Williams, harks about to

[1] *Life and Correspondence of Sir Thomas Lawrence, Kt., P.R.A. etc.*, by D. E. Williams (London, 1831).

1 1

find him in Baronets and Knights Banneret, until he is compelled to give up the quest by a crushing letter from "C. G. Young, York Herald and Registrar." He then falls back on the modest assertion that "undoubtedly his mother was a lady by birth," and that "his father, though an innkeeper by trade, received the education of a man in middling genteel life." The facts of his extraction seem to be that his father, Thomas Lawrence senior, was of unknown ancestry, but that his mother was connected with several families of good standing. She was the daughter of the Rev. William Read, of the family of Read of Brocket Hall, Herefordshire, and was related, according to Williams, to several good Shropshire families.

Thomas Lawrence senior began life irresponsibly.[1] His first ostensible calling was that of a subordinate officer in the Excise,[2] but he was spending his time in various unsatisfactory idlings when he met and married Miss Lucy Read. The marriage was clandestine in the fullest sense of the word. The young people persuaded one of the easy-going clergy of those days to unite them, in his own house. After the ceremony the pair separated and returned to their respective homes. For some weeks they kept their union secret. At last they confessed, with the results that the lady's friends turned their backs upon her, and a favourite uncle cancelled a legacy of £5000 for which she figured in his will. This was a bad beginning, but in the long run the marriage turned out happily.

[1] In *Sir Thomas Lawrence's Letter-bag*, Mr. G. S. Layard prints a letter from one Henry Williams to the painter which is rather surprising. Unless founded on some misconception, it is difficult to reconcile it with the received accounts of Lawrence senior's circumstances. "It is a long time since," the writer says, "that a rich old man had two favourite nephews between whom to divide his wealth, and they, having for several years considered themselves as his joint heirs, were on the most intimate terms of friendship. The one of those nephews was called by mercantile affairs to Hamburgh, and during his absence the old gentleman died, having on his death-bed for some reason or other, or perhaps merely from caprice, altered his will and left the whole of his property to the nephew who remained at home. To those nephews I have always understood both you and I, Sir Thomas, are related —the fortunate one being your Father—the other my Grandfather. This unexpected alteration in the uncle's intentions destroyed the intimacy of the nephews who while they lived were never friends again. My Grandfather soon ceased to feel his pecuniary loss, having by marriage acquired a fortune of £10,000 [which in those days was a large sum], and for several years his transactions as a merchant were successful and he lived in affluence, but suddenly a reverse came, and he was obliged to stop payment. At this period your Father came forward with offers of the most ample assistance, but which were refused, and my Grandfather shortly afterwards died in comparative poverty. Some years after this your Father sought out the widow and found her with a family of several sons, of whose names and ages he took account, avowing his intention of promoting their success in life, but whatever his kind intentions were he was prevented by death from carrying them into effect . . ." (pp. 216–17).

[2] His appointment dates from January, 1747 (Williams, Vol. I, p. 35).

2

BIRTH

The young couple were hard put to it, at first, to find a livelihood. They migrated into Essex, settling at Thaxted, where Mrs. Lawrence is said to have had relations "more compassionate than those who had banished her from her home." How they lived here we are not told, but their stay lasted long enough for the production of three children, all sons. The second of these, Andrew, died in 1821, having in his time been naval chaplain to Sir Hyde Parker, Nelson, Collingwood, and Sir Robert Calder, as well as chaplain to Haslar Hospital. After the birth of these sons, the Lawrences returned to the west. In 1760, through the good offices of the Gatacres—with whom also Mrs. Lawrence is said to have been connected—Mr. Lawrence was appointed Supervisor of Excise at Bristol.

In those days the salary of a supervisor was small, but collateral gains were connived at, and it was considered to be his own fault if the incumbent of such a post did not fill his purse. It is significant that Supervisor Lawrence failed to do so, and that nine years later he gave up his appointment to become an innkeeper. All that we know of his character gives probability to the assertions of his son's biographers that he possessed neither the skill, nor the elasticity of conscience, nor the desire for wealth, required for such operations as those by which the great Pepys became a capitalist. "Nothing is recorded of him as a supervisor," says Williams, "but his vigilance and courage in circumventing and combating smugglers, and his inability to subsist by doing the State some service."

It was in 1769, the year of his famous son's birth, that Lawrence senior took the "White Lion," a commercial inn in Broad Street, Bristol. To this venture he added that of a coffee-house in the neighbourhood and a farm outside the city. Bankruptcy shortly followed. In 1772 we find him at Devizes, as landlord of the famous "Black Bear," at that time one of the best known of English coaching inns. In the "Black Bear," as well as the "White Lion," Mrs. Lawrence persevered with her indomitable maternity, until she had borne sixteen children to her husband. Several of these did well in the world, but most of them died, and the only one to reach fame was the subject of this essay. Financial disaster followed Lawrence senior to the "Black Bear," for not many years elapsed before he was bankrupt a second time. After this renewed

3

failure he never again became independent, but seems to have lived for the rest of his life partly on resources provided by Mrs. Lawrence and her friends, partly on gifts from his son Thomas. His character seems transparent enough. He appears to have been one of those men with considerable talents, amiable feelings, and a natural preference for good over evil, who are nevertheless unable to give practical effect to their abilities. With some people, anything presenting itself in the guise of a duty becomes too repulsive to face. When guests arrived at the " Black Bear," Lawrence, instead of stirring up the cooks and chambermaids and diving into the cellar after his best claret, used to appear in the parlour with a Shakespeare in his hand and a Milton under his arm, and offer to recite and discuss. He dressed above his station, and treated his patrons as if they were private guests. Such proceedings must have affected his custom for the worse, and so we need not be surprised to learn that, with him, the most profitable of trades failed to render profits.

Salvation came through his son Thomas. The boy had been born in the parish of St. Peter and St. Jacob, Bristol, on the 4th of May, 1769. The migration to Devizes had taken place when he was three years old. Before he was six his precocity had so far declared itself that Lawrence senior found the child a more acceptable theme for his eloquence than his own merits as a reciter. It was in 1775 that Mr., afterwards Lord, Kenyon arrived late one evening at the " Black Bear " with his wife.

"They were on their way to Bath, and had felt the inconveniences of the heavy style of travelling in those ' good old times,' and, as they confessed, they were not in the best possible humour when Mr. Lawrence, senior, entered their sitting-room, and proposed to show them his wonderful child. ' The boy,' he said, ' was only five years old, but he could take their likenesses, or repeat to them any speech in Milton's *Pandæmonium*.' To that place the offended guests were on the point of commending their host to go, and the lawyer's lips were just opened to pronounce the sentence, when the child rushed in, and, as Lady Kenyon used to relate, her vexation and anger were suddenly changed into admiration. He was riding on a stick, and went round and round the room, in the height of infantile joyousness. Mrs. Kenyon, as soon

4

PLATE I

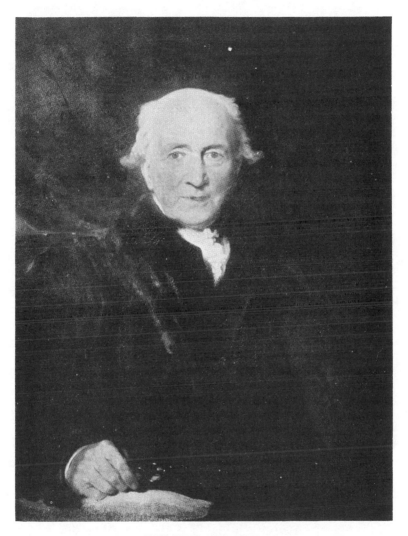

JOHN JULIUS ANGERSTEIN
FROM THE PAINTING IN THE NATIONAL GALLERY

as she could get him to stand, asked him if he could take the likeness of that gentleman, pointing to her husband. 'That I can,' said the little Thomas, 'and very like, too.' A high chair was placed at the table, pencils and paper were brought, and the infant artist soon produced an astonishingly striking likeness. Mr. Kenyon now coaxed the child, who had got tired by the half-hour's labour, and asked him if he could take the likeness of the lady. 'Yes: that I can,' was his reply once more, 'if she will turn her side to me, for her face is not straight!' Our artist learnt in good time not to speak so bluntly before ladies; but his remark produced a laugh, as it happened to be true. He accordingly took a side likeness of Mrs. Kenyon. About the year 1799, an intimate friend of Lady Kenyon's saw this portrait, and could distinctly trace a very strong likeness to what her Ladyship had been at the period when the likeness was taken. The drawing was about five inches broad and delicately shaded, but exhibited an indecision or feebleness of contour that might have been expected from a childish artist."[1]

This anecdote, and the glimpses we catch of the painter's father and mother, suffice to give a notion of the atmosphere in which his youth was passed. He was the ninth son among many brothers and sisters. By the time he had arrived at a receptive age, all the education the family could afford to pay for had been given to his elder brothers. He had, practically, to do without schooling, and to depend on his own quickness at the uptake to supply its place. To this, no doubt, was partly due a certain femininity which clung to him to the end of his life. His short experience of school could not have done much to affect his character, while the atmosphere of home, and the early demand on his native faculties, put him, as it were, in the same groove with the average middle-class young Englishwoman of his own day. An English girl was taught to "read, write, and cypher"; she was sprinkled over with a few historical facts and made to read her Bible. Her mental education was then complete and she was expected to make herself useful in the house. Lawrence was educated in the same way. He was never really exposed to that friction of a crowd of schoolfellows which at once excites and clarifies the mind. He was both sheltered and

[1] Williams, Vol. I, pp. 40, 41.

stimulated, with the result that he grew like a plant in a greenhouse, throwing out long, delicate shoots, and flowering freely, but scarcely making timber.

It is believed that the whole of his schooling consisted of two years, from the age of six to that of eight, at a school—"they ca'ed it an acaademy"—near Bristol, and some private lessons for a few weeks afterwards from one Jervis, a dissenting minister at Devizes. This training was supplemented by lessons from his mother, who seems to have been a capable teacher, so far as she went. Lawrence, in his later years, used to lament that the obligation he was under to earn money as a boy had prevented him from profiting, like his brothers and sisters, by her excellent instruction. Helpful as it was, this, however, could not take the place of a school, with its effect on character. The point is worth insisting on, as the painter's art, not being of the stern kind which defies conditions, was decisively affected by his upbringing. A man of amiable character, whose special talent has been forced in the bosom of his family while he has been protected against all those external influences which would have made for robustness and proportional development, is pretty sure to run into the most fatal of exaggerations, that of his own native tendency. For anyone but a commanding genius, the family is the worst kind of admiration society: and the more amiable its members, the more disastrous their influence. We all know cases in point, instances of men who have had some talent drawn up into such unnatural pre-eminence that it has become a vice, by the too affectionate recognition of parents—and sisters. Brothers, it must be confessed, do what they can to correct the bias; and those of Lawrence seem to have been no exception to the rule. The result was that we find him, in after life, addressing at least one of them as "Dear Sir"!

Few English painters of Lawrence's time had much of what we should now call education. They were not all so illiterate as Romney, whose grounding in his native language was on a par with what we now expect from a gardener or a groom. But not one among them, except Sir Joshua, had the ease and simplicity in expression which rest on knowledge of the springs of language and of the stages through which it has passed. Law-

6

PLATE 11

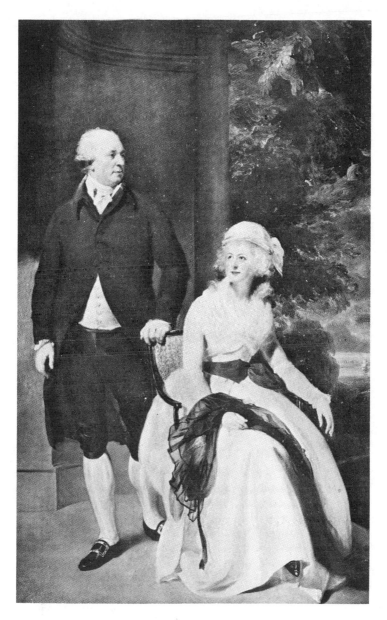

MR. AND MRS. ANGERSTEIN
FROM THE PAINTING IN THE LOUVRE, PARIS

EARLY PROMISE

rence had a far better command of English than most of his class. His letters to men of high rank are often stilted and involved, but those intended for his equals show no more than the average clumsiness of the English gentleman of the period. So far as accomplishments went, he had to educate himself, like other members of his profession, and he did it with remarkable success.

The artistic temperament has to contend with many drawbacks in facing the routine of life, but it brings with it a peculiar capacity for sifting useful knowledge. From the days of Raphael onwards, painters have shown surprising skill in carrying out the conceptions of philosophers, in illustrating histories they had read up *ad hoc*, in practising, in short, all the tricks included in what may—without offence, I hope—be called "window dressing." Shakespeare, of course, is the great example. Barring geography, he seems to have taken all knowledge for his province. But in the light of his career it is obvious that his secret was that common to all true artists. He was no lawyer, but he could use the bits of law he had gathered in such a way as to suggest that no Lord Chancellor knew more law than he. But this threatens digression, and digression not easy to justify, for after all few artists have depended less upon hints and fag ends of knowledge than Lawrence. His genius for assimilation was shown only in the way he adapted himself to a *milieu* very different from that in which he was born.

His biographers tell many stories of his precocity as a child. At four years old, we hear, he used to read the story of Joseph and his brethren with an emphasis and gesticulation which "showed that he entered into the feelings of the characters and embraced the whole scope of the action,"[1] or had been extremely well drilled. At five he recited Pope and Milton with equal success. Not long afterwards he so attracted the attention of the Garricks, when they were on their way to Bath, that they used to carry him off to a garden pavilion and amuse themselves for hours with his recitations from Shakespeare. His other talent declared itself with equal promptness. The drawings, already mentioned, of the Kenyons, were done at the age of six, but he had already excited astonishment in such a good judge as William Hoare,

[1] Williams.

7

of Bath,[1] by his drawings of eyes, a feature which he afterwards excelled in painting.[2] Perhaps the most authentic and trustworthy reference to his unchildlike powers is to be found in the *Miscellanies* of Davies Barrington. These were written before the boy was eleven and published before he was twelve, so that no revision in the light of after events can have taken place.

"As I have mentioned," he says, "so many other proofs of early genius in children, I here cannot pass unnoticed a Master Lawrence, son of an innkeeper at Devizes, in Wiltshire. This boy is now [Feb. 1780] nearly ten years and a half old ; but at the age of nine, without the most distant instruction given by anyone, he was capable of copying historical pictures in a masterly style, and also succeeded amazingly in compositions of his own, particularly that of 'Peter denying Christ.' In about seven minutes, he scarcely ever failed of drawing a strong likeness of any person present, which had generally much freedom and grace, if the subject permitted. He is likewise an excellent reader of blank verse, and will immediately convince anyone that he both understands and feels the striking passages of Milton and Shakespeare."

Enough has now been said of Lawrence's precocity and of the particular effect it had upon the father's management of his son. The general result was to develop the boy's powers in those directions which scarcely required a stimulus, and to deprive them of those correcting forces which might otherwise have been so useful. Lawrence senior objected to his son's reading books on art, but allowed him to visit and study such collections of old masters as he could win admission to in the neighbourhood of Devizes. One of the best was that of Mr. Paul Methuen, at Corsham Court. A story is told of how, when the Lawrence family was being shown round this collection, the less-than-ten-years-old Thomas was suddenly missed, and discovered at gaze before a Rubens.[3] "Ah! I shall never be able to paint like that!" he prophetically sighed.

[1] Williams says Prince Hoare, but he was only fourteen years older than Lawrence. It was probably the father, William, who came to the " Black Bear " in 1774 and saw the boy's work.
[2] " By Got," said Fuseli, " he paints eyes better than Titian ! "
[3] The " Wolf and Fox Hunt," still at Corsham.

8

PLATE III

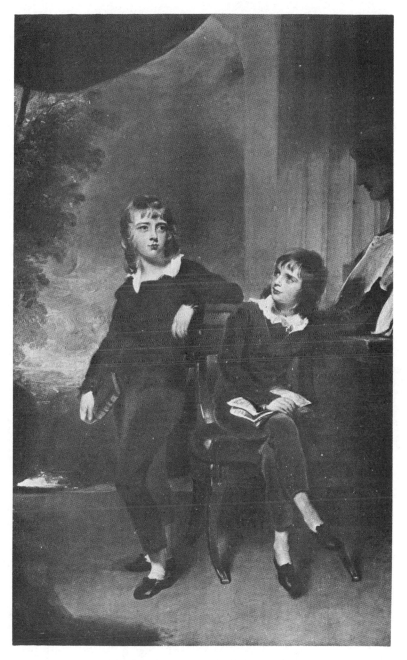

EDMUND AND GIBBS CRAWFORD ANTROBUS
FROM THE PAINTING IN THE POSSESSION OF SIR EDMUND ANTROBUS

EARLY PROMISE

It must be confessed that, on the whole, father Lawrence behaved well, according to his lights, by his son. He could hardly be expected to understand the dangers of stimulating precocity. Few great painters have been really precocious. Those who have reached any serious power of achievement when very young have seldom become great at all. The reason, perhaps, is to be sought in the double nature of painting, in the fact that its object seems, to the beginner, to be the imitation of nature, while the mature artist has learnt that such imitation is merely a vehicle for something more important. The talent which masters the first stage with facility is so pleased with its success that it becomes self-sufficient, and refuses to pass on to the more arduous adventure. This explanation receives some little support from the fact that precocity has not been so rare in the less ambiguous forms of art. Great musicians, especially, have been precocious. The development of the musician moves on one line. He is under no temptation to mistake means for ends. He knows from the beginning that, to be a composer, he must teem with ideas demanding expression in sound, and that his training aims only at enabling him to give them an outlet.

Precocious painters have been, as a rule, objective. They have reproduced beauty, instead of making it. The charm of their work has been that of the object represented, not that of the thing created by their own brains and hands. A rare exception to this rule was afforded by the career of the late Sir John Millais. He was scarcely less precocious than Lawrence. At eleven he became a student of the Royal Academy, and by the time he was seventeen had carried off every honour it had to give. But Millais had a safeguard in his gregariousness. Solitude has no danger for powers of the highest class. A Michelangelo or a Rembrandt may be left to develop alone. But for those to whom Nature has given great talent rather than overruling genius, it is better to live in a crowd. A crowd at once stimulates and prunes. It strengthens the healthy impulse and cuts back the dangerous. And yet, while it controls it also ensures sincerity. A painter surrounded by many different ideals is thrown back on himself when a choice among them has to be made. He is spared the temptation to avoid responsibility by accepting authority, and is

9

SIR THOMAS LAWRENCE, P.R.A.

compelled to select his path in the light of his own predilections; that is, to be true to his own personality. Millais was saved by his sociability from both the dangers which wait on the precocious and from those connoted by the term academicism. He began by painting like an Early Victorian R.A.; he went on to P.R.B.-ship, and finished as an interesting combination of the latter with principles taken from Velazquez.[1] Look from the chronological standpoint into the productions of other great artists, and you will find that an early blossom is rare. Nine times out of ten the preparation for a great career has been a long period of dull industry, during which all kinds of facts have been observed, reproduced, and stored up in the mind. Inquisitiveness, in short, is the prize virtue of a great painter's youth, just as sincerity is that of his maturity. And the greatest disservice which can be done to genius is to encourage its self-expression before it has laid in a sufficient store of mastery over those facts which are to be its medium of expression.

[1] An instance of precocity of a less striking kind, but, perhaps, more akin to the precocity of Lawrence, is given by the career of the engraver, Samuel Cousins, who was in later years to be so closely associated with Sir Thomas.

CHAPTER II

OXFORD—WEYMOUTH—BATH

IN 1779 the " Black Bear " adventure came to its inevitable end. The genius of Lawrence *père* for bankruptcy asserted itself anew, and the family was again obliged to shift its field of action. The first move was to Oxford, where the Lawrences reckoned on finding many friends. Their hopes were justified. At Devizes they had enjoyed many opportunities of showing off their prodigy to influential members of the University, travelling from Oxford to Bath. By some of these the young artist was at once employed. One commission led to another, until he had recorded the features of a large proportion of the richer dons and undergraduates. From this time forward he seems to have been the family mainstay. So far as we can now discover, his father did nothing for his living from the time the boy was ten years old until his own death. The other children contributed in some degree to the common fund, but the earning power of Thomas was the chief asset. And he drew upon it with unsparing generosity to the end of his life.

Williams, his biographer, mentions " an old book "—I suppose a notebook—of which one part was headed " Names of the nobility and gentry who have been pleased to subscribe to a likeness of a young artist painted by Mr. Hoare of Bath and engraved by Mr. Sherwin ; subscription 10s. 6d." " The names," he goes on to say, " were chiefly those of heads of houses and clergymen at Oxford ; but I find those of the Bishops of Oxford and Llandaff, the Earls Bathurst and Warwick, Lords Barrington, Deerhurst, Apsley, Wellesley, and Fincastle, the Vice-Chancellor of Oxford, Lord Charles Murray, Lady Egremont, His Excellency Count Bruhl, etc. etc. etc. Of the younger subscribers

to this print, then at Oxford, many have since become eminent in literature or in public affairs." It is probable that most, if not all, of those who thus subscribed had sat for their portraits. These portraits were at first pencil drawings, but afterwards what we now call pastels. They must at one time have been extremely numerous, judging by their results in cash to the Lawrence family. But such things are easily lost, worn out, and destroyed, and few have survived.

After some months at Oxford the family moved down to Weymouth, the Brighton of the eighteenth century.. There the Oxford programme was repeated, and the Oxford success. Patrons were found among those who had been drawn to the Dorset coast by the example of George III, and we may fairly suppose that not only was a good income earned, but that Lawrence senior so far modified his ways as to make some attempt at "putting by." However this may have been, it is certain that in 1782, three years after the "Black Bear" had been abandoned, the family settled in Bath, in a good situation, paying the then very high rent of £100 a year for a house. It was No. 2 Alfred Street, opposite the new Assembly Rooms, and not far from the Circus, where Gainsborough had lived and painted for so many prolific years. The household consisted of old Mr. Lawrence, his wife, an unascertained number of their children, and a Mrs. Alcock, the deformed sister of Richard Cumberland. This lady was a "paying guest," her contribution to the common fund being £120 a year. The eldest son, Andrew Lawrence, contributed an annual £80 out of his stipend of £140. He was reader at St. Michael's, the old church down by the Avon, at the junction of Walcot and Broad Streets. Williams is our authority for all these sums, which seem so liberal for the time. He also tells us that the two daughters of the family were now sent to good schools, the elder shortly afterwards being engaged as companion to the daughters of Sir Alexander Crawford, and the younger as head teacher in a school at Sutton Coldfield.

The painter's biographer, yielding to the temptation to be terse, says that at that time "Bath was London, devoid of its mixed society, and vulgarity." So far as it was "London," Bath was more mixed than the metropolis. The new-rich had a better

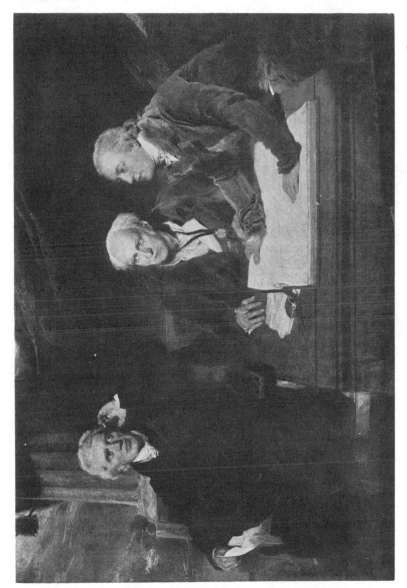

PLATE IV

SIR FRANCIS BARING WITH HIS SON JOHN, AND HIS SON-IN-LAW CHARLES WALL
FROM THE PAINTING IN THE POSSESSION OF THE EARL OF NORTHBROOK

BATH

chance of rubbing shoulders with "the great" than they could find in Pall Mall. Society was made up of selections from various strata in London and the provinces. The power of exclusion built up by Beau Nash had been considerably relaxed since his time, and Bath was satisfied with a much lower standard than was then applied in St. James's. When the Lawrences settled in the town its glory had been long on the wane. The comparative isolation which had given it so unique a prestige in the days of George II had come to an end. Intercourse with London had become easier, with the inevitable result. Visitors stayed for weeks, or even days, instead of months. The spirit of the place had grown more suburban and less independent. In some ways, however, it still preserved its autonomy. Happily for the Lawrences, portrait-making was one of these, and the tradition that sitting for one's picture was the thing to do between Pump Room in the morning, and Assembly Rooms at night, had not yet died out. William Hoare—"Hoare of Bath"—was still alive, and his son, Prince, was doing his best to live on his father's fame; Gainsborough had flitted to London eight years before, but Robert Edge Pine, a good though totally uninspired artist, still extracted a handsome income from those who had thought the Suffolk man's terms too high. With his experience of Devizes, Oxford, and Weymouth to guide him, Lawrence senior was doubtless justified in launching his little barque on such a sea, even though the talent of a boy of thirteen was the main source of its buoyancy.

It is now impossible to give an account of Lawrence's Bath career in any detail. All we really know is that while there he practically confined himself to the modest forms of art in which he had begun, reserving oil painting for the wider stage of London. It soon became the fashion to sit for his small, oval portraits in pastel.[1] For these he began by charging a guinea, but his terms were promptly raised, first to a guinea and a half, and afterwards to double that price, and even more.[2] All the shifting society of

[1] It is curious that so few of Lawrence's pastels have come down to us, or, at least, been recognized as his. Large numbers of similar things by other men, especially those by the Irishman Hugh Hamilton, are still extant and in good condition, so that the precarious nature of the medium, already alluded to, seems an insufficient explanation of the rarity of those by Lawrence.

[2] There is reason to suppose that a few crayon portraits, for which he received five guineas, were painted before he left Bath.

13

SIR THOMAS LAWRENCE, P. R. A.

the place sat to him. Admiral Barrington, that Samuel Barring-
ton who was a Post-Captain in command of a line-of-battleship
before he was nineteen, once filled his sitter's chair; so did his
brother, Lord Barrington; while among other notable clients
whose names have come down to us, were the bewitching Georgiana,
Duchess of Devonshire, and her successor, Lady Betty Foster;
Elizabeth Carter, of *Epictetus* fame; Sir John Sinclair of
Ulbster; Sir Elijah Impey; Dr. Falconer; and three members of
the Royal house, the Prince of Wales and the Dukes of York and
Clarence. One of the most frequent visitors to his studio, the
great Sarah Siddons, who was afterwards to count for so much in
his life, began her sitter's career in Bath. The first, perhaps, of
the many versions he left of her is the pastel in the National
Gallery, but he also portrayed her as "Zara" in *The Grecian
Daughter*, the portrait engraved by Sherwin. Judging from these
early pastels, of which so few have been identified, Lawrence had
in him the makings of a greater artist than he ever became. They
are free from that sense of the importance of fashion which after-
wards controlled his brush, and almost succeed in holding their
own, as works of art, with the earliest productions of Reynolds or
Gainsborough.

His interests in Bath were not confined to the studio. The
histrionic ambitions awakened by his early dealings with Milton
and Shakespeare were not easily killed. Garrick had once asked
him, at Devizes, whether he would rather be player or painter, and
the query seems to have suggested the idea that he might excel as
both. In the last quarter of the eighteenth century the Bath
theatre was both a half-way house to Drury Lane and a
dépendance upon it. The best plays and actors of the time were
to be seen there, and success on the Bath boards meant London
for a young player. Lawrence determined to try his fortune, and
see whether he could not enact portraits as well as paint them.
This resolution, we are told, alarmed his father, who wisely clung to
the bird in the hand. Portraiture was filling the family coffers, and
he dreaded the effect of a divided ambition. So, if we may believe
Allan Cunningham and the writer (Alaric Watts?) of the notice in
the *Annual Obituary* for 1830, he conspired with "Bernard, the
Comedian, to evoke the evil spirit of the sock and buskin wholly

14

PLATE V

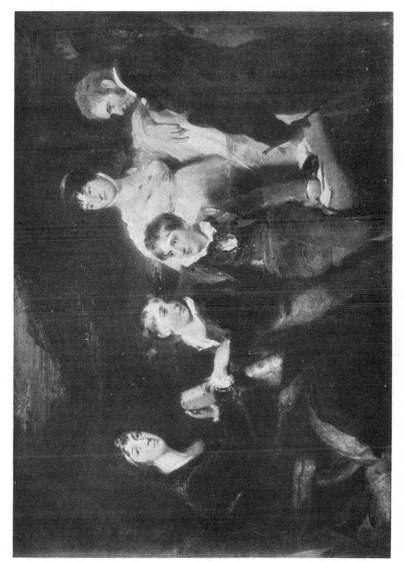

SIR THOMAS BARING WITH LADY BARING, HIS SISTER MRS. WALL, AND H.S SON AND NEPHEW, FRANCIS J. BARING AND BARING WALL

FROM THE PAINTING IN THE POSSESSION OF THE EARL OF NORTHBROOK

out of him." The plot was laid clumsily enough. Lawrence was
to be invited to give a sample of his powers, an ordeal in which,
thought the plotters, he would be sure to break down. The
account of what actually took place is given by John Bernard.[1]
" All the parties assembled : old Lawrence and his friends in the
back parlour ; young Lawrence, Mr. Palmer (the manager of the
Theatre) and myself in the front. The Manager was no sooner
introduced, than, with great adroitness, he at once demanded a
specimen of the young man's abilities, and took his seat at one end
of the room. I proposed the opening scene between Priuli and
Jaffeir.[2] We accordingly commenced, I, Priuli ; he, Jaffeir ; he
went on very perfectly till, in the well known passage, ' To me
you owe her,' he came to the lines—

> ' I brought her, gave her to your despairing arms :
> Indeed you thanked me, but——'

Here he stammered and became stationary. I held the book, but
would not assist him ; and he commenced and stopped, reiterated
and hemmed, till his father, who had heard him with growing
impatience, pushed open the door and said, ' You play Jaffeir,
Tom ! hang me if they would suffer you to murder a conspirator.'
Mr. Palmer, taking young Lawrence by the hand, assured him in
the most friendly manner that he did not possess those advantages
which would render the stage a safe undertaking. The address
did not produce an instantaneous effect ; it was obvious the young
artist was of a reverse opinion—a conversation ensued, in which I,
abusing the life of an actor, and other friends representing the
prospects of a painter, young Lawrence at length became con-
vinced, but remarked, with a sigh, that if he had gone on the stage
he might have assisted his family much sooner than by his present
employment." It was not a convincing experiment, and young
Lawrence might be excused for thinking that to convict him of a
momentary lapse of memory was not to prove him unfit to become
an actor. It is probable that the force which really kept him from
the stage was the rapid growth of his popularity as a painter.

Williams tells various stories of his career in the west which
are hard to believe. He says he copied, in chalk, the " Trans-

[1] *Reminiscences.*　　　　　　[2] In *Venice Preserved.*

15

figuration" of Raphael, the "Aurora" of Guido, the "Saint Romualdus" of Andrea Sacchi, the "Descent from the Cross" of Daniele da Volterra ; and that for these copies—including, perhaps, one from "Saul receiving sight from Ananias," by Pietro da Cortona—Lawrence senior received, and refused, an offer of three hundred guineas. We are also told that when a "Derbyshire Baronet,[1] struck with the beauty and genius of the lad, offered to send him to Rome at the expense of £1000, his father told Sir Henry that his son's talents required no cultivation." Three hundred guineas for four or five chalk copies of copies was a quixotic offer in those days, as it would be now. Had it ever been made, it would surely not have brought a negative from Lawrence senior, or even junior. As to the offer of a year or two in Rome, that may well have been declined, seeing how the family depended on the boy's earnings. But to name a thousand pounds as the cost, hints at either credulity or exaggeration somewhere. According to Williams, Lawrence painted in 1786, when he was seventeen years old, a whole-length figure of "Christ bearing the Cross" on a canvas eight feet high, this being the first attempt at oil painting of which any record could be found. It was an ambitious beginning. He went on to paint his own portrait, in which, again according to Williams, he combined the characteristics of Rembrandt and Sir Joshua! But down to the time of his migration to London, his energies were mainly given to those heads in pastel on which his regular income depended.

In the year 1785 certain events occurred to bring renewed thoughts of a change into the heads of Lawrence and his father. The boy himself was only sixteen, so he may have had little to do with the decision they came to. In 1782, when he was thirteen, he had produced the chalk copy of Raphael's "Transfiguration," already referred to. It had been made from a good copy in the possession of one of the Hamilton family in the neighbourhood of Bath. Acting, probably, on the belated advice of some admiring patron, he sent this drawing to London in the spring of 1784, in competition for a gold medal offered by the Society of Arts. It was the only work sent in in the class to which it belonged, but it failed to get the prize for a reason which

[1] Sir Henry Harpur, Bart.

rather enhanced its merit. It was dated 1782, whereas the conditions required that all drawings should have been produced during the twelve months immediately preceding the date of sending in. Although thus disqualified for the gold medal, Lawrence was awarded a silver palette, gilded all over, and five guineas, in consideration of the remarkable merit of his work.[1]

The perplexing Williams, after narrating the facts as here recapitulated, including the evidence of the Society's minute books, given below, goes on to say that " the beauty, the fine form, and graceful manners of the boy, forcibly struck everybody present when he appeared before the Society "; also that the copy of the " Transfiguration " was on glass, and in colour ! The copy, of course, was on paper, in chalk, as the biographer himself had said a page or two before, and the boy never appeared before the Society at all.[2] In reliance on this eccentric biographer's state-

[1] The entries in the minute book of the Society of Arts may be given :—

"ADELPHI, *March* 5, 1784.

"Valentine Green, in the chair. Mr. Whitford and Mr. Mathews.

"Took into consideration the single claim, Class 129. Marked the claim G.—Examined the claim.—Resolved that, as the drawing marked G appears, by the date upon it, to have been executed in the year 1782, it cannot, according to the conditions, p. 107, be admitted a claimant."

"ADELPHI, *March* 30, 1784.

"Valentine Green (in the chair), Dr. Johnson, Mr. C. Smith, Mr. Hincks, Mr. Samuel, Mr. T. Smith.

"Took into consideration the drawing of the Transfiguration, marked G, and opened the paper containing the names of the candidates, according to the directions of the Society ; and it appeared to the Committee, that the candidate was Thomas Lawrence, aged thirteen, 1783, in Alfred Street, Bath.

"The Committee having received satisfactory information that the production was entirely the work of the young man,

"Resolved, to recommend to the Society to give the greater silver palette, gilt, and five guineas, to Mr. Lawrence, as a token of the Society's approbation (!) of his abilities."

"ADELPHI, *May* 5, 1784.

"James Davison, Esq., Vice-President, in the chair.

"A motion is made, that the inscription on the palette voted to Mr. Thomas Lawrence, jun., be—Drawing in Crayons, after the Transfiguration of Raphael, 1784.—Agreed to."

(No date.)

"Owen Salus Brereton, Esq., Vice-President, in the chair.

"Mr. W. R. Lawrence attended on behalf of Mr. Thomas Lawrence, jun., to whom the silver palette and five guineas have been adjudged, as a bounty for the drawing of the Transfiguration ; and received the same for his brother."

[2] Samuel Rogers tells a curious story of Lawrence and his reception at Bath of the silver-gilt palette forwarded by his brother in London. " Sir Thomas Lawrence told me," he says, " that when he, in his boyhood, had received a prize from the Society of Arts, he went with it into the parlour where his brothers and sisters were sitting ; but that not one of them would take the slightest notice of it ; and that he was so mortified by their affected indifference, that he ran upstairs to his own room, and burst into tears."—*Table-Talk*, p. 143, ed. of 1903.

ment, later writers have made 1787 the year of Lawrence's appearance in London. It was, indeed, in September of that year that he became a student of the Royal Academy; but just twelve months earlier he had written this surprising letter to his mother from London, where he was evidently busy installing himself:—

"*September*, 1786.
"MY DEAR MOTHER,
 "I think myself much obliged to you for the books you sent me; and the shirts, which, believe me, were acceptable, as my stock was a little reduced. Rollin would be very acceptable; but, perhaps, Andrew cannot spare him. Having received no answer from Mr. Brummell, I wrote to the Earl of Gainsborough, informing him that the picture was at his service, and expect an answer soon. Lady Middleton said he was mad after it. I am now painting a head of myself in oils; and I think it will be a pleasure to my mother to hear it is much approved of. Mr. P. Hoare called on me; when he saw the crayon paintings he advised me to pursue that style; but after seeing my head, and telling me of a small alteration I might make in it, which was only in the mechanical part, he said the head was a very clever one; that to persuade me to go on in crayons he could not, practice being the only thing requisite for my being a great painter. He has offered me every service in his power; and, as a proof of fulfilling his word, I have a very valuable receipt from him, which was made use of by Mengs, the Spanish Raphael. His politeness has indeed been great. I shall now say what proceeds not from vanity: nor is it an impulse of the moment: but what from my judgment I can warrant. Though Mr. P. Hoare's studies have been great, than any paintings I have seen from his pencil, mine is better. To any but my own family I certainly should not say this: but, excepting Sir Joshua, for the painting of a head, I would risk my reputation with any painter in London. I hope you and Andrew will not be disappointed when you see it; for it will be sent, that I may know your opinions. I have had the pleasure of seeing the great Mr. Barry; he did not recollect my name, nor did I wish to make myself known—as, being ignorant of it, I became what I desired, a spectator. He is,

18

PLATE VI

HENRY, THIRD EARL BATHURST
FROM THE PAINTING IN THE WATERLOO GALLERY, WINDSOR

in truth, a great man. To his wonderful talents for the profession he unites the classic truth of his scholarship, and the noblest and most sublime mind I ever met with. There is a clearness and precision in his ideas, together with a strength of language by which they are conveyed to you, so that even the most indifferent subject, when taken up by him, appears in a different light to what you ever before viewed it in. How great the pleasure, then, I received, when that mind was employed, for the most part, in canvassing my loved pursuit, you may easily conceive. The large pictures, and the large books, would look well here if you can spare them. I can think of no better present for my dear mother. Uncle Codger must e'en sit for his portrait in oils, which shall not disgrace the original. I now conclude myself,

" Your ever affectionate and dutiful son,

" THOS. LAWRENCE.

"Send the prose volumes of Miss Bowdler's works, unless wanting."

Williams also prints a long letter from Miss Sarah Thackeray to Miss Jewsbury which throws additional light on this question of date. " My intimate acquaintance," she writes, "with Sir Thomas, was confined to the last months of 1785 and to the first six months of the ensuing year; these I spent in the house of his friend and patron, Dr. Falconer, of Bath." This, taken together with his own letter, shows that the migration to London took place between the end of June and the beginning of September, 1786.

These two letters give us an interesting glimpse into the by-ways of the character with which he faced the great world of the metropolis. I have already quoted his own at length, and here I may give the rest of Sarah Thackeray's. The date upon it is May 15, 1830, more than four months after the painter's death, but its contents have to do with his boyhood.

" He (Lawrence) passed several evenings in every week with us; and I scarcely recollect anything with more pleasure than the little social circle that surrounded that joyous tea table: he was one of its pleasantest members; and his appearance, which de-

19

SIR THOMAS LAWRENCE, P. R. A.

pended upon his inclination or convenience, was ever hailed with delight. A kindred taste for the art drew him and Sir Sidney Smith together, and he (Smith) sometimes, though more rarely, made one of the little party. I have seen the future President and the future hero of Acre drawing at the same table; the one tracing a human countenance, the other a ship. Sir Thomas was very engaging; he was kind and warm-hearted, and his manners were graceful and easy. I am told they lost in warmth more than they gained in polish, in his after intercourse with the world. He often recited long passages from Milton and Shakespeare, which he did even then with taste and feeling; and frequently sketched, for our amusement, the celebrated beauties, or the distinguished public characters, he had seen at the Rooms the evening before. These he impressed upon his own memory, by tracing them, with imaginary lines, upon the crown of his hat; and he rarely failed to give, in a few hasty strokes, so correct a likeness that we easily recognized the characters (when we afterwards saw them) from the representation. At this time he was painting Portraits for three or four guineas a-piece in crayons. A mutual friend has a likeness of me in this style. He became acquainted with Bunbury, and drew his portrait, with one of his long caricatures depending from his hand—I believe his ' Long Minuet.' The drawings I possess of his are, two masterly sketches in black chalk, the one of a younger sister, the other, of myself, and a personification of Contemplation from Milton's ' Il Penseroso,' a very highly finished and beautiful pencil drawing. He was remarkably handsome as a boy; he wore his collar thrown back, and his hair, which was beautiful, was so redundant, that its rich dark curls almost obscured his face when he stooped to draw. You must remember, my dear Miss Jewsbury, I am describing the costume of half a century back. I was told he lost much of his beauty when he assumed the manly attire, and reduced his fine hair to the trammels of the stiff powdered fashion of that day; but I never saw him after. All this I feel is just nothing; but to supply the deficiency I will write to Dr. Falconer (son of the one above-mentioned) whose excellent memory and longer intimacy will supply, I hope, much that may be useful. His Father and his Uncle (the learned editor of the *Oxford Strabo*) were very kind

PLATE VII

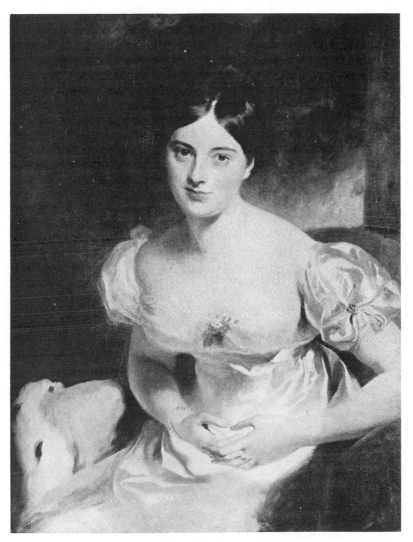

MARGUERITE, COUNTESS OF BLESSINGTON
FROM THE PAINTING IN THE WALLACE COLLECTION

to young Lawrence, and fostered his early genius with the encouragement and assistance that even genius requires in its first efforts."

From other sources we hear that at this time young Lawrence's manner was not free from an offensive affectation. As he pleased some and annoyed others, we may, perhaps, conclude that he belonged to that large class of people whose manner depends on the company in which they find themselves.

CHAPTER III

LONDON

LAWRENCE came to London just as the ebb began to be discernible in that great spring-tide which had carried English painting to a level it had never reached before. Romney, indeed, was in the full delight of his devotion to "the divine lady," and had still ten years of good work to do. Hoppner had only begun to exhibit in 1780, and Raeburn was preparing to leave Rome for his great career in the north. But Hogarth had been dead for more than twenty years, Sir Joshua was within four seasons of his end as a working artist, and Gainsborough was within two of his death. The next word was to be with the landscape painters. Turner was eleven, and was selling drawings for shillings in Maiden Lane, emulating the precocity of Lawrence in another *genre*. Constable was ten, and already looked, no doubt, on wind-milling as his fate and playing with paint and pencils as a furtive joy. The creative genius—the genius of the time—which had raised English portraiture to an equality with that of sixteenth-century Venice, was giving way before a more conscious and artificial spirit, and in Lawrence, unhappily, it found one who was to help it on the downward road.

An exact idea of the young painter's doings on his first arrival in the capital is now beyond our reach. His early biographers contradict themselves and each other, and we have little or no means of controlling their assertions. Williams says he came to London in 1787, taking Salisbury on his way: a statement adopted by his successors with a query from the more cautious. I have given my reasons for believing 1786 to be the true date, and, consequently, that the visit to Salisbury was made from London rather than from Bath. In London the young man's first home

22

PLATE VIII

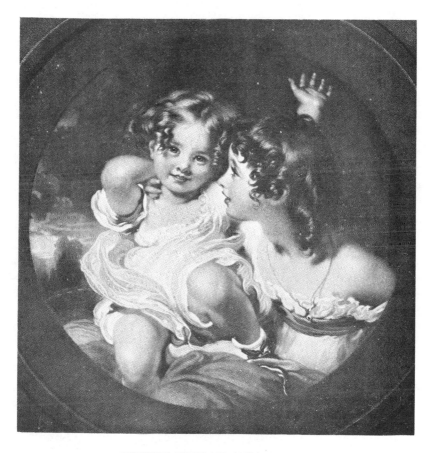

"NATURE." (EMILY AND LAURA CALMADY)
FROM THE MEZZOTINT BY SAMUEL COUSINS

was at No. 4 Leicester Fields, within a stone's throw of Sir Joshua.
The reader will remember that his age was but seventeen, which,
taken with the high standing of the neighbourhood at the time,
makes it probable that he was here domiciled with friends rather
than in lodgings on his own account. But he soon quitted Leicester
Fields for St. James's, as we find him in 1787 sending seven pic-
tures—five portraits and two "fancy pieces"—to the Royal
Academy from an address in Duke Street.

It was, perhaps, in 1786, on his first arrival in London, that he
sought and obtained an interview with Sir Joshua Reynolds. Prince
Hoare, his Bath friend, who was afterwards to become Foreign
Secretary to the Royal Academy, had given a letter of introduc-
tion. Taking in his hand a portrait of himself, just finished, he
walked across the "Fields," presented his letter, and found the
President in the act of shaking off a previous suitor for advice.
Turning to young Lawrence, Sir Joshua took his picture, set it in
a favourable light, looked at it attentively, and paid the young
man the compliment of a serious discussion before he sent him
away pleased both with himself and his mentor. "You have been
looking at the old Masters," said Reynolds; "but my advice is
this: study nature, study nature." Reynolds, no doubt, saw in the
work, and perhaps in the features of Lawrence, the dangers which
were likely to beset him, and framed his advice accordingly. He
also gave a general invitation to his house, which, we are told,
Lawrence freely used. His admiration of Sir Joshua was so sin-
cere that he adopted his style of the moment for his own model.
The earliest of his oil pictures which can now be traced bear
a strong family likeness to such Sir Joshuas as the two "Fanny
Kembles," the "Lady Caroline Price," and others of the same
class and date.[1]

I have explained why I believe that Lawrence's visit to Salis-
bury in 1787 was made from London, and not *en route* from Bath.
His stay in the cathedral city was long enough for the production
of several crayon portraits, and it seems probable that, at its close,
he went on to Bath and thence travelled to London with the rest

[1] A striking instance of this similarity was to be seen at the Exhibition of Historical Por-
traits at Oxford in April–May, 1906. There Lawrence's "Viscount Tracy of Rathcoole"
hung not far from Sir Joshua's "Thomas Warton." The likeness in manner between them
approached identity.

23

of his family. In any case it appears fairly certain that in 1787 the father, mother, and son shared between them two addresses in St. James's. They seem to have lived in Duke Street, while the artist did his work at 41 Jermyn Street. Williams says the house overlooked the yard of St. James's Church, and that Lawrence found the situation affected his clients' spirits for the worse! The biographer can scarcely have been familiar with a portrait painter's arrangements! Sir Martin Shee, at any rate, was not afraid of the influence of the churchyard, for when Lawrence migrated to Soho, he took the vacant studio.

Before the end of 1787 Lawrence had been admitted into the schools of the Royal Academy. His entry on the books is dated 13 September. Howard, who was then Secretary, says: " His proficiency in drawing, even at that time, was such as to leave all his competitors far behind him. His personal attractions were as remarkable as his talent! Altogether he excited a great sensation, and seemed, to the admiring students, as nothing less than a young Raphael suddenly dropt among them." Allan Cunningham's account, written while many still alive could remember Lawrence in youth, at least embodies a tradition : " His large, bright eyes, his elegant form, his hair, long and plentiful, flowing down upon his shoulders, and a certain country air which London is long in removing, made many look after him more than once. His person, however, was nothing to the beauty of his drawings: he soon made two—'The Fighting Gladiator' and the 'Apollo Belvedere'—of such excellence as surpassed all competition. He was satisfied with the result ; he contended for no medal, and left the prizes for those who needed such distinction." In short, the boy painter—he was even yet only eighteen—had such a reception from the junior and more generous members of a generous profession, that his head was a little turned, and his confidence in his own powers stiffened more than ever.

He did not long frequent the Academy schools. Finding himself the best student there, he thought he could make a better use of his time. We have evidence that he spent some, at least, of his evenings in drawing and etching with various companions. Daniel Lysons, author of the *Environs of London*, speaks of Lawrence having frequented the chambers of his

24

PLATE IX

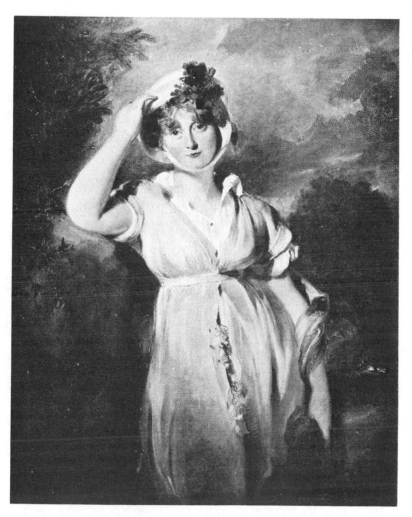

QUEEN CAROLINE AS PRINCESS OF WALES

FROM THE PAINTING IN THE VICTORIA AND ALBERT MUSEUM

brother, Samuel Lysons,[1] for the purpose of etching, and mentions two plates, one from a drawing of Mrs. Siddons, the other from a head of an old woman, which were in his possession in the year of the painter's death. These were dated 1790 and 1791. One of his friends at this time was Benjamin West. We do not know how the acquaintance was made. Williams calls the two men contemporaries, and writes as if they had been students together at Somerset House! In 1787 West, of course, was nearly fifty years of age, and one of the foundation members of the Royal Academy. West was a *persona gratissima* with the Royal Family, and it was probably through him that Lawrence was presented to the King and won his early footing at Court. " At this time," says Cunningham, " he spent much of his leisure in the society of Farington, and Smirke, and Fuseli, and other artists; and it was his pleasure, when conversation flagged, to rise up and recite passages from Milton, which he did with a softness of voice and gentleness of manner, 'very much,' as Fuseli said, 'like Belial, but deucedly unlike Beelzebub.'"

Accounts of the impression he made on people at this time of his life vary curiously. To one observer he wore an air of offensive affectation in all he said or did; but the same person, a lady, confessed that when, in after life, she looked for traces of this original sin, it was all she could do to find them.[2] Sir Martin Shee, writing to his brother in 1789, says: " Lawrence is a very genteel, handsome young man, but rather effeminate in manner. . . . He is wonderfully laborious in his manner of painting, and has the most uncommon patience and perseverance." A year later he writes to the same correspondent: " I cannot conceive who could have so much misinformed you about Lawrence. He is the very reverse of what he has been represented, bears an excellent character, and is the entire support of his father and family. He is modest, genteel, and unaffected, by no means inclined to dissipation, and one of the most laborious, industrious men in his profession that ever practised it."[3] Other quotations might be made in support of both these opinions. Their discrepancy is merely the result of varying goodwill and varying penetration on

[1] Samuel Lysons was Lawrence's senior by six years. He was appointed antiquary to the Royal Academy in 1818.
[2] Cunningham, p. 29, Vol. II [3] *Life of Sir Martin Archer Shee*, Vol. I.

SIR THOMAS LAWRENCE, P.R.A.

the part of their authors. Traits which seemed offensive to an inexperienced girl may well have lost their importance with a woman of the world, and a fellow student like Shee could see through a skin which was opaque to the man in the street. For no doubt Lawrence had a manner which might be put down to affectation by careless or unkind observers. It finds an echo in his writing. His letters are often stilted and artificial, even when addressed to his mother. So far as such things have an external cause, this arose partly from the hothouse atmosphere, of flattery and forcing, in which his mind had grown : partly from his consciousness that his talents were lifting him above the social level in which he was born. Ladies and gentlemen, a century ago, wrote almost as simply as they do now. But the gulf was wider between them and the class immediately below, who were apt to believe that good breeding and fine language should go together.

To turn to a more agreeable subject : Lawrence must have had a very sweet disposition to put up with the vagaries of his father and preserve his affection for that appalling parent unbroken to the end. Lawrence senior appears to have been totally unable to learn wisdom from experience. No sooner had he settled in London than he renewed his disastrous attempts to better the family fortunes. Williams tells us that, in 1787, when his second daughter Anne [1] came of age, he persuaded her to let him use, "for the good of the family," a legacy of £200 to which she was entitled under the will of a relation.[2] He invested the money in a collection of "curiosities." With these and some of his son's works he made a little exhibition. This failed to pay its expenses, and the collection was finally sold for a mere trifle. Four years later the painter himself came of age and received a similar legacy. This again his father handled. He took a long lease of No. 57 Greek Street, Soho, at a rent of £80 per annum. It was an ill-omened house. It had been occupied by a surgeon who was suspected of malpractices identical with those of which the patrons of Burke and Hare were to be accused half a century later. It had even been raided by the neighbours, who had taken up the floors and drains in quest of hidden "subjects." How this move turned out financially we do not know, but we may suspect

[1] Afterwards Mrs. Bloxam. [2] A Mr. Agaz.

it to have been a failure, like the others. None of the outside speculations of either father or son succeeded, and the family fortunes rested, from first to last, almost entirely on the earning power of the younger man.

When Lawrence came of age, in 1790, and moved to the home acquired with the help of Mr. Agaz's legacy, his future as a portrait painter had already been secured. He had been presented to the King—probably by West—and had painted both Queen Charlotte and the King's favourite daughter, Amelia.[1] The nine-teen-year-old painter seems to have stepped almost at once into the place left vacant by Gainsborough's death in 1788. Stories are told of his skill in making good his footing. " He pleased the princesses," says Cunningham, " by his manners, and he won the regard of the foreign domestics by well-timed and gentle flirtations with the spouse of one of the Court musicians. These latter were in their nature so harmless as to amuse the lady herself, and excite merriment in the King and Queen, who occasionally rallied him on his gallantry." This story sounds improbable enough, but in any case we cannot doubt that he won the King's approval at the earliest possible moment. For he was not yet twenty-one when George III " offered "—as they say in Ireland—to force the statutes of his own Academy in the young man's favour. At the election of Associates in November, 1790, Lawrence arrived at the ballot, being then but a few months over twenty-one. Wheatley beat him by sixteen votes to three. On this occasion Dr. Wolcot (" Peter Pindar "), assuming a number of unproved facts, attacked the Academy for resisting the King, Reynolds and West for supporting the King, and Lawrence himself, by a sort of back-hander, for aspiring to glory he had not earned. The following year, however, brought the young painter full compensation. He was elected to the Associateship in November, and within three months afterwards had succeeded Sir Joshua as painter in ordinary to His Majesty. The Dilettanti Society, following the Royal Academy's example, suspended one of its fundamental laws in his favour,[2] and elected him both a

[1] In September, 1789, he had been commanded to Windsor, with his " painting apparatus," the Queen proposing to sit on the 18th (Layard, p. 10).
[2] According to their Rules, only those who had visited Italy were eligible. This Lawrence did not do till many years later.

member of their body and their painter. Two years later, in February, 1794, he became a full Academician, wanting even then some three months of the age required by the statutes for the lower rank of Associate. " Never, perhaps, in this country," say the Redgraves, " had a man so young, so uneducated, and so untried in his art, advanced as it were *per saltum* to the honours and emoluments of the profession." The explanation, of course, is that the peculiar constitution of the Royal Academy, its entire dependence on the personal protection of the sovereign, from whose goodwill it obtained that " instrument " which gave it the status of a corporate body, made it unable, statutes or no statutes, to resist any intimation of the King's will.

PLATE X

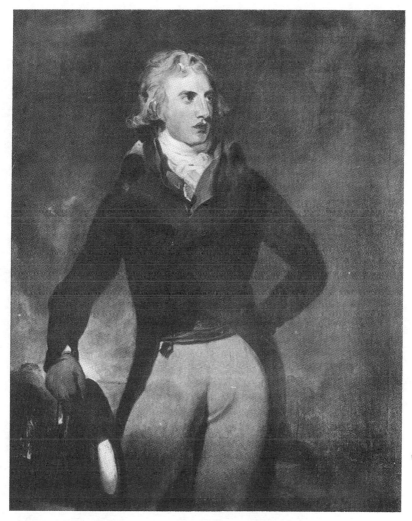

VISCOUNT CASTLEREAGH, LATER SECOND MARQUESS OF LONDONDERRY
FROM THE PAINTING IN THE POSSESSION OF THE MARQUESS OF LONDONDERRY

CHAPTER IV

EARLY TRIUMPHS IN LONDON

THE Royal Academy catalogue for 1790 includes the entry: "No. 41. Portrait of an Actress: Thomas Lawrence." The actress was Eliza Farren, who seven years later was to sign herself "Elizabeth Derby," and the picture was the famous canvas which lately passed from the collection of Lord Wilton into that of Mr. Ludwig Neumann.[1] In some ways this portrait corresponds, in the career of Lawrence, to the full-length of Keppel in that of Sir Joshua. But between 1753 and 1790 portrait painting had made such strides in England that, even with the assistance of the exhibition, the younger man did not repeat Sir Joshua's success with the public. The "Keppel" soon became famous, although but few people saw it, while the "Miss Farren" was received without any marked emotion. For more than twenty years visitors to the Academy had been accustomed to find from ten to thirty masterpieces of portraiture hanging on the walls at once. With all our admiration for our early school, we are apt to forget this amazing fact. Gainsborough and Reynolds were not only two of the greatest artists who ever painted portraits; they were also two of the most prolific. What should we think, in these days, if we had thirty portraits, all fine in colour, hanging in one exhibition? We should call it the best exhibition ever seen, and yet there would be but thirty good pictures among eighteen hundred; whereas in 1783, the last year of Gainsborough's appearance at Somerset House, the numbers in the catalogue only ran to a total of 465. And Hoppner was there as well. If Romney had done his share, the collection would have been more amazing still. With all this on the palates of the

[1] It has now become the property of Mr. Pierpont Morgan.

town, it was not surprising that the "Portrait of an Actress," work of a boy though it was, was not welcomed with more enthusiasm. Its practical results were great, however. It set Lawrence at once at the head of his trade. Sir Joshua's work was done. Hoppner, a dangerous rival, had to contend against an unlucky facility in rubbing people the wrong way. Raeburn was far away in Edinburgh. The younger man had come to London with a reputation; he had pleased the heads of his profession and won the patronage of the King; and this he had now followed up with a picture to which his admirers could point as a justification of all their panegyrics.

The "Portrait of an Actress" was last seen publicly at Burlington House, in 1904.[1] It was then hung in the same room with another important full-length, the "Cardinal Consalvi," painted in 1819. A comparison between the two showed that the youth of 1790 was technically the same man as the P.R.A. of thirty years later. The Cardinal was somewhat better in colour than the actress, but not so good in design, while the peculiar leathery texture of the paint was the same in both. The conception of the "Miss Farren" may have been suggested by Sir Joshua's "Lady Crosbie," painted and exhibited twelve years before. No evidence, however, of Lawrence having seen the Reynolds can be given. Both pictures contain the same idea, carefully differentiated, and both are open to those fault-findings in matters of literal fact which are so obvious and so irrelevant. Lady Crosbie prowls in a wet autumn park in her *robe de bal;* Eliza Farren muffles herself in furs to the chin in July. When this defect was pointed out, Burke consoled the painter very sensibly: "Never mind what the little critics say, for painters' proprieties are always the best." Miss Farren herself seems to have been put out of conceit with the picture by her friends. "One says it is so thin in the figure that you might blow it away; another that it looks broke off in the middle: in short, you must make it a little *fatter;* at all events, diminish the *bend* you are so attached to, even if it makes the picture look ill; for the owner of it (*Lord Derby?*) is quite distressed about it at present. I am shocked to tease you, and dare say you wish me and the portrait in the fire; but as it was

[1] Since this was written it has been exhibited at the Old Bond Street Gallery.

PLATE XI

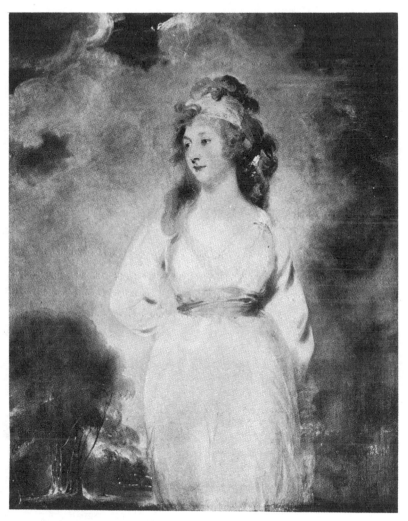

VISCOUNTESS CASTLEREAGH
FROM THE PAINTING IN THE POSSESSION OF THE MARQUESS OF LONDONDERRY

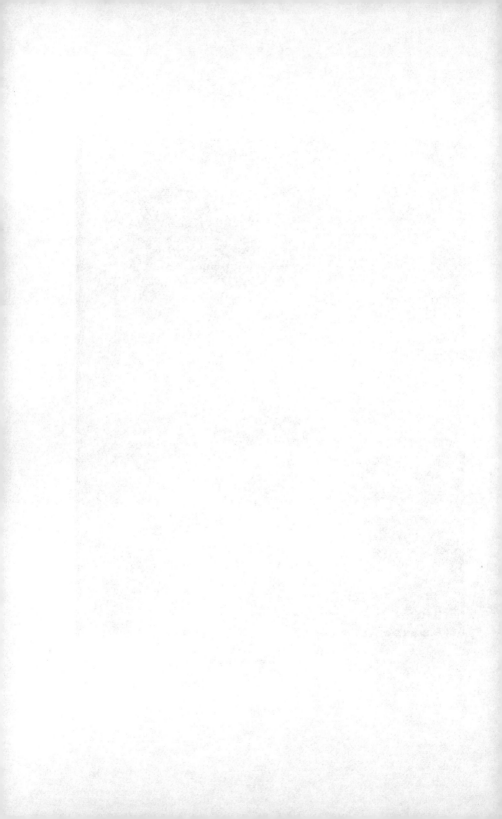

impossible to appease the cries of my friends, I must beg you to excuse me." [1]

The real defect of the Lawrence is its want of character as a work of art. If only the painter had contrived to see the thing as a whole, had breathed individuality into it, and made us feel that all its facts had an inevitable relation to each other, we could have forgiven the poor colour and unpleasing texture. But this he failed to do. Feeling no *necessity*, himself, for one thing more than another, he has left us with no deep impression of unity. His conception is essentially objective, a tasteful arrangement of selected facts rather than a new birth. His " Eliza Farren " may be more like the actress than Sir Joshua's " Diana Crosbie " was like the lively daughter of Lord George Sackville; that is possible enough; but Lawrence's *picture* is not a person, while that of Reynolds is.[2]

Here we strike the keynote to Lawrence's inferiority. Among the six men who made British portraiture illustrious during the reign of George III, he is held down in the lowest place, not so much by the weight of mannerisms and apparent affectations, as by the absence of that overpowering impulse towards creation through self-expression which must be at the root of all great art. A passionate attachment to any æsthetic virtue would have saved him. With Gainsborough, Reynolds, Raeburn, Romney, and, though to a less degree, with Hoppner, we feel that all subjects which offered themselves had to pass through their fire, had to be born again as their children, as the results of their own individual passion, before they could set out on their career of appeal to the world at large. With Lawrence we feel nothing of the sort. We can see him manipulating, arranging, feeling here for the air of fashion, there for the note of political strength or dexterity, or, again, of childish innocence. Now and then a face stimulates his curiosity, and leads him to do his best to set down what he sees;

[1] Layard, p. 15. Mr. Layard also prints (p. 12) the draft of a letter from the painter to his sitter, from which it appears that he had given serious offence by the form of the entry in the Academy catalogue. He explains that he had described his picture as the "Portrait of a Lady," and hints that the change to "Portrait of an Actress" had been made with some *malice* by the Academy officials.

[2] At the death of Eliza, Countess of Derby, her portrait passed into the possession of her only surviving child, Mary Margaret, who had married Thomas, second Earl of Wilton, in 1821. A copy hangs at Knowsley.

but he never succeeds in making the whole height and breadth of his canvas a thing created and alive. The French term *enveloppe* sounds too technical, perhaps,—it seems to connote skill rather than passion—for use in attempting to define what it is that Lawrence wants. But in truth it is *enveloppe* in its highest sense, the atmosphere which comes from a genius which will not be denied, that we miss.

I may be blamed for going too fast in thus discussing his defects in connection with the first ambitious picture he ever exhibited. My excuse for doing so is that, in essentials, his *art* never improved. As we see it in the "Portrait of an Actress," so it remained. He was sometimes to paint a better picture. Poor colour and unpleasing texture were often to be less conspicuous than we find them here. Subjects even better fitted to his powers than Miss Farren were to present themselves in his studio. But the temperamental coldness which prevents her portrait from taking a place beside a Gainsborough or a Sir Joshua marks his work to the end, and makes it impossible to take him to our hearts as we do his rivals.

By 1790, however, Lawrence had already been three years an exhibitor. In 1787 he had sent seven pictures to Somerset House, all portraits but two, "A Vestal Virgin" and "A Mad Girl." [1] In 1788 he had sent six, all portraits, and in 1789 thirteen, again all portraits. Among his sitters for this last year was the Duke of York, who was followed in 1790 by Queen Charlotte and the Princess Amelia, and in 1792 by King George himself. Such patronage as this encouraged the young painter to improve his style of living. In 1790, the year which saw him of age, he left the studio in Jermyn Street and established himself at 24 Old Bond Street. There he began those twenty years of rivalry with Hoppner in which the favour of the King was pitted against that of the Prince of Wales.

In those days Lawrence was considered a man's painter. Romney was still in full work, and Hoppner was next in favour with the ladies. Thanks chiefly to the mezzotints of Samuel Cousins, we are now apt to look upon the painter of "Lady Peel,"

[1] These two appear to have been pastels. The latter is now in the possession of Mr. Leggatt.

PLATE XII

RIGHT HON. JOHN WILSON CROKER, M.P.
FROM THE PAINTING IN THE NATIONAL GALLERY OF IRELAND

"Lady Gower," "Lady Dover," as essentially a painter of women. The plates after those pictures, and scores of others, have made us familiar with a Lawrence stripped of his worst faults. They have kept before us his brilliant facility, his vivacity, his sympathy with feminine modishness of a harmless kind, and have allowed us to forget his shortcomings as a colourist and brusher. But the public of a century ago was right. His best pictures are those of men. Before a male sitter whose head betrayed the "moving accidents" through which he had passed, a curiosity stirred in Lawrence which no woman could excite. In his long series of male portraits qualities more serious, more interesting, are to be discovered than anything in his pictures of the other sex. Pius VII, William Pitt, Wilberforce, Curran, Sir John Moore, Consalvi, above all, perhaps, Warren Hastings, drew out powers of divination and co-ordination he never displays in his pictures of women.

That by the way. Let us go back to our summary of Lawrence's work at this period of his life, the period which stretched from his first establishment in London to the disappearance of all serious rivalry through the disablement of Romney and Hoppner, and the successful repulse of Raeburn.[1]

In the Academy catalogue of 1792 the "A" is affixed to his name, his election as an Associate having taken place, as already told, in the previous November. Shortly before the exhibition opened, he was nominated Principal Painter in Ordinary to the King in succession to Reynolds. He also succeeded Sir Joshua as painter to the Dilettanti Society; the Society's law that all candidates for membership should have visited Italy being suspended in his favour. On his flitting from Jermyn Street to Old Bond Street he seized the opportunity to raise his prices, charging a hundred guineas, fifty guineas, and twenty-five guineas respectively for a full-length, a half-length, and a head.

In 1793 he sent nine pictures to the exhibition—"Prospero Raising the Storm" and eight portraits. The portraits were of Mr. Whitbread, Sir George Beaumont, the Duke of Clarence, Lord Abercorn, Hon. Fred Robinson (afterwards Viscount Goderich and Earl of Ripon), Mrs. Finch, Lady Catherine Harbord, and

[1] The story that Raeburn was dissuaded from settling in London by the arguments of Lawrence may not be true, but it seems probable enough.

SIR THOMAS LAWRENCE, P.R.A.

Mr. (afterwards Earl) Grey. In 1794, when he exhibited as an incomplete Academician—"R.A. elect."—he again sent eight portraits, among them those of Sir Gilbert Elliot, the Archbishop of Canterbury, Lord Auckland, Lady Emily Hobart (afterwards Lady Castlereagh and Marchioness of Londonderry), and Mr. Richard Payne Knight. This year was marked by an outbreak of more than ordinary virulence from "Peter Pindar,"[1] "Anthony Pasquin,"[2] and other mad dogs of the Press who then passed for critics. "As this portrait (Sir Gilbert Elliot) is not finished, I shall forbear to investigate its merits or demerits"; "this likeness of the spiritual Lord of Canterbury conveys a full idea of the florid, well-fed visage of this fortunate arch-prelate; and a monk better appointed never sighed before the tomb of Becket"; "this heterogeneous nobleman (Lord Auckland) is so fantastically enveloped in drapery that I cannot ascertain what is meant for his coat, and what for the curtain"; "this likeness of Mr. Knight is repulsive in the attitude. It fills me with the idea of an irascible pedagogue explaining Euclid to a dunce. Mr. Lawrence began his professional career upon a false and delusive principle. His portraits were delicate, but not true and attractive—not admirable; and because he met the approbation of a few fashionable spinsters (which, it must be admitted, is a sort of enticement very intoxicating to a young mind), vainly imagined that his labours were perfect; his fertile mind is overrun with weeds; appearing to do well to a few, may operate to our advantage in morals, but will not be applicable to the exertion of professional talents. Many have caught at transitory fame from the ravings of idiotism, but none have retained celebrity but those who have passed through the fiery ordeal of general judgment. There appears to be a total revolution in all the accustomed obligations of our being. Men can do as well and be as much respected, now, after the forfeiture of character, as before; and artists seem to think that they can paint as well, and be as much encouraged, without a knowledge of the common elements of their profession as with them. This surely is the Saturnalia of vice and insignificance." That, surely, is the Saturnalia of criticism, to string together a number of assertions which

[1] John Wolcot (1738–1819), priest, physician, and versifying satirist.
[2] John Williams (1761–1818), professional satirist, and defendant in suits for libel.

have no relation to an inquiry into a painter's merit, and no result, except to prove the willingness to wound of their author. This same " Anthony Pasquin," a year or two later, finds it convenient to say : "I have much reason to believe that this gentleman (Lawrence) has been injured in his professional movements by the presuming interference of men who were not calculated to pass judgment on the Fine Arts." It is a pity he did not hit a little sooner upon that idea ![1] But, in the words of Hazlitt, the object of such a critic is "not to do justice to his author, whom he treats with very little ceremony, but to do himself homage, and to show his acquaintance with all the topics and resources of criticism."

Lawrence was not a man who could profit much by criticism. Sir Joshua, impervious to attack as he seemed, would probably have given due weight to anything said even by a professed enemy which appeared to have some foundation. His career was so controlled by judgment that we cannot believe he would have rejected truth even had it issued from the lips of Williams or Wolcot. It was not so with Lawrence. Neither his character nor his training predisposed him to take in, digest, and re-create ideas. He perceived and arranged ; seeing the outside of beauty, and a little beneath it in the case of men and women with history in their faces. Abuse would only make him angry for an hour, and depressed, perhaps, for a week, but would have no permanent effect either on his art or his happiness. Certainly we can discover no change or faltering after 1794. The storm, provoked, no doubt, as much by his rapid elevation on official stilts as by anything in his art, subsided as fast as it arose. Pasquin made no allusion to him in 1795, beyond saying that his portraits were among the best in the exhibition.

The early months of 1795 were marked by another change of address. He left Old Bond Street for Piccadilly, where he took a house facing the Green Park. Among the nine pictures he sent to Somerset House, the best, no doubt, was the full-length of Miss Mary Moulton Barrett, exhibited as " Pinkie " at the " Old Masters " of 1907. It was catalogued as the " Portrait of a Young

[1] Pasquin follows up this unconscious hit at himself with a gibe against Arthur Young, for saying that Sir Robert Strange's plate after Raphael's "St. Cecilia" had "done ample justice to the original," an opinion which a hundred years of consideration has confirmed.

Lady." It may fairly be considered the masterpiece of Lawrence, during his early maturity, in that lively, momentary manner which he was afterwards to make so popular. In colour and method of painting it repeats the "Miss Farren," and is open to the same strictures. But the design is so agreeable, the vivacity so spontaneous, and the snatch at nature so sincere and vigorous, that we forgive the rest. This canvas was accompanied to Somerset House by a portrait of Cowper. The poet had made the painter's acquaintance two years before. Williams prints a letter in which occurs a testimony to the painter's general charm as strong as any we can quote. " As often," Cowper writes, "as I have comforted myself with the hope of seeing you again soon, I have felt a sensible drawback upon that comfort from the fear of a disappointment, which considering your profession and your just pre-eminence in it, appeared to me extremely probable. Your letter, most welcome otherwise, gave me this most unwelcome information the moment I saw your name at the bottom of it. . . . You do me justice, if you believe that my invitation did not consist of words merely; in truth it was animated by a very sincere wish that it might prove acceptable to you : and once more I give you the same assurance that at any time when you shall find it possible to allow yourself some relaxation in the country, if you will enjoy it here, you will confer a real favour on one whom you have already taught to set a high value on your company and friendship. I am too old to be hasty in forming new connexions : but short as our acquaintance has been, to you I have the courage to say, that my heart and my door will always be gladly open," etc. This was written at the end of 1793, when Cowper was sixty-two and Lawrence twenty-four. It is true that the poet's recovery from his last attack of madness, six years before, had never been quite complete, but there is no echo of his affliction in his letter.

To the 1796 exhibition Lawrence sent eight portraits ; to that of 1797 six pictures, five portraits and the notorious " Satan calling his Legions." In the catalogues for these years his address is given as " Piccadilly." In 1798 it is changed to that house in Greek Street, Soho, in which his parents had been living ever since their move from Duke Street. His mother had died in May, 1797.

PLATE XIII

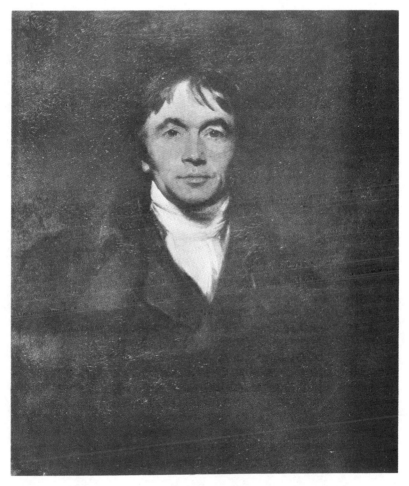

JOHN PHILPOT CURRAN
FROM THE PAINTING IN THE NATIONAL GALLERY OF IRELAND

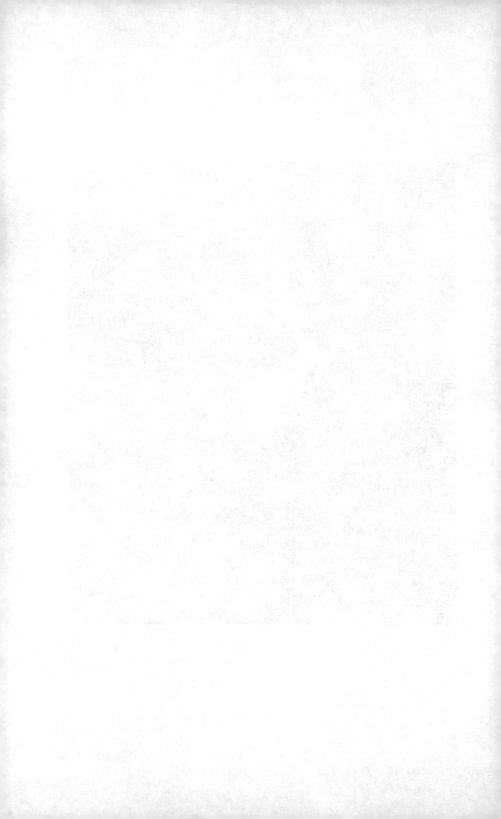

He had thus announced her death to a friend within a few minutes, apparently, of its occurrence :—

"I have mentioned other griefs in order to turn my thoughts from that pale virtue whose fading image I can now contemplate with firmness. I kiss it, and not a tear falls on the cold cheek. You can have no notion of the grand serenity it has assumed. I think, I cannot but persuade myself, since the fatal stroke, it seems as if the soul, at the moment of departure, darted its purest emanations into the features, as traces of its happier state. Have you seen death often ? . . . But half an hour since, I had the dear hand in mine, and the fingers seemed unwilling to part with me."

Six months later he lost his father also. Some weeks before his death he—the son—had written :—

"I have not yet let or sold my house, and matters in Greek Street are as they were. My father, at times, is much troubled with his cough ; but I hope and believe he is not otherwise worse than when you saw him, but rather better. The country air, peace, and content, will, I trust, soon restore health, and gratify the wishes of his children, to whom, whatever difference of character or disposition there may have been, his essentially worthy nature and general love for them make him too dear an object of regard, not to form the greatest portion of their solicitude. To be the entire happiness of his children is, perhaps, the lot of no parent."

"To be the entire happiness of his children" : by this phrase he meant, no doubt, "to be the cause of nothing but happiness in his children." In October he writes :—

"My dearest Friend,—

"The cause of my silence is a terrible one—my father's death. He died before I could reach him ; but he died full of affection to us, of firm faith and fortitude, and without a groan."

Lawrence was at work in his Piccadilly studio when a servant burst in and said his father was dying. He rushed out without his hat and ran to Greek Street, but Death was there before him.

SIR THOMAS LAWRENCE, P.R.A.

He appears to have soon changed his mind about letting or selling the Greek Street house, for six months later he had moved there from Piccadilly. He had contrived to form a lofty studio by removing the floor between the first and second stories, so that he could admit light from the upper row of windows when required. Here he worked for sixteen years, his final address of 65 Russell Square[1] appearing for the first time in the catalogue for 1814. The years from 1794 to 1814 may be conveniently taken as his middle stage. The period before was more or less tentative, with frequent changes of *milieu* as well as medium, and a rapid rise from provincial to metropolitan reputation, while the years which were to intervene between his move to Russell Square and his death were marked by the increased opportunities brought by the peace of 1814, and the crowding westwards of the Sovereigns and great captains of Europe.

The picture of " Satan calling his Legions " now hangs on the staircase of the Diploma Gallery in Burlington House. It is enough, by itself, to justify any biographer of Lawrence in refusing to waste time over his incursions into " history." Pasquin called it " a mad German sugar-baker dancing naked in a conflagration of his own treacle "; Fuseli said it was " certainly a d——d thing, but not the Devil," and we cannot honestly disagree with either. The painter has had nothing whatever to say. The idea of Satan summoning his army has suggested merely an attitude, an attitude so commonplace that we might count upon a fourth-rate actor taking it in a harangue to the pit. Fanny Kemble[2] tells a story of her introduction to this picture, which seems to claim for it the power to impress some one; and Cunningham reports a curious conversation about it with Lawrence himself. " The last time I had the pleasure of being alone with him," he says, " these were his words: ' Fuseli, sir, was the most satirical of human beings; he had also the greatest genius for art of any man I ever knew. His mind was so essentially poetic that he was incapable of succeeding in any ordinary subject. That figure of Satan, now before you,

[1] The house was pulled down in 1910 to make room for an hotel extension. It was numbered 65 until its disappearance. The rooms were few, but very large, and would not in these days be considered suitable for painting in. The lighting seems to have been entirely from the east and west, and the windows not very high.

[2] *Records of a Girlhood.*

38

PLATE XIV

THE COUNTESS OF DYSART (SECOND WIFE OF FOURTH EARL)
FROM THE PAINTING IN THE POSSESSION OF COL. D. J. PROBY

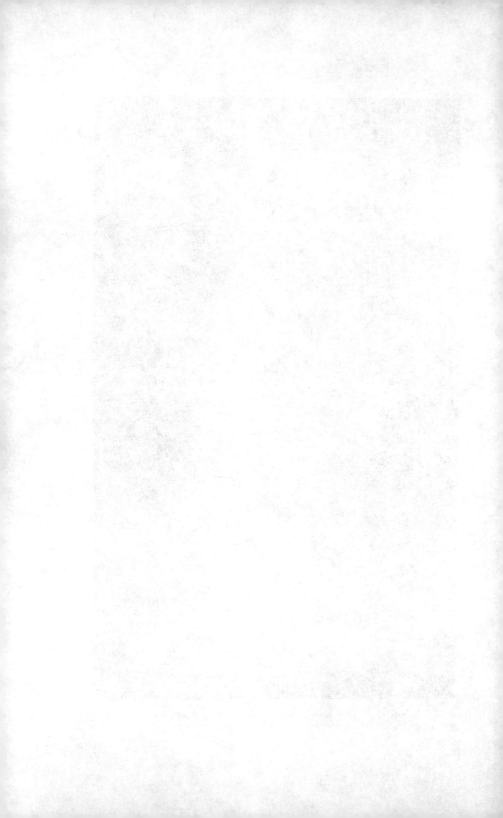

occasioned the only interruption which our friendship, of many years' standing, ever experienced. He was, you know, a great admirer of Milton, from whom he had made many sketches. When he first saw my Satan he was nettled, and said, " You borrowed the idea from me." " In truth, I did take the idea from you," I said, " but it was from your person, not from your paintings. When we were together at Stackpole Court, in Pembrokeshire, you may remember how you stood on yon high rock which overlooks the bay of Bristol and gazed down upon the sea which rolled so magnificently below. You were in raptures ; and while you were crying, ' Grand ! Grand ! Jesu Christ, how grand ! how terrific !' you put yourself in a wild posture. I thought on the Devil looking into the abyss, and took a slight sketch of you at the moment. Here it is. My Satan's posture now was yours then !" ' " Many years before, he had been tempted by some admirers to recite Satan's address to the Sun. He opened his Milton to begin, when a piece of paper dropped out on which was written in his father's hand : " Tom, mind you don't touch Satan." All those who climb the backstairs at Burlington House will share the Redgraves' regret that he did not bear the warning in mind.

Happily Lawrence was not encouraged to renew such attempts. He never realized his own limitations. He continued to the end of his life to cherish a belief that he would have shone in the Grand Style if conditions had been favourable. But he yielded gracefully to the persuasion of his interest, and made none of those struggles against an obvious vocation which have prevented or delayed the triumph of more stubborn characters. His nearest approaches to success in what are called, so clumsily, subject pictures are to be found in a few portrait groups which have come down to us under fancy names, such as that group of the Calmady children which Cousins engraved as " Nature," and the *tondo* of a young woman, a child, and a dog, in the Duke of Abercorn's collection.

CHAPTER V

THE TRAGEDY OF THE SIDDONS

THE Manchester Exhibition of 1857 included a chalk portrait of Mrs. Siddons by Lawrence, which was described in the catalogue as done when the lady was twenty: that is, in 1775. It was lent by George Combe, the phrenologist, who married Cecilia, the third daughter of the actress, and died in 1858. In 1775 Lawrence was six years old, so that if Combe was right in his facts, the acquaintance which led to so much began very early indeed. In 1775 the majestic Sarah had been married two years. She had acted with her husband at Cheltenham, and was on the eve of that fiasco at Drury Lane which preceded her triumph in the same house by no less than seven years. It is possible that before her journey to London, in 1775, or on it, she may have stopped at Devizes and sat to the infant prodigy at the " Black Bear." But it seems more probable that Lawrence's first draught of her features was made in Bath, where she spent most of her time and energies between 1777 and 1781. Judging from the hair, costume, and features, the pastel in the National Gallery belongs to about the latter year. The acquaintance between painter and sitter fast ripened into a close friendship, so that when Lawrence established himself in London, the Siddons' house became a second home.

In 1786 the family consisted of the actress, her husband, and four children, two boys and two girls. In that year the elder girl, " Sally," was twelve, and Maria seven. In 1790 these two were sent to school at Calais, where they remained until shortly before war broke out with the French Republic in the February of 1793. Returning to London, they found Lawrence's foot securely established on the ladder of fame, while their own beauty soon

allowed them to stretch out a timid toe to the same inviting ascent. They were both *poitrinaires,* and we know from various sources, including the correspondence of Mrs. Piozzi, that immediately on their return to England both had attacks of illness which caused anxiety. How soon the friendship with Lawrence ripened into love it is impossible to say. In the light of after events it seems probable that both girls soon lost their hearts to him, and that he so far returned their double passion that he could not decide without experiment which he preferred! He tried Sally first. Some time before 1797, probably in 1795, when the lady was twenty, the pair came to an understanding, and, apparently, won the consent of Mrs. Siddons to some sort of engagement. Informal it must have been, for Mr. Siddons was not taken into their confidence. In her *Records of a Girlhood,* Fanny Kemble, the girl's first cousin, gives an account of the whole affair, but her statements are not always consistent with the facts as we may glean them from the letters of Lawrence and the Siddons family.[1] Upon these letters the following sketch of what occurred is based.

So far as we can now tell, the loves of Lawrence and Sally floated on smooth waters but a short time. For by the end of 1797 the younger sister, Maria, is writing to a friend in terms which imply rights over the young man. About this time the engagement to Sally was broken off, and the sanction of the girl's mother obtained to the transfer of the young man's allegiance to Maria. How this had been managed we can only guess, but what we know of the characters involved enables us to guess with some confidence. Sally's character was nobler than her sister's. She was more sensible, more unselfish, and better endowed with the virtue moralists call humility. She thought it natural that Lawrence should prefer Maria, who was better looking, more vivacious, and more self-assertive than herself. There seems to be no doubt that the change was quietly made. It was accomplished, at any rate, without any serious opposition from the mother, and Maria's letters never show the least sign of remorse. It appears likely that Sally had noticed Maria's growing love, and

[1] *An Artist's Love Story:* told in letters of Sir Thomas Lawrence, Mrs. Siddons, and her daughters. Edited by Oswald G. Knapp, M.A. (London, 1904). "An Artist's Love Story," by Lady Priestley (*Nineteenth Century* for April, 1905).

a certain reciprocity in Lawrence, and that she sacrificed herself deliberately to make them happy. We know from what occurred later that her own attachment had never waned, and so can only suppose that, in her want of experience, she thought she was acting for the best in submitting without a word to her supersession. The strange thing about it all is that her mother was not clearer sighted. Mrs. Siddons not only failed to oppose, she even agreed to an understanding so secret that it had to be concealed from Mr. Siddons by telling fibs. Maria was allowed to meet her lover *sub rosa*, with no overlooker except a young unmarried friend, Miss Bird. In a letter to this lady, written about the end of 1797, Maria describes how she came home from one of these clandestine meetings so late in the afternoon that she had to change her dress in the dark—" I would not ring for candles," she says, " that they might fancy I had been in a great while "—and how, when she came down about the middle of dinner, " my father ask'd me where I had been, I told a story, and there was an end of it ! " In the same letter she says that Sally has been very ill. She sends notes to Lawrence by Miss Bird, because her mother does not like to carry a letter.

These meetings and note-carryings, which persisted through the last few weeks of 1797, were accompanied by such a rapid failure in Maria's health that at last Mr. Siddons was confided in and a formal engagement between the young people sanctioned. A letter from Sally, dated January 5th, 1798, announces this to Miss Bird :

" I'm sure you are impatient to hear how Maria is. . . . She is, dear girl, to all appearance, very much better, but Dr. Pierson does not say so ; he seems entirely to rely on her pulse, and that goes (or at least did yesterday) at the same galloping rate that it has done for this week past. He says she is in a *very* doubtful state, and has given us too plainly to understand that a consumption may be the consequence. . . . Do not, for Heaven's sake, breathe a syllable . . . which may reach Mr. Lawrence's ears, for `I suppose, if he could imagine her so seriously ill, he would be almost distracted, now especially, when every desire of his heart is, without opposition, so near being accomplished. For now, dear Miss Bird, I must tell you a piece of good news, which will,

PLATE XV

A CHILD WITH A KID (LADY GEORGIANA FANE)
FROM THE PAINTING IN THE NATIONAL GALLERY

THE TRAGEDY OF THE SIDDONS

I know, surprise and please you; my father at last consents to the marriage, and Mr. Lawrence has been received by him in the most cordial manner as his future son-in-law. . . . Should not this happy event have more effect than all the medicines? At least I cannot but think it will add greatly to their efficacy. But what will our friend do without some difficulties to overcome? But perhaps, in this pursuit, he has found enough to satisfy him, and will be content to receive Maria, tho' there now remain no obstacles. Well, I rejoice sincerely that there is an end to all mystery, and I think Maria has as fair a prospect of happiness as any mortal can desire."

Unfortunately, Maria's ill-health and Sally's only half-smothered affection were not the only obstacles to that happiness. Lawrence himself was not sufficiently in love. Sally hit the nail on the head when she asked, "What will our friend do without some difficulties to overcome?" Lawrence the lover answered to Lawrence the artist. His passion was superficial, depending rather upon the febrile excitability developed by opposition than upon a tap root, drawing its nourishment from the depths of his nature. No sooner was all resistance overcome than his feelings for Maria began to cool and those for Sally to revive. The change was quickly felt by Maria. Coupled with blood-letting and bad air—the treatment then meted out to consumptive patients—it may have hastened her end. The recent discovery—in the legal sense—of two long letters from Sally to Lawrence throws a vivid light on their proceedings. Neither letter is signed, but the later of the two is dated 24th of April, 1798, more than five months before the death of Maria.[1] They are too long to quote. The reader must be referred to Lady Priestley's article, where they are printed in full. They show clearly enough that Sally's heart had been all the time in the painter's keeping, and that her withdrawal before Maria had been dictated partly by sisterly affection, partly by youthful ignorance of how a passion reined in can avenge itself. Her affection is not blind. She understands the danger she runs from her lover's inconstancy. "Need I tell you there is one (*if he is but constant*) whose company I would prefer to all the world?"

[1] These letters are printed by Lady Priestley in the *Nineteenth Century* for April, 1905. They have been preserved among the letters of the painter's sitters, which are now in the possession of the Keightley family.

"Think not when you have won my heart you may abandon me and I shall soon recover. I tell you now, before you proceed any further, that *if I love you again* I shall love more than ever, and in that case *disappointment* would be *death.*" (The italics are Sally's own.)

In this same letter she tells Lawrence that she waits "but for the time when Maria shall be evidently engaged by some other object" to declare her intentions, also that his absence affects Maria so little that she, Sally, was convinced that her sister had never loved. These comfortable dreams were to have a rude awakening.

During the summer of 1798 Maria's health rapidly failed, until with the approach of autumn it became evident that the end could not be long delayed. It came at Clifton, on the 7th October, and the following day Mrs. Pennington, a lady under whose roof the last weeks had been passed, wrote a letter to Lawrence in which these passages occur:—

"How am I to proceed? How tell you that all you feared has happened? In her dying accents, her last solemn injunction *was* given, and repeated some hours afterwards in the presence of Mrs. Siddons. She call'd her sister—said how dear, how sweet, how good she was—that one only care for her welfare pressed on her mind. 'Promise me, my Sally, never to be the wife of Mr. Lawrence. I cannot bear to think of your being so.' Sally evaded the promise; not but that a thousand recent circumstances had made up her mind to the sacrifice, but that she did not like the positive tye. She would have evaded the subject also, and said, 'Dear Maria, think of nothing that agitates you at this time.' She insisted that it did not agitate her, but that it was necessary to her repose to pursue the subject. Sally still evaded the promise, but said, 'Oh! it is impossible,' meaning that she should answer for herself, but which Maria understood and construed into an impossibility of the event ever taking place, and replied, 'I am content, my dear sister—I am satisfied.' . . . She desired to have prayers read, and followed her angelic mother, who read them, and who appeared like a blessed spirit ministering about her, with the utmost clearness, accuracy, and fervour. She then turned the conversation to you, and said, '*That man* told you, mother, he

had destroyed my letters. I have no opinion of his honour, and I entreat you to demand them'; nor would be easy until she (Mrs. Siddons) had given the strongest assurances that she would use every means in her power to procure them from you, or a confirmation that they were destroyed. Strong and delicate were the reasons she alleged for this request. She then said Sally *had promised her never* to think of an union with Mr. Lawrence, appeal'd to her sister to confirm it, who, quite overcome, reply'd, ' I did *not* promise, dear, dying Angel, but I *will*, and *do*, if you require it.' 'Thank you, Sally: my dear Mother, Mrs. Pennington—*bear witness*. Sally, give me your hand—you promise me never to be his wife; Mother—Mrs. Pennington—lay your hands on hers' (we did so). ' You understand ?—bear witness.' We bowed and were speechless. 'Sally, sacred, sacred be this promise'—stretching out her hand and pointing her forefinger—'Remember me, and God bless you.'

"And what, after this, my friend, can you say to Sally Siddons? She has entreated me to give you this detail—to say that the impression is sacred, is indelible—that it cancels all former bonds and engagements—that she entreats you to submit, and not to prophane this awful season by a murmur."

To analyse the feelings of Maria Siddons in exacting this pledge, and of Sally in submitting to it, is not our business, but the sentiments of Lawrence are a different matter. In describing the career of an artist, nothing should be neglected which will help us to build up our idea of that personality on which the value of his art depends. The history of the most tragic of Lawrence's many love affairs, and the only one on which our information is fairly complete, throws too strong an illumination on his character to be ignored. In love he showed the vivacity, facility, and want of depth we find in his art. He passed from Sally to Maria, and back again to Sally, just as he passed from one sitter to another. He was satisfied with the first emotions aroused, and accepted them as a sufficient foundation for happiness in love, exactly as he accepted the effect produced by a fine lady in his sitter's chair as a basis for art. He felt no compulsion to go deeper, to reach those more intimate sympathies in which a single-hearted sexual love and a genuine gift for æsthetic creation

are alike rooted. From the whole story of his dealings with the daughters of Mrs. Siddons, and especially from his letters to the mother and Mrs. Pennington, we gather an impression so entirely consistent with his art, that we feel we can accept their witness to his character with unusual security.

Sally Siddons kept her promise to Maria, in the letter, though not in the spirit. During the five years of life which remained to her, she seldom met Lawrence, but the letters published by Mr. Knapp show that if the painter had chosen to come forward, he would have found her love too strong for her resolution. But his *feu de paille* had died out, and poor Maria's soul remained at peace. Sally died in March, 1803, of the disease which had carried off her sister less than five years before.

Here, perhaps, it would be well to say what little more need be said of Lawrence's amorous adventures. It cannot be denied that he was a philanderer all his life. He was continually getting into scrapes of varying severity through his passion for dancing round the fire, heedless as to whether his partner singed her skirts or not. His *amitiés amoureuses* were numerous, and, of course, both at the time and after he died, they gave rise to gossip. Mr. Layard prints a curious document " written in what is suspiciously like Lawrence's own handwriting, but signed ' Lavater,' " which poses as a character of the artist by the famous physiognomist. It is dated 6 March, 1810, nine years after Lavater's death, so we may accept Mr. Layard's theory that it really is the painter's own view of himself. Now, although men form illusions about their own powers and have no gift for seeing themselves as others see them, they know the foundations of their own characters vastly better than even their most intimate and perspicacious friends. So that we shall do Lawrence no injustice if we allow his own confession to colour our ideas as to how he behaved in his relations with women.

" In the lower part of the cheeks and the play of Muscles round the Mouth there are Passions powerful to ruin, to debase or elevate the Character. The Mouth itself has strong but impetuous determination and there is some appearance of fortitude in the Chin but wholly unconnected with Reason. Indeed of that Philosophy which can mould wishes to circumstances and subdue

46

PLATE XVI

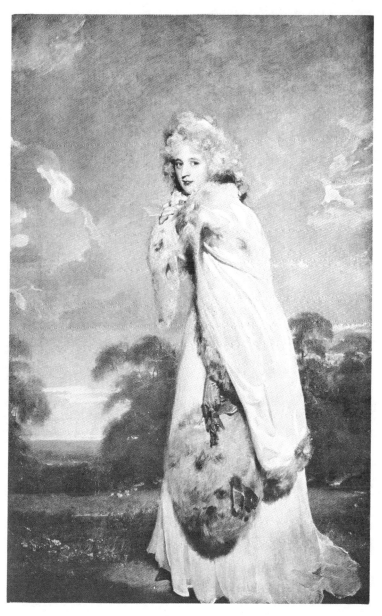

ELIZA FARREN, COUNTESS OF DERBY

FROM THE PAINTING IN THE POSSESSION OF J. PIERPONT MORGAN

the influences of Passion to those of Fortune this Countenance has not a Vestige." "The power of the Senses certainly is great yet the Traits that mark the Voluptuary stamp him not with grossness. They speak him *Man* but not unmindful of his purer nature."

In spite of their pomposity, these sentences have the ring of sincerity, and it would be absurd to contend that he who could write them of himself had deliberately stopped short of life's full experience. But that is all we can say. Many women flash across the path of Lawrence, and a few "set" him part of the way, some even to the end. But no evidence has come to light which would justify us in asserting that any one among them was more than the heroine of an emotional friendship. Only once, in the case of Mrs. Wolff, do we get hints [1]—and those the vaguest—of love on his side. But the same can hardly be said of the ladies. From Mrs. Siddons downwards—I mean in age!—they vibrated to his charm, and a delicate perfume of more than friendship seems to breathe from their letters. Lawrence himself was either very wary indeed, or never sufficiently moved to make him cautious. He went through life stirring passions all about him, but feeling, perhaps, nothing more fatal than tender emotions and flattering remorses. Shortly after his death Fanny Kemble wrote to a friend: "The elegant distinction of his person, the exquisite refined gentleness of his voice and manner—had I sat to him for the projected portrait of Juliet, in spite of the forty years' difference in our ages and my knowledge of his disastrous relations with my cousins, I should have become in love with him myself and have become the fourth member of my family whose life he had disturbed and embittered. His sentimentality was of a particularly mischievous order, as it not only induced women to fall in love with him, but enabled him to persuade himself that he was in love with them, and, apparently, with more than one at the same time!" [2]

For such a man to approach the wife of the Prince Regent was obviously dangerous. However little might actually come of the friendship, the reputations of both were such that tongues would

[1] See the letter quoted by Mr. Somes Layard on p. 148, and its significant mutilation.
[2] J. B. Frith, *Fortnightly Review* for April, 1905.

most certainly wag. And so, when the famous " Delicate Investigation" began in 1806, Lawrence had to defend himself against the charge of being one of the Princess's lovers. This he did not only to the satisfaction of the Commissioners, but even to that of society at the time. For a year or two, however, the ladies who sat to him were less numerous than before.

PLATE XVII

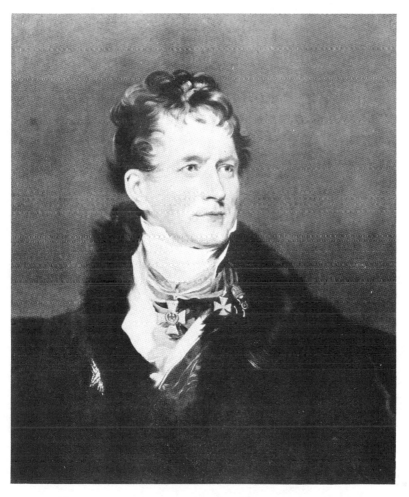

BARON FRIEDRICH VON GENTZ
FROM THE PAINTING IN THE FÜRSTLICH METTERNICHSCHEN GEMÄLDE-GALERIE, VIENNA

CHAPTER VI

LAWRENCE'S MIDDLE PERIOD—HIS RIVALS—THE POPULARITY OF PORTRAIT PAINTING IN ENGLAND—ITS CAUSE

BETWEEN the close of the Siddons episode and the end of the war with France, the career of Lawrence was comparatively uneventful. His position as a portrait painter was firmly established, and he grew steadily in favour as a social unit. His most dangerous competitors fell away in rapid succession. These were Opie, who died in 1807; Hoppner, who lost his reason some years before his death in 1810; Beechey, who survived Lawrence; and William Owen, who, like Hoppner and Romney, sank into mere existence during the last years of his life. In 1810, indeed, a greater rival threatened danger for an hour. Mr. Henry Raeburn paid a visit to London and sounded Lawrence as to what success he might find if he migrated from the Scottish to the English capital. The story goes that he was persuaded to rest content with his northern monopoly, and not to risk his own position—and that of Lawrence!—by coming south. From our point of view, it is a pity the Scot was so easily discouraged. The one thing he wanted to bring out all his powers was a spur to his ambition. In Edinburgh he was too *facile princeps*. A struggle between himself and Lawrence might have done good to both.

Hoppner is now so fashionable that I may be blamed for putting anyone above him among the contemporaries of Lawrence. But I think there can be no doubt that Raeburn was the greater artist, actually, and much the greater, potentially, of the pair. Nearly all Hoppner's art was echo. As a portrait painter he based himself on Reynolds, with a strain of Gainsborough thrown in. This derivative quality is well illustrated by his sketches of landscape. These are first-rate in themselves, but they are so

dependent on Gainsborough that more than a glance is often required to discover their true authorship. Originality is of two kinds. The more obvious sort is merely difference—difference between the works of any given artist and those of other people. This kind leads too often to productions which have no merit but novelty, like certain readings of Shakespeare we have seen in these latter years. The right sort of originality is synonymous with sincerity. No two men's individualities are identical in their tendency, and the painter we love is he who contrives to express an interesting personality in terms of art. We can accept any personality but the negative. Boswell's genius for worship, his capacity for spending on another man a passion most people lavish on themselves, has made him immortal. And if a painter could make his work explain the powers and character of another as Boswell explains Johnson, he might claim a similar immortality. But echoes are not explanations. Hoppner is contained in Reynolds and Gainsborough, and so, in spite of his undeniable charm, he will never stand up before us as a great person, like the other two; or like Raeburn, who deserves a place among the few painters who have given the world something at once new and good.

Accidents have secured for John Opie, the " Cornish wonder," all the fame he deserves, in spite of the comparative rarity of his work. None of his better pictures have yet found their way into the national museums, but his links with the world of letters have saved him from falling into the obscurity which might otherwise have been his fate. As for Beechey, he might have won a great place in the English school had he been able to live up to the standard set by his best works, such as the large " Review," at Hampton Court, or the really splendid " Sir John Read," which was lately passing through the picture market. But the vigour and breadth there so conspicuous are not repeated in his later productions.

The case of William Owen is rather different. Various causes have united to delay the recognition of his considerable powers. He is entirely ignored by such historians of English painting as the brothers Redgrave. No good example of his art has yet been acquired by any of the metropolitan collections. His style was not suited to the portrayal of pretty women, so the modern

PLATE XVIII

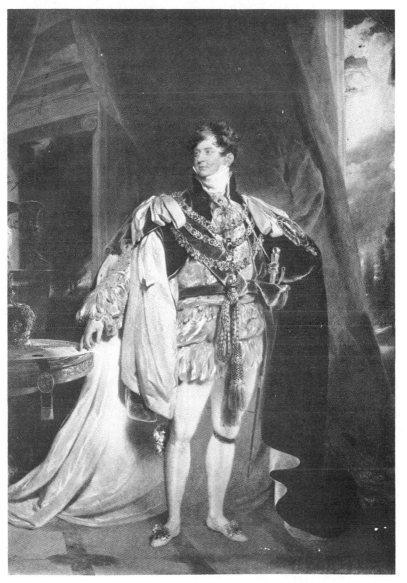

GEORGE IV

FROM THE PAINTING IN THE VATICAN, ROME

millionaire and his purveyor take no interest in what he did. And, it must be confessed, his imagination was not specifically pictorial. He turned a portrait into a work of art by the simplicity of his purpose and the broad vigour of his execution, when, as a conception, it had scarcely been above the level of a commercial photograph. Some of his better things are well known as engravings: the " Dean Cyril Jackson," at Christ Church, for instance. Still better and more characteristic are the " Lord Tenterden," at Corpus, and " Lord Eldon," at University, which were also included in the Oxford Loan Exhibition of 1906. Owen painted subject pictures too, but there his want of imagination told against him too strongly, and in spite of a power to draw and model which was rare in the England of his time, his works of that class are on a much lower plane than his portraits. Owen was more than half a Welshman. He was born at Ludlow in 1769—a vintage year for men!—and so was exactly Lawrence's contemporary. He rapidly won a high position in the art world of London, for the exhibition of 1798 included nine portraits by him, two of the sitters being the Lord Chancellor[1] and the " Lord Warden of the Cinque Ports."[2] In 1810 he became portrait painter to the Prince Regent, and was offered knighthood. The last years of his life were passed in almost total helplessness. His death, in 1825, was caused by his taking a fatal dose of opium, through a chemist's blunder.

Owen was to the England of 1800 much what Bonnat has been to the France of the last forty years. He was not inspired by beauty, or by the decorative impulse, or by any comprehensive sense of the possibilities of æsthetic expression. He loved to say trenchantly what he had to say. The first idea suggested by a sitter appeared to him good enough to be the foundation of the fat, vigorous painting in which he excelled. He was not a colourist, but his colour is seldom actively disagreeable. He was no master of design : he would probably have denied its existence in the sense in which the word is here used; but as a rule he contrived to bring a sitter's " movement " into harmony with his character. Taken as a whole, his art deserves to be rescued from the almost total oblivion into which it has fallen.

[1] Alexander Wedderburn, Lord Loughborough, Lord Chancellor in 1798.
[2] The Rt. Hon. William Pitt, the younger, Lord Warden of the Cinque Ports in 1798.

SIR THOMAS LAWRENCE P. R. A.

A few other men—John Jackson, Thomas Phillips, Sir Martin Archer Shee—might be included among those with whom Lawrence competed for public favour, but none of these could in any way be called his rivals. They were essentially portrait-makers, antecedent substitutes for the camera, who seldom divagated into art.

As for the public to which Lawrence appealed, it was still under the spell of the great names of the previous generation. Ever since the days of Holbein portraits had been popular in England, while with the advent of Hogarth, Gainsborough, Reynolds, and their satellites, the fashion had spread over every class of the community which could afford the cost. Nothing like the industry which then arose had ever existed before. In Italy portraits were rare and special things outside the Venetian school, which alone had thrown up a portrait painter, in the modern sense, in Giambattista Moroni. In Germany it was the same. Holbein, the only German portrait-painter, would probably have remained an artist at large had he not been tempted to cross the English Channel. The case of the Low Countries is somewhat different. They were rich in portrait painters and their patrons. An exhibition confined to portraits would give a fair idea of their artistic resources. But even Holland and Belgium afford no parallel to what took place here between 1750 and 1790. During those forty years Sir Joshua, Gainsborough, and Romney turned out at least five thousand portraits between them. In 1757 Reynolds had one hundred and eighty-three sitters, and for several years his total never sunk below a hundred. Such a rate of production implies a demand ingrained in the national habits, and, as a matter of fact, portraiture in England has only lost popularity when its practitioners have lost skill. Which is curious: for our worst enemies do not call us the vainest of nations!

The explanation, perhaps, of the apparent anomaly is to be found, not exactly in vanity, but in a national characteristic which is its substitute; for an intense individualism, the distinctive feature of the English, has affected the course of our art as profoundedly as that of our politics. It was the originating and shaping force of the English reformation, by which our art was robbed of its widest and most time-honoured sphere of activity. It

52

PLATE XIX

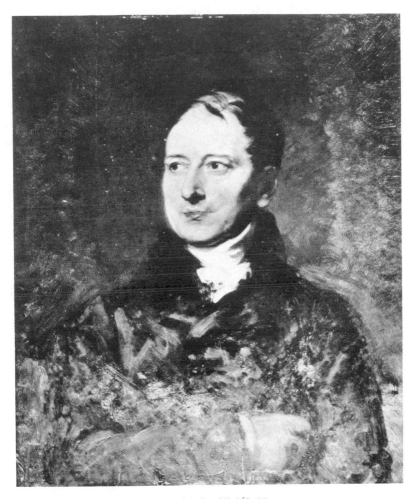

FRANÇOIS, BARON GÉRARD
FROM THE PAINTING AT VERSAILLES

led to the strange pleasure in isolation which has made us good soldiers to fight and bad ones to combine, good foremen and bad cooks, good colonists and "shocking bad" actors, good schoolboys and bad scholars, good painters of landscape and portrait, and the poorest of poor decorators. The habit of isolated production discourages the execution of those great monumental works which require a disciplined co-operation between a master and a large staff of scholars and assistants. I might go further, and declare that the English temperament and bent of mind are inconsistent with easy success in any form of decoration. The first demand upon the decorator is that he shall take his cue from the thing to be decorated. The decoration of a building, to take the most obvious example, should be the complement of the architect's conception. It should appear to have been foreseen from the beginning, and should have the same congruity with the structural forms as a flower has with the plant on which it blooms. This principle is obvious enough, but the subordination on which it insists has always irked the Anglo-Saxon. He has even rebelled against its very theory, fundamental as it seems to the Latin mind. In England such a proceeding as the disguising of a masterpiece of renaissance architecture in a Byzantine decoration excites no surprise and very little protest, and the principle that St. Paul's, for instance, should determine its own ornament has utterly failed to make its way into the national intelligence. Many other bad effects of our individualism might be pointed out, such as the existence of our anti-patriotic party, those curious people who take for their only discoverable principle the axiom that England is always in the wrong.

To any man with an aggressive individuality the system in which he forms a unit can never be anything but irksome. The better fitted he is to become a Robinson Crusoe the more difficult will he find it to accept any social theory not of his own creation. In answer to this it may be urged that the Anglo-Saxons have shown a rare, perhaps a unique, capacity for pulling together in politics, and preferring a practical compromise leading to results, to a barren fight for an ideal. There we seem to have one of those startling inconsistencies which are so universal in the characters both of nations and individuals as to suggest the existence of some

profound, natural law. Individually the English are lavish spenders—*Engländer Gelt-Verschwender*, as the German street-boy puts it—while, as a nation, we are almost as jealous of expenditure as the Dutch. And look at the French! Conservative as Chinese in domestic life, changeful as girls in politics; hoarders at home, spendthrifts in their Parliament; undisciplinable, and yet with an unrivalled genius for combination under certain conditions. Exaggerations in one direction, either in national or individual character, appear to imply their opposites, to restore the balance. The mind incapable of concentration is also incapable of a wide embrace. The nation which is too individualistic is also the easiest to lead into some absurd surrender to a fetish.

But where am I going? All this has little enough to do with Lawrence, and not enough, perhaps, with the remarkable development on which he was carried like a straw on a mill-race. It will suffice to say that national movements in art always depend on some permanent feature of the national character, and that the characteristic which brought about the British school of portraiture was not the vanity of the sitter, but the individualism of both portrayer and portrayed.

And, as we go on, it will have to be confessed that in spite of his weaknesses and shallownesses, Lawrence had an impregnable individuality, of a sort. He moulded things to his own fashion with more persistence than Reynolds. He had his own way of seeing, selecting, and expressing. He did not imagine much, but he preferred; and once his dependence on Sir Joshua was put aside —which was, apparently, on the day of the master's death—he set about the creation of a painted society of his own, with features as characteristic as those of a family. Unhappily for his permanent fame, their character was neither strong and distinguished, nor expressed in the highest pictorial dialect.

PLATE XX

WARREN HASTINGS
FROM THE PAINTING IN THE NATIONAL PORTRAIT GALLERY

CHAPTER VII

MIDDLE PERIOD CONTINUED—PICTURES BETWEEN 1798 AND
1814—HIS TROUBLES FROM PROCRASTINATION—HIS FINAN-
CIAL EMBARRASSMENTS

D URING the first fourteen years of the nineteenth century
Lawrence held an enviable position in English art. His
only dangerous rival in London became less dangerous
every year. Raeburn was four hundred miles away. The men
on whom the hopes of our native school were centred worked
in a different *genre*. All the official recognitions open to a
portrait painter were heaped upon him, and his name naturally
suggested itself when great commissions were in the air. The
list of his contributions to the Royal Exhibition, as it used to be
called, between 1798 and 1814, show his increasing vogue, if they
fail to hint at any corresponding expansion in his art. In 1798
his most important work was " Kemble, as Coriolanus." A year
later we find the Duke of Norfolk and General Paoli among his
sitters. Kemble, as " Rolla," [1] Lord Eldon, John Philpot Curran,
and John Julius Angerstein, sat in 1800 ; Curran for the fine half-
length, now in the Irish National Gallery, which was so long at Dray-
ton Manor. In 1801 there was yet another Kemble, the " Hamlet "
now in the King's collection. The two following years, 1802
and 1803, were almost monopolized by " the great," the best works
they produced being, perhaps, the group of Princess Charlotte
and her mother, in the Royal Collection, the first of his portraits
of Erskine, and the Lord Thurlow. Kemble and his sister,
Sarah Siddons, both sat in 1804, a year from which also dates
one of the best known of his male portraits, the half-length of
Sir James Mackintosh now in the National Portrait Gallery.

[1] This picture was afterwards (1816) sent to Paris, to hang in the Duke of Wellington's
house, and afford a specimen of the artist's powers to possible French clients (Layard,
p. 104).

SIR THOMAS LAWRENCE, P. R. A.

The "Siddons" is the full-length in the same collection. The following year probably dwelt in the memory of Lawrence himself as that in which the contagious laughter of Lady Betty Foster, the "incomparable Bess" as he calls her, was first heard in his studio. This lady, quaintly described by Mr. Somes Layard as "a woman of great learning, boundless benevolence and far-reaching influence," remained the staunch friend of Lawrence until her death in Rome twenty years later. The year 1806 saw the addition of nothing very notable to the artist's catalogue, but in 1807 he produced the first of the Baring family groups, and the posthumous attempt to do justice to the remarkable personality known as the younger Pitt. None of those who painted William Pitt succeeded in suggesting all his possibilities: but that was scarcely their fault. Nature likes her little joke now and then, and sends a great man into the world with a face of little promise, side by side, perhaps, with another whose features promise more than any man can fulfil. "No man can be as wise as Lord Thurlow looks," said a good authority.

Lawrence's only blank year at Somerset House was 1809. But he made up for it in 1810 by sending three statesmen who were then very much *en évidence*—Lord Castlereagh, George Canning, and Lord Melville—to the royal show, in company with the second of his Baring groups. Two of his sitters, Castlereagh and Canning, had exchanged shots on Putney Heath the year before, while a third, Lord Melville, had only just emerged from the darkest moment of his parliamentary eclipse: so they made a more than usually *piquant* trio. Among other things of 1811— "Mrs. Stratton," "Gen. Hon. Charles Stewart," "Sons of— Labouchere, Esq.," "Benjamin West, Esq., P.R.A." (picture sent to America), "Hon. C. A. Cooper"—we find one of his best works, one of the few portraits which give him some claim to be enrolled among those who have really helped to immortalize a great man: I mean the half-length of "Warren Hastings" now in the National Portrait Gallery. To my eye, this picture seems to declare more objective curiosity on the part of Lawrence than anything else he did. It is a record not only of the Viceroy who hanged Nang Kumar and winged Sir Philip Francis, who re-organized Bengal and re-established his own family in its native

PLATE XXI

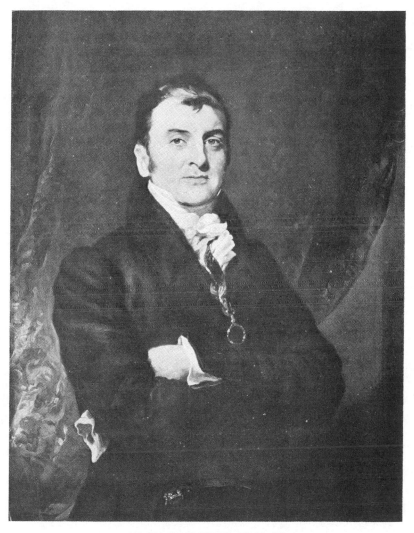

SIR GEORGE TRAFFORD HEALD, K.C.
FROM THE PAINTING

seat, but of the student of man who found room in his mind to be interested in a quiet painter whose career had been so eventless beside his own. To paint a hero *as a sitter* and yet to leave him a hero was not a common achievement.[1]

The most notable of Lawrence's productions for the year 1812 was perhaps the full-length of Kemble as " Cato." Like all the rest of his attempts to strike out in the direction of the ideal, it shows his complete lack of gift for any such adventure. His imagination curls up when he spurs it; the more he tries to get away from the obvious, the more hopelessly he sinks into it. All the pictures of this stamp—the " Cato," the " Rolla," the " Hamlet," the " Wellington at Waterloo," the " Wellington with the Sword of State," etc.—are pompous failures. With the year of Leipsic, however, he begins to be shone upon by the glory of the great war. He paints Lord Lynedoch, then Lieut.-General Sir Thomas Graham ; Sir Charles Stewart (not for the first time) ; Lord Wellesley, and his second portrait of Castlereagh ; as well as his famous group of Lady Grey with her children, and the beautiful " Miss Thayer." These pictures bring us down to 1814, when his fame, at least, was to enjoy an expansion through the Peace and the command of the Regent to paint the heroes of the war.

During these years which I have passed over so rapidly, Lawrence lived what seemed, at least to the public, a most un-eventful life. Various things contributed to hide his tracks, and to prevent people from forming any very definite idea of his personality. He was no advertiser. He seems, indeed, to have had a gift for avoiding publicity, and in this he has been abetted by those with whom he left the best materials for a comprehensive portrait. But in spite of all this silence, it is not difficult, I think, to arrive at a trustworthy notion of the man. Any attempt at a full-length portrait must be left for my last chapter, but as we go along it is well to take stock of what we have learnt, and to carry with us, if possible, an image consistent with events as they happen. Enough, perhaps more than enough, has already been said about his aspect towards women, and the particular brand of unsteadfast emotion on which alone they had to rely.

[1] A story was current at the time that some one had mistaken this " Warren Hastings " for an old lady ! Mr. Layard sensibly remarks : " Either the story was untrue or the person who made the mistake was blind or idiotic."

SIR THOMAS LAWRENCE, P. R. A.

In other matters his character has exactly the same colour. All his impulses were good, but his ambitions were never profound. He served a friend loyally, but not energetically. The last claim on his time was the most irresistible, and the last picture begun the one he found it most congenial to finish. He was one of those happy but tormented beings who live in the day that is. For him " Yesterday " and " To-morrow " were like wasps at a picnic : irritating, now and then, but easily ignored. We feel that although he passed his whole life in financial difficulty and had his share of smaller troubles besides, he could never have been other than a happy man. A characteristic illustration of his friendliness is given in a series of letters to Dr. Charles Burney, the brother of Madame d'Arblay, which have been kindly lent to me by the present Dr. Burney—" Charles the Fifth " in descent from " Evelina's " father. The majority of these letters refer to Dr. Burney's election to the Royal Academy Professorship of Ancient History. Not one among them is dated, and as the postmarks of a century ago are absurdly reticent, I have had to arrange them in their order as best I could :—

I

" Dear Dr. Burney,

" Forgive *my servant* for not letting me see you this morning. *I believe the thing will do*, and in order that it may be done *in the best way* you shall so far place confidence in me as to refrain from anything like a canvas. This is no light opinion. You should receive the place as the homage of the Academy to one whose character claims it as a right. Perhaps Mr. Mitford may have Gibbon's place you Dr. Johnson's and both be elected at the same time with no bustle but as if it was the unanimous sense of the Academy.

" No canvas though, Sir Joseph !! We pretend to great independence and foreign influence was the cause of Sir Joshua's quarrel.

" I could laugh to find myself writing in this decided tone, but I write in great haste and with some emphasis, because with the concurrence of wiser heads than my own.

" Believe me, Dear Dr. Burney,
" Ever yours,
" THOS. LAWRENCE."

PLATE XXII

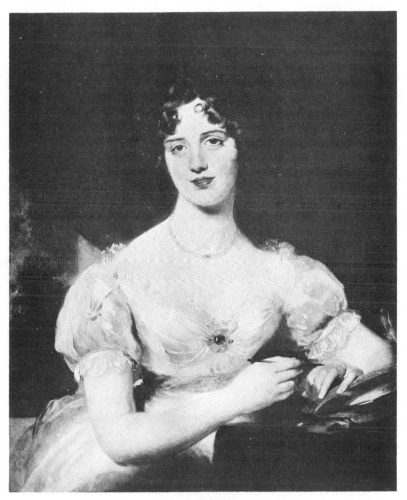

MRS. FREDERICK HEMMING
FROM THE PAINTING IN THE POSSESSION OF A. HIRSCH, ESQ.

TROUBLES FROM PROCRASTINATION

II

"MY DEAR DR. BURNEY,

"All goes well and it is still the advice of Mr. F(arington)[1] that all should go quietly and that there should be nothing like canvassing for the present at least. He reckons up above sixteen who are staunch men for the honour and character of the Royal Academy (of course yours) and he is certain whatever may be the number of proselytes Mr. C. may gain they will soon yield when the push comes. The matter cannot be in better hands than his— Mr. F's, I mean, Grammarian—and he cannot I think be more decidedly your friend.

"We will contrive if you can so arrange it to call upon him in the next week for I have told him that the fates decree that you shall be friends and he is very anxious to second their views.

"Have you seen Mr. Spencer lately? Alas, for our fine new theatre! Was anything ever like the grand indignant morality of Messrs. Sheridan & Harris. I suppose your hair stands on end at the wickedness of the age! Surely the theatres might be quiet, for there is little chance of rivalry either in talent or vice.

"Erskine says it is strictly legal. Now in this case would you go on or be bullied out of it for gentle gentlemanly remonstrance has not been tried. 'Go on' says spirit I'm afraid 'Sneak off' says wisdom I say 'Who's afraid'—*but only, Dr. Charles Burney, don't tell Perry I am a subscriber.*"

III

"DEAR DR. CHARLES,

"Pray if possible contrive to eat your dinner to-morrow with me at Mr. Farrington's [*sic*]? He dines at half-past four precisely. Pardon me for the hurry of this note.

"Ever, my dear Dr. Charles,

"DR. C. BURNEY, "Yours etc.,
 "GREENWICH." "T. L.

IV

"MY DEAR DR. BURNEY,

"The immediate is got rid of and the election put off for a sufficient time to secure this pleasant event for the Academy. I

[1] "How Farington used to rule the Academy! He was the great man to be looked up to on all occasions; all applicants must gain their point through him. But he was no painter. . . . He loved to rule. He did it, of course, with considerable dignity, etc."— Northcote: *Conversations with James Ward.*

am very ill qualified to give an opinion upon any point of dexterous conduct not indeed that there seems much occasion for it in this instance however. I still hold to quiet proceeding in the business and not the less so from the influence that I see you already have. Since your getting it appears certain the higher the professorship holds up its head the better.

"I wish to God I were a good Companion! Tis better than being a safe one and Pope must have meant it when he wrote the latter. If a man have learning he is lov'd as well as respected and if he has not why he is still lov'd and that I take it is one of the best things that can happen to him. Don't you find it so, Dr. Charles Burney?

"But you will say you must be lov'd for something more and since you will have it so you are then only *popular* and the nearer we get to you the more we shall discover of 'warts, and wrinkles, and eye offending moles.' Keep me at arm's length then or your picture will suffer for it."

Dr. Charles Burney duly took his place in Dr. Johnson's chair. He was elected to the Professorship of Ancient History in 1803, in succession to Bennet Langton, who had stepped into "Ursa Major's" shoes fifteen years before.

Unimportant as they are, I have ventured to print these letters for the light they throw on the character of Lawrence. In the selections hitherto given to the public from the painter's correspondence, his more spontaneous side is seldom shown. We are allowed glimpses of his more artificial moments, with the result that his franker personality is thickly veiled. These letters to Dr. Burney have a curious affinity with those of a much greater artist. The last of the series is almost pure Gainsborough. Its loose phrases and complete freedom from pose excite a sympathy akin to that felt for the warm-hearted Suffolk painter, and very different from the feelings stirred by Lawrence's elaborate letters to the great ones of the earth.

Throughout his published correspondence we can trace the advancing prestige of the artist in this middle period of his life. At first his own youth, as well as the newness of his fame, led the more coarse-grained among his patrons to treat him with occa-

PLATE XXIII

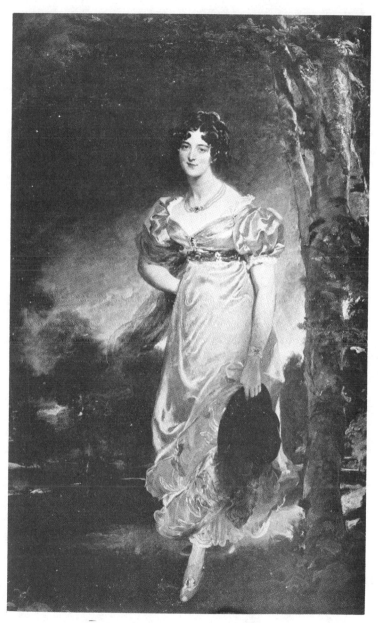

SARAH SOPHIA, COUNTESS **OF** JERSEY
FROM THE PAINTING IN THE POSSESSION OF THE EARL OF JERSEY

sional rudeness. Mr. Layard prints a few letters, from women as well as men, which would scarcely be written in these days to an offending tradesman. Against such attacks the painter had a double defence, in his placid temper and in an Italian flexibility which made it easy to put a thrust by, beneath his arm, without too violent a parry. It is amusing to see how offended fair ones, especially, had to simmer down, one after the other, from their initial violence before his complete indifference as to whether their pictures got themselves finished or not. All this comes to an end, however, with the increase of fame and dignity brought him by the conclusion of the great war and his share in its commemoration. From that time onward there is no more browbeating, nothing, indeed, but fault-finding of the most sucking-dove kind, even when the painter has given extreme provocation. It must have been trying to the most long-suffering to have their portraits put aside for years, after the first sitting—and the first payment!—only to be taken up again, in many cases, after the sitters had grown from youth to middle age. Here again we are reminded of Gainsborough, and of his quarrels with the Thicknesses. But with all his *insouciance* Gainsborough was a paragon of punctuality compared to Lawrence, whose failures to carry out his engagements were frequent enough to be notorious. Of these failures many instances are betrayed by his published correspondence. Now and then he allowed as many as twelve or fourteen years to elapse between the first and last touches on a portrait, and we may fairly conclude that he was saved only by the sweet vanity of woman from the worst penalties of his breaches of faith. A lady who had given her first sitting at twenty-five was only too keen at forty to have her picture finished. She would put her pride in her pocket and forget her injuries if only she could get such a record of liquid eyes and velvet cheeks home and hung up!

The painter's financial embarrassments had their origin in the same defect of character as his troubles with the ladies, and his difficulties with the last stages of his pictures. He was never forethoughtful, and so, although he was by no means reckless in his expenditure,[1] he gradually allowed a head of debt to accumulate which affected his independence, and would have destroyed all

[1] Always excepting that on drawings by the old masters.

pleasure in life had his spirit been less elastic. He had begun life with the worst example before his eyes, in the conduct of his father. As soon as he was able to earn money at all, and long before he could expect to have any say in its disposal, he had become accustomed to see it disappear into the gaping pockets of father, mother, brothers, and sisters. When he grew up his generosity to his relations knew no bounds, and, at the same time, his own desire to possess works of art awoke. He began to form that collection which, at his death, included nearly all the first-rate drawings by the great masters which existed outside the national museums.

As a result of all this, the painter's affairs were in such a state by the year 1804, when he was only thirty-five, that Thomas Coutts, the banker, was called in to see what could be done. Coutts, an admirable specimen of a Scot, was no doubt applied to in the first instance for an advance : at least, that is what our knowledge of Lawrence allows us to assume. He would then insist on being fully informed of the painter's liabilities and earning power. Mr. Layard prints a letter from Coutts to Lawrence, dated 25th August, 1804, from which we may conclude that the banker was ready to provide the funds needed to discharge all pressing claims, provided that future earnings were scrupulously paid in to the bank, whence an agreed sum would be allowed for the artist's current expenses before applying the rest to the liquidation of his debts.

To this arrangement Lawrence appears to have been only partially faithful. Further arrangements were made with Coutts, who, in the year 1807, strongly urged a Commission of Bankruptcy as the only means of extrication. To this, however, Lawrence would not listen, and as time went on and his income grew, his burden of debt became less unmanageable. His liabilities were still heavy when death overtook him, but the assets he left behind were more than sufficient to pay his creditors. For the whole of his life he was never quite free from financial anxiety, which every now and then became acute. This, added to the troubles due to inability to maintain some reasonable proportion between his promises and his achievements, must have helped to wear out his vitality before its time.

PLATE XXIV

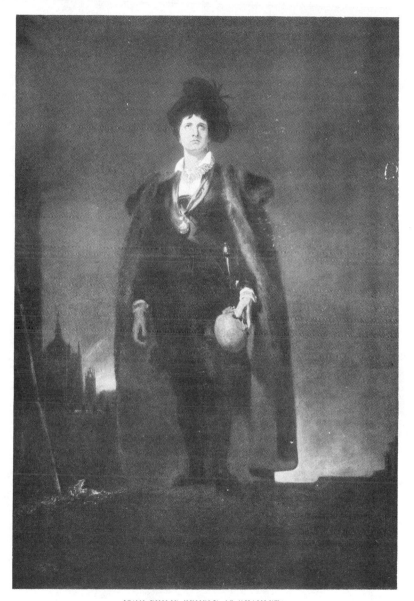

JOHN PHILIP KEMBLE AS "HAMLET"

FROM THE PAINTING IN THE NATIONAL PORTRAIT GALLERY

(A slight amount of retouching, owing to defects on the original, has been necessary, but this does not affect the face)

CHAPTER VIII

AIX-LA-CHAPELLE—VIENNA—ROME

IN the last days of 1813, or the first ones of 1814, Lawrence moved from Greek Street to No. 65 Russell Square. He took a great deal of pains with his new house, and, if we may judge from an engraving in the British Museum, succeeded in making it a very dreadful place indeed. A sitting-room with some five-and-twenty life-size casts—including the " Apollo " and the " Laocoön "—standing round to watch one's proceedings ! Could anything be more appalling ? There is something pathetic about it, too, when we remember that he who contrived such an arrangement passed through life combining a belief that his true vocation was to ideal art, with a really sound judgment wherever the works of other men were concerned. One of the strangest things about Lawrence was the way in which a profound faculty of appreciation was united in him with a blank inability to create. As we shall see later, his understanding of the Elgin Marbles was more complete than that of any other artist or amateur who was examined before the Elgin Committee. At a time when the influence of Winckelmann was still dominant, and the " Apollo " was still considered the last word of sculpture, he saw the infinite superiority of Phidias, and spoke of the Parthenon as we think of it to-day. And yet he could pass from the " Theseus " or the " Ilissus " to invent as feebly as West or Haydon.

While the public would have nothing to do with his " high art," his fame as a portrait painter expanded enormously in this year 1814. Like every one else who was interested in art, he rushed over to Paris as soon as peace was secured, to see those stolen treasures in the Louvre, which were about to be restored to their owners. His stay in the French capital was cut short by

a new demand on his powers. This was an order from the Regent to begin that long series of state pictures which were to carry him over more than half Europe, and to occupy his brush, off and on, till his death. This commission came at a critical time for his finances. Early in 1815 he had almost reconciled himself to the measure pressed on him by Coutts. He wrote to Farington, saying that temporary expedients had failed, and that "general ruin" is not now to be averted, but to be met in the wisest way! i.e. by a Commission of Bankruptcy.[1] This tardy conviction was no sooner formed, however, than the change in his prospects occurred. Knighthood gave a useful fillip even to his reputation and orders for portraits of kings, emperors, and generals poured in by every post. According to a document prepared for Farington's information,[2] his income in 1807 must have been about £3000. In 1815–16 it must have risen—according to calculations based on the pictures finished—to at least three times that amount. As we have no reason to doubt the painter's own declarations, that he had no hidden demands on his income, such a revenue, nearly a century ago, would allow for a good sinking fund, after paying the cost of his collecting and even luxurious living. So we need feel no surprise that financial pressure diminished during the last quarter of his life, and that we hear no more of Commissions of Bankruptcy after 1815.

Taking up again the list of pictures sent to the Academy at the point where we left off, we find that in 1814 he exhibited a second portrait of Castlereagh, the picture now in the Waterloo Gallery at Windsor Castle; the "Duke of York," engraved by Charles Turner; the full-length of Lord Abercorn ("th' ould Marquess," as he is still called in the North of Ireland), which hangs at Baronscourt; and three portraits of women, "Lady Leicester," "Lady Grantham," and "Lady Emily Cowper." In 1815 the full tide of patronage from the political world had begun to flow—had, in fact, been flowing long enough for its results to be evident at Somerset House. To that year's exhibition Lawrence sent portraits of the Prince Regent, of Metternich, of Wellington, of Blücher, and of the Hetman Platoff. All these were painted for the Regent, and are now at Windsor. They were accompanied

[1] Layard, p. 97.　　　　[2] Layard, p. 53.

PLATE XXV

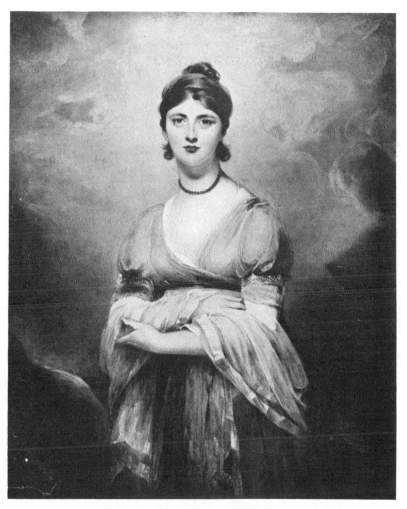

ELIZABETH JENNINGS, MRS. LOCKE

FROM THE PAINTING IN THE COLLECTION OF M. EUGÈNE FISCHOF, PARIS

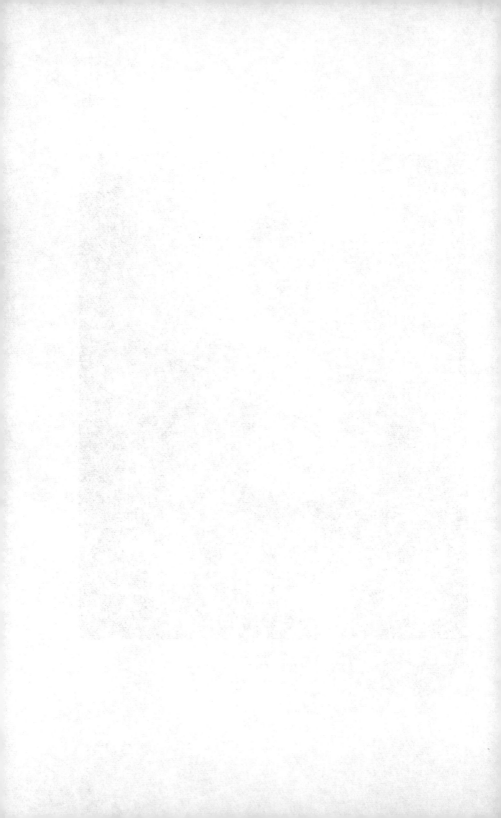

to the exhibition by the beautiful portrait of Mrs. Wolff, afterwards engraved by Cousins. Of all the later works of Lawrence this is perhaps the freest from any sort of pose or artificiality. Even in his pictures of children we generally find some passage introduced for the sake of effect, some touch which puts an echo of grown-up modishness into the innocence of childhood. There is nothing of the sort in the " Mrs. Wolff," unless it be the book and cushion. Of these, indeed, she appears supremely unconscious. Her thoughts are absorbed by the work being done and the man who is doing it. If we wished to discover some proof that the lady's interest in the painter was deeper than a friend's, I do not know that we could find anything more significant than her expression here. No doubt Lawrence transferred it to his canvas with as much delight as success !

In 1815 the flow of official portraits—if I may call them so—was arrested for a time. Napoleon had come back from Elba. The great adventure of the Hundred Days had begun, and had drawn all the statesmen and soldiers of Europe back to the threatened centres. So Lawrence had to fall back, for the nonce, on the rank and fashion of his own country. In 1816 he exhibited the portrait of John Julius Angerstein, now in the National Gallery,[1] together with two bishops, London and Durham, the " Duke of York " in the Royal Collection, and the head of the Marchese di Canova, which, with a fine sense of compliment, he catalogued merely as " Canova." Among the contributions of the following year, 1817, we find the full-length of Lord Anglesey, Wellington's famous lieutenant, whose marquessate rewarded him for the services he had rendered as Earl of Uxbridge. This picture was bought from the painter by the Duke of Wellington, and now hangs in Apsley House. It was accompanied to Somerset House by a second portrait of Lord Lynedoch, by one of the wit Joseph Jekyll, and by one of Wellington's great friend, Mrs. Arbuthnot. The harvest of 1818 included portraits of the Prince Regent, the Duke of Wellington on Copenhagen, in his habit as he fought at Waterloo ; and two ladies, Lady Elizabeth Leveson - Gower, afterwards Lady Elizabeth Belgrave and

[1] This picture was afterwards acquired by George IV. It was presented to the National Gallery by William IV in 1836.

Marchioness of Westminster; and Lady Acland, the latter with two small sons, both still in the petticoat stage.

In 1819 came a burst of silence. It was the year of Lawrence's triumphal procession as an artist through the European capitals. In 1816 he had received a letter [1] from his friend Lord Stewart, Castlereagh's brother, in which a scheme for painting the potentates of Europe is first sketched out. "When the gay scenes in London close," Stewart writes, "and the sittings of your beautiful women languish from their emigration to the Verdure and Shades of the Country—Furnish yourself with Letters from our Royal Master to the Emperors F. and A., representing H.R.H.'s desire that you should proceed to their Capitals to take their pictures for H.R.H.

"Place yourself next with a Messenger going to Vienna, and you will arrive with me in 10 days. At Vienna You shall have everything as in *Russell* Square.

"You shall paint the Emperor and Empress. If you will, Swarzenburg, Metternich, *Madame Murat*, and *Young NAPOLEON.*"

This programme was eventually carried out, except the painting of the Empress and Madame Murat. But the expedition did not begin until the autumn of 1818, when sovereigns and diplomats were assembled at Aix-la-Chapelle. Obeying the orders of the Regent, Lawrence betook himself to the capital of Charlemagne. Before he left London he had received a letter from Wellington, in which, after promising to help him in every way in his power, the Duke goes on, with characteristic downrightness, to say: "I confess I wish you was certain before you will leave London that the Sovereigns would sit to you. I should doubt it." But the Duke for once was wrong. The sovereigns turned out to be all amiability, and the painter's only difficulties arose from the want of such prosaic facilities as convenient windows,[2] blinds, chairs, and so on. Before he started he wrote to Farington, in confidence, telling him the terms on which he went. They were "500 guineas for whole lengths, smaller sizes in proportion, and

[1] Written from Milan, 6th March. See Layard, pp. 100 and 101.
[2] The chamberlains with whom these arrangements lay acted on the assumption that the *sine qua non* for a painting room was to have plenty of windows facing south, with a blaze of sunlight searching every corner!

PLATE XXVI

CHARLES STEWART, THIRD MARQUESS OF LONDONDERRY
FROM THE PAINTING IN THE POSSESSION OF THE MARQUESS OF LONDONDERRY

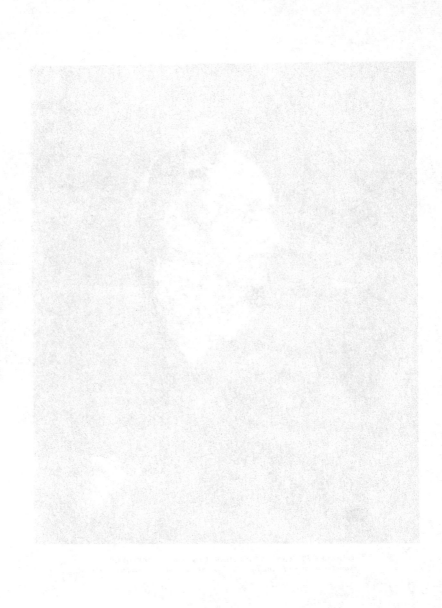

£1000 for loss of time, expence, etc."[1] The pictures, which were all commissioned by the Regent, were to include the three sovereigns—the Emperors of Austria and Russia, and the King of Prussia—their first ministers and generals. The Duke of Wellington had also commissioned a portrait of the King of Prussia for himself. Mr. Layard prints a series of letters—to Smirke, Miss Croft, Mrs. Wolff, and an unnamed correspondent—which give an interesting account of the progress of this artistic pilgrimage, and show with what consideration and almost affection Lawrence was treated by many of his important sitters. With Metternich he became intimate. In one of the letters from Aix-la-Chapelle we find a piquant touch. "At five minutes before Four I went into the Court (of the Czar's lodging), having seen Mr. Dawe prowling close to it ; (I beg his pardon) *creeping* round it in the street." George Dawe was a dozen years junior to Lawrence. He crept around the Czar's house to some purpose, for in 1819 he was commissioned by Alexander to proceed to Russia and paint the chief officers who had fought against Napoleon. This is not the only jealous fling we find in our hero's letters. He had quite a liberal allowance of that alertness in censure for which Constable was also blamed, from which a third famous painter of the time—I mean Turner—was so generously free. There was little malice in it with Lawrence.

The painter remained at Aix about two months. Early in December we find him established in Vienna, where he had a painting room in the old palace. Here he finished the portrait of Alexander, and began the Emperor Francis, as well as the " Young Napoleon," the Archduke Charles and his wife and daughter, and several Austrian generals. He was accepted with unusual readiness in Viennese society, and had every opportunity of seeing how life was lived in the most exclusive capital of Europe. On the 20th March, 1819, we find him addressing a letter to his friend Farington, from which an extract must be made, as it gives a passing glimpse of his own view of himself at the age of fifty :—

" I am very nearly bald, and my hair is quite grey, and other indications of increasing age are not wanting, and amongst them

[1] Layard, p. 133.

*de*creasing strength, so that I am now not equal to that whole day's occupation of my mind and employment of my faculties, which I could once at any time command.

" I am glad that I can with truth inform you that my professional success increases. Aware that there is no competition, I strive to keep my mind up to our Exhibition at home, and never rest satisfied with my work because it satisfies the partial spectators around me." The last sentence is curious, for it is true; the Royal Academy was then richer in genuine art than any exhibition east of Paris.

In a letter to Farington, written immediately after his arrival in Rome, in May, 1819, Lawrence gives the following list of the " subjects of his pencil "—as he calls them—at Vienna [1]:—

" Large whole lengths, in oil.

" The Emperor, Prince Swartzenburg, the Archduke Charles, the Archduchess, and a small whole length.

" Half Lengths.

" Comte Capo d'Istrias, General Tchernicheff, General Ovaroff; besides greatly altering, improving, and almost completing Prince Metternich.

" Three Quarters.

" Princess Ce Metternich, Child of the Archduke, Lord Stewart, Chevalier Gentz, Mr. Bloomfield, Lady Selina Meade, Child of Comte Fries, Sketch of Comte Libromiski's [*sic*] child.

" Drawings.

" Princess Rosamoffsky; Comtesse Thurskeim, Madame Sauran, Lady S. Meade, Princess Lichnowsky, Mademoiselle Rici, Comtesse Murveldt's Son, Comtesse Rosalie, Comtesse Vincent Esterhazy, Mr. Khammer, the known oriental scholar, Comte V. Esterhazy, Prince Schwartzenburg."

" When I remind you," he goes on to write, " that not only the resemblances in the large pictures are entirely finished, but likewise parts of the figures, and every part accurately drawn, to enable me to complete them; and that this is the case with the smaller

[1] Williams, Vol. II, pp. 145-6.

PLATE XXVII

FRANCES ANNE, MARCHIONESS OF LONDONDERRY
FROM THE PAINTING IN THE POSSESSION OF THE MARQUESS OF LONDONDERRY

pictures, five of which are finished—that it is not now in my power to make slight sketches, from my habit of accuracy, and love of studying the finer traits of the human countenance, you will, I am sure, give me credit for as full and intense occupation of my time during my stay at Vienna as during any period of the same limitation in London."

No reader of Lawrence's correspondence can fail to be struck with the rarity of his allusions to the great pictures and great masters of the past. We do not know, of course, what the letters still withheld may contain, but those of the three or four instalments already printed supply scarcely any evidence that Lawrence had ever heard of Titian, or Rembrandt, or Velazquez, or even of Raphael, whose name, at that time, overshadowed all others. As a matter of fact, we know, from the comparatively few critical remarks he has left us, as well as from his action with regard to the purchase of the Elgin Marbles, the founding of the National Gallery, and the enrichment of his friends' collections, that his insight into art was both deep and catholic. We also know from his devotion to the quest and acquisition of drawings that he had a great admiration for the old masters as draughtsmen, as proficients in that pursuit within a pursuit which was his own chief preoccupation. We find Lawrence using the phrase " mere colouring " as if the colourist were to the draughtsman what the child who colours a " drawing-book " is to the modest artist who produces it. We do not require any evidence outside his pictures to prove that Lawrence took but little interest in the more grandly sensuous qualities of paint. There may, however, be some use in considering how far his neglect of pictures was a cause and how far an effect of this indifference.

It was probably nothing more than a result of his own want of forethought. One of the most practically useful gifts a man can receive from his ancestors is a true instinct for the cubical capacity of time! To the man so endowed it is easy to fit his duties to his days, leaving any margin he chooses for his pleasures. Lawrence was entirely without any such gift. He believed time to be infinitely elastic, that it would, at a pinch, hold everything he might wish to put into it. The result was

that his days were so overcrowded that no leisure remained for incidental things, and that he probably passed year after year without seeing any pictures but his own and those of his Academy colleagues. Such conditions do no harm to the very great artist, nor even to the comparatively mediocre man to whom artistry is the chief interest of life. For the first individuality, for the second sincerity, will secure fame sooner or later. But Lawrence was neither a very great artist, nor even a man absorbed in his art. If ever a painter required a stimulus from without, it was he. So that when he so ordered his life as to leave himself no time for intercourse with the great Venetians, Dutchmen, and Spaniards, he cut himself off from a source of inspiration he could ill do without.

In May, 1819, Lawrence left Vienna for Rome. Williams prints a long letter to Farington[1] from which a few paragraphs may be usefully quoted; it is dated May 9th, 1819 :—

"When I found it impossible from the state of my engagements at Vienna, to get here (Rome) in the Holy Week, I determined to complete every little work that I had undertaken, and then to start with a courier's speed for Rome; leaving Venice, Florence, and Bologna, either to be seen at the close of my labours here, or to be left for another visit, should Providence enable me conveniently to undertake it.

"I found, however, that I must of necessity stop at Bologna; accordingly, for the only time on my journey, I slept out of my carriage, getting to Bologna at two in the morning, and resting till seven : then I breakfasted and went to see the pictures of the Academy. The Martyrdom of St. Agnes, and other large works of Domenichino, and the Carraccis, Guido, etc. I then returned and came to Rome by the Farlo-Monte road, through magnificent scenery, and (with one day's exception), fine weather—catching my first view of St. Peter's on an exceedingly fine morning, between six and seven o'clock. Mr. Thomson and Mr. Howard can well imagine the pleasure of that moment—a pleasure increasing every fifty yards, till I entered the Porto del

[1] Vol. II, pp. 143–55. The list of Viennese sitters has already been taken from it.

ROME

Popolo, when (what will they say to me?) I found Rome small. If, however, they are indignant at this, tell them the injustice has been amply punished; for I am at this moment overpowered by its immensity and grandeur."

Then follows one of his rare passages of critical comparison:—

"Rome I must leave, comparatively, unseen—Rome, which only Byron has feeling and capacity to describe. 'The Niobe of Nations' it is, indeed—an eternal city to the sons of time; for with that it must exist, linked as it is to every feeling, sentiment, impression, and power of the human heart and mind. Paris and the Louvre, Rome and the Vatican!—the dissoluteness, the puppet show decorations, and dissonance (Rome's purer space in it excepted) of a common fair, to the public devotion of a people, in gratitude displaying its magnificence in its highest temple.

"Bonaparte forces himself upon you in the Vatican, and you involuntarily exclaim, 'How could he see this?'—and then you remember that he never saw it, and that one addition, therefore, of crime and disgrace, is spared him in the having seen it, and still retained his hard and low ambition. You have seen his countenance, but could you have seen it at the moment that Rome and the Vatican met his eye, how dark would have been its expression, or that daring and arrogant spirit had retired within itself, baffled and defeated—for unless he could have fixed his seat of empire here, his toils had been nothing; and in the hands of this old man had still existed an empire over the soul, that even to himself had shamed his tyranny.

"I have already been often at St. Peter's and the Vatican, and for many hours each time. The latter I determined to see alone. Hereafter we shall have many a talk on the comparative merits of the two great men.

"Yesterday I dined at half-past one, that I might remain till night in the Sestine Chapel and the Vatican, or rather the Chambers of Raphaele, for, as you know, the former is part of the immense building.

"It often happens that first impressions are the truest. We change, and change, and then return to them again. I try to

71

bring my mind in all the humility of truth, when estimating to myself the powers of Michael Angelo and Raphaele, and again and again, the former 'bears down upon it,' to borrow a strong expression, 'with the compacted force of lightning.' The diffusion of truth and elegance, and often grandeur, cannot support itself against the compression of the sublime. There is something in that lofty abstraction, in those deities of intellect that people the Sestine Chapel, that converts the noblest personages of Raphaele's drama into the audience of Michael Angelo, before whom you know that, equally with yourself, they would stand silent and awestruck. Raphaele never produced figures equal to the Adam and Eve of Michael Angelo—though it is Milton's Eve, it is more the mother of mankind, and yet nothing is coarse or masculine, but all is elegant, as lines of the finest flower. You seem to forsake humanity in surrendering Raphaele, but God gave the command to increase and multiply before the fall, and Michael Angelo's is the race that would have been. But you must read Mr. Fuseli, his only critic. In both the Sestine Chapel and the rooms of Raphaele, all, in too many parts of them, is ruin and decay ; at least, it appears so to me, who was not sufficiently prepared for the ravages of neglect and time.

.

"The Duchess of Devonshire [1] is here and very condescendingly kind ; the rest of the English residents who remained here are gone to Naples, where the Emperor of Austria now is. . . . I was the day before yesterday presented to the Cardinal Consalvi, and . . . yesterday was honoured with an audience of the Pope, at the Quirinal Palace. . . . I was introduced into a small closet, in which the Pope sat, behind the opening of the door, and after bending the knee was left alone with him. He has a fine countenance—stoops a little—with firm yet sweet toned voice, and, as I believe, is within a year or two of eighty, and through all the storms of the past, he retains the jet black of his hair. I remained with him, I think, between seven and ten minutes, during which time he held my hand with a gentle pressure, from which I did not think it respectful to withdraw it. With a

[1] Better known, perhaps, as Lady Betty Foster.

PLATE XXVIII

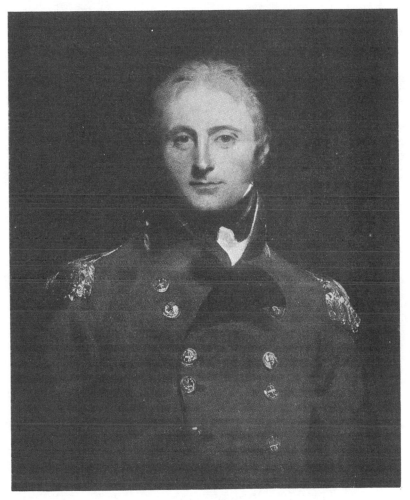

SIR JOHN MOORE
FROM THE PAINTING IN THE NATIONAL PORTRAIT GALLERY

phrase or two of French (which he does not like to speak), and then the rest in Italian, he spoke his sense of the Prince Regent's attention to him, and his gladness to gratify his wish, accompanying it with compliments to me. I then defectively expressed my gratitude and reverence, bent to kiss his hand, and retired. . . .

"I found the maître d'hotel of the Cardinal Consalvi waiting to conduct me to apartments which, amidst the pressure of business and full occupation of the Palace by the Emperor and his suite, as well as by the Pope and Cardinals, his munificent care had provided for me in one part of it. They consist of four sitting rooms, newly and handsomely furnished, bed rooms, rooms for my servants, kitchen, etc.—in addition to these comforts, a carriage is ready for me at all hours. . . .

"The Cardinal is one of the finest subjects for a picture that I have ever had—a countenance of powerful intellect and great sympathy—his manners but too gracious, were not the attentions solely paid to the mission of the Prince Regent—the expression of every wish was pressed upon me, and the utterance of every complaint. . . .

"In all this, which so fixes the character of my station here, I write, as a duty I owe to such constancy of friendship as yours, to place everything before you exactly as it occurs. Your knowledge of *mankind*, of *human nature*, will tell you *how much of prosperity is to be veiled*, if we would have any but our hearts' friends sympathise in it: since it is a severer test than adversity, in which something of secret pride and self-love is generally an accompaniment to service. But heartily to rejoice with a friend in that state in which he needs not our assistance, and to whom fortune may seem for the moment too partial in her kindness, is friendship beyond the reach of doubt; and this, with Mr. Angerstein, and two or three others (but in this none superior to yourself), you have invariably been."

In a letter written a month later to his friend Lysons[1] occurs the interesting passage in which he anticipates the judgment of

[1] Samuel Lysons, F.S.A., F.R.S., Keeper of the Records in the Tower of London, Vice-President and Treasurer of the Royal Society, Antiquary to the Royal Academy. Born 1763, died 1819, a few hours after receiving this letter from Lawrence.

SIR THOMAS LAWRENCE, P.R.A.

Ruskin on the comparative merits of Turner and Gaspar Poussin as painters of the scenery in the neighbourhood of Rome:—

"This morning I breakfasted with the Prince (Metternich), his daughter, Comtesse Esterhazy, and their friends, at the early hours of six . . . and then set off for Tivoli. . . . Such a union of the highly and varied picturesque, the beautiful, grand and sublime, in scenery and effect, I hardly imagined could exist. Like the Vatican and St. Peter's, it is infinitely beyond every *conception* I had formed of it; although so many fine pictures, by Gaspar and others, have been painted from it. The only person who, comparatively, could do it justice, would be Turner, who (*I write the true impression on my eye and on my mind*) approaches, in the *highest BEAUTIES* of his noble works, nearer to the fine lines of composition, to the effects and exquisite combinations of colour, in the country through which I have passed, and that is now before me, than even Claude himself."

From a letter written at this moment[1] to J. J. Angerstein, we learn that Lawrence found time to think of his friend's interests as a collector, and that he took steps to induce him to buy the two famous Correggios, the "Mercury, Venus and Cupid," and the "Ecce Homo," which were afterwards purchased—no doubt again on Lawrence's initiative—by the second Marquess of Londonderry, who figures so largely among the painter's friends and correspondents as Lord Stewart:—

"Ah! There is a picture—there are two, *elsewhere*," he writes to Angerstein; but I had better copy out the whole section of the letter which refers to pictures, as it will help us to an understanding of the painter's calibre as a critic. "I have seen the Lionardo da Vinci" (he begins, after a page or so about the Pope and the great people in Rome), "the 'Modesty and Vanity'[2] mentioned by Mr. Day. It is an undoubted and fine picture, in most perfect preservation (in this respect very fortunate), and painted, I should think, in his best time; and yet with all this is so *very* low in tone,

[1] Williams, Vol. II, p. 165. The date is printed "May 23, 1818," but that is a mistake for 1819.
[2] The picture in the Palazzo Barberini, now no longer accepted as the work of Leonardo.

PLATE XXIX

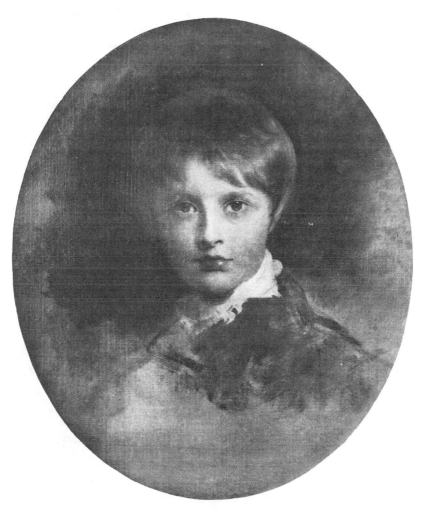

THE KING OF ROME
(FRANÇOIS CHARLES JOSEPH NAPOLEON, DUC DE REICHSTADT)
FROM THE PAINTING IN THE POSSESSION OF THE DUC DE BASSANO

so dark, and the Vanity so far from handsome, that—although if
you liked it, I would not dissuade you from buying it—I cannot
recommend it for an additional ornament to a collection which has
greatly increased in my estimation since my visit to the Continent.
There is a noble Raphaele in the Borghese,[1] though in his second
manner, that I would (recommend), but that is not to be sold.
That Raphael and the 'Diana' by Domenichino[2] stamp the
Borghese as the first private collection in Rome, though Cardinal
Fesch's is very rich both in the Roman and Venetian Schools;
and I am told in the Flemish, the whole of which I have not yet
seen. Ah! there *is* a picture—there are two, *elsewhere*, that would
indeed have adorned and crowned your collection; but I dare not
advise their purchase to you, and (be entirely secret here, both
you, dear sir, and Mr. J. Angerstein) I have not found in my
heart to mention them to others. Tell Mr. J. Angerstein quietly
to find out the present possessor of a picture (a fine one), called
Correggio, and sold in Mr. Udney's sale, an 'Ecce Homo': it is
engraved by Ludovico Carraci. It (the picture he is recommend-
ing to his correspondent) is the original of that (Mr. Udney's)
picture, and the other is the original of the 'Mercury teaching
Cupid to read,' in the Marquess of Stafford's Gallery, by the same
master. I had them both brought down for me, and placed by me
in all lights, and know them to be both rare and precious. The first
was sold by Mr. Day to its present owner. Be sure, dear Sir, to
tell Mr. J. Angerstein and Mrs. John, if they can trace that
picture (Mr. Udney's), to see it and tell you how they like it; and
if *that* in character and expression be fine (and I know her dear
father would have pronounced it so), tell them the original is *far
before it*. It is a celestial work, and the other equally pure, of
more celebrity, though in my opinion not demanding for its execu-
tion so penetrating and pathetic a genius.

"Colnaghi would get you a print of it (clumsy and gross as it
is, compared with the noble work) under this title, Ludovico or
Agostino Carraci's print of the 'Ecce Homo,' by Correggio. At
present, the whole collection[3] is not to be separated, and an offer

[1] "The Entombment of Christ," painted for Atalanta Baglioni in 1507.
Not a word of the Titian!
[3] That, no doubt, of Caroline Bonaparte, ex-Queen of Naples. The pictures had been
sold to Murat by their previous owner, Sir Simon Clarke, owing, it was said, to the difficulty
of removing them from Italy.

has, I know, been made for these two of six thousand pounds, but perhaps not in immediate money. . . . Many and many anxious thoughts, *hours* of debatings in my mind, have I had upon that picture; and (what never occurred in my life before) depending on the exertion of this one hand of mine, I have actually made the offer of a considerable sum to an agent if he ever brings that picture to England, and gives to me the refusal of it for three months, and I would exert myself to do so. Yet you not having it, it is better where it is, in hands distant from hence, *that once were royal.*

"Pray, pray let Mr. and Mrs. J. Angerstein oblige me by seeing Carraci's copy of it, named as the original in Mr. Udney's collection. At the very time I was first introduced to you by Mr. Lock of Woodlands, I had been so struck by the grandeur of that character, and its composition, that from memory I attempted to copy or imitate it; and when I get home I will show you its beginning—one of my very first attempts in oil, *I* only can *find it*—or I would order it to be sent to you. I have an attachment and respect for you not common, as the causes of it have not been common; but I am old enough to have a sort of paternal feeling for the Pall Mall Collection, as Sir Joshua or Mr. West would have had, had they so gradually witnessed its formation; and this has kept me resolutely dumb, although the mention of it in two quarters[1] (both of which you can guess) was repeatedly pressed upon me. I would, if I had power, improve the arts of my country, knowing its superiority in existing talent and genius, but I am not liberal enough to wish these works brought to it, and in other hands. I have said my say, and to say it have had a long conflict, and I now feel like a person disburthening his conscience of long hidden crime.

"Mrs. John Angerstein, your painter of so many years, and grown exceedingly old and ugly in your service, implores you to go and see that same picture (once Mr. Udney's) that would have given occasion to pure and eloquent criticism at Narberry [*sic*] Park!"

It may not be impertinent to offer a construction, in the legal sense of that term, of this remarkably involved communica-

[1] The Prince Regent and Lord Stewart.

PLATE XXX

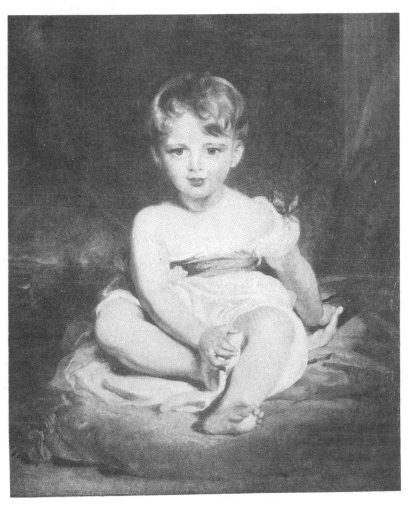

GEORGE HENRY, VISCOUNT SEAHAM

FROM THE PAINTING IN THE POSSESSION OF THE MARQUESS OF LONDONDERRY

tion. Its meaning seems to be that Lawrence had seen the
two Correggios in the collection of Caroline Murat, ex-Queen
of Naples, and was torn between two desires, one that the pictures
should not be lost to Italy, the other that they should pass into
his friend Angerstein's collection in Pall Mall. Copies by
Ludovico Carracci of both pictures were in English collections,
one in that of Lord Stafford, the other in that of Mr. Udney.
Lawrence wished the Angersteins to see these copies, and under-
stand that they fall far short of their originals, so that the less
hesitation might be felt in buying the latter if he should urge
the purchase.[1]

One of the fine points in Lawrence's character was his in-
difference as to whether he obtained the credit due to him for
personal exertions of his own or not. So long as the desired
results were reached, he was satisfied. We shall find him giving
evidence before the Committee on the Elgin Marbles which will,
on the whole, bear the examination of a later and, as we think,
sounder criticism, better even than that of men like Flaxman and
Nollekens. It was evidence which may well have weighed
heavily in favour of the purchase. It was the same with the
acquisitions of Mr. Angerstein, of Lord Stewart, and of the
Regent himself. All these were greatly influenced by Lawrence,
who therefore deserves to be numbered among those who gave our
national collecting so excellent a start.

It has been noticed that in speaking of the Vatican frescoes,
Lawrence expressed opinions which are at least in harmony with
those of our later—and more competent ?—generation. " There is
something in those . . . deities of intellect that people the Sestine
Chapel that converts the noblest personages of Raphaele's drama
into the audience of Michael Angelo "—it would be hard to find a
happier figure for the contrast between the Florentine and the
Urbinate. It is enough by itself to prove Lawrence's capacity as
a critic, and suggests that if he had left himself time and leisure
for comprehensive study, he might have been a more enlightened
judge than any other man of his age. As it was, the chief outlet
for the student side of his nature was the collecting of drawings,

[1] The copy of the " Ecce Homo " was afterwards in the National Gallery for a short
time, until it was superseded by the original. Its present whereabouts I have failed to
trace.

which flowed into his Bloomsbury home from every corner of Europe. The story—the tragedy, I may call it, from our English standpoint—of his collection will be told presently.

To go back to his foreign experiences, Lawrence was in Naples in the late summer of 1819. There he enjoyed the Museo Borbonico thoroughly, and writes of it in a way which makes us wonder more than ever that he could have supported the society of those casts in his dining-room at home. Early in 1820 he began his journey to England, where he arrived towards the end of March, to find Benjamin West dead, and to be himself promptly elected President of the Royal Academy. He had brought eight full-length portraits home with him for the King, to say nothing of minor works, and George IV showed his approbation by the gift of that gold badge and chain which the P.R.A.s have worn as their insignia ever since.

Lawrence was now at the height of his *vogue*. The events of the last four years had driven his financial cares into the background, and had set him conspicuously in the forefront of the competing army of painters. He had been elected member of academies all over Europe and America, and we find that, at home, his attention was besought as a favour even by sitters of the highest rank and importance. All through his life, his inability to measure his engagements by his time had led him into difficulties, but now we find that even those who had waited ten, fifteen, even twenty years, for the completion of their pictures, importuned him with diffidence, as if they quite accepted the notion that humility was due from them to him. Even the Duchess of Wellington begs piteously for her Duke's portrait, to be put in the Library at Strathfieldsaye, as if its completion would be a favour for which no thanks would be too great.

Lawrence was not spoilt by all this. In spite of his faith in " Satan," he could in many things take his own measure. " I can never expect," he writes to his brother Andrew, " that the labours of my pencil will have so great an interest at any future time as they now have, nor their superiority be so generally acknowledged." How great this interest was may be gathered from the fact that Hurst and Robinson entered into an agreement in 1822 to pay £3000 per annum, for two years certain, for the right

PLATE XXXI

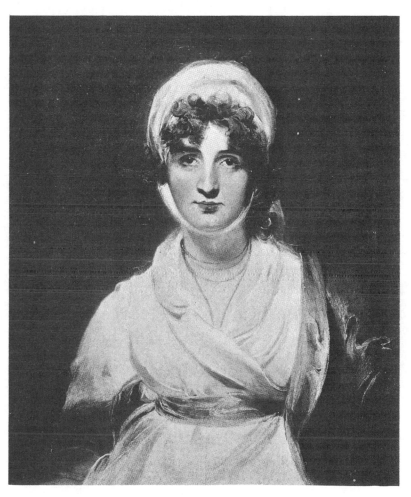

MRS. SIDDONS
FROM THE PAINTING IN THE NATIONAL GALLERY

to engrave his pictures. "Two years certain" would bring him close to the catastrophe of 1825, when Hurst and Robinson failed.

Lawrence's friend John Julius Angerstein died in this year (1822). Soon after his death a movement was started to buy his collection of pictures for the nation. Two years later the transaction was actually concluded. The collection was acquired by Lord Grey's Government, together with the house in Pall Mall [1] in which it hung. Seguier was appointed keeper, and Lawrence was invited by Lord Grey to become one of the Trustees to which its control was committed.

[1] It occupied part of what is now the site of the Reform Club.

CHAPTER IX

LAWRENCE AS A COLLECTOR OF DRAWINGS

IT is curious that England, which was the latest of the great European nations systematically to collect works of art, should have been a pioneer in the same field so far as individuals were concerned. To say nothing of Tradescant and his Ark, two of the earliest and most intelligent of collectors were Charles I and the Earl of Arundel, both of whom included drawings among their acquisitions. After their day the next great collector was Sir Peter Lely, whose gatherings, so far as we can now judge, were comparable to those being made by Rembrandt almost at the same time. When Lely died his collections were sold, and are said to have fetched the huge sum, for those days, of £20,000. Then came Lord Somers, and Jonathan Richardson, the painter. All through the eighteenth century English artists collected drawings, although they made so few. The chief instance of this was Sir Joshua Reynolds, who bought with more eagerness than discrimination, although he was himself one of the rare examples of a great artist almost entirely neglecting the use of the point. The collections of George III, Lord Spencer, the Duke of Devonshire, Uvedale Price, Udney, and Willett, were all celebrated in their time and some are famous still. The fashion of the Grand Tour promoted collecting. Young men of rank and fortune travelled with tutors who had scraped together the beginnings, at least, of culture at Oxford or Cambridge. Many a masterpiece owes its presence on the walls or in the cabinets of an English great house to the advice of an eighteenth or nineteenth century "bear-leader." A few examples of this occur to me, and many no doubt could

80

PLATE XXXII

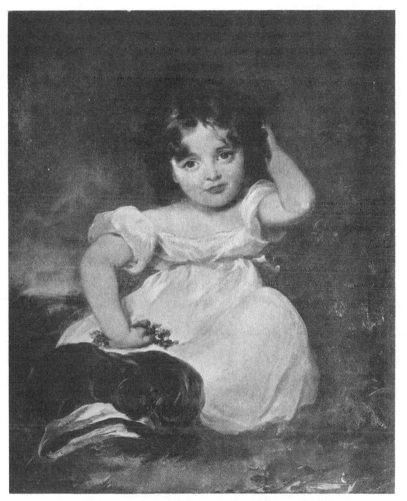

LADY ALEXANDRA VANE, COUNTESS OF PORTARLINGTON
FROM THE PAINTING IN THE POSSESSION OF THE MARQUESS OF LONDONDERRY

be discovered.[1] But, of course, the bear-leaders had good soil to work in. The English are born collectors, even when they take no profound interest in the objects they bring together. Between the beginning of the eighteenth century and the middle of the nineteenth, they were the chief agents in stripping Italy of her more portable treasures.

Napoleon's wars completed what the northern purse and habit of acquiring had begun. Money grew scarce abroad and property precarious. English dealers threw themselves into what had become a sort of battle, and bought as furiously as the Imperial Commissioners robbed. Collection after collection passed into their hands, to filter through to their clients at home. In the matter of drawings, the most active of these men was Samuel Woodburn, one of four brothers who then carried on the most important picture-dealing business in London. He was the chief purveyor to Lawrence, and was destined to be his successor in the ownership of the collection he had helped to make. He was, however, by no means the only person through whom Lawrence made his purchases. William Young Ottley sold Sir Thomas a collection he had bought from the Chevalier Wicar,[2] one of the French Commissioners, who had looked after his own interest while making requisitions for his employers. For these Wicar drawings Lawrence paid Ottley £10,000. Other cabinets he acquired were the Zanetti Collection made by the Marchese Antaldi, mainly by purchases from Wicar; the Le Goy Collection; the Italian drawings of Thomas Dimsdale (for which he paid Woodburn £5500); and a hundred and fifty of the best drawings collected by Count de Fries, of Vienna. According to Woodburn,[3] he gave £2200 for the collection of a French amateur solely on account of six Michelangelo and Raphael drawings it included. These, together with many other acquisitions, were made during a visit to Paris in 1825, when he painted Charles X.

[1] One magnificent example of a great Flemish *primitif*, hanging in a well-known English house, threw its purchaser into deep disgrace with his father. The boy bought the picture in Rome, on the urgent advice of his tutor, paying for it with a draft on the paternal bank account for £150. Boy and tutor were recalled, and the latter dismissed ; but the present value of the picture is at least a hundred times what it cost.

[2] Jean Baptiste Wicar (1762–1834). The fine collection, left to his native city of Lille, was chiefly made, however, between 1800, when he ceased to be a Commissioner, and his death.

[3] Sir J. C. Robinson's introduction to his *Critical Account of the Drawings by Michelangelo and Raffaello in the University Galleries, Oxford* (Clarendon Press, 1870).

SIR THOMAS LAWRENCE, P. R. A.

The same excellent authority declares that Sir Thomas acquired every fine drawing brought to London in his time, until he ended by practically absorbing the whole floating supply of studies by the old masters outside the permanent museums, and so putting an end to collecting for the nonce. In England, indeed, he killed the fashion. Before his day it had always attracted a large number of amateurs, but for the last sixty years and more it had been confined to comparatively few individuals, most of whose accumulations have now happily passed into the ownership of the nation.

So far as can be ascertained, Lawrence owned, at his death, between four and five thousand drawings by the old masters. This total included about 150 ascribed to Michelangelo, 160 to Raphael, 430 to Fra Bartolommeo, 75 to Leonardo da Vinci, 200 to Rembrandt, 150 to Rubens, 50 to Van Dyck, and 100 to Albrecht Dürer. The schools popular in his own day were over-represented, no doubt: 175 Parmigianos, 50 Primaticcios, 160 Carraccis, 85 Pierino del Vagas, for instance: while many of our modern favourites—Botticelli, Mantegna, etc.—were almost entirely neglected. But on the whole the collection showed a catholicity of taste which seems not a little remarkable in a painter whose own work was so very far from catholic. We are not surprised to find Rembrandt risking bankruptcy for the sake of possessing fragments of Raphael, Titian, Mantegna, and Correggio, but that Lawrence, with the narrowest range, perhaps, of any artist who has filled the eye of the world, should do so too, shows how little the appreciative power depends on the creative.

There is good evidence for the belief that his collection cost Lawrence, from first to last, more than £40,000. To consider here what became of it may seem a little out of place, but the story once begun had better be told to the end. His will contained the following passage:—

" My collection of genuine drawings by the Old Masters, which, in number and value, I know to be unequalled in Europe, and which I am fully justified in estimating, as a collection, at twenty thousand pounds, I desire may be first offered to his most Gracious Majesty King George the IV, at the sum of eighteen thousand pounds; and if his Majesty shall not be pleased to purchase the

PLATE XXXIII

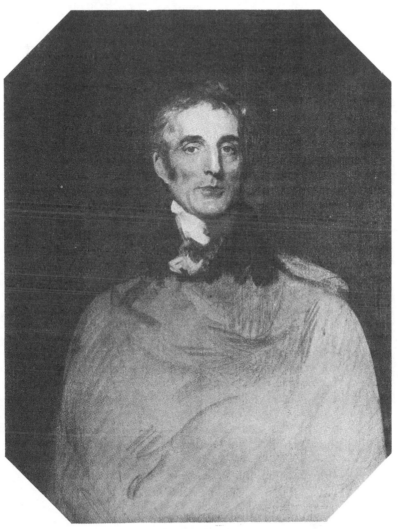

ARTHUR, DUKE OF WELLINGTON
FROM THE PAINTING IN THE POSSESSION OF THE EARL OF JERSEY

same at that price, then, that the collection be offered, at the same price, to the Trustees of the British Museum ; and afterwards, successively, to the Right Honourable Robert Peel, and to the Right Honourable the Earl of Dudley ; and if none of such offers shall be accepted, then I desire that the said collection may be forthwith advertised in the principal capitals of Europe and elsewhere ; and if, within two years, a purchaser shall not be found at the sum of twenty thousand pounds, then I desire that the same may be sold by public auction, or private contract, in London, either altogether or in separate lots, at such price or prices, and in such a manner, as my executor shall think best."

The King's death followed so closely on the painter's, and was preceded by so much ill-health, that his right of pre-emption was never seriously considered. The Trustees of the British Museum —who at that time were looked upon as informal guardians of the young National Gallery also[1]—failed to rise to their opportunity, while Sir Robert Peel and Lord Dudley both declined to purchase. An attempt was next made to raise the money by subscription, and place the collection in the National Gallery. After beginning well, this attempt also failed. At last the brothers Woodburn offered sixteen thousand pounds for the whole collection, and this was accepted by the disheartened executor. No sooner had the drawings ceased to figure among the Lawrence assets, than the Government changed its mind, and opened negotiations for its purchase. But the case of the Sibylline Books was repeated. The price had risen and the collection diminished, so nothing was done. The Woodburns started a series of exhibitions of the more important specimens. These exhibitions answered their purpose. Twelve were held altogether, the aggregate of the prices asked for some 2500 drawings by twenty-three artists, scarcely more than half the whole collection, being well over £40,000. A large portion was disposed of in this way, but the most important series, the Michelangelos and Raphaels, still hung on hand. The King of Holland (William II) was allowed to pick them over, but, as Sir Charles Robinson says,[2] "fortunately for this country the knowledge and experience of the Royal amateur were not on a

[1] Many of the early bequests and gifts to the National Gallery were made, formally, to the Trustees of the British Museum, in trust for the National Gallery.
[2] Introduction to his *Critical Account*.

83

par with his zeal." He preferred the elaborately finished drawings and copies by scholars and assistants to the vivid and spontaneous sketches and studies of the great masters themselves. Thus it came about that in 1842, twelve years after the painter's death, these two series were still practically intact and still awaiting a home.

By a fortunate coincidence a most appropriate haven offered itself. Some years before a movement had been set on foot to provide the University of Oxford with a gallery in which the Pomfret Collection of antique marbles and various other works of art could be worthily housed. The late Professor Cockerell had been commissioned to furnish a design, and in 1842 the existing building, in which classic forms are so happily adapted, was rapidly approaching completion. It was urged by some of those who had been working for years to keep the collection together, that the drawings of the two great Italians should be acquired for the new institution. The drawings were exhibited at Oxford, and a subscription opened in the hope of obtaining the £7000 required. It went on gaily until some £3000 had been given and promised, when there was an ominous pause. Another fiasco seemed to be in view. But in some matters Alma Mater has a power of touching her sons which the nation lacks. The second Earl of Eldon, whose famous grandfather had been High Steward of the University, came forward with a donation of £4000 to complete the necessary sum, and the drawings at last found rest. It is a pity that Oxford did not come into the field a little sooner. Had she done so she might have made herself the Mecca for ever of all students of painting at a cost of not more than £20,000.

Why is it that the English cannot learn even the commercial value of art—of art as an investment? A late distinguished statesman once asked, "Who cares about art?" It is safe to say that no human passion, once the radical necessities of life are satisfied, is so universal as that for art, in one form or another. From the most primitive savage up to the most elaborate specimen of civilized man, the desire for decoration and self-expression in all ways that appeal to the higher senses is practically universal. Even in England, where art is consciously accepted as a civilizing agent, less, perhaps, than anywhere else, it is the greatest of all the stimulating forces, with, of course, the two obvious exceptions.

84

PLATE XXXIV

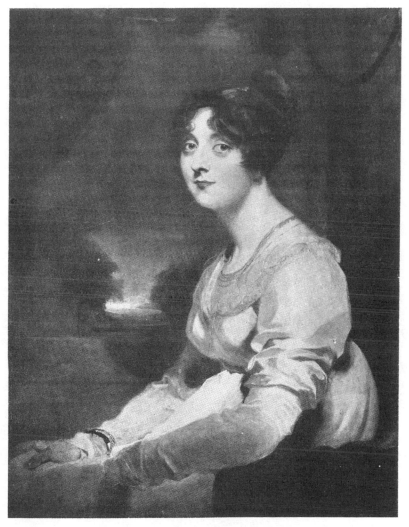

LADY WHEATLEY
FROM THE PAINTING IN NEW YORK

AS A COLLECTOR OF DRAWINGS

More money and more energy is expended upon it than upon the gratification of any other civilized desire. The draught towards it is almost as universal as that of one sex to the other, and much more permanent. Indeed, the two propensities are closely allied. In saying this, one includes, of course, all phenomena of the art impulse, from the shells on a Samoan canoe to the Cathedral of St. Paul. Strip even English civilization of all that depends on the instinct for art, and half the nation would be unemployed. And yet as a race we will not draw the obvious conclusions. During the last century we have had opportunities which, if seized, would have made England as rich in the world's inheritance from the great artists of the past as all the rest of Europe put together. And that at so trivial a cost that its pressure on any single taxpayer could only be expressed in fractions of a penny.

Nothing, even now, is so cheap as a first-rate work of art. It is an inexhaustible mine. What is the "Madonna di San Sisto" worth to Dresden, or the "St. Cecilia," a second-rate Raphael, to Bologna? A writer in the *English Review* recently declared that it should be "the ideal of a state directed upon soundly commercial lines to become the Art Centre of the world," and I do not see how the proposition is to be denied. Think of what their collections have done for Italy and for Holland. Compare the fortunes of those German cities which have great museums or other artistic attractions with those which have not. The national individualism makes it very difficult to persuade Englishmen to use their imaginations in connection with matters outside their own groove. When the purchase of the Ansidei Madonna was being discussed a distinguished treasury official said to me, " I call it monstrous to pay £70,000 for a picture: no picture is worth half the money!" Testing value in any way you please, the remark was absurd. The value of unique things, which cannot be reproduced, can only be measured by the desire of men to possess them. It would be interesting to know what the Kaiser Friedrich Museum, as an investment, has done for Berlin; interesting, but heartbreaking: for the great majority of the pictures which have enabled Dr. Bode to raise the collection from the third to the first rank among European galleries came out of England.

SIR THOMAS LAWRENCE, P.R.A.

THE ELGIN MARBLES

Finally, before leaving Sir Thomas as a connoisseur, I must give some account of his share in the acquisition of the Elgin Marbles for the Nation. It was not until 1816 that the Committee of the House of Commons, which finally recommended their purchase, was appointed, although the marbles had arrived in this country a good many years before. Meanwhile, they had been the school of not a few of our young painters and sculptors, and Lawrence, among others, had become familiar with their beauties. The Committee was appointed early in 1816, and on the 5th of March Sir Thomas Lawrence was called before it. His evidence is so short, and yet so conclusive as to his power to judge works of art, that I shall venture to give it *in extenso*. Examined by the Chairman, Mr. Henry Bankes,[1] he said he was well acquainted with the Elgin Marbles.

Q. In what class of art do you consider them ?

A. In the very highest.

Q. Do you think it of importance that the public should become possessed of these marbles for the purpose of founding a school of art ?

A. I think they will be of very essential benefit to the arts of this country, and therefore of that (? great) importance.

Q. In your particular line of art, do you consider them of importance ?

A. In a line of art which I have very seldom practised, but which it is still my wish to do, I consider that they would be: namely, historical painting.

.

Q. Can you form any estimate of the comparative merit of the finest of the Elgin Marbles, as compared with the finest things (lately in Paris, now back in Italy) ?

A. I think the Elgin Marbles present excellences of a higher style of sculpture than any I have seen.

Q. Do you conceive any of them to be of a higher class than the Apollo Belvidere ?

[1] M.P. for Corfe Castle from 1780 to 1826. He published a history of Rome.

PLATE XXXV

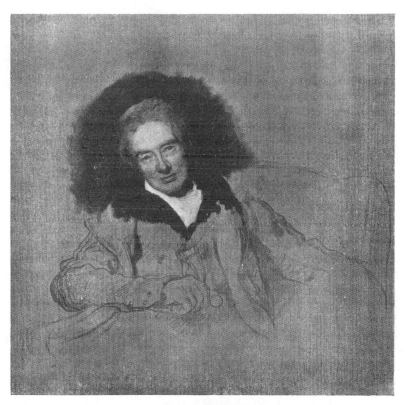

WILLIAM WILBERFORCE
FROM THE PAINTING IN THE NATIONAL PORTRAIT GALLERY

THE ELGIN MARBLES

A. I do ; because I consider that there is in them an union of fine composition and very grand form, with a more true and natural expression of the effects of action upon the human frame, than there is in the Apollo, or in any of the other most celebrated statues.

Q. Are you well acquainted with the Townly collection of marbles ?

A. Yes, I am.

Q. In what class should you place the Elgin Marbles, as compared with those ?

A. As superior.

Q. Do you consider them more valuable than the Townly Collection ?

A. Yes, I do.

Q. Is that superiority . . . applied to the fitness of the Elgin Marbles for a school of art, or to what you conceive to be the money value ?

A. I mean as to both.

Q. Are you acquainted with the Phygalian Marbles, as compared with the Elgin Marbles ?

A. Yes. I think generally that the composition of the Phygalian Marbles is very fine, that some of the designs are fully equal to those in the Elgin Marbles, but the execution generally is inferior.

Q. As to the comparative ages of the Phygalian and Elgin Marbles ?

A. I should guess that they must have been very nearly of the same age.

Q. Do you consider the metopes (of the Parthenon) to be equal or inferior to the frieze ?

A. I think the Panathenaic Procession is of equal merit throughout. I do not think the same of the metopes ; but I think some of the metopes are of equal value with the frieze.

Q. Do they appear to be of the same age ?

A. Yes, I think so. The total and entire difference of the character of relief appears to have arisen from the difference of situation in which they were placed.

87

Q. You have stated that you thought these marbles had great truth and imitation of nature. Do you consider that adds to their value?

A. It considerably adds to it, because I consider it as united to grand form. There is that variety which is produced in the human form by the alternating action and repose of muscles that strikes one particularly. I have myself a very good collection of the best casts from the antique statues, and was struck by that difference in them in returning from the Elgin Marbles to my own house.

Q. What do you think of the Theseus, compared with the Torso Belvidere?

A. I should say the Torso is the nearest, in point of excellence, to the Theseus. It would be difficult to decide in favour of the Theseus; but there are parts of the Torso in which the muscles are not true to the action, which they invariably are in what remains of the Theseus.

Q. You have seen the Hercules in Lord Lansdowne's collection?
A. Yes.
Q. How does that compare with the Theseus or the Neptune?
A. I think it inferior.
Q. Do you think it much inferior?
A. There are parts that are very inferior. There are parts in that that are very grand, and parts very inferior.
Q. Do you consider, on the whole, the Theseus as the most perfect piece of sculpture, of a single figure, you have ever seen?
A. Certainly, as an imitation of Nature; but as an imitation of character I could not decide unless I knew for what the figure was intended.

Four sculptors were also called as witnesses. Two of them, Nollekens and Flaxman, were a good deal less sure of the supreme merit of the Parthenon Marbles than Lawrence, who, curiously enough, was only backed up to the full by two less famous men—Westmacott and Rossi. Rossi was even more positive than Lawrence. "If you have not seen Lord Elgin's marbles," he wrote to Canova, "you have seen nothing!" Richard Payne-Knight, the great dilettante of those days, was also called. His evidence is almost enough to justify all that artists have ever said

PLATE XXXVI

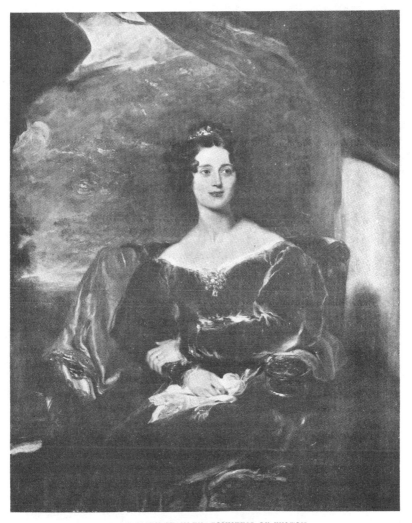

LADY MARY STANLEY, COUNTESS OF WILTON
FROM THE PAINTING

against amateurs: "The (Fates) are of little value, except from their local interest"; "the Townly *Venus* and the Lansdowne *Mercury* are each worth any two of the Elgin Marbles," etc. etc. And yet he had passed his life of sixty-six years among objects of ancient art, and had written much about them.

Fortunately the opinion of Lawrence and his fellow-artists prevailed against those of the "gentlemen," and a hundred years of intimacy with the spoils of the Parthenon have confirmed their verdict.

CHAPTER X

LAST YEARS

IN the autumn of 1825 Lawrence spent three months in Paris. The excuse for his visit was a commission from George IV to paint the French King, Charles X. But judging from his letters his chief occupation, when there, was the hunting up of drawings by the old masters. By the King he was as kindly received as he had been by other crowned heads. He had a painting-room in the Tuileries, described by himself as the best he had ever used. Judging from his description it was one of the square rooms, looking north, which occupied the *bel étage* of the old Pavillon Marsan, the pavilion, since rebuilt, which now forms part of the *Musée des Arts Décoratifs*. The King's sittings were carried on in a fashion which would have tried any temper less equable, any patience less courtier-like, than those of Lawrence. The children of the Duchesse de Berry climbed about the studio and over the royal person, as if the whole performance had been got up for their amusement.[1] Charles himself was hardly an inspiring sitter, and no more significant commentary on the Days of July need be wished for than the narrow, obstinate, imperceptive physiognomy the painter transferred to his canvas. In spite of the little Bourbons, the portrait was a success. He also painted the Duchesse de Berry, as well as some less important sitters, so that with painting and collecting his time was fully occupied down to the end of the autumn of 1825. The characteristic pleasures of Paris did not attract him greatly. " I am not framed (chiefly because I am too old)"—he confesses to Mrs. Wolff—"for the full swing of Parisian dissipation, so that I have been but once to the theatre." The

[1] These children were Henri de Bourbon, afterwards so well known as Comte de Chambord, and his sister, the future Duchesse d'Angoulême.

90

PLATE XXXVII

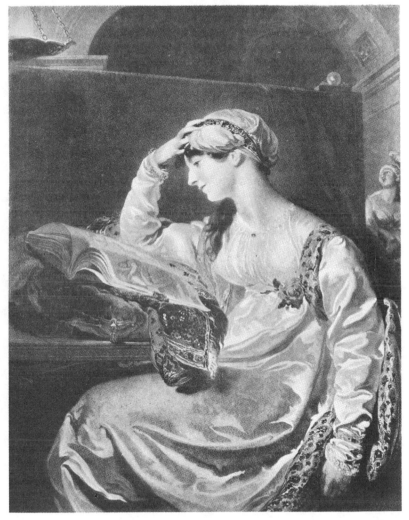

MRS. WOLFF
FROM THE MEZZOTINT BY SAMUEL COUSINS

whole Royal Family of France showered attentions upon him, the Duke of Orleans, afterwards Louis Philippe, among the rest. Besides the usual recognitions the King presented the painter with the set of Sèvres porcelain which he afterwards left to the Royal Academy.

The years immediately after the last sojourn of Lawrence abroad were full of incident for himself. The suicide of Lord Londonderry (Castlereagh) had taken place in 1822, and had set the coronet of a Marquess on the head of the painter's old friend, Lord Stewart. It was followed rapidly by the death of the Emperor Alexander, a hero of the new Marquess and once a kind patron to Lawrence. The advent of Canning to power in 1827 brought with it the resignation by the Duke of Wellington of the Command-in-Chief of the army, which seems to have led to some generous outburst on the part of Lawrence at the Academy dinner. Allusion to this[1] is made by " Vane Londonderry " in a letter printed by Mr. Layard. " It is impossible for me, loving you as I do, to refrain from expressing my deep and unqualified admiration at your dignified conduct in the Chair on Saturday. This is a time when whatever may be the ingratitude of a venal Press . . . the D. of Wellington should never die, and every Honourable and High Minded man will consider him a public property. Believe me your conduct is universally and most enthusiastically applauded."

During these latter years he was often appealed to for opinions on pictures by such collectors as Sir Robert (then Mr.) Peel. " I have seen the Vandykes," he says in one letter,[2] "very interesting portraits, and in each *identity* itself; of his earliest time in execution, but still of great truth and force. They are entirely free from the ravages of repair, and their present husky appearance will yield to new lining, and their being varnished." These are the pictures now in the Kaiser Friedrich Museum, Berlin. Lawrence's own "pencil," as he preferred to call it, was frequently employed by Peel. Three of his most remarkable portraits are those of Peel himself, of Lady Peel, and of the poet Southey, still at Drayton Hall. In connection with the last-named sitter, I may quote from a letter addressed by the painter to the statesman, given

[1] I can find no report of what he did or said in the newspapers of the time.
[2] Williams, Vol. II, p. 479.

by Williams,[1] as it helps to illustrate the complete reasonableness, which was one of Lawrence's qualities. Some might call this reasonableness a defect, and indeed it does not often co-exist with genius.

"Perhaps," he writes to the Secretary of State, "in the poet, you would like something that should obviously separate the character from the grave repose of the statesman. Mr. Southey's countenance is peculiar, and I shall, therefore, not err on the other side. But should anything strike you as your own wish in the choice of action, etc., let me know it before one to-day, for then he sits to me."

The portrait, when finished, was certainly quite unmistakable for that of a statesman, unless, indeed, in the sense in which the word is understood in Southey's own Cumberland. The hungry, fierce-eyed poet might stand for a farmer in a bad year. He has none of the cynical repose of the men of blue books.[2] The portrait of Mrs. Peel, which has now been cruelly separated from the rest of its family, is one of the most popular of the painter's works. It is well known through the mezzotint by Cousins. The march of fashion has had something to do with its revival of fame, by bringing its penthouse of a hat into a renewed probability. Together with these portraits of the current generation Lawrence painted Peel's little daughter, Julia, afterwards Lady Jersey, which stands in his *œuvre* as a kind of pendant to the Master Lambton.[3] In this connection I shall venture to quote from Williams another letter from Lawrence to Peel, partly because its subject-matter is not without interest, partly because one illustration, at least, must be given of the remarkable style in which a painter was apt to address a patron when George IV was King. The letter is concerned with the plate by Cousins after the "Mrs. Peel":—

"RUSSELL SQUARE,
"*Nov. 7th*, 1828.

"MY DEAR SIR,

"... The accompanying prints are not what I could have wished to present to your eyes, or to those of the friends of Mrs.

[1] Vol. II, p. 480.
[2] Not even if we include the perpetrator of the famous dispatch, "In matters of Commerce the fault of the Dutch," etc., which had been sent across the North Sea two years before by another of Lawrence's sitters.
[3] It was sold in 1907.

PLATE XXXVIII

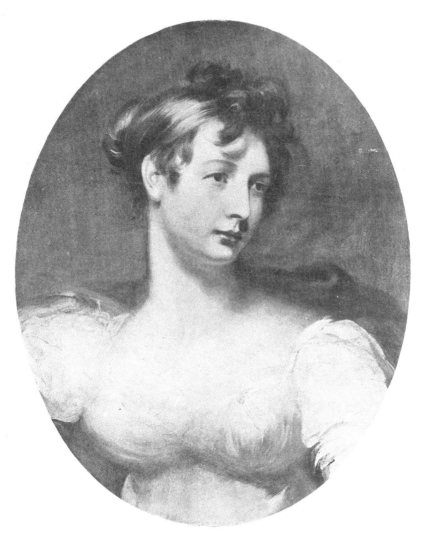

PORTRAIT OF A LADY UNKNOWN
FROM A PAINTING SOLD AT CHRISTIE'S IN 1902

Peel, and of that extended circle of them that we call the world. The print is far from doing justice to her beauty, nor does it to its attempted resemblance in my picture. The engraver makes excuses from the difficulty of the task, and the exceeding hardness of the steel plate; over which, he says, he 'had no controul.' He is, however, the first engraver in the delicate style of engraving, and has produced, I think, an admirable print, though the essence of the work be lost. I have been vexed and irritated by its having been exhibited in the print shops, before proofs being sent to me for yourself and Mrs. Peel. But you shall see the letter in which he assigns the cause of it, viz. his absence at Paris, and my not receiving, till the night before last, a finished impression. I have to receive from him twenty-five impressions for the honour of your acceptance.

"Let me know if you will receive them, and if (when you can spare the picture) you will permit Mr. Cozens [*sic*], the engraver of young Lambton, the Duke of Wellington, and Miss Croker, &c. to vindicate the subject and the picture, and reward his genius, by assigning to it its hitherto most delightful task.

"I beg my respects to Mrs. Peel, and have the honour to be, ever your obliged and faithfully devoted servant,

"THOMAS LAWRENCE.

"P.S.—You cannot, in this pause of the House of Commons' duties, and the claims of London society, honour this room by bringing Mrs. Peel with you on some evening, either Saturday next, Tuesday or Wednesday, to look over Rembrandt, or Claude, or Parmegiano, or Raphael?"

The curiously worded invitation in the P.S. was accepted, and often renewed, and the Peels seem to have taken a real pleasure in turning over the painter's collection of drawings.

We have seen that in some, at least, of his correspondence with those friends whom he looked upon as equals, Lawrence could be as natural and simple as anyone, so that the stilted obscurity, which was the chief result of his striving after a grand manner in writing, may be taken as a measure of the gulf which then lay between the most successful artist and such an important figure as a Secretary of State and leader of the House of Commons.

93

Once or twice, however, Lawrence writes with curious formality to his nearest and dearest. Some of his letters to Mrs. Bloxam, his favourite sitter, have a touch of pomp, while more than once he addresses his brother, Major Lawrence, as " My dear Sir."

The last year of Lawrence's life was probably one of the happiest. It is true that we can tell from his letters that he was more conscious of advancing age than most men of sixty. He often complains of fatigue, and alludes to the " Down Hill Slope," which brings "gentlemen of a certain age" to the end of the Dance before they desire it. Apart from this his last months were freer from certain forms of care than any he had known since he had arrived at manhood. His earning power had so far overtaken his expenses that his assets were equal to his liabilities, and although he was still hard pressed now and then for cash, he at least knew there was no longer question of commissions in bankruptcy. On the other hand, it is impossible to avoid the suspicion, if not the conviction. that his mind was not so clear at sixty as it had been at fifty-nine. His last letters are not, indeed, more involved than many which had preceded them, but they have a groping quality, a sense of feeling round, on the part of the writer, for an idea which had escaped him, which is new, and suggests that the loss of vitality of which he is conscious in his body had also affected his mind. The idea of approaching dissolution seems to have been constantly present with him. He told his friend Mrs. Hayman, who was his senior by sixteen years, that she would survive him ; he talked of having heard a death-watch, and frequently alluded to the various signs of decay.

The most curious thing about this is that to the very end his art showed no symptom of failing vigour. It changed, of course, as his life wore on. It lost delicacy, a quality in which it was never rich, and became less curious about texture and the harmonics of expression. But it said what it had to say with as much promptitude as ever, and was free from the usual hesitations of advancing years. The portraits he sent to the Exhibition during the last completed year of his life were those of the Duke of Clarence, Miss Macdonald, the Duchess of Richmond, Lord Durham, Robert Southey, the Marchioness of Salisbury, Sir John (then Mr.) Soane, and Mrs. Locke of Norbury. Not one among them be-

PLATE XXXIX

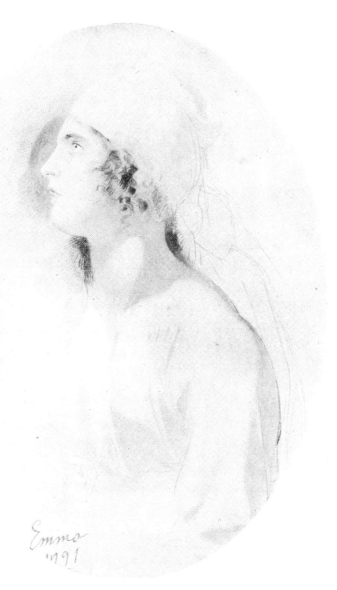

EMMA, LADY HAMILTON
FROM THE CHALK DRAWING IN THE BRITISH MUSEUM

trays the fatigue and sense of failing powers of which he so often complained. It is not in vigour that they fail. He had often shown more sympathy with his sitters—in his portraits, for instance, of Pius VII, of Consalvi, of Warren Hastings, and the best of his Wellingtons—which I take to be that belonging to Lord Jersey, at Middleton—but never in his whole career had he set upon canvas with greater vivacity the personality which seemed to him to be filling his sitter's chair, than in the "Southey," painted for Sir Robert Peel. This is really an astonishing performance for a man who complained of being worn out before his time, for a man who was to die within the year for no better cause than a general inability to remain alive.

I have said that his last years were comparatively free from financial cares. The comforting assurance that when death overtook him his property would be found equal to the discharge of all his liabilities was at last his. On the other hand, as time went on another result of his peculiar disposition must have been an ever-increasing cause of worry. This was the accumulation of unfulfilled promises. As I have already ventured to assert, nature had denied him what, I believe, the phrenologists call the bump of causality. The impression received from all that has been written about him and all that he wrote about himself, is that he was transparently sincere, that he never made a promise without intending to fulfil it, or undertook a duty without hoping, at least, that he might be found equal to its discharge. But he seems to have been quite without the instinct which compels the majority of men to consider a moment, before they make a promise, what means, in the way of time and opportunity, they may have of fulfilling it. The unscrupulous sow promises broadcast, looking only to their immediate effect, and caring nothing as to whether they will ever get them carried out or not. But unscrupulous is the last epithet to be applied to Lawrence. Every action of his which did not involve a draft upon the future is marked by honesty, fairness, and good judgment. He was altruistic to a fault, shrinking from anything which might have the appearance of self-seeking, and leaving behind him no record of any kind which would justify us in ascribing his failure to keep engagements to want of principle. His friend of thirty years, Miss Croft, tells a story

of Georgiana, Duchess of Devonshire, which might have been applied to himself. "One evening when Fox, and Sheridan, and Hare, and Sir Thomas (Lawrence) were . . . in her boudoir, the Duchess retired to a writing-table, pleading that she must write a letter she had too long neglected. Mr. Hare declared they could not spare her so long, and offered to write the letter for her; she laughingly inquired how that was possible, as he knew not her correspondent or her business. He persisted and sat down to write, and soon produced a letter full of the most lively assurances of esteem and interest, the most ardent desire to serve the parties by all means in her power—then came regrets that pressing exigencies of her own, and a long list of friends to serve, must for a time impede her efforts; and it closed with new professions of services at some future time. The Duchess confessed that the letter would answer the purpose perfectly well. Then said Hare, 'You will sign and I will direct it.' This caused more amusement, and she defied him to direct it properly. He very gravely folded and sealed it, and then wrote, 'To Anybody, Anywhere.'"[1] This little comedy must have been watched by Lawrence with mingled feelings.

Like most artists, Lawrence was deeply interested in the stage, although, after his early threat to become an actor, his own crowded life and inability to lay out his time made him but an intermittent playgoer. He once, indeed, actually trod the boards, for in 1785 he appeared with Mrs. Jordan at Drury Lane in the play of *Philaster*. In the last few months of his life his active interest was reawakened by the debut of Fanny Kemble, the niece of his unswerving ally, Mrs. Siddons. She drew him frequently to the theatre, and he seems to have been in the habit of writing his impressions to her afterwards. His own letters are not forthcoming, but Mr. Layard prints some of her replies, which go to prove that his criticisms were useful; although he does seem on one occasion to have taken her own hair for a bad wig! The following quotation shows how affection for her family and appreciation for her talent were mingled in Lawrence's judgment on Fanny Kemble:—

"Yes, Fanny Kemble has succeeded greatly in Belvidera ('Venice Preserved'), and exhibited still greater power than she

[1] *Recollections of Sir Thomas Lawrence, P.R.A.*, printed by Mr. Somes Layard in *Lawrence's Letter Bag*, pp. 250–1.

PLATE XL

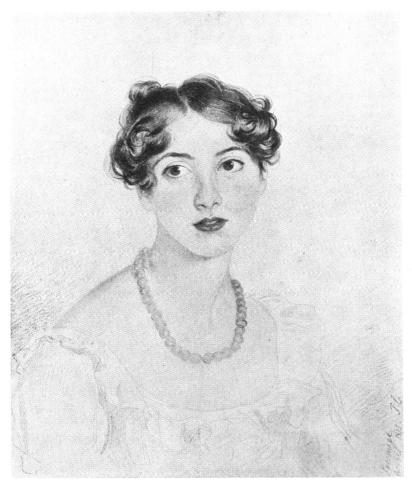

MISS MARSHALL (NIECE OF MRS. WOLFF)
FROM THE CHALK DRAWING IN THE BRITISH MUSEUM

did in Juliet. . . . Let me give you Washington Irving's opinion of her to me, the other night at Mr. Peel's. ' She is much more beautiful in private than she is on the stage, and the nearer one gets to her face and to her mind, the more beautiful they both are.' Now *I* have never ventured to say half so much, for why, my Dear Friend? Why because, be it known to you, I have the shackles of sixty upon me, and therefore these Love-chains would turn into skeletons of Roses, did anyone attempt to throw them round me. But tho' I seldom see her, I have almost a Father's interest for her, and a Father's resentment towards those who will not see the promise of almost all that Genius can do, because they have seen the unequall'd power, the glorious countenance and figure of Mrs. Siddons or are captivated by the contortions of Mr. Kean. . . . To give you a notion of the range and power of which Fanny Kemble is capable, her Juliet is the sweetest I have ever seen, and yet I should not have the slightest doubt of her success were she to appear to-morrow as Lady Macbeth. In five minutes she would conquer all disadvantage of figure, and people would only feel that creatures of the most daring energy were to be found in women of small stature as in men." [1]

Few people have been described in more different, not to say contradictory, terms by different people than Fanny Kemble, and perhaps the magnetic effect every woman of the Kemble blood seems to have had upon Lawrence may lead us to discount his praise. But his criticism carries internal evidence of its truth, nevertheless. His phrase about " Love-chains " and " skeletons of Roses " derives piquancy from Fanny's own confession, in after years, that his tender *façons* with women did not leave her unmoved, in spite of the forty odd years between their ages.

It is in accord with everything else we know of Lawrence that in religion he fell into line with the people about him, accepting his Church as a matter of course, and turning to it for support and consolation at certain moments of his life. Religious doubts, speculations, and even inquiries were quite foreign to his nature. Christianity, as taught by the Church of England, was there to guide and comfort, and to it he turned when the death of friends

[1] Letter to Mrs. Hayman (Layard, pp. 222-3).

SIR THOMAS LAWRENCE, P. R. A.

or a sense of his own approaching end led his thoughts in that direction. "I have missed no Sunday," he writes to Miss Croft, "since my arrival in town without attending Divine Service. . . . An irreverent thought never yet passed through my mind. . . . Religious education, I mean, in its ordinary habits in families, inculcates gratitude and humbleness of mind towards the Creator, and . . . disposes us to thankful feelings for any good rendered us by our fellow men—whilst the entire absence of it has the opposite effect, and by leaving us independent of another World makes us self-loving and proud in this."[1]

Lawrence died on the 7th of January, 1830. His death was almost sudden, for although he had been ailing for some days before, no fear of a fatal conclusion was entertained until a few minutes before it came. He had been suffering from indigestion and faintness, had, according to the practice of the time, been freely bled, had even lost more blood than was intended through the slipping of the bandages. Syncope was the immediate cause of death, but in the notices published in the papers, ossification of the vessels about the heart was named. A post-mortem failed, however, to establish any such condition, and Mr. Somes Layard tells us that a medical friend of his own, to whom the doctor's report of the post-mortem was submitted, could find nothing incompatible with continued existence for some years except a condition of the blood-vessels apt to induce apoplexy or a clot.

Sir Thomas Lawrence was buried in the crypt of St. Paul's on the 21st of January, 1830.

[1] Layard, pp. 225–6.

CHAPTER XI

THE ART OF LAWRENCE

THE weak point of Lawrence as a whole is that he was not a whole. His individuality was in compartments, one compartment having little enough to do with another, and his general personality being held together by nothing more binding than an excellent disposition, on the moral side, and a quick, though perhaps rather narrow, intelligence on the side of intellect. His virtues were numerous and his vices few, both as an artist and as a social unit, but he was without that solid centre to which the details of character have to bear a certain well-defined, harmonizing relation before we can feel ourselves in the presence of a great person. What we know of his parentage explains his character. His mother, on the one hand, fulfilled her duty bravely as a woman, bearing many children and doing all she could to train them in her holidays; his father, on the other hand, overflowed with intelligence, amiability, and Micawberism. In neither can we discover the smallest trace of sins of commission. In what we know of Mrs. Lawrence, we divine a woman who might have filled a great place in the world under happy conditions; in her husband we see, quite unmistakably, one of those men who, for lack of a fly-wheel, cannot be reckoned on to do their share, or any part of it, in guiding the adventures of a family. Lawrence was the true son of the pair, but the characteristics they handed down did not blend to form a new whole; they lay side by side, in streaks. In the persistence with which he followed his art for half a laborious century, we see the echo of his mother's indefatigable maternity; in his incapacity to lay out his time, to concentrate his own powers, to prosecute a task to the end when it had lost its initial charm, we recognize his impossible father.

SIR THOMAS LAWRENCE, P.R.A.

In previous chapters I have dealt more on the private side of his career, on such things as his relation to Mrs. Siddons and her daughters, for instance, than some may consider judicious. A sort of sliding scale in such matters has been established. In the case of a man of first-rate importance in any walk of life, the world thinks no detail too petty to be recorded. It likes to know that Napoleon shaved himself; that Rembrandt's mistress, Hendrickje, washed Titus Rembrandtsz and put him to bed; that Henry VIII was proud of his legs. But as we descend the scale of greatness we are expected to put aside such little facts, in due proportion to our descent: unless, indeed, we happen to be Boswells, and can interest the reader in our hero's way of taking snuff! It cannot be asserted that Lawrence was a first-rate man, any more than the writer of these lines can pretend to be a Boswell: so it is with some sense of the need for a justification that so much has been said about events which may appear to have but little bearing on the painter's doings as an artist. And yet, what part of a man's character does not affect his creative powers? Imagine Goldsmith worldly wise, cutting his coat according to his cloth, and walking warily among his fellow members of the club: the "Vicar" and "The Deserted Village" and "The Good Natured Man" would then have been possible to him only as elaborate ironies, producing on ourselves an effect the reverse of agreeable. The congruity which we know to have existed between Goldsmith and his inventions is a chief element in the charm of both, spreading the creative quality over a wider field, and substituting a large unity in the man plus his work, for the small unity we should have if confined to the latter.

More, much more, than usual did the moral character of Lawrence affect his art. The instability inherited from his father, and shown so conspicuously in his affairs with Sally and Maria Siddons, is reflected in his want of depth, and in the strong contrast between the vivacity of his first attack and the dullness of his finishing. For his shallowness is the result more of a dying down of his interest, on each occasion, than of any want of vigour in his original idea. You will scarcely find a picture by Lawrence in which, so far as it goes, the first steps to a masterpiece are not to be descried. In this he is comparable to Reynolds, and superior

to Gainsborough. I might even say he is superior to both, for there is a spontaneity in the fling of Lawrence, in the way in which he throws the germ of a design upon canvas, which Sir Joshua never equalled. Reynolds thought out his conceptions. He had the knack of combining criticism with creation, of improving, expanding, and deepening his idea as it grew. Gainsborough's idea, again, was a very floating quantity. He gave little thought to a scheme. He was like a writer who trusts for success to the fascination of his style, to his gift for the creation of beauty in detail as he goes. Lawrence, on the other hand, saw a picture on his empty canvas. Masses fell into place in his mind without an effort. Form was easy to him, indeed he could not have avoided it had he tried. The result is that in the whole range of his productions you will scarcely find one which is positively bad in pattern. I avoid the word "composition" because composition seems to imply a gradual process, a putting together at the bidding of taste of the elements to be used. And Lawrence's pattern always has the air of an impromptu, with no further preparation than a kind of salute to the canvas with his stick of charcoal.

Hereupon, however, his defects intrude. We become convinced, after sufficient familiarity with his work, that his customary phrase —" My professional labours "—accurately represents his own permanent feeling towards the production of pictures. His facility, vivacity, and real æsthetic gift made their inception easy and the first stage of their execution delightful; while his instability, his alternation of hot fits with cold, turned their prosecution into a labour, and made him instinctively choose those methods which shortened his task.

This it is which makes his work so inferior in individuality to that of either Raeburn or Romney, to say nothing of Gainsborough and Sir Joshua. The impulse which governed his beginnings did not persist to the end, so that we have pictures characterized by extreme vivacity and spontaneity in their conception, degenerating into time-saving dexterity in their execution. Finishing had to be done, but gave him no delight, and so our pleasure is arrested too. Stories are told, no doubt, which seem inconsistent with this theory. On one occasion a friend found him busy over the Garter robes in a full-length of George IV. Asked how he had the patience

101

continually to repeat such things, Lawrence replied that he always found them interesting, and ever hoped that the latest was the best. The story is probably true, but we have only to look at the robes in question to be convinced that the pleasure he took in painting them was mechanical rather than artistic. As an artist his impulse was exhausted when he had discovered a pictorial equivalent to the royal swagger of that particular Majesty. For the rest, pleasure in his own dexterity rather than the desire to express was the motive power.

This *passagère* quality in Lawrence's creative fire, which deprives his actual brushing of interest, was combined with a great deficiency in the colour sense. The scanty allusions to the old masters in his letters show that he was chiefly attracted by design. He appreciates Michelangelo and sees clearly how much greater he was than Raphael, but in the Borghese Gallery he is so busy admiring Parmigiano that he has no eyes for Titian. His admiration of Michelangelo was no pose. It was as sincere as that of Sir Joshua and more sympathetic. Intellectually, Reynolds had more in common with the great Florentine, as we can tell both from his pictures and his writings. But Lawrence felt more because he felt in the same way, although on such a vastly lower plane. A picture like the Duke of Abercorn's *tondo* of Mrs. Maguire with a boy and a dog comes nearer to talking the same *æsthetic* language as a Michelangelo—such a Michelangelo as the bas-relief in Burlington House—than any Sir Joshua. The moral and intellectual ideas conveyed by the Michelangelo relief and the Lawrence picture are at such opposite poles that the comparison may, at the first blush, seem absurd; the similarity is there, nevertheless, and explains both Lawrence's passionate collecting of drawings and his insight into the greatness of the Parthenon Marbles.

The æsthetical defects in his art, then, seem to me to be two: a want of significance in his execution, which comes mainly from inability to keep his inspiration alive long enough; and poor colour, which must also be referred to congenital disability. Occasionally his interest in his subject was so great that the vivacity of his first attack was preserved to the end, and the former defect disappears. We then get such pictures as the "Pius VII," at Windsor, the "J. J. Angerstein" in the National Gallery, and the "Warren

THE ART OF LAWRENCE

Hastings" in the Portrait Gallery, all of which require only reasonably fine colour to be masterpieces. Nothing, of course, would have made him a real colourist, although more study of the great colour schools would have improved him in that particular. As for his other shortcomings, his want of depth, breadth, and distinction, they too are part of himself, and make any attempt to lift him quite into the first rank of modern painters a hopeless task. He spoke the truth when he said, in a letter to his brother, " I can never expect that the labours of my pencil will have so great an interest at any future time as they now have, nor their superiority be so generally acknowledg'd." [1]

At the present moment, however, his reputation is higher than it has been at any time, perhaps, since his death. To some extent this is to be accounted for by the fact that he has only lately been rediscovered by the French and other Continental nations, with whom his defects as a colourist do not count for so much as it does in England. Attempts are often made to belittle that love for colour which has been a distinction of the English school ever since its rebirth in the eighteenth century. The colourist is he who loves colour for its own sake, and makes it a vehicle of emotion as well as imitation. Colour is to him what sound is to the musician. It has an intrinsic expressive power of its own, apart from all objective considerations. The finest colourist of all is he who can create a complete colour unity, in which the place, the shape, the quantity, *and the quality* of each note shall be active in bringing about the final harmony. In short, he uses colour as a means of free expression within those limits of respect for objective truth imposed on all who take any form of imitation for their vehicle. In an age like ours, when the objective elements, in all arts, continually encroach on the subjective, and scientific truth tends ever more and more to oust sincerity of expression as the supreme test, the colourist, in the old sense, is at a discount. But his day will return, and when it does the work of art will not so often be confused with the *procès-verbal.*

As a colourist Lawrence was scarcely a member of the English school. If schools were divided by their tendencies, he would rather find his place among the French. His affinities were with

[1] *Sir Thomas Lawrence's Letter Bag*, p. 156.

103

men like David, Gros, Gérard, Ingres, Bonnat, and so it was but reasonable that the renewal of his vogue should have begun on the other side of the Channel. Not, of course, that his renewed fame is based on a defect, as what I have just said may appear to imply. The positive grounds of the present inclination to accept Lawrence as a remarkable artist are his vivacity, the modish elegance of his women, and the vigour and thoroughness he put into the painting of the heads of such men as excited his interest. He did not see deeply into these heads. Before his " Wellington," his " Warren Hastings," his " Angerstein," we have to do our own character-reading. No one would say of a portrait by Lawrence, "it is more like than the man himself." He only sees what he has before him, and a sitter, even when great, is, as a rule, a great man dormant! His grip on the outside, however, is strong. There is no vagueness, no slurring, no guessing. His painting is like a Frenchman's logic: it is weak only in induction.

As for the elegance of his women, it is not elegance of the highest type. We shrink from calling it distinction. Its elements are too trivial. They consist too much in the hang of curls, the play of fingers, the ripple of a scarf. It is, in short, a modish rather than a well-bred elegance. Occasionally he rises to a higher level: in the portrait of Miss Farren, for instance, or that of Miss Barrett-Moulton, or the " Lady Peel," or the " Lady Dover." In all these elegance merges into grace, although it still falls short of distinction. Distinction is the child of repose, and no important painter has less repose than Lawrence. His chief virtue, on the moral side of his art, is perhaps responsible for this particular want. For it is only given to the finest genius to combine repose with vivacity. The vivacity of Lawrence circles round his painting of eyes. Fuseli used to say, " he paints eyes better than Titian," and that, no doubt, is true if we substitute "imitates " for " paints." When the work was fresh and the pigments still free from that touch of horny dryness they have even in his best pictures, his eyes must often have been startling in their illusion. They struck a note which had to be played up to over the rest of the canvas, and that was not to be done, at least by Lawrence, without loss of breadth and tranquillity. On the other hand, he was an excellent designer. The

intrinsic relations between one form and another lay so open to him that he could not miss them. So the linear constituents of his pictures rarely fail to be at peace with themselves, to play into each other's hands, and to bring about in the end a unity—of a kind. That this unity is not of a higher class is due to the undeniable fact that, blameless and lovable as he was, Lawrence had neither the intellect nor the character required to constitute what the world means by a great man.

CATALOGUE OF PICTURES

THE following abbreviations are used :—

R.A. = Spring Exhibition of Royal Academy.

O.M. = Winter Exhibition of Old Masters, etc., at Royal Academy.

B.I. = British Institution.

S.K. = Exhibition of Portraits at South Kensington in 1867-8-9.

M. 1857 = The Loan Collection at Manchester in that year.

Chr. = Christie's Sale Room.

RIGHT and LEFT are throughout to be understood as the true right and left of *picture*, and not of the *spectator*.

The works of Lawrence in the following Catalogue are arranged thus :—

OIL (i.) Portraits. Sitter identified.

 (ii.) Portraits. Sitter not identified.

 (iii.) Subject pictures.

CHALK AND PENCIL. (i.) Portraits. Identified.

 (ii.) Portraits. Not identified, and Miscellaneo
 Studies.

LANDSCAPES . . In various materials.

106

CATALOGUE OF PICTURES

OIL—PORTRAITS

Abercorn, 1st Marquess of (1756–1818). Succeeded to Earldom 1789, Marquess 1790. Friend of Pitt and Sir Walter Scott. [Duke of Abercorn. B.I. 1833; O.M. 1885.]

R.A. 1814. 43×39. Half length; standing, to right; nearly full face. Stick in right hand. Landscape background.

Abercorn, 1st Marquess of. [Duke of Abercorn.]

R.A. 1793. No. 80, as " Portrait of a Nobleman."

Abercorn, 1st Marquess, Children of. See Hamilton.

Aberdeen, George Hamilton Gordon, 4th Earl of (1784–1860). Grandson of 3rd Earl. Succeeded to Earldom 1802. Travelled in Greece. Ambassador to Vienna and Paris, 1813–14. Premier 1852–5. [Sir Robert Peel. B.I. 1833; O.M. 1855; Victoria Exhibition, 1891; Graves' Gallery, 1908.]

R.A. 1830. 56×44. To knees, facing, eyes looking a little to left. Black hair in loose locks and slight whiskers. Dark, sallow complexion. Black clothes and sash of Order (Garter ?), nearly black. High-collared coat. Left hand resting on paper on table with yellow cloth. Background of red curtain and accessories unfinished.

MEZ. BY S. COUSINS, 1831.

Aberdeen, George, 4th Earl of, in his 23rd year. [Earl of Aberdeen, lent to B.I. 1830.]

R.A. 1808. Bust, open loose collar. Dark green plaid thrown over shoulder. Three-quarters to right, but head turned round to left. Loose short hair over forehead. " Of a severe style; sober in tone."

MEZ. BY C. TURNER, 1809.

Aberdeen, Harriet, Countess of. Daughter of Hon. John Douglas. Married (1) James, Viscount Hamilton (1809); (2) George, 4th Earl of Aberdeen (1815). Mother of first Duke of Abercorn. Died 1833. [Earl of Aberdeen. Agnew's Gallery, 1906.]

Circa 1815. 30 × 25. Half length, facing. Head three-quarters to right. Black hair in loose locks over forehead. Hazel eyes. Red dress crossed over breast, showing white chemisette. Over right shoulder a shawl of some oriental stuff, in stripes with floral design.

Aberdeen, Harriet, Countess of. [Ex Sir John Milbourne. Chr. June 10, 1909; 1850gs.]

Circa 1815. 29½×24½. To waist, facing, head turned a little to right. Black hair in loose curls over forehead. Crimson dress, cut low in the neck, crossing over breast and showing white chemisette. Shawl of oriental material over right shoulder.

Apparently replica of preceding.

Abington, Mrs. Actress, *née* Frances Barton. Born 1737. Performed for first time in London 1755. Died 1815. [Ex J. Bibby. Robinson and Fisher, June 27, 1901; 900gs.]

Early portrait. In white dress, with powdered hair. Landscape background.

Abernethy, John, F.R.S. (1764–1831). Born at Abernethy. Surgeon to St. Bartholomew's Hospital, 1787. Noted for wit and eccentric manners. [St. Bartholomew's Hospital. S.K. 1868; O.M. 1877.]

R.A. 1820. 55×44. Standing, as if addressing audience, facing. Right hand rests on papers on table. Loosely buttoned coat.

ENG. BY W. BROMLEY, 1827.

(Subscription portrait presented to the Hospital by his pupils.)

107

SIR THOMAS LAWRENCE, P.R.A.

Acland, Lydia Elizabeth, Lady, and her two sons—Thomas (1809–98) and Arthur (1811–57). Daughter of Henry Hoare. Married Sir Thomas Dyke Acland, 10th Baronet. She died 1856. [Sir T. Dyke Acland. O.M. 1904.]

R.A. 1818. (Painted 1814–15.) 60×46. Seated, nearly full length, holding cap in hand. High-waisted gown of dark red, and black shawl over shoulders. Children standing on couch to right and left. To left the dog Bronte looking up. Landscape background.

MEZ. BY S. COUSINS, 1826. (His earliest plate.)

Adair, Mrs. (?) Wife of Robert Adair, the diplomatist and friend of Fox.

1785–90. Painted for 10gs.

Adam, John (1779–1825). Member of Supreme Council of Bengal. Acting Governor-General of India in 1823. [Government House, Calcutta.]

Seated, full length, facing; head and eyes to left. High white cravat tied in loose bow. Right hand on papers on table to right. On footstool volume entitled "Central India."

LARGE MEZ. BY CH. TURNER, 1829.

[This picture was sent to London in 1886 to be cleaned.]

Agar-Ellis, George Welbore. See Dover, Lord.

Agar-Ellis, Lady Georgiana. See Dover, Lady.

Albemarle, Earl of. The portrait of Lord Albemarle, attributed to Lawrence on the engraving by S. Freeman, is by Shee.

Alexander, Emperor of Russia. [Windsor Castle, Waterloo Gallery. B.I. 1830. A copy in Hermitage, St. Petersburg.]

Full length, facing a little to right; hands clasped in front. Dark green Hussar uniform with silver epaulettes, worn at Leipsic.

Painted in the Hôtel de Ville at Aix-la-Chapelle in 1818.

For alteration, by which this portrait at one time had four legs, see letter to Mrs. Wolff from Aix.

Replicas or copies of this picture were commissioned by Czar and by King of Prussia (see letter from Lawrence to niece, November 26, 1818).

Allnutt, John. Of Clapham Common. Wine Merchant. Patron of Lawrence, Turner, and other artists. Lent large sums of money to Lawrence, secured on policy of insurance. As much as £5000 was, it is said, repaid at Lawrence's death. His granddaughter was married to Mr. Thomas Brassey,

108

later Lord Brassey. [Earl Brassey, Normanhurst.]

R.A. 1799. [No. 5, erroneously described as "Mr. Hunter" in; catalogue.] Full length. Standing beside his horse.

Allnutt, Mrs. Elizabeth, daughter of John Douce Garthwaite, 1st wife of above. [Earl Brassey, Normanhurst.]

R.A. 1798. (No. 30.) Full length of tall lady with kerchief or turban round her head, with black locks protruding. White dress with high waist, and light cloak under left arm. To the right a little girl of 4 or 5, holding up her frock as she walks. They are advancing by a footpath through open fields.

ENG. BY CH. ROLLS for the "Amulet" of 1828, as "The Morning Walk," with acknowledgments to "J. Allnut, Esq., of Clapham Common, a liberal and extensive patron of British Art."

Allnutt, Mrs., *née* Brandram, second wife of John Allnutt. [Messrs. Colnaghi. Robinson and Fisher's, Dec. 1907; 2900gs.]

1815–20. 30×25. Seated, half length; facing. In crimson plush dress, cut low. Dark hair, in loose curls over forehead. Jewel on breast, and long thin gold chain round neck. Background of dark blue.

There was a portrait of Mrs. Allnutt in the British Institution, 1843.

Alten, Count, Commander of the German Legion under Wellington. [Windsor Castle.]

Amelia, Princess (1783–1810). 6th and youngest daughter of George III. Of delicate health. Died unmarried. [Windsor Castle, Private Apartments. B.I. 1833 ; S.K. 1868 (lent by the King).]

R.A. 1790. Oval. 21×17. Child of 7 years. To waist, looking to left. Rosebud in left hand. Long flaxen hair.

Lawrence about this time received 15gs. for a portrait of the Princess.

STIPPLE ENG. BY F. BARTOLOZZI, 1792.

Another portrait of Princess Amelia was in the R.A. 1788.

Amherst, Baron (1773–1857). William Pitt Amherst ; sent as envoy to Pekin, 1816. Governor-General of India, 1823–8. Declared war with Burmah, 1824. Created Earl, 1826.

R.A. 1805. 56×44. Nearly to waist, facing, looking to left. In baron's robe. Short, rough hair.

ENG. BY S. FREEMAN, 1839.

Amherst, Baron. [Painted for British Factory at Canton.]

Circa 1818. Full length, standing, facing, looking to left. Right hand resting on parapet of column on which are papers and books, one entitled "Embassy to China." View of river and settlement at Canton to right.

ENG. BY CH. TURNER, 1824.

OIL–PORTRAITS

Anderson, Mr. Lawrence received 25gs. for a portrait of this gentleman soon after his establishment in London. Circa 1790.

Anderson, Miss Emily. "Little Red Riding Hood." [Mrs. Gordon Watson. Ex the Rev. A. Anderson.]

R.A. 1822. *Girl of 10 or 11, standing, facing, in centre of wooded landscape. Black curls over forehead. Red hood over back of head. Plate with food, tied up in handkerchief in right hand.*

ENG. BY R. J. LANE, 1824.

Anderson, Miss Emily (?). [At Böhle's Gallery, Munich, 1910.]

Circa 36×24. *Panel. Powerful sketch of young girl. Full length, with dark locks over forehead. Red hood and tippet. Holds flowers in right hand. Landscape with trees. Perhaps a sketch for the above.*

Angerstein, John Julius (1735–1823). Merchant, philanthropist, and amateur. Of Russian extraction. Underwriter at "Lloyds" and founder of modern "Lloyds." Assisted Lawrence by loans on several occasions. Purchased old masters on advice of West and Lawrence. His collection formed the nucleus of the National Gallery. [National Gallery; No. 129. Lent to B.I. 1833 by King.]

1828. 36×27. *Replica of earlier picture. Seated. Right hand, holding spectacles, rests on table. Facing, as if speaking. Fur-lined cloak.*

ENG. BY E. SCRIVEN, 1829

Painted for George IV, and presented to National Gallery by William IV in 1836. Lawrence writes of it: "As perfect a copy as I could possibly make of it" (July 28, 1828).

Angerstein, John Julius. [B.I. 1830 (lent by J. Angerstein). Probably Angerstein sale, July, 1896, 180gs. (described as "half-length, in red robe").]

R.A. 1816. 35½×28. *This is the original picture from which the replica was made for George IV in 1828. Lawrence appears to have had this picture with him in Rome (see letters from Lawrence to J. J. A., Rome, May, 1819). The replica was apparently made by Lawrence at the same time as the original, but it was finally touched up from the original (borrowed for the purpose) in 1828.*

Angerstein, John Julius. In the Angerstein sale was a second portrait of John Julius (35 × 28) said to be finished by Smart. This may have been originally the sketch for the 1816 picture. It sold for 125gs.

Angerstein, J. J., and Wife (widow of Charles Crockett). [Louvre. Ex Angerstein Collection.]

R.A. 1792. 100×62. *Mrs. A., in white dress and turban, seated, looking up and round to her husband, who stands to right, resting hand on chair. Mr. A., in knee-breeches, facing, head three-quarters to left. Landscape to left.*

Angerstein, John. Only son of John Julius. Married daughter of W. Locke, of Norbury.

R.A. 1830. *Completed in summer of 1829. See letter to J. A., Nov. 22, 1829. Lawrence says: "I am much pleased with it, and others like it as a picture."*

Angerstein, Children of John. [New York, Jefferson sale, April, 1906, $8000.]

R.A. 1808. *Elder boy standing to left. Girl of 5 or 6 holds up baby, who plays with a large spade. Younger girl to right, seated on ground, playing with slipper. Scene in woodland glade. A picture with this title was lent by John Angerstein to the British Institution in 1830 (see "Burlington Mag.," 1906, vol. i., p. 287).*

Angerstein, Mrs. John, and Child (John W. Angerstein). [L. Hirsch, Esq., O.M. 1904; B.I. 1851; Chr. Angerstein Trustees, July 14, 1896; 2050gs.]

R.A. 1800. 105×70½. *Full length, standing, to right, head facing. Child of 4 or 5 years stands by her, holding her left hand. White dress, open in front, with short sleeves, and yellow scarf over arms. Flower in hair. Landscape background of Norbury Park. The boy is said to have been added later.*

Anglesea, Henry W. Paget, 1st Marquess of (1768–1854). Eldest son of first Earl of Uxbridge. Created Marquess 1815. Field Marshal 1846. [Colonel Blake. Vict. Exhibition. 1891.]

R.A. 1817. 30×25. *Half length, life-size, facing. In Hussar uniform. Ribbon of Bath, with three crosses and a medal. High black stock.*

ENG. S. FREEMAN, 1831.

Anglesea, Henry W. Paget, 1st Marquess of (1768–1854). [Duke of Wellington, Apsley House. S.K. 1868.]

Commenced 1818. 93×53. *Standing, facing, full length. Hussar uniform, holding shako in left hand. Landscape to right, with smoke from cannon.*

ENG. BY J. R. JACKSON, 1845.

Commissioned by the Duke in 1818 for 200gs., and the money paid, but never delivered. The unfinished canvas recovered from Lawrence's executors ("Apsley House Catalogue," p. 272).

SIR THOMAS LAWRENCE, P.R.A.

Angoulême, Duc d'. Son of Charles X and of Marie Thérèse of Savoy. Born 1775. Died at Görz, 1844. Married 1799 to Madame Royale, daughter of Louis XVI. [B.I. 1830. The picture now in the Waterloo Gallery at Windsor is a copy.]
Painted in Paris, 1825. Standing, full length. Cloak over right shoulder. White breeches. Stormy landscape background.

Annesley, Mrs.
1790–5. Lawrence obtained 120gs. for a portrait of this lady.

Anstey, Christopher (1724–1805). Author of "New Bath Guide," 1766.
Early. Half length. Seated at table, looking to left, holding pen in hand.
ENG. IN STIPPLE BY W. BOND, 1807.

Antrobus, Sir Edmund. Born *circa* 1750. Eldest son of Philip Antrobus, of Congleton; uncle of the two boys Edmund and Gibbs Crawford. Created Baronet 1815. Died 1826. [Sir Edmund Antrobus, Amesbury Abbey.]
R.A. 1801 (as "Mr. Antrobus"). 48×39. Standing, nearly to knees. Facing three-quarters to right. Greyish hair. Holding papers in right hand. Quill pen and inkstand at side.
ENG. BY GEORGE CLINT, 1803.

Antrobus, Edmund (1792–1870). At Eton 1805–9. [Provost's Lodge, Eton College.]
Circa 1810. 36×27. As young man. Half length, facing, head a little to right. Light hair brushed from either side over forehead. Glove on left hand.

Antrobus, Edmund and Gibbs Crawford. Sons of John Antrobus, M.P. The elder (born 1792) succeeded his uncle as 2nd Baronet in 1826. [Sir Edmund Antrobus, Amesbury Abbey.]
Circa 1800. 93×57. Two boys with long hair and white collars. One to left seated by table with hand on book. The other to right standing, with arm resting on chair. High-buttoned trousers reaching only to ankles. Landscape background.
LARGE MEZ. BY GEORGE CLINT, 1802.

Antrobus, Philip. Brother of Edmund, 1st Baronet. [Sir Edmund Antrobus, Amesbury Abbey.]
Circa 1810. 48×39. Standing, nearly to knees. Facing, and looking out of picture. Elderly man with heavy eyebrows and projecting forehead. Right hand, holding just opened letter, rests on table.
ENG. BY G. CLINT.

110

Apsley, Georgina, Lady, 3rd daughter of Lord George Lennox. Married 1789 to Lord Apsley (later 3rd Earl Bathurst). Died 1841, aged 75. [Earl Bathurst). O.M. 1881 and 1904. Grafton Gallery, 1909.]
R.A. 1789 (No. 232). 29×24. "Portrait of a Lady of Quality." Three-quarter length; nearly life-size. Seated, looking down to needlework held in both hands. Fillet bound round curly powdered hair. White dress, loose fichu over breast. Landscape to left.
Lawrence received 20gs. for a portrait of Lady Apsley shortly after his arrival in London in 1787. See also under "Miss Lennox."
STIPPLE ENG. BY C. KNIGHT. (On later prints Bartolozzi's name appears. Cf. Eng. of Miss Farren.)

Apsley, Georgina, Lady.
R.A. 1792 (No. 150). This, rather than the last, may be Lord Bathurst's picture, and the one engraved by C. Knight.

Arbuthnot, Harriet (born Fane). Second wife of the Right Hon. Charles Arbuthnot, M.P. Died 1834. [Lent by Gen. Arbuthnot to B.I. 1865.]
R.A. 1817. Half length, seated, three-quarters to right. Leaning forward and looking round to left. Low white dress with long sleeves and high waist. Long neck, black hair. Eyeglass in right hand.
MEZ. BY H. W. GILLER, 1829. Also eng. by W. Ensom for "Bijou," 1830 (hair slightly altered).

Armagh, Archbishop of. John George de la Poer Beresford (1773–1862). Second son of 2nd Earl of Waterford. [Lent by Archbishop to B.I. 1845.]
R.A. 1830. Seated, three-quarters to left. Looking out of picture. Dark hair, brushed over bald head. Full lawn sleeves. Ribbon round neck with locket.
MEZ. BY C. TURNER, 1841.

Armistead, Mrs. (? Mrs. C. J. Fox).
1790–5. Lawrence received 50gs. for a portrait of this lady.

Ashburton, Alexander Baring, later 1st Lord (1774–1848). Second son of Sir Francis Baring. By 1810, head of Baring firm. Raised to peerage 1835. [Lord Ashburton. Victoria Exhibition, 1891.]
50×40. Three-quarter length. Left hand resting on paper on table. Right hand in trouser pocket.
ENG. BY C. E. WAGSTAFF, 1837; and by B. A. Artlett, 1838. (Called on engraving, Francis Lord Ashburton, but this impossible.)

Ashley, Lady. Lady Emily Cowper (q.v.), eldest daughter of 5th Earl Cowper. [Chr. 19 May, 1904: "Head of Lady Ashley," as a child, panel, oval, 20 × 15½," was ascribed to Lawrence, and was sold for a small price.]
? ENG. BY J. R. JACKSON, 1844.

OIL–PORTRAITS

Ashley, Maria Anne. Daughter of Colonel Baillie. Married 1831 to Hon. Anthony Ashley, second son of 6th Earl of Shaftesbury. [Lent to B.I., 1833, by Col. Hugh Baillie.]

Circa 1828. Standing, facing. Right arm resting on pedestal. White satin dress with full black sleeves. Hands with fingers interlaced. Vandyke cuffs. Black curls over forehead.

MEZ. BY G. H. PHILLIPS, 1842.

Atherley, Mr. Lawrence received 50gs. for a portrait of this gentleman.

1790-5. "The Portrait of an Etonian" (R.A. 1792, No. 209) is called by one contemporary critic "Mr. Atherley," but others call it "young Mr. Sheridan" (q.v.).

Auckland, William Eden, 1st Baron (1744–1814). Statesman and diplomatist. Negotiated commercial treaty with France 1786. Irish peer, 1789. Ambassador at The Hague. Served under Pitt and Addington. [Christchurch, Oxford. S.K. 1867. " Hist. Portraits," Oxford, 1906.]

R.A. 1794 (No. 131. "Portrait of a Nobleman". Painted 1792 for Christchurch. 51×40. Nearly full length, seated, facing, turning a little to right. Eyes prominent. Natural hair. Holding paper in left hand. Costume loosely painted. White waistcoat and frilled shirt. Glass ink bottles on table to left.

LARGE MEZ. BY W. DICKINSON, 1796.

Auckland, William Eden, 1st Baron (1744–1814). [Chr. 1876. Bought by Lord Elphinstone.]

19×14.

Babington, Mrs. Jean. Wife of Thomas B., of Rothley Temple. Daughter of the Rev. John Macaulay and aunt of Lord Macaulay. [Chr. July 13, 1901, 320gs.; again, March 8, 1902, 400gs.]

30×25. In white muslin gown, pink sash and shawl. White head-dress. Red curtain background.

Baillie, Matthew, M.D. (1761–1823). Morbid anatomist. Physician Extraordinary to George III. Bust and inscription in Westminster Abbey. [College of Physicians. S.K. 1868.]

30×25. Bust, nearly full face. Dark coat.

Baillie, Miss Maria Anne. See Ashley, Hon. Mrs. Anthony.

Baker, William, M.P.
R.A. 1806.

Banks, Right Hon. Sir Joseph, Bart., P.R.S. (1743–1820). With Captain Cook in first voyage, 1768. President of Royal Society, 1778. His collections and books are in the British Museum. [Council Room, British Museum. Ex Samuel Lysons.]

R.A. 1806. Half length, seated, facing, looking a little to left. Grey, rough hair. Right elbow resting on shelf or box. Ribbon and Star of Bath. Lace cuffs, hand touching volume of Proceedings of R. Society. On table the mace of the Society.

ENG. BY A. CARDON, 1810.

Bannister, Junr.
R.A., 794. No. 199. is so described in MS. note.

Barber, Master Thomas. [Chr. July 8, 1910, n.n.; 1000gs.]

Circa 1810-15. 56×43½. Boy of about 10 to 12 reclining on a bank; facing; left hand to side of face. Brown hair brushed over forehead. White frill collar. Holding hat under right arm. Landscape background.

Baring, Alexander. See Ashburton, Lord.

Baring, Sir Francis (1740–1810), with his son John, and his son-in-law Charles Wall. Founder of the Baring commercial house. Made Baronet 1793. [Earl of Northbrook; at Stratton. Guildhall, 1890. B.I. 1830 (lent by Sir Th. Baring).]

R.A. 1807. 89×61½. Sir Francis to right, holding left hand to ear, paper in right hand. The son and son-in-law consulting large ledger on table, on page of which "Hope and Co." may be read.

MEZ. BY JAMES WARD.
A miniature copy of this group, on enamel, by Ch. Muss. is in the National Portrait Gallery.

Baring, Sir Thomas (1772–1848). 2nd Baronet. Eldest son of Sir Francis Baring, with Lady Baring, his sister Mrs. Wall, and his son and nephew, Francis J. Baring and Baring Wall. [Earl of Northbrook; at Stratton. B.I. 1830 (lent by Sir T. Baring).]

R.A. 1810. but painted somewhat earlier. Sir Thomas to left, Lady Baring, seated, to right. with book on lap; between them the two boys. Mrs. Wall, in white dress, standing.

Baring, Mrs. H., and Children. Maria, daughter of W. Bingham of Pennsylvania. Married Henry, 3rd son of Sir Francis Baring. [Chr. May, 1872, Du Blaisel Exors., 1400gs. Chr. Dec. 16, 1911, Exors. of the Countess de Noailles, 8000gs.]

R.A. 1821. In white, high-waisted dress, dark hair falling over shoulders, seated on sofa. Her little daughter, afterwards Mrs. Simpson, at back, playing with her mother. At her foot, a little boy with dog. Sky background. The costume points to the picture having been begun at least 10 years earlier.

111

SIR THOMAS LAWRENCE, P.R.A.

Baring, Mrs., and Child.
Circa 1815–20. Resting on bank in wood. Veil over head. Facing left, and looking out. Child of 5 or 6 years resting elbow on mother's knee.
SMALL ENG. BY R. GRAVES.

Baring, Right Hon. Francis T., as a boy. [Lent to B.I., 1843, by Right Hon. F. T. Baring, M.P.]

Barnard, Andrew. Secretary to Lord Macartney, whom he accompanied to the Cape. The husband of Lady Anne Barnard, the poetess. Died 1809.
Circa 1808. Half length, seated to right. Face three-quarters to right. Greyish hair. Hands folded on table to right. Coat with large collar.
MEZ. BY CHARLES TURNER, 1809.

Barrett, Miss Mary Moulton. "Pinkie," aunt of Mrs. Barrett Browning. [O. Moulton Barrett, Esq. O.M. 1907.]
R.A. 1795 (No. 75, as "Portrait of a Young Lady"). 57½ × 39½. Full length of young girl standing, facing, and looking sharply out with great animation. White dress with pink sash. Hat with long pink ribbons floating in wind. Right hand behind back. Background of sky with scattered clouds; landscape below.

Barrett, Elizabeth (Mrs. Barrett Browning) (1806–61). Daughter of Moulton Barrett. Poetess. [E. E. Jackson, jun., Esq., Brooklyn, New York.]
Circa 1828. Oval. 23½ × 20. Bust, face only finished. A "Portrait of a Young Lady" lent to the British Institution, 1856, by Mr. Edward Barrett, may have been this or the previous portrait ("Pinkie").

Barrington, William Wildman, 2nd Viscount (1717–93). Statesman. Brother of Shute Barrington, Bishop of Durham. Served in several administrations.
R.A. 1792. Half length. Seated, facing and stooping. White wig. Coat buttoned by top button. It is possible that this may be a chalk drawing.
ENG. (in circle) BY RIDLEY, AND BY C. KNIGHT ("by direction of his surviving brothers").

Barrington, William Wildman, 2nd Viscount. [Lent by Lord Barrington to B.I., 1864.]
Perhaps identical with last. Lawrence received 30gs. for a portrait of Lord Barrington shortly after his first coming to London. This would be the price of an oil picture.

112

Barrington, Shute, Bishop of Durham (1734–1826). Brother of the 2nd Lord Barrington. A bishop for 57 years. Interested in philanthropy, and author of works on religion.
R.A. 1796 (No. 147). "Portrait of a Bishop." In his 62nd year.

Barrington, Shute, Bishop of Durham.
R.A. 1816. In his 80th year. Three-quarter length. Seated, facing, looking to left. Lawn sleeves and wig. Hands on arm of chair. To right a large volume, inscribed BIBLIOR. COMP.
ENG. BY CH. TURNER, 1817.
There is a portrait by Lawrence of this bishop in the Palace at Bishop Auckland.

Barton, Mrs., and Daughter. [In America. Chr. 1874. Fearon, £44.]
Full length.

Basset, the Daughters of Lady.
1790–5. Lawrence received 50gs. for a picture of these ladies.

Bath, Thomas, 1st Marquess of. Born 1734, succeeded his father as Viscount Weymouth, 1751. Created Marquess of Bath 1789. Died 1796. [Marquess of Bath. S.K. 1867; O.M. 1904.]
R.A. 1796 (No. 163, "Portrait of a Nobleman"). 49 × 39½. To knees. Elderly man, seated to right, in peer's robes and wig. Looking out of picture. Hands on arms of chair. Ionic columns to right.
ENG. BY CH. HEATH.

Bath, Marchioness of. Wife of 2nd Marquess. [Marquess of Bath, Longleat.]
Lord Bath writes to Lawrence in 1818, complaining of the delay in the execution of Lady Bath's picture. It was destined, he said, for a definite place in his portrait gallery.

Bathurst, Henry, 3rd Earl (1762–1834). Served in various Governments from 1807 to 1830. Secretary for War 1812–17. [Duke of Wellington. B.I. 1830; S.K. 1868.]
30 × 25. At age of 56. Bust, nearly full face. White hair brushed off forehead. White ribbon in bow on right shoulder.
Commissioned in 1818 for the Duke, and 200gs. paid. But only delivered by Lawrence's executors in 1830.

Bathurst, Henry, 3rd Earl. [Windsor, Waterloo Gallery. B.I. 1830.]
Circa 1816. 52 × 43½. Seated, to right; to below knees. Looking out. Civil dress. Dark blue coat. Eyeglass in right hand. Star on breast. Short, rough hair. Wooded landscape to right, seen through opening. Left hand holds paper.

OIL–PORTRAITS

Bathurst, Georgina, Countess. See Apsley, Lady.

Bathurst, Lady Georgina. Daughter of Georgina, Countess Bathurst. [Earl Bathurst.]
24×21. Head only finished.

Bathurst, Hon. Mrs. Seymour. Julia, daughter of J. P. Hankey; m. 1829 Thomas Seymour, 3rd son of Earl Bathurst. Died 1877. [Earl Bathurst. O.M. 1904.]
Painted 1829, unfinished at artist's death.
55¼×44. Three-quarter length. Seated, facing, in landscape. Right hand grasps left wrist. Black hair curled high on head. White satin and gauze dress, cut low. Pink sash and tie. Pearl necklace with jewel pendant.
LITHO. BY R. J. LANE, after drawing for picture.

Beauclerk, Mrs. Perhaps to be identified with Miss Ogilvie, which see. [Chr. 1885, Johnson, 195gs.]
"In landscape."
Major Beauclerk lent to the Winter Exhibition of the Society of British Artists, 1832, two portraits of ladies.

Beaumont, Sir George (1753–1827). Patron of art and landscape painter; friend of Dr. Johnson, Wordsworth, etc. Presented several pictures to the National Gallery.
R.A. 1793. No. 15. "Portrait of a Gentleman." "Clearness and pearliness of colour" praised by contemporary critics.
About 1793 Lawrence received £15 for a portrait of Sir George, but that was probably a drawing. In the Lawrence sale, May 18, 1831, a portrait of Sir G. Beaumont sold for £12 10s.
Again, June 18, 1831, an "Unfinished Portrait" of the same sold for 19gs.

Beaumont, Lady. Wife of Sir George Beaumont. [In America. Ex Sir George Beaumont.]

Beaumont, Thomas Wentworth (1792–1841). Son of Th. Beaumont, of The Oaks, Yorkshire. At Eton 1803–9. [Provost's Lodge, Eton College.]
36×28. As young man. To waist, seated; head to right and looking to right. Chestnut hair brushed over forehead. Left arm on arm of chair, holding glove. Landscape and sky background.

Beckett, Sir John. [Sir Hickman Bacon, Bart.]
Bust of elderly man. Facing. Late portrait, cut down.

Beckett, Sir John. [Earl of Lonsdale.]

8

Bedford, John, 6th Duke of (1766–1839). Grandson of 4th Duke. Succeeded to title, 1802. [Duke of Bedford. B.I. 1830 and 1833.]
R.A. 1822. Bald-headed man of about 60. High white stock, and coat with loose dark red lappets. Half length, nearly facing, looking to right.
ENG. BY T. A. DEAN, 1833.
A replica of the above (30×25) was sold at Christie's, May, 1906, for 500 guineas.
There was a portrait of the Duke of Bedford in the Lawrence sale, June, 1831.

Bedford, Georgiana, Duchess of. Fifth daughter of the 4th Duke of Gordon. Married 1803 to John, 6th Duke of Bedford (as 2nd wife). Died 1853. [Chr. July 13, 1901, n.n.; 310gs.]
Oval. 23×19. "White dress with pearl ornament on shoulder."
In the Roussel sale (Paris, March, 1912) a portrait of "Georgina, Lady Gordon," was sold for 11,250fs.

Bedford, Georgiana, Duchess of. [Duke of Bedford. B.I. 1830 and 1833.]
Early portrait, as Lady Georgiana Gordon.

Belfast, Countess of. Harriet Anne, daughter of 1st Earl of Glengall. Married 1822 to George Hamilton, Earl of Belfast, later 3rd Marquess of Donegal. [Marquess of Donegal.]
R.A. 1830. "Fine, late portrait."

Belgrave, Lady Elizabeth. Daughter of George, 1st Duke of Sutherland. Born 1797; married, 1819, Richard, Viscount Belgrave, afterwards 2nd Marquess of Westminster. Died 1891. [Duke of Sutherland, Stafford House. O.M. 1904.]
R.A. 1818 (as Lady Elizabeth Leveson-Gower). 29×24. Half length, facing spectator, head turned to left. Low white dress, with long loose sleeves, with frills at shoulders and wrists. Black hair in knot at top of head. Short curls over temples.
ENG. BY J. THOMSON, 1825. A later mez. by SAMUEL COUSINS (1837).

Belgrave, Lady Elizabeth. [R. B. Angus, Esq., Montreal.]
24×20. A replica of the Duke of Sutherland's picture, but without the hands.

Bell, Charles W. Son of Thomas Bell. [M. Camille Groult, Paris. Exposition de l'Art Anglais à Bagatelle (called "Sir Thomas Bell").]
R.A. 1798 ("Mr. Bell"). Nearly to waist. Young man in costume of Directoire type, with long black hair falling over forehead. Facing, three-quarters left, looking to left. High white stock. Loosely and boldly painted.
MEZ. BY W. WHISTON BARNEY, 1805.

113

Belmour, Lord (? Earl of Belmore).
1790-5. *Lawrence received 50gs. for a portrait of this nobleman.*

Bentinck, Lady C. Probably Lady Charlotte, the eldest daughter of the 3rd Duke of Portland; married 1793 to Charles Greville. Died 1862.
R.A. 1792. No. 225, " Portrait of a Lady of Quality." *Lawrence received 25gs. for this portrait. Perhaps a drawing.*

Bentinck, Lady Mary. Daughter of 3rd Duke of Portland. Died unmarried in 1843. [Duke of Portland. Welbeck.]
Half length. Seated to left. White dress, grey drapery on left shoulder. Right arm resting along back of chair. Unfinished.

Bentinck, Lady Mary. Daughter of 3rd Duke of Portland. [Duke of Devonshire. International Exhibition, 1862.]
Copy or replica of the picture at Welbeck, reduced to a bust.

Bentinck, Lord William H. Cavendish, G.C.B. (1774-1839). 2nd son of 3rd Duke of Portland. Governor-General of India, 1828-35. [Duke of Portland. Welbeck Abbey.]
To knees, standing, to right. Grey hair. Brown coat, white waistcoat, red ribbon coming below waistcoat; right arm resting on stone pedestal. Left unfinished by Lawrence; coat and hands painted in later.

Bentinck, Lord William H. Cavendish.
1804. Bust, head turned a little to right, and eyes looking farther to right. Short hair. White cravat tied in bow.
LITHO. BY R. J. LANE, 1827.
An earlier engraving by R. H. Cook (1816) differs from this—facing to left, tightly buttoned coat—but is probably from the same portrait.

Bentinck, Lady William Cavendish. Mary, daughter of Lord Gosford. Married 1803. Died childless, 1843. [Duke of Portland. Welbeck.]
Probably 1804. Unfinished. Half length, seated to right. Brown hair in curls over forehead. Ruby earring. Patch of blue round the head, and dress only indicated. The sky and landscape added later by another hand.

Bentinck Family, Lady of. [Hon. Fred. Bentinck, Harley Street.]

Beresford, Mr. Irish M.P. and Barrister.
R.A. 1791. No. 97. " The curtain background does not harmonize with the face," says contemporary critic. *Lawrence received 55gs. for this portrait.*

Beresford, John George de la Poer. See Armagh, Archbishop of.

Beresford, William Carr, Viscount (1768-1854). Illegitimate son of 1st Marquess of Waterford. Commonly known as " Marshal Beresford." Served in Corsica. Organized Portuguese army in Peninsular War. Defeated Soult at Albuera. Made Duke of Elvas. [Duke of Wellington.]
Circa 1818. 93×58. Full length. Top of head bald, with fringe of greyish hair. In uniform of Portuguese Field Marshal, with ribbon and Star of Bath. Red lined, blue coat over shoulder. In right hand a telescope. Viaduct in distance.
Painted for the Duke of Wellington, but only delivered by Lawrence's executors in 1830.
In 1819 Lawrence painted a portrait of " Marshal Beresford " for the Prince Regent.

Beresford, William Carr, Viscount. [" Marshal Beresford."] [Lent by A. J. B. Beresford Hope, M.P., to S.K. 1868.]
98×60. Full length. Standing in landscape. Court dress, ribbon of Bath.

Beresford, Louisa, Viscountess. See Hope, Hon. Mrs. Thomas.

Berkely, Captain.
Circa 1787. Lawrence received 20gs. for a portrait of this gentleman about the time of his arrival in London.

Berkely, Hon. Mrs.
R.A. 1791. Lawrence received 20gs. for a portrait of this lady soon after his arrival in London. For what is apparently a second portrait of Mrs. Berkely he received 15gs. One of these may no doubt be identified with " Portrait of a Lady," No. 255, in the R.A. 1791.

Berri, Son Altesse Royale La Duchesse de. Marie Caroline, eldest daughter of Ferdinand I of Naples. Married 1816 to Duc de Berri, 2nd son of Charles X, who was assassinated in 1820. The Comte de Chambord was her posthumous son. [A portrait of the Duchesse de Berri was shown at the École des Beaux Art in 1887.]
Painted in Paris in 1825. Half length, seated, facing, looking round to left. White satin dress, with short sleeves. Arms crossed on knees. Black hat with ostrich feathers. Eyeglass in left hand.
ENG. BY THOMSON, 1830 (small); late litho. by H. GREVEDON.

Berwick, Mrs.
Circa 1790. Lawrence received 25gs. for a portrait of this lady soon after he came up to London.

OIL–PORTRAITS

Bexley, Nicholas Vansittart, Baron

(1766–1851). Wrote pamphlets in favour of Pitt. Chancellor of Exchequer 1812–23. Created Baron Bexley 1823. [Captain Robert Arnold Vansittart, Foots Cray Place, Kent.]

R.A. 1825. Seated, in crimson velvet chair, three-quarters, to left. Looking out of picture. Elderly man, in peer's robes, scarlet and ermine. White hair brushed up over forehead. Architectural background. Small landscape to right.

ENG. BY T. A. DEAN, 1831, and again 1836.

Bexley, Nicholas Vansittart, Baron.

R.A. 1823 (No. 124), as "Chancellor of the Exchequer."

This is probably the portrait at Kirk Leatham belonging to a member of the Vansittart family.

Binny, Charles, and his two Daughters.

[Sedelmeyer sale, Paris, May, 1907, 121,000fs. Chr. May 3, 1902, n.n.; 1950gs.]

1800–5. 94×72½. Mr. Binny, to right, in dark coat, seated. The elder daughter (who married later General Parkinson), in brown dress, standing by reading-desk to his left. The younger (later Mrs. Andrew Trevor), in white dress with yellow scarf, seated on ground, leaning right arm on her father's knee.

This picture came from the grandson of Mrs. Trevor.

Bisset, William, Bishop of Raphoe

(1758–1834). Made Bishop 1822. [Christchurch, Oxford.]

1822. 50×40. Seated, three-quarters to left. Looking out of picture. Short grey hair. Lawn sleeves. Right hand on trencher hat.

MEZ. BY CH. TURNER, 1830.

Blaizel, La Marquise du.

[H. C. Frick, Pittsburg.]

30×25. Painted in Paris, probably in 1825. Nearly half length; facing to right. Head inclined and looking out archly. Large straw hat with yellow ribbons and long hanging streamers. Hair in curls over forehead. Landscape background.

Blamire, E. J.

Commissioner of Sewers. [J. T. Blakeslee, Esq., New York. Ex Mrs. J. M. Kennedy. Chr. July 5, 1902, 145gs.]

30×25. "In dark coat."

Perhaps to be identified with the following portrait.

Bleamire, William, J.P.

Police Magistrate at Hatton Street. Died 1803.

Circa 1800. Elderly man in wig. Facing, seated, half length. Leaning forward and looking out of picture.

ENG. BY J. YOUNG, 1803.

"Painted for Trustees of Highgate and Hampstead Roads."

Blessington, Marguerite, Countess

of (1789–1849). Née Power. Married first Maurice Farmer, from whom soon divorced; second (in 1818) Charles John Gardiner, 1st Earl of Blessington, who died 1831. Friend of Byron and Count D'Orsay. Authoress and journalist. Bankrupt 1849, and fled to Paris to join Count D'Orsay. [Wallace Collection. B.I. 1833. (Countess of Blessington.)]

R.A. 1822. 35½×27½. Three-quarter length. Seated a little to right, bending forward and looking out of picture. Left arm, bare, over arm of chair. Low satin dress, with high waist. Flowers in breast. Smooth black hair, high on head.

MEZ. BY SAMUEL COUSINS, 1837, with Byron's lines :
> " Were I now what I was, I had sung
> What Lawrence has painted so well," etc. ;

also by S. W. REYNOLDS and W. REYNOLDS.

Blessington, Marguerite, Countess

of. [Lord Northwick's sale, 1859. Chr. May, 1899, n.n.; 210gs.]

19½×16. Lawrence is said to have painted Miss Power (Lady Blessington) as early as about 1809.

Bloomfield, Benjamin, 1st Baron

(1768–1846). Royal Artillery. Equerry to Prince of Wales, 1806 ; Minister at Stockholm, 1824 ; made Irish peer 1825. Friend of Lawrence.

Painted in Vienna, 1819. Half length, facing. Head turned a little to left. Black curly hair. Military coat. High white stock.

ENG. BY CH. TURNER, 1829.

Bloomfield, John Arthur Douglas, 2nd Baron

(1802–79). Son of above. Diplomatist. [National Portrait Gallery. Presented 1905 by his widow.]

R.A. 1820. Nearly to waist. Three-quarters to right, looking out. Young man with dark brown hair loose over forehead. Aquiline nose and pale hazel eyes. Very high white stock enveloping chin. Crimson robe, lined with sable.

Bloxam, Miss.

Cousin of Rev. R. Bloxam. See Hemming, Mrs. F.

Blücher, Field Marshal Prince

von (1742–1819). Born at Rostock. Served with the Swedes against Prussia in the Seven Years' War, and with Prussia against Napoleon. Shared in the victory of Waterloo. [Windsor Castle. Waterloo Gallery. B.I. 1830.]

R.A. 1815. Standing in open landscape. Right hand pointing, left hand on sword. Ribbon of the Black Eagle. On right an Uhlan preparing to mount his horse.

MEZ. BY C. E. WAGSTAFF, 1837.

Blücher sat to Lawrence in Russell Square.

Bonar, Mrs. Anastasia. Wife of Thomson Bonar, of Camden Place, Chislehurst. [Chr. May 8, 1897, Thomson Bonar sale ; 609gs.]
55½×43½. Three-quarter length. In brown dress.

Bonar, Mrs. Anastasia, and her daughter Agnes. [Chr., Thomson Bonar sale, 1896 ; 680gs.]
55×43. Both mother and daughter in white muslin dresses with blue sashes. The daughter about 5 years old.

Boucherette, or Boucheret, Ayscough, of Willingham. Friend of Angerstein and of John Locke, of Norbury. He married Emily Crockett, the daughter-in-law (? stepdaughter) of J. J. Angerstein. Killed by fall from curricle, 1814. [Chr. 1896, Angerstein sale, 80gs.]
30×25. Young man in black coat.

Boucherette, Mrs. A portrait under this name was exhibited at Birmingham (Art Gallery, Exhibition of Portraits) in 1900. (See also Williams, " Lawrence," II, p. 181.)

Boucherette, R., M.P., the Children of. " The Little Orator."
R.A. 1800.

Boucherette, Miss, and two Sisters. [Angerstein sale. Chr. July 14, 1896 ; 430gs.]
27×34½. Studies of heads.
This is probably the " Three Heads of Children— Study in imitation of Sir Joshua "—which was bought by J. Angerstein for 121gs. at the Lawrence sale in 1830.

Brecknock, George Charles Pratt, Earl of (1795–1866). At Eton (1809–15) as Lord Bayham. Succeeded his father as 2nd Marquess Camden, 1840. [Provost's Lodge, Eton College.]
30×25. Stout young man. Half length, a little to left, but head looking round to right. Brown hair, loose over forehead; whiskers. Brown coat with thick collar.

Bradburne, Mrs. [Chr. July, 1907, n.n. ; 2450gs. (Bought by Messrs. Agnew.)]
1795–8. 30×25. Seated, facing. Head turned three-quarters to right, and eyes turned farther to right. Young woman with high complexion and brown eyes ; black hair falling over forehead, powdered in parts. White kerchief bound over head and passing under chin. White dress crossed in front and bound under breasts by pink sash. Black lace shawl over right arm. Park-like background.

116

Bristol, Frederick W. Hervey, 1st Marquis of (1769–1859). [Marquess of Bristol, Ickworth.]
To below knees. Seated. Facing, and looking out. Short brown hair. Book in crossed hands. Ermine cloak at side.
MEZ. BY J. BROMLEY for Gage's " Thingoe."
A copy or replica of this picture is at Rushbrooke Park, Suffolk (R. W. Rushbrooke).

Brooke, Miss. Afterwards married to Captain Carisbrook. [Messrs. Colnaghi. Exhibited at Berlin, 1906. Chr. Feb. 25, 1905, 920gs. Again May 12, 1912, 720gs.]
Circa 1798. 30×25. To below waist. Three-quarters to right. Eyes looking up. Dark hair over forehead. White low dress, crossed over breast. Coral necklace and ear-rings. Landscape to right.

Brooke, Robert. Brother of preceding. [Chr. Feb. 25, 1905. 190gs.]
Circa 1798. 30×25. Half length, facing. Eyes looking up to left. Dark hair over forehead, long behind. In dark red coat, with white stock. Leaning his left hand upon an upright volume.

Brougham, Henry Peter. First Baron Brougham and Vaux (1778–1868). Born Edinburgh. Helped to found *Edinburgh Review*, 1802. Attorney-General to Queen Caroline at Trial, 1820. Lord Chancellor 1831. [Chr. 1858, Duke of Newcastle, £150.]
Circa 1810. Three-quarter length, standing, nearly facing, looking out of picture. Hands folded one over other, holding papers. Dark short hair. High white stock. Frilled shirt front.
ENG. BY H. ROBINSON, 1832. Private plate by W. Walker, 1831.

Browning, Mrs. Barrett. See Barrett, Elizabeth.

Brownrigg, Lady. Sophia Bisset, wife of Sir Robert Brownrigg, Governor of Ceylon. Died 1837.
Circa 1810. Half length, seated, facing. Jewelled turban, one end falling over left shoulder. Jewel and sprig of blossom on breast. Woman of about 40, with plain features.
ENG. BY W. WARD.

Brummel, Miss. [Sedelmeyer sale, Paris, May, 1907 ; 7800fs.]
1805–10. 34 × 31. Half length, facing : head turned a little to right. Chestnut hair falling low over forehead on each side. Coral necklace ; high waist. Left elbow resting on back of red chair. Blue eyes, small mouth and chin. High-waisted " marron " coloured dress. Arms bare ; on right wrist a large bracelet and smaller one on the left of coral. Yellow scarf passing over left shoulder.

OIL—PORTRAITS

Buccleuch, Elizabeth, Duchess of.
Daughter of Duke of Montagu. Married 1767 to Henry, 3rd Duke of Buccleuch. Died 1837. [Duke of Buccleuch, Dalkeith.]
1788–90. To knees, full face; powdered hair. White dress and black shawl with lace; red waistband. Lawrence received 30gs. for this portrait shortly after his first settling in London.

Buckinghamshire, Robert Hobart, 4th Earl of (1760–1816). Statesman. Served in American War. Governor of Madras 1794–8. Made Baron 1798. Gave his name to Hobart's Town. Served in several administrations 1801–16. [Lent by Earl de Grey and Ripon to S.K. 1868.]
Circa 1795. 50×40. Standing; nearly to knees; facing, looking to right. Black coat, buttoned. Longish loose hair. Left hand resting on papers on table—"Convention Bill" and "To Hon. East India Company."
ENG. BY T. GROZER, 1796; the name erased and replaced by R. Dunkarton in 1808.

Bulkeley, Miss. [Blakeslee sale, New York, April 11, 1902. £593 15s.]

Bunbury, Henry William (1756–1811). Son of Sir W. Bunbury, of Barton Hall. Artist and caricaturist. Drew in pencil and chalk for reproduction by engravers. "The Long Minuet as danced at Bath," publ. 1787.
Circa 1787. Oval. Seated in open colonnade. Long scroll with procession of figures on knee, inscribed "Long Minuet." Pencil in hand. Tree in background.
ENG. T. RYDER, 1789. Some examples printed in colours.

Burdett, Sir Francis, Bart., M.P. (1770–1844). Radical Politician, Member for Westminster. Committed to Tower, 1810. Imprisoned for libel in 1819. In later life a Conservative. [W. Burdett-Coutts, Esq. Lent by Lady Burdett-Coutts to B.I. 1853, and to S.K. 1868.]
Circa 1804. 100×58. Standing; full length, facing nearly front; looking to right. Black coat and stockings. Resting against pedestal, on parapet of which is placed an open roll with seal. Said to have been finished by R. Evans.
ENG. BY W. WALKER (part of picture), 1805.

Burdett, Sophia Coutts, Lady.
Youngest daughter of Thomas Coutts, the banker. Married to Sir Francis Burdett 1793. Died 1844. [W. Burdett-Coutts, Esq. Lent by the late Lady Burdett-Coutts to S.K. 1868. B.I. 1853 (as "Lady Burdett").]
95×59. Full length, seated in landscape under tree; facing to right, but looking round; hair falling over forehead; holding straw hat with long blue ribbons, filled with flowers.
Painted 1809, finished by Robert Evans, 1831.

Burgess, John Henry. [Lt.-Col. Inyr Burgess, Parkanaur, Co. Tyrone, Dublin, 1872.]
Painted 1786.

Burgess, Miss Margaret. [Chr. May 13, 1899. 90gs.]
30×25. In pink dress and white sash holding basket of flowers.

Burghersh, Lord. See Westmorland, Earl of, and Fane, George.

Burghersh, Lady, and Child. See Westmorland, Countess of.

Burghersh, Lady, and her Sisters. See Mornington, daughters of 3rd Earl.

Burney, Charles, D.D. (1757–1817). Son of Dr. Burney, the historian of music, and brother of Mme. D'Arblay. Classical scholar. His library was purchased by British Museum. [Ex the late Mr. Charles Burney. S.K. 1868; O.M. 1882.]
1795–1800. 30×25. To waist, looking a little to left. Dark coat, yellow waistcoat, white cravat. Greyish, natural hair.

Burney, Charles Parr. Son of preceding. Archdeacon of Colchester. [Ex the late Mr. Charles Burney.]
Circa 1815. 29½×25. Half length, facing. Looking to left. High coat collar, white cravat; seated in red-lined chair.

Burney, Sir F.
Signed "T. L., Nov., 1807." Profile to right. Half length. Holding right hand to ear. Long hair brushed back and apparently tied behind. High collar and frill to cravat.
PRIVATE PLATE (anonymous). Perhaps from a drawing.

Burroughs, Sir William. Indian Judge. [Calcutta.]
Whole length, to left, in arm-chair. In judge's robes.

Bury, Lady Charlotte. See Campbell, Lady Charlotte.

Bute, Lady. Daughter of Thomas Coutts. Lawrence in 1808 had commissions from Coutts, the banker, to paint portraits of his three daughters, Lady Bute, Lady Guilford, and Lady Burdett.

117

SIR THOMAS LAWRENCE, P. R. A.

Byng, Mrs. George.
R.A. 1801.

Callcott, Maria, Lady (1785–1842). Traveller and author. Daughter of General Dundas. In 1809 married Captain Graham; lived some years in S. America. In 1827 married Sir A. W. Callcott, R.A. Wrote *Little Arthur's History of England*, and several books on travel and art. [Nat. Portrait Gallery. Bequeathed 1894 by Lady Eastlake.]
Painted in Rome, 1819–20. 23×19. Unfinished. Three-quarters to right, looking to right. White turban.

Calmady, Emily and Laura, daughters of Mr. Ch. Calmady. "Nature." [Ex Vincent P. Calmady. B.I. 1830; O.M. 1872. Chr. 1886; 1800gs. Now in America.]
R.A. 1824: *also at Louvre in same year, when it gained for Lawrence the Légion d'Honneur.*
30×30. *Elder child to left with black hair, looks round to her fair-haired younger sister who, half standing on her knees, jumps up, holding her left hand above her sister's head.*
ENG. IN CIRCLE BY G. T. DOO, 1832. *Later mez. by* S. Cousins ("Nature"). *Also litho. by* Gigoux *and etch. by* E. Gaujean.

Calmady, Emily and Laura, daughters of Mr. Charles Calmady. [Sold in Paris 1906. Ex Lady Pethigrew. Chr. June 18, 1831, Lawrence sale, No. 76. "Portrait of two children on one canvas; beautiful sketch."]
1823. 26×25. *Rapid oil sketch. To right, girl with long black hair looking up to head of younger child in upper corner, left. Heads only indicated.*
ENG. BY F. C. LEWIS, 1825.
Chr. June 18, 1831. No. 71, "Two children embracing: the heads only: the group partly made out in chalk"—*was sold to Lord C. Townshend for 195gs.*
Again, No. 87, "Two beautiful heads of children, part of a group," *was bought by same for 205gs.*
Chr. April 8, 1908. "Calmady Children. Heads of Emily and Laura." Circle, 23¼. 560gs.

Cambridge, Duke of (1774–1850). Adolphus Frederick, 7th son of George III; married Augusta, Princess of Hesse. Viceroy of Hanover. Field Marshal and Colonel of Coldstream Guards. Father of late Duke. [Windsor Castle. Waterloo Gallery. B.I. 1830.]
Standing full length, in landscape, three-quarters to right. Hand on sword. Red uniform coat, with orders.

118

Camden, John Jeffreys Pratt, 2nd Earl and 1st Marquess (1759–1840). Son of Thomas, 1st Earl. Lord-Lieutenant of Ireland 1795–8. [National Portrait Gallery of Ireland.]
31×24. *Bust in oval, looking to right. In dark green coat, with star of Garter.*

Camden, John Jeffreys Pratt, 2nd Earl and 1st Marquess. [Trinity College, Cambridge.]

Camden. See also Brecknock, Lord.

Cammucini, Vincenzo. Officer of Papal Court. Assisted Lawrence when painting portrait of Pope.
Painted in Rome, 1819. Bust, facing, eyes to right. Short curly hair and whiskers. White cravat and collar.
ENG. BY PIETRO BETTELINI (from picture by "Cav. Tommaso Lawrence").

Campbell, Lady Charlotte (1775–1861). Daughter of 5th Duke of Argyll. Married (1) Sir John Campbell, M.P. 1796; (2) The Rev. J. Bury. Poetess and novelist.
R.A. 1803. *Half length, looking to left.* "In theatrical attitude."
STIPPLE ENG. BY T. WRIGHT, 1830.

Campbell, Lady Charlotte, as Lady Charlotte Bury. [? Chr. April 23, 1904. "Lady Bury," 29 × 24. 135gs.]
Circa 1815. *Half length, a little to right. Looking round to left. High waist. Hair loosely tied up, falling over forehead. Head bent on one side ; long neck.*
ENG. BY T. WRIGHT, 1830.

Campbell, Lord Frederick (1729–1816). Son of 4th Duke of Argyll, Lord Clerk Registrar of Scotland. His wife, the daughter of Earl Ferrers, was burnt to death in a fire at Coomb Bank, Kent, in 1807. [Messrs. Agnews (1908); Chr. Dec. 12, 1903, n.n.; 650gs.]
87×58. *Seated ; three-quarters to right, looking out. Old man with grey hair combed back from forehead. As Clerk Registrar, in black silk robe with gold trimming. Spectacles in right hand. Plan of house on table to left.*

Campbell, Thomas (1774–1844). Poet. Born in Glasgow. Died at Boulogne. The writing of a biography of Lawrence was in the first place entrusted to him, but he handed his materials over to Williams. [National Portrait Gallery. Presented, 1865, by Duke of Buccleuch.]
35½×27½. *To waist, standing, facing three-quarters to left. White stock. Fur-lined black dressing-gown. Aged about 40.*

OIL-PORTRAITS

Campbell, Thomas.

Circa 1810. *As a young man. Bust, facing, looking to left. High buttoned coat. No collar visible over white cravat.*
ENG. BY FREEMAN, 1812. Also several other small engravings of same picture, one by T. BLOOD, 1813.

Campbell, Thomas.

Circa 1810. *Three-quarter length; seated, facing. Left hand on paper on table. Coat buttoned. Short black curly hair. White cravat, tied in bow.*
ENG. (small line) BY J. BURNETT, 1828. MEZ. BY SAMUEL AND HENRY COUSINS, 1834.

Canning, George (1770–1827). Educated Christ Church. Entered Parliament 1794. "Anti-Jacobin," 1799; Secretary for Foreign Affairs, 1807; Duel with Lord Castlereagh, 1809; Prime Minister, 1827. [Oxford, Christ Church. "Hist. Portraits," Oxford, 1906.]

55½ × 43¾. *To knees; standing, facing, head three-quarters to right. Close-cropped hair, ? powdered. Thick coat collar and loosely tied cravat. A paper held in both hands. Another paper under dispatch-box on table to left.*
MEZ. BY W. SAY, 1813.

Canning, George.

R.A. 1810. *Seated, three-quarter length; right elbow resting on table; fingers by ear. Facing, looking out of picture. Frilled shirt front and thick-collared buttoned coat.*
ENG. BY C. TURNER, 1827.
Portraits of Canning by Lawrence were in the R.A. in 1810, 1814, 1825, and 1826.

Canning, George. [Windsor Castle, Private Apartments. Lent to B.I. 1830.]

Full length. The portrait of Canning in the Waterloo Gallery at Windsor (three-quarter length, facing, looking out, arms folded) is a copy after Lawrence.

Canning, George. [Sir Robert Peel. B.I. 1830. Graves' Gallery, 1908.]

R.A. 1826. *Full length, in large canvas. Standing, facing, looking a little to left. Bald head. Long black coat and white stock. Right arm raised and hand clasped; addressing House. To right, red dispatch-box on empty benches. To left, the mace on table.*
ENG. BY CHARLES TURNER, 1829.

Canning, George. [National Portrait Gallery.]

35 × 23. *Reduced version of the large portrait in the Drayton Hall collection. Small whole length, standing, facing the spectator. Arms crossed. Bald head, turned to right. Dispatch-box on bench.*
Commenced by Lawrence, completed by Richard Evans.

Canning, George. [Marquess of Clanricarde.]

Circa 1825. 95 × 60. *Full length, with arms crossed. Standing in House of Commons with empty benches behind. Painted for Canning himself for 1000gs. It has remained in the family.*

Canning, George. [Walker Art Gallery, Liverpool. S.K. 1868.]

Possibly R.A. 1825. 95 × 58. *Full length, standing, facing, looking out. Greyish hair and bald head. Left hand on chin. In plain black civil dress. Table with writing materials to right.*

Canning, George (?). [R. Langton Douglas. Whitechapel, 1909.]

Bust, unfinished. Young man of 25. Facing, head and eyes a little to right. Clean shaved. White stock.
This is apparently an unfinished head found in the artist's studio after his death. But the identification with Canning seems very improbable.

Canova, Antonio, Marchese di (1757–1821). Born at Possagno, near Treviso. Early work at Venice; Rome, 1779; Ganganelli tomb in SS. Apostoli, 1787. Tombs of Popes in St. Peter's. Visited Paris, and London in 1815. Received Lawrence in Rome 1819; corresponded with him after his return to England. [Vatican.]

R.A. 1816. *Begun in London on occasion of Canova's visit to England. Repainted in Rome, 1819. Presented to the Pope. Bust. "Crimson velvet, damask, gold, precious marble and fur worked up to astonishing brilliancy."*

Canova, Antonio, Marchese di. [Earl of Ilchester, Holland House.]

1815–20. 24 × 10. *Bust; sitting, facing, three-quarter face. Crimson coat, edged with fur. Yellow waistcoat. Loose white shirt front. Probably a replica of the Vatican picture.*
What is apparently another replica of this portrait was in the Ismay sale at Christie's, March, 1908. Again, May, 1910. 155gs.

Canova, Antonio, Marchese di. [M. Goldsmith. "Portraits du Siècle," École des Beaux Arts, 1885.]

This is probably the sketch for a portrait of Canova that was in the Lawrence sale, June, 1831.

Canterbury, Charles Manners-Sutton, 1st Viscount (1780–1845). Son of the Archbishop. Speaker to House of Commons. [Hanover. Provincial Museum.]

1811. 50 × 39. *Bust.*

Canterbury, Lady. See Manners-Sutton, Mrs.

Canterbury, Archbishop of (1783–1805.) See Moore, Dr. John.

Canterbury, Archbishop of (1805–1828). See Manners-Sutton, Charles.

119

SIR THOMAS LAWRENCE, P.R.A.

Canterbury, Archbishop of (1828–48). See Howley, William.

Capel, Miss, daughter of John Capel, M.P., maintainer of public rights and supporter of the Queenborough fishermen. [Lent by Mr. Capel to B.I. 1830.]
Begun 1827, not finished at Lawrence's death.

Capo d'Istrias, Count (1780–1830). Born at Corfu. Diplomat in the service of Russia. Represented Russia at Congress of Vienna. President of Greek Provisional Government in 1828. Assassinated at Nauplia, 1830. [Windsor Castle, Waterloo Gallery. B.I. 1830.]
Painted at Vienna, 1819. Nearly full length, seated. Right hand grasping his fur coat, which is thrown open. Lawrence calls this " the last and best portrait painted at Vienna."

Capper, Mr.
1785–90. Lawrence received 20gs. for a portrait of Mr. Capper shortly before or after his arrival in London in 1787.

Caroline, Queen. Amelia Elizabeth Caroline of Brunswick (1768–1821). Princess of Wales and later Queen Consort of George IV. Daughter of Duke of Brunswick and of Augusta, sister of George III. Married George, Prince of Wales, 1795. Trial at Westminster, 1820. She died a few days after the coronation of her husband. [Nat. Portrait Gallery. Ex Lord Berwick.]
Circa 1810. 55×44. Seated on sofa, facing, to the knees. In red dress with frills. Holding sculptor's modelling tool (?) in hand. Bust of father (?) to right.

Caroline, Queen, as Princess of Wales. [Victoria and Albert Museum. Bequeathed by Mrs. White.]
Dated at back 1798. 49½×39½. To knees, facing, looking out. Loose yellow hair falling over eyes. Straw hat bound under chin. White robe with high waist. Right elbow resting on rock. Right hand on hat.
At the Blakeslee sale, New York, April 13, 1899, a portrait of " Queen Caroline " was sold for £280.

Caroline, Queen, as Princess of Wales, with her daughter Princess Charlotte. [Buckingham Palace.

120

ace. (Removed from Windsor Castle 1902). S.K. 1868.]
R.A. 1802. Painted at Blackheath for the Marchioness of Townshend. 119×81. Princess Charlotte, as a girl of 6, on sofa to left, holding up a sheet of music in right hand. To right, the Princess of Wales in scanty quasi-classical costume, standing, playing a harp.
In the Winter Exhibition of the Society of British Artists, 1832, was a picture of " Queen Caroline and Princess Charlotte," lent by Mr. Dobree. See also Charlotte, Princess.

Carrington, Sir Codrington Edward (1769–1849). Chief Justice of Ceylon. M.P. for St. Mawes 1826–31. Published legal pamphlets. [Victoria and Albert Museum. Bequeathed by Miss L. Carrington. B.I. 1830.]
Painted 1801–2. 29½×24½. Half length. Looking round to left. High white stock with frill below. Black, high-collared coat.

Carrington, Paulina, Lady. First wife of Sir C. E. Carrington. [Victoria and Albert Museum. Bequeathed by Miss L. Carrington.]
Painted 1801–2. 29½×24½. Seated, half-length. Left arm over back of chair. Facing, looking out. Black hair falling over forehead. Coral necklace. White dress : blue drapery over left shoulder.

Carrington, Lady Anne. Died 1827.
Circa 1825. Three-quarter length, seated, nearly facing, looking out of picture. Light dress, and shawl over shoulders. Left arm rests on table. Hair elaborately curled over forehead. Bracelets with cameos.
SMALL ENG. BY CH. ROLLS.

Castlereagh, Henry Robert, Viscount. Later 2nd Marquess of Londonderry (1769–1822). Son of Robert, 1st Marquess of Londonderry. Supporter of Pitt in effecting union of Ireland. With his brother, Sir Charles Stewart, represented England at Congress of Vienna in 1814. Succeeded his father in April, 1821. Died by his own hand in 1822. [National Portrait Gallery. Ex Lord Clancarty. B.I. 1830.]
R.A. 1814. 29×24½. Half length. Facing, looking out of picture. Short rough grey hair. In fur-lined cloak. White cravat tied in loose bow. Column to left.
ENG. BY H. MEYER, 1814.

Castlereagh, Viscount (1769–1822). Later 2nd Marquess of Londonderry. [Marquess of Londonderry, Londonderry House.]
Circa 1795. 50×40. Standing, facing, to knees. Head three-quarters to left. Long natural hair powdered. Left arm akimbo. Large conical hat in gloved right hand. Landscape background.

OIL–PORTRAITS

Castlereagh, Viscount (1769–1822). Later 2nd Marquess of Londonderry. [Sir George Holford. Grosvenor Gallery, 1889.]

Probably R.A. 1810. Standing, almost to knees, acing and looking out. Short rough hair, slight whiskers; white cravat and white waistcoat. Black dress coat. Star on left breast. Left hand holding gloves, or papers, resting on table. Head quite similar to that in N.P.G. MEZ. BY C. TURNER, 1814.

Castlereagh, Viscount (1769–1822). Later 2nd Marquess of Londonderry. [Windsor Castle. B.I. 1830; S.K. 1868.]

54 × 22. Standing, full length, resting left hand on papers. Star and ribbon of Garter.
The portrait now in the Waterloo Gallery is a copy.

Castlereagh, Viscount (1769–1822), when Marquess of Londonderry.

Perhaps R.A. 1821. Half length, facing, looking to right. Short rough hair. Garter robes.
ENG. BY C. TURNER, 1822, AND G. ADCOCK, 1832.

Castlereagh, Viscount (1769–1822), when Marquess of Londonderry.

1821. Full length, facing, head three-quarters to right. In peer's robes with collar and George. Left arm outstretched to plumed hat. Colonnade to right.
ENG. BY CH. TURNER, 1823 (as " the late Marquess ").

Castlereagh, Viscountess. The Lady Amelia Anne (Emily) Hobart, daughter of 2nd Earl of Buckinghamshire. Born 1771; married 1794 to Lord Castlereagh, but had no children. Marchioness of Londonderry 1822. Died 1829. [Marquess of Londonderry, Londonderry House.]

R.A. 1794. No. 168, " Portrait of a Lady of Quality ". As Juno. Painted shortly before marriage. Nearly full length, facing, head turned a little to right. Abundant hair, bound by white fillet, falling on shoulder. Right hand behind back. Trees to right.
MEZ. BY H. T. GREATHEAD (" Lady Castlereagh ").

Castlereagh, Viscountess.

Circa 1810. Half length, facing. Head and eyes to right. White dress with high waist and frill round neck. Very stout figure. Hair high on head, in short curls, bound by ribbon.
ENG. BY J. THOMSON, 1826.

Cavendish, Lord G. This is probably George Augustus Henry, the second son of the 4th Duke of Devonshire. Born 1754; created, 1831, Earl of Burlington.

1792-6. Lawrence received 70gs. for a portrait of this nobleman.

Cawdor, Elizabeth, Countess of. Daughter of 2nd Marquess of Bath. Married John Frederick, 1st Earl of

Cawdor, 1816. Died 1866. [Earl of Cawdor. O.M. 1880; B.I. 1843.]

Circa 1816. 26 × 20. Head nearly full face, slightly to left. Looking round to left. Black curly hair over forehead. Rest of picture unfinished.
ENG. (small vignette) BY C. MARR (" The Amulet," 1832).

Chantrey, Sir Francis Leggatt (1781–1841). Son of a carpenter. Learnt his art in Sheffield. Painted portraits and carved in wood. Later, fashionable sculptor and Academician. [Sir Robert Peel. Graves' Gallery, 1908.]

Nearly full length; leaning on pedestal of bust to left, looking round to right. Fat face with bald head and short, greyish hair. Marble bust in profile to left. All background shades of warm grey. Has suffered from cracking. Lawrence's authorship dubious.

Chaplin, Francis, M.P. [Lent by Mr. Chaplin to B.I. 1830.]

Charlemont, Francis William Caulfeild, 2nd Earl of (1775–1863). Succeeded his father James (the chief of the Volunteer army) 1799. [National Gallery of Ireland.]

R.A. 1812. This is a fragment from the full-length group of Lord and Lady Charlemont with their infant son, formerly at Roxborough Castle, Co. Tyrone.

Charles X (1757–1836). King of France. Younger brother of Louis XVI and Louis XVIII. Reigned from 1824 to 1830. [Windsor Castle, Waterloo Gallery. B.I. 1830.]

Painted in Paris, 1825, for George IV. Standing, facing a little to the left. Plumed hat over right arm. Silver-lined black coat and blue ribbon.
Part of " Thuileries " introduced in background, as mentioned in letter of Lawrence.
ENG. BY. CH. TURNER, 1828, AND BY S. COUSINS.

Charles, Archduke (1771–1847). The famous General. Son of the Emperor Leopold II. [Windsor Castle, Waterloo Gallery. B.I. 1830.]

Painted 1818-19. R.A. 1820. Full length. Standing, facing, resting on sword. Right leg raised on rock.
Lawrence was detained in Vienna to paint this picture as the Archduke was ill.

Charles, Archduchess (Princess Henrietta of Nassau-Weilburg). Married 1815 to the Archduke Charles. [Emperor of Austria.]

" Small whole length." Painted in Vienna in the winter of 1818-19. Lawrence, writing from Vienna to Lord Stewart, speaks of the Archduchess as " a very sweet, amiable and homely being . . . the portrait of the Archduchess is for the Emperor " (Feb. 12, 1819).
One of the pictures that Lawrence brought with him to Rome on the top of his travelling carriage.

121

SIR THOMAS LAWRENCE, P.R.A.

Charles, Daughter of Archduchess.
R.A. 1820. *Small picture. "Three-quarter length," of infant. Painted in Vienna, 1818-19.*
Lawrence brought to Rome, on top of his travelling carriage, a very small whole length of the infant daughter of the Archduchess.

Charlotte, Queen. Charlotte Sophia of Mecklenburg-Strelitz (1744–1818). Queen Consort of George III. Married 1761. [Bought by Sir M. W. Ridley at Christie's, June 18, 1831. Lent by him to B.I. 1833.]
R.A. 1790. *Seated in an apartment—a rich landscape, with Eton College, seen through opening.*
An earlier portrait of Queen Charlotte was in the R.A. 1788. A " Study of the Queen's Head," oil on canvas, was in the 1831 sale.
Lawrence, about 1790, received 60gs. for one and 80gs. for another portrait of the Queen.

Charlotte, Princess. [Earl of Ilchester, Abbotsbury.]
About 1815. To below waist. Facing a little to left and looking out. Dark dress, cut low, with short sleeves. Left arm raised to breast. Jewel on right arm.

Charlotte, Princess (1796–1817), as a girl of 6. [Windsor Castle, Private Apartments. Lent to B.I. 1833.]
Circa 1802. Seated, facing a little to left, but head turned to right ; looking up at a bird perched on her right hand. Short curly hair. Left hand holds birdcage.
The figure of the Princess nearly identical in position to that on the left of the large upright picture of Queen Caroline, where, instead of birdcage, she holds the music to her mother, who plays the harp.
ENG. BY T. GARNER.

Chatfield, Major Charles. Aide-de-Camp to Warren Hastings. [Lent to the Winter Exhibition of the Society of British Artists, 1833, by C. Chatfield, Esq.]
" Painted at the age of 16."

Cholmondeley, Mr.
Circa 1790. Lawrence received 25gs. for a portrait of this gentleman soon after he came up to London.

Clam-Martinics, Countess. See Meade, Lady Selina.

Clanwilliam, Richard, 3rd Earl of (1795–1879). Succeeded his father 1805. Ambassador to Berlin 1823-8. Made peer of U.K. 1828. [Duke of Sutherland, Stafford House.]
R.A. 1824. *Full length.*

Clanwilliam, Richard, 3rd Earl of. [Earl of Clanwilliam.] Replica of preceding (?).

122

Clarence, Duke of. See William IV.

Clarke, Richard (1739–1830). Lord Mayor, 1784 ; Chamberlain of City of London, 1798. [Corporation of London. Art Gallery.]
R.A. 1827. *56×44. In extreme old age. Seated, nearly whole length and nearly full face ; left hand on knee. In loose sable-lined robe. Short white hair roughly brushed back. Loose collar and stock with chain hanging below.*
This portrait was a commission from the Corporation in 1825, from whom Lawrence received 420gs.
ENG. BY J. S. DAVIS, 1829.

Clements, Miss. Probably some member of the Leitrim family. [Leopold Hirsch, Esq. Ex T. L. Fitzhugh, Esq.]
Circa 1805. 50×40. Seated, nearly full length, to right. Eyes looking out. Brown hair low over forehead bound by green fillet. Left arm, bare, over back of chair. Simple white dress, cut low and fastened by band below bosom. Red shawl over left shoulder. Landscape opening to right.

Clive, Hon. Edward (1785–1848). Afterwards 2nd Earl of Powis. Accidently killed. At Eton 1798-1803. [Provost's Lodge, Eton College.]
Circa 1805. Young man of about 20 to 22. Nearly half length ; facing, looking out. Hazel eyes. Dark coat, closely buttoned up, with two rows of brass buttons. Short, rough, light hair and slight whiskers.

Clive, Lady Harriett (1797–1869). Daughter of 5th Earl of Plymouth. Married 1819 to Hon. Rob. H. Clive. Baroness Windsor, 1855.
Circa 1825. Seated in landscape, nearly full length, almost facing. Black satin dress. Sleeves full at shoulders, bare arms. Left arm on table on which rests hat. Black hair, high on head, curls at side. Right hand gloved.
MEZ. BY SAMUEL COUSINS, 1840.

Clutter, Mr.
R.A. 1789. *(" Portrait of a Gentleman.")*

Codrington, Admiral Sir Edward (1770–1851). Commanded ship at Trafalgar. Commander - in - Chief in Mediterranean 1827. Joined the French and Russian squadrons in destroying the Turkish fleet at Navarino. [Lent by General Sir W. J. Codrington to S.K. 1868. B.I. 1830.]
1815-20. 30×25. To waist, looking to right. Naval uniform with ribbon of Bath, and Trafalgar medal. Bald head.
MEZ. BY CH. TURNER, 1830.
At the Blakeslee sale, New York, April 13, 1899, a portrait of "Admiral Codrington" was sold for £200.

OIL–PORTRAITS

Coke, Thomas W., M.P. for Norfolk (1752–1842). Great improver of agriculture. "Father of House of Commons." Created Earl of Leicester 1837.

Circa 1818. To waist, seated to right, but looking out of picture. Elderly man with dark eyebrows and white hair. Loose open waistcoat.

ENG. BY C. TURNER, 1819, AND BY EDWARD SMITH.

Coke, Thomas W. Later Earl of Leicester.

Half length. Looking to right. High-buttoned coat. Left hand on hip. Perhaps identical with last.

ENG. BY W. T. FRY, 1821. (Frame with agricultural emblems.)

Coke, Thomas W. Later Earl of Leicester.

Nearly whole length, standing. High-buttoned coat; looking to left. Right hand on Magna Charta.

MEZ. BY CHARLES TURNER, 1814.

Combe, Cecilia. See Siddons, Cecilia.

Cole, General Sir Galbraith Lowry (1772–1842). Younger son of 1st Earl of Inniskillen. Commanded 4th Division in Peninsular. Governor of Mauritius and Cape. [Lent by Countess Cowper to S.K. 1868.]

Oval. 30×25. Bust; facing a little to left. Military coat with ribbon of Bath and high black stock. Stars of G.C.B., etc. Short rough hair.

ENG. BY C. PICART, 1816.

Consalvi, Cardinal (1757–1824). Secretary of State under Pius VII. Negotiated the Concordat with Napoleon, 1801. Imprisoned three years at Rheims. When released returned with the Pope to Rome. [Windsor Castle. B.I. 1830; O.M. 1904.]

Painted at Rome in 1819. 104×67. Full length, seated a little to left, looking out of picture. In Cardinal's robes. Papers and biretta in right hand. Left hand rests on table, in which is a book entitled "Moto Proprio alla Santità Papa Pio VII." Façade of St. Peter's to right.

ENG. BY C. E. WAGSTAFF, 1840.

Consalvi, Cardinal. [R. W. Hudson, Esq., Danesfield, Marlow. Ex. Colonel Thorpe. Chr. 1897, n.n.; 800gs.]

Circa 1819. 94×67. Replica of Windsor portrait.

Consalvi, Cardinal. [Chr. July 8, 1910, n.n.; 850gs.]

92×59. Replica of the Windsor portrait. Perhaps identical with the preceding.

Conyngham, Lord Francis (1797–1876). Son of 1st Marquess Conyngham; succeeded his father 1832. [Marquess Conyngham, Slane Castle.]

R.A. 1823. 30×25.

Conyngham, Lady Francis. Wife of preceding. [Marquess Conyngham, Slane Castle.]

50×40. Seated figure; low-cut white satin dress; red curtain. Not entirely by Lawrence.

There is also a good old copy of this picture at Slane Castle.

Conyngham, Lady Elizabeth. Daughter of 1st Marquess, later Lady Aloyne. [Marquess Conyngham, Slane Castle.]

1810–15. 50×40. Nearly full length, facing, looking out. Right hand turning key of harp. Left arm outstretched. White dress with jewelled buckle.

ENG. IN COLOUR BY R. SMYTHE.

Conyngham, Lady Maria. Daughter of 1st Marquess. [Marquess Conyngham, Slane Castle.]

1810–15. Young girl of 15, seated in landscape. Smiling; hair in loose curls over forehead. Fingers clasped. Dog to right.

MEZ. BY NORMAN HIRST.

Cooper, Sir Astley, Bart. (1768–1841). Son of Samuel Cooper, divine. Surgeon with lucrative practice, and lecturer at various hospitals. F.R.S. 1802; created Baronet 1821. [Royal College of Surgeons. S.K. 1868; O.M. 1873.]

R.A. 1828. 56×44. Standing; three-quarter length; looking to right. In close-buttoned coat; left hand in pocket; right hand resting on table.

MEZ. BY SAMUEL COUSINS, 1830.

Cooper, Hon. C. A. See Shaftesbury, Earl of.

Cooper, Robert Bransby, M.P. Elected Member for Gloucester 1818.

Circa 1818. Bust; facing; looking up to left. Grey hair and whiskers. White frilled cravat.

ENG. BY W. F. FRY, 1820. (Dedicated to the Freemen of City of Gloucester.)

Copley, Miss Juliana. Daughter of Sir Joseph Copley. Married 1789 to Sir Charles Watson. [Ex Sir W. T. Watson, Bart. Chr. June 25, 1904. 2400gs.]

Early portrait. 30×25. Facing three-quarters to left. In white muslin, with dark sash. Powdered hair bound by white muslin scarf.

Cornwallis, Marchioness. See Gordon, Lady Louisa.

SIR THOMAS LAWRENCE, P.R.A.

Cotton, Joseph, F.R.S. Deputy Master of Trinity House (1745-1825). Mariner. Director of East India Dock Company. Compiled *History of Trinity House*, 1818.

1810-15. *To knees ; standing ; turning to left, but looking out of picture. White, natural hair. On table, plan of East India Dock.*
MEZ. BY CH. TURNER, 1818.

Cotton, Mrs. Probably wife of the preceding.

1810-15. *Nearly whole length, seated, facing. Head a little to right and looking to right. Elderly lady, with turban and square-cut bodice. Flowers and work-box on table to left.*
MEZ. BY C. TURNER, 1825.

Cowper, Peter Leopold, 5th Earl (1778-1837). Married Amelia, daughter of 1st Viscount Melbourne. [Countess Cowper. O.M. 1881.]

R.A. 1802. 49×39¼. *Half length, standing ; face nearly in profile to left. Leaning left arm against column. Peer's robes.*

Cowper, Amelia, Countess. See Lamb, Hon. Amelia.

Cowper, Lady Emily. " The Rosebud." Eldest daughter of the 5th Earl Cowper. Married 1830 to Baron Ashley, who succeeded his father as 7th Earl of Shaftesbury in 1851. [Countess Cowper. Ex Lady Edith Ashley; ex Lady Palmerston. B.I. 1830; International Exhibition, 1862.]

R.A. 1814. *Oval. Bust of child of 4 or 5. Facing and looking out of picture. Low white frock, with sash. Pearl necklace.*
ENG. BY TH. WRIGHT, 1830.

Cowper, Lady Emily. See also Ashley.

Cradock, or Caradock, General Sir John. See Howden, Lord.

Cranmer, Mrs.
R.A. 1789. (" *Portrait of a Lady.*")

Cremorne, Philadelphia Hannah, Viscountess. Granddaughter of William Penn, the founder of Pennsylvania ; married 1770 to the first Viscount Cremorne. [Lent by Granville J. Penn, Esq., to B.I. 1864.]

R A. 1789. (" *Portrait of a Lady of Quality.*") *Full length ; black dress. Huge white mob-cap.*
Lawrence, shortly after his first settling in London, received 40gs. for a portrait of Lady Cremorne.

Cremorne, Thomas Dawson, Viscount, d. 1813. [Earl of Dartrey.]
Full length (?).

124

Crewe, John, 1st Lord (1742-1829). John Crewe, of Crewe Hall. Sat for County of Chester 1768-1806. Baron Crewe 1806. Married daughter of Fulke Greville. [Earl of Crewe. Lent by Lord Houghton to S.K. 1867.]

Circa 1810. 30×25. *Nearly to waist. Three-quarters to right. Head facing. Short greyish hair, brushed back.*
ENG. BY W. SAY.

Crewe, Frances Anne Greville, Lady. Wife of John, 1st Baron. Fashionable beauty and Whig partisan. Died 1818. [Earl of Crewe. Lent by Lord Houghton to S.K. 1867.]

Circa 1810. 30×25. *Seated figure, to waist. Nearly front face, looking out of picture. High white frill round throat, black veil over head.*
MEZ. BY W. SAY, 1816.

Crewe, Miss Emma. See Cunliffe-Offley, Mrs.

Crichton, Lady Caroline, and Miss Hervey. Lady Caroline was the daughter of Lord Erne. Married 1799 to Lord Wharncliffe. Died 1856. Miss Hervey was married later to Lord Howard de Walden. [Hon. Mrs. J. Stuart-Wortley. " Fair Women," 1894. Amateur Art Exhib. 1898.]

Painted 1783, when Lawrence was 14, but probably a drawing.

Croker, Right Hon. John Wilson, M.P. (1780-1857). Born at Galway. Educated at Trinity College, Dublin. Entered Parliament 1807. Secretary to Admiralty 1809-29. [National Gallery of Ireland. Purchased from Earl of Lonsdale, 1887.]

Probably R.A. 1825. 29¼×25. Seated, half length, front face, eyes looking out of picture. Bald, black hair. Gold chain, with keys over velvet waistcoat.
MEZ. BY SAMUEL COUSINS, 1829.

Croker, Right Hon. John Wilson. [John Murray, Esq. Loan Exhibition, Dublin, 1872.]

Half length, front face, looking out of picture. Bald head, short black whiskers.
J. W. Croker lent a portrait of himself to the B.I. 1830, and to Manchester 1857.

Croker, Right Hon. John Wilson. [Follett Pennell, Esq. S.K. 1868 and Vict. Exh. 1891.]

30×24. *Half length, seated, facing.*

OIL-PORTRAITS

Croker, Miss. Rosamund Hester Elizabeth Pennell, sister-in-law and adopted daughter of J. W. Croker. Married 1832 to Sir George Barrow, Bart. [J. Pierpont Morgan. B.I. 1830, Manchester 1857, O.M. 1895.]

R.A. 1827. 29½×24½. *Half length, seated, facing. Low-cut white satin dress, with gauze sleeves full at shoulder. Right arm rests on side of chair ; right hand holds eyeglass. Hair in dark curls round forehead. A replica(?) of this picture was sold in Paris in May, 1907, for £352 (Sedelmeyer sale).*
MEZ. BY SAMUEL COUSINS, 1829.

Croker, Miss.
Half length ; three-quarters to left, looking round, smiling. Black hair bound high behind head. Pearl necklace and ear-rings. Satin dress, with long sleeves, cut low in front. Flowers in left hand.
ENG. BY GEORGE T. DOO.

Crouch, Mrs. Anna Maria Phillips (1763–1805). Vocalist. Sang at Drury Lane 1780–1801. Lived afterwards with Michael Kelly. "Famed even more for her beauty than her singing."

Early portrait. Oval, to waist ; looking out of picture. White frilled fichu over shoulders. Hair loosely curled and powdered. Curls over shoulder.
SMALL STIPPLE ENG, BY RIDLEY (" General Magazine and Impartial Review." 1792).

Cumberland, Prince George of. Afterwards King of Hanover. Son of Ernest Augustus, 2nd Duke of Cumberland. Born in Berlin 1819. Died 1878. [Buckingham Palace. B.I. 1830 and 1833.]

Boy of 9, in light blue riding-dress, with whip in hand, leaning against a rock. Painted 1828 at Cumberland Lodge.

Cunliffe-Offley, Hon. Mrs. Emma, daughter of John, 1st Lord Crewe. Married 1809 to Foster Cunliffe, of Acton Park, Wrexham, who took the name of Offley in 1829. She died in 1850. [Earl of Crewe. Grosvenor Gallery, 1888 ; Agnew's Gallery, 1904.]

1800–5. 50×40. Nearly full length, seated, turned to left. White cap or veil. Low-cut white dress with high waist. In front, a King Charles's spaniel. Landscape background.
MEZ. BY SCOTT-BRIDGEWATER.

Cunningham, Lady. This is probably the wife of Sir William Cunningham, 4th and last Baronet of that stock. He was married in 1799 to Mrs. Graeme.

R.A. 1802.

Curran, John Philpot (1750–1817). Educated Trinity College, Dublin. Sat in Irish Parliament. Master of Rolls, 1806. Died in London. [Earl Grey. S.K. 1867.]

1800. 30×25. Half length. Facing, looking upwards to right. Loosely buttoned coat. Black hair over forehead. Made at one sitting, the morning before Curran was leaving for Ireland, after failure with a previous portrait.
MEZ. BY J. R. SMITH, 1801.

Curran, John Philpot. [National Gallery of Ireland. Presented by Lord Iveagh. Sold Robinson and Fisher, "Peel Heirlooms," May, 1900. B.I. 1849 (Sir R. Peel).]

R.A. 1800. 30×24. *Half length, facing, looking out of picture. Thin black hair over forehead. White cravat.*

Curtis, James Brewer.

R.A. 1804. *Seated, to knees, facing and looking out. Short white hair or wig. Right arm over back of chair. Beaver hat in left hand.*
ANONYMOUS MEZ. (private plate).

Lawrence, writing about this time, speaks of "going to eat beef-steaks at Jemmy Curtis's brew-house."

Curtis, Sir William, Bart. (1752–1829). M.P. for City, 1790–1818, and Lord Mayor 1795. Founder of the banking firm, Robarts, Lubbock and Co. Friend of George IV. [Windsor Castle, Private Apartments. Lent by Queen Victoria to Interl. Exhib. 1862, and to S.K. 1868.]

R.A. 1824. 36×21. *To waist, seated, facing, head turned to right. Old man with thin grey hair, partly hiding ear, in fur-lined coat. Triple gold chain.*
MEZ. BY WILLIAM SAY, 1830.

Curtis, Sir William. [Lent to B.I. 1832 by Sir William.]

R.A. 1812. *Seated, facing, full length ; head three-quarters to right. Grey hair or wig ; ear fully seen. Plain loose-collared coat.*
ENG. BY W. SHARP, 1814, AND BY W. FRY, 1822 (" From an original painting ").
Another (head only) by T. L. BUSBY (1822).
The same head in a highly coloured full-length seated portrait, in Lord Mayor's robes. " Painted and engraved by T. L. Busby, 1823."
A portrait of Sir W. Curtis, "a finished picture—very fine," was in the Lawrence sale, June, 1831. It was bought by Sir William for 43gs.

Cuthbert, Mr. [M. C. Groult, Paris, from the Graves family.]

Circa 1814. 93×57. *Full length, standing, facing. Rough short hair with locks falling over forehead. Eyes looking to right. Left arm resting against plinth of column, holding handkerchief in left hand. Black coat and black silk hose. Red curtain to left.*

SIR THOMAS LAWRENCE, P.R.A.

Cuthbert, Mrs. [Comte Carolus de Beistégui, Paris. "Portraits de Femmes et d'Enfants," Paris, 1897.]

R.A. 1817. *Seated, nearly full length, to right. Right arm stretched over book, headed " Cowper," on table. Left arm hanging down. Crimson velvet robe, yellow fur-trimmed mantle over back of chair.*

MEZ. BY J. B. PRATT.

Czernitschef, Prince (or Tchernicheff). [Windsor Castle, Waterloo Gallery. B.I. 1830, lent by George IV.]

1818. *Almost to knees, a little less than full face. Pointing with right hand. Cloak over left shoulder. Writing from Vienna (December, 1818), Lawrence says he has " completed a strong likeness of General Czernitschef " (Layard, p. 141).*

Dance —. (Probably either George or Nathaniel Dance.)

R.A. 1788. *(" Portrait of a Gentleman.") Highly praised by a contemporary critic (" The Bee ").*

Darnley, Emma Jane Parnell, Countess of. Wife of 5th Earl. Daughter of Sir Henry Parnell (Lord Congleton). Married 1825. Died 1884. [Lent by National Gallery to Walker Art Gallery, Liverpool. Ex Vernon Collection.]

1825–9. 24×26. *Oval. Head and neck only painted in. Facing. Black hair in loose short curls.*

ENG. BY R. A. ARTLETT. Pl. to Art Journal, 1850, " The Countess."

Darnley, Emma Jane Parnell, Countess of. [Sedelmeyer sale, Paris, May, 1907, £1190.]

About 1825 ? 18×14. *Bust, three-quarters to right. Looking up with listening attitude. Brown hair in masses over forehead and neck. Right hand to neck, playing with gold chain. Low dress, only slightly indicated. Attribution to Lawrence doubtful.*

Darnsey, Mr.

No. 147 *in the R.A.* 1788 *is called in MS. note to Catalogue, " Mr. Dance or Dansie." Lawrence received 15gs. for a portrait of this gentleman about the time of his arrival in London in 1787, or perhaps earlier at Bath.*

Dartmouth, Earl of. See Legge, Hon. William.

Dashwood, Anna Maria. Daughter of Sir Henry Watkin Dashwood, Bart. Married 1810 to John, 2nd Marquess of Ely. Died 1857. [Ex Sir George Dashwood. Christie's, Dec. 14, 1907 ; 1400gs.]

About 1805. 30×25. *Half length, facing, looking out of picture. Brown hair in loose locks over forehead. In white dress with high waist, short sleeves, and light mauve*

sash. *Right elbow resting on parapet. Dark oblong jewel and small red flowers in centre of breast. Park-like landscape background.*

Davis, Richard Hart. M.P. for Bristol. Patron of art and friend of Lawrence. His collection of pictures formed the nucleus of the Leigh Court Gallery. [B.I. 1830 and 1833. Lent by Mr. Vaughan Davis to Intern. Exhibition of 1862 and to O.M. 1871.]

R.A. 1815. 35½×24½. *Half length, facing, looking slightly to left. Long thin face. Short black hair. Cloak over left shoulder. High loose fur collar to coat.*

ENG. BY W. SHARP, 1816.

Davis, Richard Hart, M.P. [Chr. June, 1831, Lawrence's executors.]

Oil study of head.

Davis, Hart, Junior. Son of preceding (1792–1854). At Eton 1803–8. [Provost's Lodge, Eton College.]

30×25. *Young man of about 20. To waist, facing ; head turned a little to right. Brown hair and slight whiskers. Red coat with fur collar loosely buttoned over white choker.*

Davis, Hart, Junior. [Lent to B.I. 1833 by R. Hart Davis, M.P.]

Davis, Mrs. Hart, Junior. [Lent to B.I. 1833 by R. Hart Davis, M.P.]

Davis, Miss Louisa. [George Coats, Esq.]

30×25. *Seated, facing. Head sloping to left ; looking out of picture. Dark hair falling over forehead. White dress with high waist and frilled jacket, open in front. Jewel with pendant pearl between breast.*

Davy, Sir Humphry, Bart., P.R.S. (1778–1829). Educated at Penzance. Poet, chemist, and physicist. Invented the Miners' Safety Lamp. [Royal Society. Manchester 1857. Intern. Exhibition 1862. S.K. 1868.]

R.A. 1821. 52×36. *Nearly full length, facing, looking out of picture. Left arm akimbo, right with knuckles on table, on which stands a safety-lamp.*

ENG. BY ROBERT NEWTON, 1830. ALSO BY W. H. WORTHINGTON AND E. SCRIVEN.

Day, Harriet Maria. Daughter of Benjamin Day, of Yarmouth and Norwich. Married 1794 to Ichabod Wright, banker, of Nottingham. Mother of the translator of Dante. [A. Smith Wright, Esq., M.P., " Fair

126

Women," 1894. Chr. 1899; 2800gs. Cronier sale, Paris, 1905; 43,000 fs.]

R.A. 1791. No. 122, " Portrait of a Lady." 31×25. Half length. Thick, reddish hair surrounding face and hanging over shoulder. Right arm supported on cushion. White dress with wide frill. Sash of blue velvet. Forest background.

Lawrence received 25gs. for a portrait of "Miss Day" soon after coming to London.

De Grey, Henrietta Francis, Countess. See Grantham, Lady.

Derby, Edward Geoffrey, later 14th Earl of (1799–1869). Succeeded to Earldom 1851. [Lassalle sale, Paris, 1901, 16,100fs.]

Circa 1810. 50×37½. Portrait of a boy of about 10 years. Full length, with broad white collar. Seated on rock, facing, looking out. To left a spaniel; to right handkerchief and hat on rock. Mountain background.

Derby, Edward Smith Stanley, afterwards 13th Earl of (1775–1851). M.P. from 1796 to 1832. Succeeded to Earldom 1834. President Linnæan Society, etc. [Earl of Derby, Knowsley Hall. S.K. 1867.]

1795–1800. 21×18. Oval. Head to left. Crimson coat, high collar, long fair hair.

Derby, Edward Smith Stanley, afterwards 13th Earl of. [Provost's Lodge, Eton College.]

1790–2. 30×25. Lad of 16 or 17. Half length, facing; head to right, looking round to right. Long hair, powdered. Black coat with brass buttons, loosely buttoned. Large frilled choker. Pillar to left.

Derby, Countess of. See Farren, Eliza.

Devonshire, William Spencer Cavendish, 6th Duke of (1790–1858). Succeeded to Dukedom 1811. Bibliophile and collector of coins. [Admiral Sir A. W. Clifford. S.K. 1868.]

51×47. Seated, left hand on table, holding roll of paper. A portrait of the Duke was in the R.A. 1824.

Devonshire, William Spencer Cavendish, 6th Duke. [Earl of Carlisle, Castle Howard. (The Duke's sister married the 6th Earl of Carlisle.)]

Devonshire, William Spencer Cavendish, 6th Duke. [Windsor Castle.]

Devonshire, Elizabeth, Duchess of.

Lady Elizabeth (Betty) Foster, daughter of 4th Earl of Bristol and widow of J. T. Foster. 2nd wife of 5th Duke of Devonshire (married 1809). Died 1824. [Sir Vere Foster, Glynde Court, County Louth. B.I. 1855, lent by Sir Frederick Foster, Bart.]

R.A. 1805. As Sibyl. Temple of Tivoli in background. Full length, standing, in dark robe. Right arm outstretched. Head turned a little to left and looking upwards as if declaiming. Scroll of paper in left hand. The "Temple of the Sibyl" had been bought by her father, the Earl of Bristol.

A picture hangs in the corridor at Windsor Castle which is described as a copy by Etty, from a portrait of Elizabeth, Duchess, by Lawrence.

Devonshire, Georgina, Duchess of.

In the Private Apartments at Windsor Castle is a portrait of the Duchess and a child, said to be a copy by Lawrence after Reynolds.

Donegal, Marchioness of. See Belfast, Countess of.

Dottin, Abel Rous. M.P. for Southampton. Early patron of Lawrence at Bath. Died 1852.

1800–5. Half length, facing, looking down to left. Youngish man, with hair curling over forehead; loosely buttoned coat.

ENG. BY H. B. HALL, 1838.

Douglas, Mr. Silvester. "The Counsellor."

R.A. 1792. Lawrence received 66gs. for this portrait.

Douglas, Lord.

1785–90. Lawrence received 25gs. for a portrait of this nobleman about the time of his first settling in London.

Douro, Lord. See Wellington, 2nd Duke of.

Dover, George Welbore Agar-Ellis, 1st Lord (1797–1833). M.P. 1818. Suggested to Government purchase of Angerstein Collection. Created Lord Dover 1831. Wrote life of Frederick the Great, and edited Walpole's Letters. [Lent to the B.I. in 1825 and in 1833 by Lord Dover.]

Late Portrait. Half length. Seated by table. Facing, looking out of picture. Thick curly hair. Fur-lined coat, high black stock. Head resting on left hand with elbow on table.

MEZ. BY W. BRETT, 1827.

SIR THOMAS LAWRENCE, P.R.A.

Dover, Georgiana, Lady, and her son, the Hon. Henry Agar-Ellis.
Daughter of 6th Earl of Carlisle. Married 1822 to Hon. George Welbore Agar-Ellis, afterwards 1st Lord Dover. Died 1860. Her son became Viscount Clifden. [Lord Annaly. B.I. 1830 and 1833 (lent by Lord Dover). O.M. 1904.]

R.A. 1828. 50¼×40¼. *Nearly full length. Seated to left in red chair. Looking round to right. Black, low-cut dress with short sleeves. She clasps her son, a boy of 3, who is climbing on to her lap. High coiffure with curls.* ENG. BY J. H. WATT, 1830. MEZ. BY S. COUSINS, 1831.

Dover, Georgiana, Lady.
To waist, facing a little to right and stooping forward. Low dress with frilled lining and short puffed sleeves. Hair in loose curls on either side of forehead. ENG. BY CH. HEATH for "The Keepsake," 1830.
("Lady Georgina Agar-Ellis, from a picture lent by the Hon. George A.E.")

Downe, John Christopher Dawnay, 5th Viscount (1764–1832). Succeeded his father 1780.
1810–17. *Nearly half length, to right, but turning and looking out of picture. Short hair brushed up from forehead, and whiskers. Peer's robes.*
Lord Downe, writing to Lawrence in 1817, complains that his portrait had been in hand for eight years. LITHO. (small private plate) BY W. SHARP.

Downe, Viscount.
Full length, standing, facing to right. In peer's robes. Foot on a step. Perhaps to be identified with the preceding. ENG. BY TH. LUPTON.

Dowry. See Towry and Ellenborough.

Doyle, Major.
Lawrence obtained 25gs. for a portrait of "Major Doyle" about 1790.

Drake, Miss. [Christie's, Feb. 1906. 300gs.]
Circa 1805. 30×25. *Facing three-quarters to left, but looking out of picture. In white dress, with high waist and short plain sleeves. Pink cloak ; holding fan in hand.*

Droop, Mrs., née Richmond. [Ex Henry Richmond, Stamford Hill.]
Bust, facing, head turned a little to right. Low dress, with high waist and wide sleeves. Jewel on bosom. Short black curls over temples.
Left unfinished by Lawrence at his death and completed by Samuel Lane. LITHO. BY R. J. LANE.

Ducie, two sons of Francis Reynolds, 3rd Baron. Thomas (born 1775, afterwards 4th Baron) and Augustus (born 1777).
R.A. 1790. *No.* 151. "*Portraits of a Nobleman's Sons.*" "*Executed in manner of Vandyke*," *says a contemporary critic. Lawrence received 80gs. for this picture.*

128

Du Crest, Madame. See Duvausel, Sophie.

Dundas, Sir Robert (1761–1835).
One of the principal clerks of the Court of Sessions in Scotland. Made a Baronet 1821. [Andrew K. Hichens, Esq. O.M. 1904.]
Early portrait. 29½×24½. *Half length, to left. Looking out of the picture. Brown coat.*

Dundas, Thomas, 1st Baron. Born 1741. Created Baron 1794. Died 1820. [Dilettanti Society. S.K. 1868.]
1819. *At the age of 78. Nearly to waist, facing. Looking up to left. White hair. High white cravat and frilled shirt-front.* MEZ. BY CH. TURNER, 1822.

Dundas, Margaret, Lady (1715–1802). Daughter of Major Alexander Bruce. Married Sir Lawrence Dundas, father of 1st Baron Dundas.
1799. *At the age of 84. Nearly full length, seated facing, turning a little to right. Mob-cap with bow of ribbons in front. Small table in front of knees, with some kind of knitting. Bobbin in right hand.* MEZ. BY G. CLINT.

Durham, Bishop of (1780–1826). See Barrington, Shute.

Durham, Bishop of (1826–36). See Mildert, William van.

Durham, John George, 1st Earl of (1792–1840). Eldest son of W. H. Lambton, M.P. for Durham. Married daughter of Earl Grey. Baron 1828 ; Earl 1833 ; Governor of Canada 1838. [Earl of Durham. B.I. 1830 and 1833 ; S.K. 1868 ; Guelph Exhib. 1891.]
R.A. 1829. 30×25. *Half length, slightly to right. Black hair. Fur-lined coat. Left hand holding cloak with crimson lining. Chain over shoulder.*
MEZ. BY C. TURNER, 1831.
" C. E. WAGSTAFF, 1838.
" S. COUSINS, 1837.

Durham, Louisa Elizabeth, Countess of (1797–1841). Daughter of 2nd Earl Grey. Married 1816 to J. G. Lambton, afterwards 1st Earl of Durham.
R.A. 1821. *As* "*Lady Louisa Lambton.*" *Standing, three-quarter length, right arm on parapet. Full sleeves. See also the portrait of Lady Grey, in which Lady Louisa appears as a small girl.*
MEZ. BY S. COUSINS (private plate). ENG. BY J. T. THOMSON, 1831.

OIL–PORTRAITS

Dysart, Countess of. Either Magdaline Lewis, 2nd wife of Lionel, 4th Earl, or Anna, wife of Wilbraham, 5th Earl. [Col. D. J. Proby, Elton Hall, Peterborough. Chr. 1888, Lord Oxenbridge, 550gs.]

Circa 1805. 99×61. Whole length. Descending step to right. Head turned and looking out. Right hand holds rose. Peacock to left. Garden scene. Very high in tone.

Earle, Mrs. [Lionel Earle, Esq. New Gallery, 1899.]

29×24½. Three-quarter length, seated to right, looking out of picture. Hands folded on lap. White dress and gold ribbon. Pink rose at waist. Landscape background.

Eden, James. Second son of Sir Frederick Morton Eden, author of *The State of the Poor*, 1797. The boy was cousin to the 1st Lord Auckland. [Sir William Eden. " Fair Children," 1895.]

Boy of 4 years. Painted after death.

Egerton, Lord Francis. [Stafford House.]

Egerton, Lady Grey. [Sir Philip Grey Egerton, Oulton Park, Cheshire.]

Eldon, John, Earl of (1751–1838). John Scott, born at Newcastle. Younger brother of Lord Stowell. Educated at Oxford University, of which he was Chancellor. Solicitor-General 1788, Chief Justice Common Pleas 1799. Lord Chancellor, with one short interval, from 1801 to 1827. [Earl of Eldon. S.K. 1868; Guelph Ex. 1891.]

Painted 1799. R.A. 1800. 31×26. As Chief Justice of the Common Pleas. Bust, facing, eyes looking up to left. Black coat with loose collar.
MEZ. BY J. R. SMITH, 1800.

Eldon, John, 1st Earl of. [Windsor Castle.]

R.A. 1828. Half length, seated, facing fully out of the picture. White hair. At age of 77.
ENG. BY T. DOO, 1828.

Eldon, John, 1st Earl of. [National Portrait Gallery. Presented 1877 by Hon. Society of Judges and Serjeants-at-Law.]

R.A. 1825 ? 36×28. To waist, seated, facing. White hair, heavy eyebrows. White frill projecting under chin.

Eldon, John, 1st Earl of. [Sir Robert Peel, Bart. Graves' Gallery, 1908.]

R.A. 1825 ? Nearly full length, seated, facing. Close-cut grey hair. Left hand on arm of chair. Black clothes with black silk stockings.

9

Ellenborough, Edward, 1st Lord (1750–1818). Son of Edmond Law, Bishop of Carlisle. Leading Counsel for Warren Hastings. Lord Chief Justice and Baron, 1802. Father of 1st Earl of Ellenborough. [Earl of Ellenborough. S.K. 1868.]

R.A. 1806. 56×44. Seated, facing, head turned to right. Judge's robes and full-bottomed wig. Collar of the Bath (?). Left hand on arm of chair.
MEZ. BY CH. TURNER, 1809.

Ellenborough, Lady. Anne, daughter of Captain Towry, R.N. A famous beauty. Married to Lord Ellenborough in 1789. Died 1843. [Chr. 1895, Ellenborough sale, 460gs.]

R.A. 1813. This portrait was the subject of a long correspondence between Lord and Lady E. and Lawrence, who had taken offence, and declined to go on with it. An unfinished sketch of it was given to Miss Locker. In the Metropolitan Museum of New York is a portrait (29×24½) entitled " Lady Ellenborough."

Ellenborough, Lady. Jane Elizabeth Digby, 2nd wife of Edward, 2nd Baron and 1st Earl of Ellenborough. Married 1824. Divorced, 1828, for adultery with Prince Schwarzenburg. Married an Arab Sheikh at Damascus. Known as " Ianthe." Edmond About, who met Ianthe in Syria, said of her : " Elle avait l'air d'un portrait de Lawrence perdu dans une cuisine." [Ex J. W. Wilson. Exhibited Brussels 1873. Ex Camille Groult, Paris. Portraits du Siècle, École des Beaux Arts, 1885.]

Circa 1824. 24×19. Bust, head only finished. Facing, looking to right. Black hair, ear unfinished.
ETCHED BY CH. WALTNER.

Elliot, Right Hon. William. Twice Chief Secretary for Ireland. Friend of Burke. [Earl of Minto. Loan Exhib. of Scottish Portraits, 1884.]

30×25. Bust, facing. White hair, grey coat.

Elliot, Sir Gilbert (1751–1814). Viceroy of Corsica (1794–6), Baron Minto (1798), Governor-General of India (1807–13), Earl of Minto (1813). [Earl of Minto.]

R.A. 1794. No. 78, " Portrait of a Gentleman " in R.A. Catalogue. " Pasquin " complained that it was not finished.

Elliot, Sir Gilbert. [W. Burdett-Coutts, Esq.]

Circa 1795. Seated to right, to knees ; holding letter in left hand. Coat with loose collar over large white stock. Natural hair brushed out around head.

129

Elphinstone, Hon. Mount-Stuart (1779–1859). Governor of Bombay. Historian of India. [Painted for the National Education Society, Bombay.]
A late portrait, partly by Simpson. Whole length, seated, slightly to left. Right foot on footstool, paper in left hand. Tall hat on floor. Indian coast scenery visible on left.
MEZ. BY CH. TURNER, 1833.

Elphinstone, Miss Mercer. Baroness Keith and Nairn in her own right. Married the Comte de Flahaut, one of Napoleon's Generals, who was himself descended from Louis XV. Her daughter was the mother of the present Lord Lansdowne. [Marquess of Lansdowne.]
To below the waist ; painted when she was a girl.

Ely, Marchioness of. See Dashwood, Miss A. M.

Englefield, Sir Henry C., Bart. (1752–1822). Antiquary and scientific writer. President of Society of Antiquaries. Gold Medallist of Society of Arts. [Dilettanti Society. B.I. 1846; S.K. 1868.]
R.A. 1813. Nearly half length. Seated to right, stooping and looking up out of picture. White cravat tied in bow. Looks a man of about 50, with short hair.
ENG. BY W. BROMLEY, 1816.

Erskine, Colonel Sir James, of Torrie, Bart. (Died 1825.) Sir James Erskine bequeathed the Torrie collection of pictures to the National Gallery of Scotland. [Lent by Mrs. Scott Erskine's trustees to Loan Exhibition of Scottish Portraits, 1884.]
29×24. Bust. Dark brown hair and brown whiskers ; red uniform, steel cuirass.

Erskine, Hon. Thomas, afterwards Baron (1750–1823). Son of the Earl of Buchan. Defended Horne Tooke, 1794. Lord Chancellor in Grenville Ministry, 1806. [Sir Robert Peel, Bart. Graves' Gallery, 1908.]
R.A. 1802. To waist, seated, head turned slightly to right. Short and rough dark hair, grey eyes. Plain red background.
ENG. BY GEO. CLINT, 1803. MEZ. BY CH. TURNER, 1806.

Erskine, Hon. Thomas, 1st Baron Erskine. [J. Carrick Moore. S.K. 1868 (lent by Lady Moore); Loan Exhibition of Scottish Portraits, 1884.]
30×25. Bust, seated, resting on left arm, nearly full face. Dark coat.

130

Essex, Countess of. See Stephens, Catherine.

Esten, Mrs., in the character of "Belvedira."
R.A. 1787, the first year that Lawrence exhibited. Painted probably at Bath.

Exeter, Henry (Cecil), 10th Earl and 1st Marquess of (1754–1804), with his Wife and Child. [Marquess of Exeter, Burghley House. S.K. 1867.]
R.A. 1797. No. 74. 86×57. Lord Exeter at full length, in red coat and breeches and with powdered hair, standing by a pillar. Lady Exeter with fair hair, white dress and yellow robe over knees, seated holding her child, Lady Sophia Cecil. This Lady Exeter was the "Cottage Countess," Sarah Hoggins, who was the heroine of Tennyson's "Lord of Burleigh." She married Lord Exeter in 1791 and died in 1797.

Exeter, Brownlow Cecil, afterwards 2nd Marquess (1795–1867), with his Brother and Sister. [Marquess of Exeter. S.K. 1868.]
Circa 1800. 64×48. The three children of the "Cottage Countess," second wife of the 10th Earl of Exeter. Full lengths, one holding a cap and feather. The youngest was born in 1797, the year of his mother's death.

Exeter, Brownlow Cecil, 2nd Marquess. [M. of Exeter, Burghley House.]
To knees, facing. Dark hair and whiskers. In Garter robes. Right hand resting on sword.

Exeter, Elizabeth, Marchioness of, 3rd wife of 1st Marquess (10th Earl). Married 1800. Daughter of Peter Burrel. At the time of her marriage Dowager Duchess of Hamilton. She died 1837.
R.A. 1802. Full length, seated to right (head facing) at base of tree in park. House seen among trees to right. High waist, veil over head, fastened under chin. A small long-haired black dog at her feet.
LARGE MEZ. BY S. W. REYNOLDS, 1803.

Exeter, Isabella, Marchioness of. Daughter of William Stephen Poyntz, of Cowdray. Married 1824 to 2nd Marquess of Exeter. Died 1879.
Late portrait. Nearly full length, seated a little to left, nearly full face. Left elbow resting on ermine cloak thrown over arm of couch. Vandyke cuffs, leg of mutton sleeves. Elaborate curls round face.
ENG. BY W. C. WASS.

Exmouth, 1st Viscount, Admiral Sir Edward Pellew, Bart. (1757–1833). Took the first French frigate in the war, 1793; Baronet, 1796;

OIL–PORTRAITS

Commander-in-Chief in East Indies, 1804; bombarded Algiers 1816; created Viscount Exmouth same year. [H. E. Pellew, Esq. S.K. 1868. ? Lent by Lord Sidmouth to B.I. 1833.]

1818. 50×40. *Half length, standing, in naval uniform, with ribbon of the Bath.*

ENG. BY H. ROBINSON.

There is a copy by Lane in the Senior United Service Club.

Exmouth, 1st Viscount.

Ch. Turner engraved a portrait of Lord Exmouth by Lawrence, "from a picture belonging to Edw. Hawke Locker," which differs somewhat from the last described. He wears a white cravat, and the ribbon, star, and cross are absent.

Fairlegh (or Fairlie), Miss.
Perhaps Louisa Fairlie (q.v. under Drawings). [At Messrs. Lewis and Simmons in 1909. Bought at Lawrence's sale by Mr. Pelham.]

Circa 1820. 24×20. *Bust, facing a little to right. Head turned a little to left, and eyes looking left. Hair in short, dark brown curls over forehead. Aquiline nose, and blue eyes.*

Falmouth, Countess of.
Marie Anne Bankes. Married (1810) to Edward, 4th Viscount, later 1st Earl of Falmouth. Died 1869. [Mrs. Bankes, Kingston Lacy.]
Kit-cat size.

Fane, George.
Later Lord Burghersh (1819–48). Eldest son of the 11th Earl of Westmorland. Died before his father. [James Price sale, Chr. 1895 ; 225gs.]

1822. *Circle, 13½ diam. Boy of three. Full face, curly hair. Blue background.*

Fane, Hon. J.
[Lent to B.I. 1833 by Lord Burghersh.]

Fane, Lady Georgiana.
"A Child with a Kid." Daughter of John, 10th Earl of Westmorland. Died 1874. [National Gallery. Bequeathed by Lady Georgiana. Lent to B.I. 1830 by the Earl of Westmorland.]

Painted 1800. 56×37½. A bare-legged child of 5 resting against the bank of a stream and looking upwards. A kid standing in the water beside her. Inscribed at bottom, to right, "Lady Georgiana Fane, 1800."

ENG. BY CH. TURNER, 1828.

ENG. BY C. ARMSTRONG as "The Mountain Daisy." Amulet, 1829.

Farington, Joseph, R.A. (1747–1821).
Landscape painter. R.A. 1785. Kept house for Lawrence in early London period. Corresponded with Lawrence while the latter was in Rome. Lawrence always sought his advice.

R.A. 1796. *(No. 164, " Portrait of an Artist "). " A striking likeness," according to Pasquin.*

A portrait of J. Farington, pencil, dated 1790, was bought at the Lawrence sale, May 20, 1830, by Mr. Gott, for £4 6s.

Farington, Joseph, R.A.
At the age of 60.

R.A. 1808. *Half length, seated to right in arm-chair. Bald head. Holds drawing in hand. Fur-collared coat.*

ENG. BY H. MEYER, 1814.

Farnham, John Maxwell, 5th Baron (1767–1838).
Representative Irish peer. Succeeded his kinsman, the 2nd and last Earl, in 1823. [Lord Farnham. Portrait Exhib., Dublin, 1873.]

In the Lawrence sale, June, 1831, was a drawing of Lord Farnham in black and white chalk. This may perhaps have been of the last Earl of Farnham.

Farren, Eliza, Countess of Derby
(1759?–1829). Daughter of Mr. James Farren, of Cork. Well-known actress. Married in 1797, as his second wife, Edward, 12th Earl of Derby. [J. Pierpont Morgan. Ex Earl of Wilton and L. Neumann. Manchester, 1857 ; S.K. 1867; O.M. 1904.]

R.A. 1790. *No. 171, " Portrait of an Actress."* 90×57. *Full length, in a landscape ; walking towards the right. Fur-trimmed mantle, which she holds up to her chin with her right hand. Her left hand hangs by her side, holding a fur muff. Landscape suggesting early autumn. There is a copy at Knowsley.*

ENG. BY BARTOLOZZI, 1792.

[The plate really stippled by Ch. Knight, whose name occurs on the first state.] Re-issued in colours, 1797.

Farren, Eliza.
[Cholmondeley sale, Chr. 1897 ; 2250gs. Formerly belonged to Sir Francis Grant.]

Circa 1790. *To waist, facing to left, but head turned and looking out of picture. Hair powdered and frizzled out, enclosing face. Hands in muff. Black boa over left arm.*

LARGE MEZ. BY J. B. PRATT, 1898.

The " Portrait of a Young Lady," No. 258 in the R.A. of 1787, is said by Mr. Anderdon to represent Miss Farren.

Farren, Eliza.
[Lord Allendale. Lent by Mr. Wentworth Beaumont to New Gallery, 1899.]

Circa 1789. 15×12½. *Oil sketch of head, looking to left. Hair long and powdered.*

131

SIR THOMAS LAWRENCE, P. R. A.

Fawcett, John (1768–1837). Comedian. Born in London. Many years manager of Covent Garden Theatre. Excelled in the clowns and fools of Shakespeare. [National Portrait Gallery. Deposited by Nat. Gallery (Vernon Coll.). B.I. 1833.]

1825–9. 29½×24½. *Nearly to waist, head turned to right. Black stock and white collar, and white shirt front.* ENG. BY W. J. EDWARDS. " Art Journal," 1854.

Finch, Mrs.

R.A. 1793 (*No.* 235. " *Portrait of a Lady* "). *A contemporary critic calls it* " *The Celebrated Mrs. Finch.*"

Fitzwilliam, William Wentworth, 2nd Earl (1748–1833). Nephew and heir to Marquess of Rockingham. President of Council under Pitt, 1794. Lawrence describes him at Newmarket with a coach and six, attended by four gentlemen and twelve outriders. [Earl Fitzwilliam, Wentworth Woodhouse.]

An animated but unfinished portrait.

Foote, Maria? (1797?–1867). Actress, afterwards Countess of Harrington. [Messrs. Agnew.]

1810–15. *To waist, facing. Dark blue eyes, looking out. Hair in brown locks over forehead. Dark crimson high-waisted dress, with plain buckle on waistband. Lace shawl wound round head, resembling a bonnet. Blue background. High in tone with rich impasto.*

Forster, Mrs. Probably the mother of Miss Forster (q.v. under Drawings). Lawrence corresponded with Mrs. Forster while she was living in Rome. [Exposition de l'Art Anglais à Bagatelle.]

1800–5. *Seated, seen to below waist. Lady of about 30 with dark eyes and dark hair bound above forehead by fillet. High waist, front of dress crossed over breast; left elbow rests on arm of chair.*

Fortescue, Susan, Countess of. See Ebrington, Lady (under Drawings).

Foster, Lady E. See Devonshire, Duchess of.

Fox, Charles James. The Statesman (1749–1806). [Chr. June, 1831, Lawrence's Exors.]

Oil study of head on canvas.
Another portrait of Charles James Fox, "a copy by Simpson," was in the same sale.

Francis I, Emperor of Austria. Son of Leopold II. Born 1768. Emperor 1792, as Francis II. Declared

132

himself hereditary Emperor of Austria, as Francis I, 1804. Died 1835. [Windsor Castle,ʼ Waterloo Gallery. B.I. 1830.]

1818. *Painted at Aix-la-Chapelle, in seven sittings. Seated in chair, facing slightly to left. Left foot on stool. White uniform with orders and black ribbon. Cocked hat on table to right. In a letter to Farington, Lawrence says of this portrait :* " *I had some difficulties to encounter. His countenance is long and thin, and when grave is grave to melancholy. When he speaks, benevolence itself lights it up.*" *A copy was made for the King of Prussia.* MEZ. BY G. H. PHILLIPS, 1837.

Fraser, Mrs., of Fraser Castle. [Col. Mackenzie Fraser, " Fair Women," 1894.]

Frederick William III, King of Prussia (1770–1840). Succeeded his father 1786. Married 1794 to Princess Louisa of Mecklenburg. Came to England with Blücher and the Emperor Alexander in 1814. [Windsor Castle, Waterloo Gallery. B.I. 1830.]

1818. *Standing full length, facing slightly to right. Black uniform, plumed hat in right hand. Painted at Aix-la-Chapelle. A replica is in the White Hall of the Berlin Schloss.*

Fries, Graf Moritz von. Count von Fries belonged to the *haute finance* of the time. His house was the meeting place of the cosmopolitan art world. He had a famous collection of drawings by the Old Masters; 150 of the best of these Lawrence bought at a later date. [Count August von Fries, Vienna.]

Painted at Vienna, 1818–19.

Fries, Victor von, child of Count Moritz von Fries. [Count August von Fries, Vienna.]

1818–19. *Boy of from 7 to 9 years old. Head only finished. Painted in Vienna.* ETCHED BY UNGER.

Fry, Miss Caroline (Mrs. Wilson) (1787–1846). Authoress of works on education and religion. Married 1831. [National Gallery. Bequeathed by Mr. W. Wilson, 1890. S.K. 1868.]

R.A. 1830. 28½×24½. *Half length, seated, face turned to left and eyes looking up. Loose curls. White muslin dress, embroidered with gold braid, and blue sash. Right arm, partly covered by mantle of brown silk lined with crimson, resting on table.* ENG. BY A. J. SKRIMSHIRE, 1892.

OIL–PORTRAITS

Fullarton, the Misses. [Mr. Max Michaelis. Ex Ch. Tattershall Dodd. Chr. July 10, 1897 ; 2200gs.]

61×57. *Seated on couch. The sister to left holding a book, her sister's arm round her. Crimson curtain. Unfinished in parts.*

Fuseli, Henry, R.A. [Ex Sir Robert Peel, Bart. B.I. 1833. Robinson and Fisher, Sale of Peel Heirlooms, May, 1906.]

56×43. *To knees, facing, holding a purle crayon. "Fuseli's head was left unfinished. It had much of the flighty, imaginative, and discontented expression of the original" (Cunningham).*

ENG. BY H. MEYER.

Perhaps identical with the "half-length, bust only finished," of the 1830 sale.

Gardner, Alan Hyde, 2nd Baron (1772–1815). Eldest son of Admiral Alan, 1st Lord Gardner. Entered Navy. Captured Colombo 1796. Succeeded to peerage 1809. [Lord Burghclere. Lord Gardner, S.K. 1868.]

39×29. *Half length, standing, facing to right, looking round. Right arm outstretched, Naval uniform. Ribbon and Star of the Bath.*

ENG. BY H. COOK, 1832.

Gataker, Mr.

1785–90. *Lawrence received 15gs. for a portrait of this gentleman soon after he came up to London.*

Writing to Mrs. Wolff (?) in 1827, Lawrence mentions that he has found a portrait of Mr. Gataker, painted many years since, which, when cleaned, he will send to his son. Mrs. Gataker was his mother's first cousin.

Gentz, Baron Friedrich von (1764–1832). Political writer and jurist. Born at Breslau. Employed by Metternich to write in opposition to Napoleon. [Windsor Castle. Removed from Hampton Court 1901. B.I. 1833.]

1818. 30×24½. *Bust, facing, head and eyes to left. Short rough hair over forehead. High fur-lined collar, white cravat, shirt front partly covered by ribbon to which three crosses are attached. Unfinished.*

Gentz, Baron Friedrich von. [Vienna, Fürstlich Metternichschen Gemälde Galerie.]

George III (1738–1820). Eldest son of Frederick, Prince of Wales, and of Princess Augusta of Saxe-Gotha.

Painted 1792. Full length.
Taken out to China by Lord Macartney as a present to the Emperor.

George III. [Windsor Castle, Audience Chamber, for which position the picture was especially painted. B.I. 1833.]

R.A. 1792. *Nearly facing, looking to left. In state robes. Garter and other decorations. Plumed hat to left.*

ENG. BY W. HALL, 1830.

George III. [Chr. Lawrence Exors., May 13, 1830. Sold, together with a landscape sketch, for 31gs.]

Early work. Small whole length.

George III. [Coventry, St. Mary's Guildhall.]

Painted 1794. Full length. In state robes. Hand resting on table to right, on which is hat with plumes.

Presented to the Corporation by Sir Samuel Gideon, later Lord Eardley, who paid Lawrence 300gs. for the picture.

George III. [Town Hall, Liverpool.]

Circa 100×60. *Dated on frame 1821. Standing, full length. Head turned to left and looking farther to left. In royal robes with Garter, chain, etc. Hat with plumes on table to right. Landscape to right.*

George IV. [Windsor Castle. Throne Room.]

R.A. 1822. *Standing, full length, in robes of Garter, looking to right. Right hand on table. Crown to right.*

A copy of this picture in the Waterloo Gallery.

Lawrence only received 300gs. for these Coronation pictures, instead of the 600gs. that he was then asking for full-length portraits.

ENG. BY T. HODGETTS, 1829.

George IV. [Buckingham Palace.]

110×71. *In Coronation robes. Full length.*

George IV. [Picture Gallery of the Vatican.]

1822. 108×72. *Full length, facing, turned slightly to right. In the robes of the Garter. On table to right, a papal bull with signature of Pius VII. Red curtain in background. This picture is extravagantly praised in a letter to Lawrence from Cardinal Consalvi.*

George IV. [St. Mary's Guildhall, Coventry. Given by William IV.]

Standing, full length. In Coronation robes. Right hand resting by side of crown at table to right.

George IV. [Petersburg. Imperial Collections.]

Lawrence was at work on this picture a few days before his death, " very anxiously desiring its completion, as it was," he said, " to go to Russia " (Miss Croft).

George IV.

There were formerly four portraits of George IV. by Lawrence, in the collection of the King of Hanover. Some are probably in the possession of the Duke of Cumberland.

George IV. [Brighton Corporation Gallery. Presented by the Athenæum Club.]

The full length, in Coronation robe, bought by the " Athenæum " at the Lawrence sale, June, 1831, for 115gs. Lawrence is said to have been working on it a few hours before his death (cf. the Czar's Portrait).

133

SIR THOMAS LAWRENCE, P.R.A.

George IV. [John Cleland, Esq., of Stormont, Guelph Exhib. 1891.]

Circa 1821. 34×26. Small full length, standing, to right. In Coronation robes. Right hand rests on table, the left on hip.

George IV. [Wallace Collection.]

1822. 104½×68¾. Seated on sofa, full face, hand on knee. Plain clothes. Writing in 1822, Lawrence says: "I am completing . . . a portrait of the King in his private dress—perhaps my most successful resemblance."
ENG. BY C. TURNER, 1824.

 FINDEN, 1829, ETC.

George IV (as Regent). [National Portrait Gallery, Edinburgh. Ex Sir Wm. Knighton.]

1805–10. To waist, facing, head to right, looking round. Frock coat edged with fur. High collar and black stock. Orders of the Garter and the Golden Fleece.
ENG. BY W. ENSOM, 1829 (" Bijou," 1838).

George IV. [National Portrait Gallery.]

27×20½. Oval, face in profile, to right. Head only finished. High stock up to ear.
A study from life, made in 1820-1, for the head on the new coinage.

George IV. [At the Lawrence sale, June, 1831, was a head of George IV— "The original head from which all the state pictures were painted." Sold to General Grosvenor for 76gs. ? Lent by Mrs. Grosvenor to B.I. in 1856.]

George IV.

Portraits of George IV, owing their origin at least to Lawrence, are in the possession of the Duke of Richmond, the Marquess Conyngham, Lord Sackville, the Junior United Service Club, the Castle and the Vice-Regal Lodge, Dublin, and many other owners and institutions. The late Duke of Cambridge owned two, which were sold at Christie's, June 11, 1904.

George IV, as Prince Regent.

Portraits by Lawrence of George IV, as Prince Regent, were in the Academy Exhibitions of 1815 and 1818.

Gérard, Francois, Baron (1770–1837). Born in Rome of French parents. Pupil of David. [Versailles.]

30×25. Only head finished. Half length, arms folded, looking slightly to right.

Gifford, Lord. [Chr. June, 1831. Lawrence's Exors.]

" Unfinished head."

Glenbervie, Right Hon. Sylvester Douglas, Lord (1743–1823). Educated at Aberdeen. Barrister. King's Counsel 1793. Member first of Irish and then of English Parliament. Baron of Irish peerage 1800.

Early portrait. Seated in arm-chair; nearly full length. Natural hair, long and powdered. Glove in left hand. Right hand rests on cravat. Legs crossed.
ENG. BY E. HARDING, 1794.

134

Gloucester, Bishop of (1802–15). See Huntingford, Dr. George Isaac.

Gloucester, Duchess of (1776–1857). Mary, fourth daughter of George III. Married 1816 to her cousin, the 2nd Duke of Gloucester. [Ex Duke of Cambridge. Chr. June 11, 1904; 130gs.]

R.A. 1817. Oval, 24×19. Nearly to waist, in oval feigned frame. Facing, looking out of picture. Low white dress with high waist. Pearl necklace. Jewelled chain and jewel on bosom. Short full sleeves.
MEZ. BY J. E. COOMBS, 1841.

Gloucester, Duchess of. [W. Dacre Adams, Esq.].

C. 36×32. Seated, to knees, hands on lap ; short sleeves, with bare arms. White satin dress. Pearl necklace, with diamond snap and diamond band-like jewel in hair ; a rivière of diamonds descends from left shoulder. Many other jewels.
This is the picture given by the Duchess to Miss Adams, her Lady-in-waiting. Miss Croft relates in her Memoirs that she sat for the arms.

Gloucester, Duchess of. [Chr. July 5, 1902 ; 620gs.]

R.A. 1824. 35½×27½. Seated ; white dress, pearl and diamond ornaments. Holding rose in hand. Red curtain background. Painted in April at Burlington House.
A portrait of this Princess was sold at the Lawrence sale in 1831.

Glover, Miss, "of Bath." [Ex Maurice Kann. Sold Paris, January, 1911 ; £3000.]

1810–15. 30×27. To waist, facing, head a little to right. Chestnut hair loosely coiled over head ; blue eyes. Black velvet dress, cut low. Light scarf over right shoulder. Small bouquet to right of breast. Gold eyeglass suspended by slight chain. Bare arms only seen to elbow. Red drapery and sky background.

Goderich, Lord. See Ripon, Earl of.

Goodwin, William (1756–1836). Writer. Married Mary Wollstonecroft 1797. She died the same year, after giving birth to Mary Godwin, later the wife of Shelley. [Lady Shelley. Guelph. Exhib. 1891.]

30×25. Half length, full face ; brown coat.

Gonsalvi. See Consalvi.

Gordon, Duke of. George, 5th and last Duke (1770–1836). Succeeded to title 1827. [Society of British Artists, 1831.]

" The head and hands painted by the late Sir Thomas Lawrence ; the arrangement and completion of the picture by J. Simpson " (Catalogue).

Gordon, Lady Georgiana. See Bedford, Duchess of.

OIL-PORTRAITS

Gordon, Lady Louisa. Fourth daughter of 4th Duke of Gordon. Married 1795 to the 2nd Marquess Cornwallis. Died 1850.

R.A. 1795. No. 189?. " Portrait of a Lady of Quality."
" The hands are finely painted," says a contemporary critic. The portrait of Lady Louisa is given to A. Hickel in the R.A. Catalogue, probably in error.

Gordon, Lady William. ? Frances, daughter of the 9th Viscount Irvine. Married William, second son of third Duke of Gordon.

1805 ? Oval; to waist. Nearly facing. Head raised and eyes looking up. Shawl over head and right shoulder. Jewel, with pendants, on high waistband. Some doubt attaches to the identification of the sitter.

ENG. BY J. E. EDWARDS as the " Evening Star " for the " Amulet " of 1833.

Gott, Benjamin. Mayor of Leeds 1799. Died 1840. Father of Bishop of Truro. Friend of Lawrence and collector of mezzotints. [Ex Bishop of Truro. O.M. 1904. Chr. 1897, Gott heirlooms, 1650gs.]

55½ × 44½. Nearly full figure. Seated, a little to right, in red arm-chair, full collar. Fur collar. Architecture and curtain background. Landscape to left.

Gott, Mrs. Elizabeth. Daughter of W. Rhodes. Married 1790 to Benjamin Gott. Died 1857. [Ex Bishop of Truro. O.M. 1904. Chr. 1897. Gott heirlooms, 850gs.]

55½ × 44½. Nearly full length. Seated to right in a red chair; head turned to left. Dark velvet dress, open at neck, with ruff. Black hat with white feathers. Architectural and landscape background.

Gower, Harriet, Countess, and Child. Daughter of 6th Earl of Carlisle. Married, 1823, George, Earl Gower, afterwards 2nd Duke of Sutherland. Died 1868. She was the mother of Elizabeth, Duchess of Argyll, who died in 1878. [Duke of Sutherland, Stafford House. B.I. 1830; O.M. 1904.]

R.A. 1828. 92½ × 57½. Lady Gower is seated, full length, in a red chair; head turned slightly to right; book in right hand. Holds her little daughter with her left hand. The child has only one shoe on; the other shoe is on table to left. Black dress, low body, red head-dress. Lawrence is said to have received 1500gs. for this picture.

MEZ. BY S. COUSINS, 1832.
Later prints by FINDEN, DEAN, and PHILLIPS.

Gower, Lady Elizabeth Leveson. See Belgrave, Lady Elizabeth.

Gower, Lord Francis Leveson (1800–57). Second son of 1st Duke of Sutherland. Created Earl of Ellesmere 1846.

R.A. 1827.

Graham, Sir Thomas. See Lynedoch, Lord.

Grant, Sir William (1752–1832). Entered Parliament 1790. Solicitor-General 1799. Master of the Rolls 1801–17. [National Portrait Gallery. Formerly in the Rolls Court. B.I. 1830; S.K. 1868.]

R.A. 1820. 93½ × 57½. Full length, seated, face three-quarters to right. In robes of Master of Rolls. Full-bottomed wig. Holding papers in right hand.

ENG. BY RICHARD GOLDING.

Grant, Sir William. Master of the Rolls. [Corporation of London. Art Galleries. Presented by Sidney Young, 1894.]

R.A. 1802 ? 30 × 25. To waist, facing, looking up a little to left. Clean-shaved, with grey or powdered hair. White stock and white frill of shirt showing above close-buttoned black coat. Black background.

Grantham, Lady. Henrietta Frances, daughter of the Earl of Enniskillen. Married (1805) 3rd Lord Grantham, afterwards Earl de Grey. She died 1848. [Marquess of Ripon. B.I. 1830 (lent by Lord Grantham).]

R.A. 1814. Half length, facing, head to right, nearly in profile. Black hair. Low white dress with short sleeves. Jewel on breast, attached to chain passing over right shoulder. Holding a vase in both hands.

ENG. BY J. H. ROBINSON, 1828, as " Psyche " (Front. to " Anniversary ").

Granville, Leveson Gower, 1st Earl (1773–1846). Youngest son of 1st Marquess of Stafford. Ambassador to Petersburg and Paris. [Earl Granville. S.K. 1868.]

94 × 57. Full length, standing, leaning against base of column covered with crimson drapery. Full face. Coat of arms to left.

Greenwood, Charles. Member of the firm of Cox and Greenwood, army bankers.

1800-5. Seated, to knees, nearly facing, looking out of picture. Knee breeches, legs crossed, frilled shirt. Elderly man.

ENG. BY CH. TURNER, 1828.

Greville, Lady Charlotte. See Bentinck, Lady Charlotte.

135

SIR THOMAS LAWRENCE, P.R.A.

Grey, Charles, 1st Earl (1729–1807), when General Sir Charles Grey. Wounded at Minden 1759; served in America and West Indies. Baron 1801; Earl 1806. [Earl Grey. S.K. 1867.]

R.A. 1795. 50×40. *" Portrait of an Officer." Standing, nearly to knees, facing, head turned slightly to right. General's uniform with star. Castle, flying Union Jack, on right.* ENG. BY J. COLLYER. 1797.

Grey, Charles, 2nd Earl (1764–1845), when Mr. Grey. Entered Parliament 1786. Foreign Secretary under Lord Grenville. Led Whig party after death of Fox. Foreign Secretary 1806–7. Prime Minister 1831; passed Reform Bill 1832. [Painted for Dr. Heath, Master of Eton.]

R.A. 1793. *" Portrait of a Gentleman." As Mr. Grey. To knees, standing, as if just risen from seat to speak. Right hand on table, gloves in left hand.* ENG. BY W. DICKINSON, 1794. *Title later altered to "Viscount Howick."*

Grey, Charles, 2nd Earl, as the Hon. Charles Grey. [Earl Grey. S.K. 1867.]

R.A. 1805. 50×40. *Half length, to right, resting right hand on papers on table. Black dress.*

Grey, Charles, 2nd Earl. [Earl Grey. S.K. 1868 ; Victorian Exhibition, 1901–2.]

R.A. 1828. 44×30. *Nearly to knees, facing. Right hand thrust in breast of coat, left arm resting on pedestal. Bald head. White trousers. Signed " T. L. 1828."* MEZ. BY S. COUSINS, 1830.

Grey, Charles, 2nd Earl. [National Portrait Gallery.]

29½×24½. To the waist, facing. As an elderly man. Left hand supported on pilaster ; right in breast of coat. High white cravat. A late portrait, Lawrence's authorship doubtful.

Grey, Mary Elizabeth, Countess, and her two daughters. Daughter of 1st Lord Ponsonby ; born 1776 ; married (1794) Charles, 2nd Earl Grey. Died 1861. The elder daughter married 1816 to J. G. Lambton, later Earl of Durham. The second married 1826 to J. C. Bulteel, Esq. [Earl Grey. S.K. 1868 ; O.M. 1904.]

Circa 1805. Circular, 54½ in diam. Lady Grey, seated, nearly full length, facing, looking up to right. Left hand holding book on her lap : the right thrown round the elder girl, seated beside her. The younger girl clasps her round her neck. Black velvet dress ; landscape to right. MEZ. BY S. COUSINS, 1831.

136

Grey, Mary Elizabeth, Countess. [Earl Grey. S.K. 1868.]

R.A. 1813. 92×58. *Full length. Seated, to right, on a couch. Low black dress, crimson scarf. Flowers behind.*

Grimstone, Mrs. Samuel. See Barrington, Lady (under Drawings).

Grosvenor, Elizabeth, Countess. See Belgrave, Lady Elizabeth.

Gubbins, Mrs. [Chr. March, 1907 ; n.n.]

About 1815. 29×24. Stout lady of about 50. To waist, facing, a little to left and looking out. White cap under which black curls escape. High waist. Gold chain. Green curtain background.

Guilford, Francis North, 4th Earl of (1761–1817). Author of *The Kentish Baron*, a drama. Succeeded to Earldom 1802. Died at Pisa. [Ex Lord Sheffield. Chr. 1909 ;. 190gs.]

1805–10. 50×40. Seated, to right, looking round. Short, greyish hair, blue coat and breeches. Snuff-box in right hand. Book on table to left inscribed " Kemble on Macbeth." Landscape background. MEZ. BY CH. TURNER, 1820.

Guilford, Francis North, 4th Earl of. [Ex Lord Sheffield. Chr. Dec., 1909 ; 105gs.]

1805–10. 29×24½. Bust, to right, looking round. Grizzly white hair in rough locks over forehead. Very similar to last.

Guilford, Countess of. Daughter of Thomas Coutts, the banker.

About 1808 Thomas Coutts gave a commission to Lawrence for portraits of his three daughters. Somewhat earlier Lawrence was asked by Mrs. Coutts to make a drawing of her grandchild, the Hon. — North, just dead.

Halford, Sir Henry, Bart., M.P. (1766–1844). 1st Baronet, son of Dr. James Vaughan. Created Baronet 1809, and changed his name. Attended as physician George IV, William IV, and Victoria. [Sir Henry Halford. S.K. 1868.]

56×44. Nearly full length. Seated to left, in armchair. Full face. Black dress, with tight trousers. Star on left breast. Column and landscape background. MEZ. BY CH. TURNER, 1830.

Hamilton, Emma, Lady (1761 ?– 1815). Began life as a domestic servant. Posed as " Goddess of Health " for the quack, James Graham, at Schomberg House, Pall Mall. Lived with Hon. Ch. Greville as Emily Hart, 1780–4. Posed frequently for Romney, who called her " the divine lady."

Lived with Greville's uncle, Sir W. Hamilton, from 1786. Married him in 1791. Intimate with Queen of Naples and with Nelson, to whom she bore a daughter, Horatia, 1801. Died at Calais. [Duke of Abercorn. O.M. 1904.]

R.A. 1792. 94×57½. " Portrait of a Lady of Fashion as La Penserosa." Full length, seated, to right, at the foot of a tree ; looking up, bare-headed, yellow dress, green robe over knees. Hair falling over right shoulder. To the right a stream

Hamilton, Emma, Lady. [Right Hon. Evelyn Ashley.]

Oval. As Nymph with long dark hair. To waist. Holding bunch of grapes up to head with right hand.

Lawrence appears to have painted Lady Hamilton a second time in 1796. In a letter of May, 1796, he complains of his difficulty in getting sittings, and pronounces Romney's portraits of her to be feeble.

Hamilton, James, Viscount (1786–1814). As a child. Eldest son of John, 1st Marquess of Abercorn. Father of the 1st Duke. [Duke of Abercorn. O.M. 1904.]

R.A. 1790. No. 219. " Portrait of a Young Nobleman." Oval, 29×15½. Cherubic boy of 3. Full face, hands joined in front, looking up ; sky background.

ENG. BY H. T. GREENHEAD.

Hamilton, Lord Claude (1787–1808). Second son of John, 1st Marquess of Abercorn. [Duke of Abercorn. O.M. 1904.]

Circa 1792. Oval, 20×15½. Bust. Head turned to right. Fair hair falling over shoulders. Dark dress, open at neck. Blue background. Boy of about 5.

Hamilton, Lady Harriet. Eldest daughter of John, 1st Marquess of Abercorn. Died unmarried 1803. [Duke of Abercorn. O.M. 1904.]

1802 ? 29½×24½. Smaller than life. Seated, half length, facing. Hands with fingers interlaced. Hair bound by fillet falling over forehead.

Hamilton, Lady Harriet. As a child. [Duke of Abercorn. O.M. 1904.]

R.A. 1790. No. 275. " Portrait of a Young Lady of Quality." Oval, 20×15½. Bust, facing ; white dress, mob-cap with blue ribbon, fair hair. About 5 years old.

Hamilton, Lady Catherine. Second daughter of John, 1st Marquess of Abercorn. Married, 1805, George, 4th Earl of Aberdeen. Died 1812. [Duke of Abercorn. O.M. 1904.]

Oval, 20×15½. As a child. Half length, to right, looking at the spectator. White dress, brown hair falling over shoulder. Red curtain background.

Hamilton, Lady Maria. Third daughter of John, 1st Marquess of Abercorn. Died 1814. [Duke of Abercorn. O.M. 1904.]

Circa 1802. 29×24½. Half length, seated, with right arm over back of chair. Head turned to left, looking up. Short rough hair. White dress with red scarf over shoulder and coral necklace. Architectural background, with sea in distance to left. About 15 years old.

Hamond, Sir Andrew Snape, Bart. Died 1828, aged 90. Captain R.N., Controller of Navy. Served during American War. Created Baronet 1783.

Circa 1800. Nearly to waist, facing, head turned to right. Man of about 60. Frilled shirt front.

MEZ. BY G. H. PHILLIPS, 1830.

Hamond, Fanny and Jane. Daughters of the Rev. Horace Hamond, of Massingham, Norfolk. [Mr. Stanford White, of New York. Ex Messrs. Sedelmeyer, Paris. Chr. July 10, 1897, n.n. ; 1400gs.]

Circa 1805. 36×32½. Two girls of about 10 or 12. Seated on couch. In white muslin gowns. The one to left holds flowers in both hands, and embraces her sister with right arm.

Harbord, Lady Catherine.

R.A. 1793. No. 545. " Portrait of a Lady of Quality."

Harcourt, Edward Venables Vernon. Archbishop of York (1757–1847). Mr. Vernon took the name of Harcourt in 1831. Bishop of Carlisle 1791–1807. Archbishop of York 1807–47. Privy Councillor 1808. [Bishopsthorpe.]

R.A. 1823. Full length, standing, in robes. Bishop's wig. Trencher hat in outstretched left hand. Right arm akimbo.

ENG. BY G. H. PHILLIPS, 1836.

Hardenberg, Charles Augustus, Prince of (1750–1822). Born in Hanover. Friend of Goethe. Repeatedly Envoy to England. Represented the King of Prussia in Paris 1814. Proceeded to London. Prussian Plenipotentiary at Aix-la-Chapelle and Vienna. [Windsor Castle. Waterloo Gallery. B.I. 1830.]

Painted at Aix-la-Chapelle in 1818. Nearly full length, seated, full face. White hair. Blue and yellow ribbon across breast. Light through window to left.

Hardenberg, Prince of. [Chr. June, 1830, Lawrence Exors. ; 33gs.]

Painted probably at Aix-la-Chapelle, 1818. Oil study, head only finished.

137

SIR THOMAS LAWRENCE, P.R.A.

Hardwicke, Philip Yorke, 3rd Earl of (1757–1834). Succeeded his uncle in 1790. Lord Lieutenant of Ireland 1801–6. [Earl of Hardwicke.]
R.A. 1830. *Nearly to knees, facing, head to left. In peer's robes, with Garter, etc. Plumed hat in right hand.*
MEZ. BY W. GILLER, 1836.

Hardy, Daughters of Colonel Carteret. See Lysons, Mrs. Sarah, and Mrs. Price.

Harewood, Henry Lascelles, 2nd Earl of (1767–1841). Viscount Lascelles from 1814 to 1820. M.P. for York and various Yorkshire boroughs, 1796–1818. [Earl of Harewood.]
R.A. 1823 *(painted earlier). Full length, holding stick in right hand, gloves in left. Long great coat. Park background, with house on left.*
MEZ. BY TH. LUPTON, 1828.

Harford, John Scandreth (1785–1866). Biographer of Michelangelo, collector of pictures, friend of Wilberforce. Married daughter of R. Hart Davis. [Mrs. Harford, Blaise Castle.]
Facing, half length; seated, looking out. Short rough hair. Heavy coat collar and black stock.

Harford, Mrs. Louisa. Eldest daughter of R. Hart Davis, Member for Bristol. Married, 1812, to John Scandreth Harford, of Blaise Castle. [George Coats, Esq. Ex Mrs. Harford, Blaise Castle. B.I. 1830 and 1833 (lent by R. H. Davis).]
R.A. 1824. 30×25. *Half length, seated to left, head facing. Low dress with high waist. Short black jacket, thrown open. Short loose hair round face.*
ENG. BY W. H..WORTHINGTON, 1827.

Harrington, Countess of. Jane, daughter of Sir John Fleming. Married 1779. Died 1824. [M. Sigismund Bardoc, Paris. Chr. April 23, 1898, Grant Morris sale, 220gs.]
20×19. *Sketch of head.*

Harrington, Miss.
R.A. 1787. *No.* 231. " *Portrait of a Lady.*"

Harrison, Dr. Surgeon. Specialist in spinal diseases. [Miss Harrison.]
1810–15. *Seated, full face, to knees. Man of about 50, looking out. Brown hair and slight whiskers. Knee-breeches. Bunch of seals at fob. To right a table with anatomical work open at the figure of a skeleton. Books on chair to left. One entitled "De Spina Humana." Red curtain and chair.*

138

Harvey, Charles, M.D., F.R.S., F.S.A. Member for Norwich. Died 1843.
Whole length, standing, full face. Head and eyes a little to left. Cloak loosely wrapped round figure. White cravat with frill. Right hand grasping cloak. Left hand on papers on table to left.
ENG. BY CH. TURNER, 1820.

Hassan Khan, Mirza Abul. Persian Ambassador.
1810. *Half length, seated to right, looking out of picture. Black beard. Persian costume with high turban. Painted for Sir Gore Ouseley, our minister at Teheran, who took the picture with him to Persia.*
MEZ. BY JOHN LUCAS, 1835.

Hastings, Francis Rawdon, 1st Marquess of (1754–1826). Eldest son of Earl of Moira. Created Lord Rawdon 1783. Succeeded as Earl of Moira 1793. Served under Duke of York in Holland. Governor-General of India 1812–21. Created Viscount Loudoun and Marquess of Hastings 1816. [Earl of Loudoun. Guelph Exhib. 1891. S.K. 1868.]
30×24. *Half length, seated, facing, head to left. In Windsor uniform.*

Hastings, 1st Marquess of. As Lord Rawdon.
Circa 1790. *Lawrence received 25gs. for a portrait of this nobleman.*

Hastings, Flora, Marchioness of. Countess of Loudoun in her own right. Daughter of James, 5th Earl. Born 1780. Married, 1804, to Francis, 1st Marquess of Hastings. Died 1840. [Chr. June 4, 1904, Orrock sale, 1500gs.]
93×56. *Whole length. In black dress, with white shawl, leaning against a pedestal.*

Hastings, Warren (1732–1818). Went out to India in 1750 as writer in Company's service. Appointed 1st Governor-General of British India in 1774. After his return to England in 1785, impeached by House of Commons. Acquitted 1795. [National Portrait Gallery. S.K. 1867 (lent by J. P. Fearon).]
Painted 1810–11. 35½×27½. *Half length, seated, facing spectator. Bald head, scanty grey hair, heavy eyebrows. Left hand on knee grasping fingers of right. This portrait was painted for the wife of Col. Barton, Aide-de-Camp of Hastings.*
ENG. BY W. SAY, 1813, AND BY W. SKELTON.

OIL-PORTRAITS

Hatherton, Lady. See Littleton, Mrs.

Hawkesbury, Lord. See Liverpool, Earl of.

Heald, Sir George Trafford, K.C. [Chr. June, 1906.]
Circa 1810. *Panel,* 35×26¼. *To below waist, nearly facing, looking out ; arms folded. Short, roughish hair. Black coat and frilled shirt. Eyeglass hanging on breast.*

Heathcote, Sir Gilbert. 4th Baronet (1773-1851). Father of 1st Lord Aveland. [Lord Aveland. S.K. 1868.]
R.A. 1791. *No.* 385, *" Portrait of a Gentleman."* 30×25. *As a lad of 17. Bust, full face. Long black hair. Lawrence received 30gs. for a portrait of Sir G. Heathcote soon after his arrival in London. Perhaps, for a second portrait, 25gs.*

Hemming, Frederick H. [Ex Fred. H. Hemming. O.M. 1873. Lent to Birmingham in 1828 at the request of Lawrence.]
Painted 1824-5. 29×24. *This portrait and that of Mrs. Hemming were painted by Lawrence in return for certain drawings given to the painter by Mr. Hemming's uncle.*
See pamphlet by Mr. Hemming, according to which this portrait and that of his wife were to be bequeathed to the Royal Academy ; this intention, however, was not carried out.

Hemming, Mrs. Frederick. Miss Bloxam, cousin to Dr. Bloxam, of Rugby, Lawrence's brother-in-law. She was an accomplished painter on porcelain. [Ex Fred. H. Hemming, Esq. O.M. 1873. Birmingham 1828.]
Painted 1824-5. 29×24. *At the age of 17. Painted shortly before her marriage. She is represented as decorating a porcelain plate. Seated, facing, three-quarter length. Elaborate curls over head and forehead. Left hand resting on table on which is a dish of porcelain ; pencil in right. Low white dress ; jewel on bosom.*
ENG. BY T. H. GREENHEAD, 1893.

Hertford, Francis Charles Seymour, 3rd Marquess of (1777-1842). Vice-Chamberlain to the Regent, over whom he had great influence. Married, in 1798, Maria Fagnani, a great heiress, who was the mother of the 4th Marquess, the founder of the "Wallace Collection," of Lord Henry Seymour, and, long after her separation from her husband, of Sir Richard Wallace. The 3rd Marquess was the original of Thackeray's "Lord Steyne."
Circa 1825. *Half length, facing front, head turned to left. Plain clothes, with star. Head bald. High black stock.*
ENG. BY W. HOLL, 1833.

Hicks, Lady. [Henry Budge, Esq., Hamburg.]
Circa 1805. *Oval,* 27½×22¼. *To waist, facing, looking out of picture. Hair, loosely bound up, in curls over eyebrows. Necklace of large pearls. Black dress with short sleeves. Landscape background.*

Higginson, Mrs. [F. Klimberger, Paris.]
30×25.

Hill, Lord Arthur. Afterward Baron Sandys (1792-1860). Son of Marquess of Downshire. Colonel 7th Dragoon Guards. Baron Sandys on death of his mother in 1836.
1815-20. *Nearly to waist, three-quarters to right. Eyes looking out of picture. Young man in military cloak, open at neck, showing uniform. Black hair over forehead.*
ENG. BY W. SKELTON.

Hillyer, Mrs. [Messrs. Agnew.]
Circa 1795. 30×25. *To below waist. Facing, but head turned a little to right. Hair, powdered (?), in loose locks and falling over left shoulder. Fine gold chain falling in triple coil over bosom. White muslin dress with high waist.*

Hoare, Henry, of Mitcham Grove. Banker (1750-1828).
R.A. 1805. *Seated, facing, turning a little to right. Nearly full length. Spectacles in right hand. Legs, in knee breeches, crossed. Grey hair.*
ENG. BY H. MEYER.

Hoare, Prince (1755-1834). Artist and author. Hon. Foreign Secretary of Royal Academy, 1799. Wrote play of *No Song, No Supper,* 1790.
Circa 1810. *Unfinished picture. Head only. Nearly facing, eyes turned to left. Loose greyish hair. White cravat and frill indicated. Age about 60.*
MEZ. CH. TURNER, 1831.

Hobart, Lord. See Buckinghamshire, Earl of.

Hobart, Lady Emily. See Castlereagh, Viscountess.

Hodson, Rev. Septimus (1768-1833). Chaplain to Prince of Wales. Author of *Address on High Price of Provisions,* 1795. Husband of Mrs. Margaret Hodson.
Early portrait. Half length, nearly facing. In surplice. Long hair or wig, powdered and curled at side. Left hand over right in front.
ENG. BY W. SKELTON, 1790.

Hood, Hon. Lady. Mary, daughter of Francis Mackenzie, Lord Seaforth. Born 1783. Married first (1804) to Admiral Sir Samuel Hood ; second, to Right Hon. James Stewart. Died

139

SIR THOMAS LAWRENCE, P.R.A.

1862. Mother of Louisa, Lady Ashburton. [Marquess of Northampton. O.M. 1904; Grosvenor Gallery 1888.]

R.A. 1808. 93×57. Full length, turned slightly to left. Brown and red dress, cut low; fur-trimmed cloak over right shoulder. Architectural background with curtain. Lawrence took offence at the hanging of this picture and sent nothing to the 1809 exhibition.
Mez. by S. W. Reynolds.

Hope, General the Hon. Alexander (1769–1837). Second son of 2nd Earl of Hopetoun. Served in Low Countries during French war. General, and later M.P.

Painted 1810. Half length, to left, and looking out of picture. Military coat. Short rough hair. Frill of shirt front visible.
Eng. by W. Walker, 1825.

Hope, the Hon. Mrs. Thomas. Daughter of William Beresford, Lord Decies, Archbishop of Tuam. Married first to Thomas Hope of Deepdene; second, to Lord Beresford (1832). Died 1854. [The Deepdene. B.I. 1830 (lent by Thomas Hope, Esq.).]

R.A. 1826. Three-quarter length, seated, facing. Right arm over back of chair. Red gown with high waist and short sleeves. Rich gold-embroidered turban. "An Oriental Fatima "—says contemporary critic.
Eng. by E. Scriven; also (half length) by Hodgetts and by Ch. Heath, for the "Keepsake," 1835 ("Countess Beresford").

Hope, the Hon. Mrs. Thomas.

Circa 1825. Half length, seated. Head turned to left. Black velvet dress, with rose on breast. Black curls over forehead. Jewels on right arm.
Mez. by Th. Hodgetts.

Hope, Master. Charles, son of Thomas Hope, of the Deepdene, author of *Anastasius, Costume of the Ancients,* etc. Died young. [The Deepdene. B.I. 1830 (lent by Th. Hope).]

R.A. 1826. Circle. As boy Bacchus, holding grapes in left hand. Looking out of picture. Panther skin over right shoulder.
In an old catalogue of Mr. Thomas Hope's collection at Deepdene, there is also mention of a picture of " Mr. Hope's Children," by Lawrence.
Mez. by S. Cousins, 1836.

Hornby, Lady Charlotte (1776–1805). Eldest daughter of 12th Earl of Derby. Married, 1796, to Edmund Hornby, of Dalton Hall. [Earl of Derby. S.K. 1868.]

1795–1800. 30×25. To waist, seated, looking to right. Leaning on right hand which touches the face. Open white dress. White band round powdered hair.

Hornby, Charlotte. See Stanley, Lady.

140

Hornsby, Mr. (? Hornby.)
1792–6. Lawrence received 40gs. for a portrait of " Mr. Hornsby."

Hornsby, Miss (? Hornby). This is perhaps the lady who became later Lady Charlotte Stanley, q.v.
1792–6. Lawrence received 40gs. for a portrait of " Miss Hornsby."

Howden, John, 1st Baron (1762–1839). As General Sir John Cradock, or Caradock. Commander-in-Chief in Madras. Served during French war. Created Baron 1819.

Three-quarter length. Looking out of picture; left hand resting on sword. Military uniform. Short rough hair. Pyramid to left.
Mez. by W. Say, 1805.

Howley, William (1766–1848). Archbishop of Canterbury. Bishop of London 1813–28. Archbishop, 1828–48.

R.A. 1816. When Bishop of London. Seated, turned slightly to left, head turned to right. Holding paper in lap. Lawn sleeves and bishop's wig. (There was a portrait of the Archbishop of Canterbury in the Lawrence sale, June, 1831.)
Mez. by Ch. Turner, 1817.

Humboldt, Karl Wilhelm, Baron von (1767–1835). Famous savant and diplomat. Born at Potsdam. Represented Prussia, with Hardenburg, at the Vienna Congress. Ambassador in London, 1818. [? Windsor Castle.]

Circa 1817. Standing, facing slightly to left. Dark red velvet suit. The portrait in the Waterloo Gallery appears to be a studio replica. Waagen, who knew Humboldt, declares that Lawrence, being in a hurry, painted Humboldt's head on a body meant for Lord Liverpool !

Hunt, Sidney, the Younger. [Ex Comte de Ganay. Sold Amsterdam, 1906.]

Oval, 14×12. Boy of 7 or 8 years. Bust, three-quarters to right, looking more to right. Blond hair and blue eyes, retroussé nose. Large loose white collar.
Photo in Ganay Catalogue; ascription doubtful.

Hunter, H. L. East India Director.

R.A. 1789. " Portrait of a Gentleman." Lawrence received 30gs. for this portrait. No. 5 in Catalogue for 1799 is also entitled " Mr. Hunter," but this was a mistake for Allnutt, q.v.

Hunter, Mr. [Messrs. Sulley. Chr. February, 1911, n.n.; 350gs.]

Circa 1790. 50×40. Nearly to knees. Seated on a crimson chair. Looking round with smile. In brown coat, white vest and stock. Holding glove and letter. Perhaps to be identified with the preceding.

OIL–PORTRAITS

Huntingford, Dr. George Isaac (1748–1832). Bishop of Gloucester, 1802–15; of Hereford, 1815–32. Clerical and political writer. Warden of Winchester College.

R.A. 1805. Nearly full length, seated, turned to right. Head bent and looking round and up. Elbows resting on table and arm of chair. Bishop's robes. Church partly seen in background.

ENG. BY JAMES WARD, 1807.

Huskisson, William (1770–1830). Statesman. Member of various ministries between 1795 and 1829. One of the early Free Traders. Killed by accident at the opening of the Liverpool and Manchester Railway. [Sir Robert Peel, Bart. B.I. 1833. Graves' Gallery, 1908.]

Painted (in 1829 ?) for Sir Robert Peel. Nearly half length. Facing, and looking round to right. Scanty dark hair over forehead. Brown cape over shoulder, open in front, and grasped by right hand. Plain brown background.

ENG. BY W. FINDEN, 1831.

Hutchinson, Mrs. [Ex G. P. Fripp, Esq.]

30×25. Seated to right, in crimson chair. Black dress and veil; white cap, with ruffles round neck and wrists.

Inchbald, Mrs. Elizabeth. Actress, novelist, and dramatic writer. *Née* Simpson. Married Samuel Inchbald, an actor, 1772. Appeared at Covent Garden 1780. Died 1821, aged 68.

Early portrait. Bust, facing, head a little on one side; in turban, from which long curls escape. High waist.

ENG. BY S. FREEMAN, 1807.

Inchiquin, Murrough O'Brian, 5th Earl of. Later 1st Marquess of Thomond. Intimate friend of Burke and Reynolds. Married Miss Palmer, the niece of latter. Died 1808. [National Gallery of Ireland.]

R.A. 1797. No. 148, as " Portrait of a Nobleman." 55×42. Three-quarter length, standing. Black dress with ribbon of St. Patrick.
Two portraits of the Marquess of Thomond, one of them unfinished, were in the Lawrence sale, June, 1831. These may possibly have been of William, the second Marquess, who succeeded to title in 1808.

Inchiquin, Countess of. Afterwards Marchioness of Thomond (1750–1820). Mary Palmer, niece of Sir Joshua Reynolds. [Lady Colomb. Agnew's Gallery, 1910.]

R.A. 1795. No. 175. 35×27. Facing, to knees, right elbow on pedestal. Turban bound loosely round head by two fillets. Transparent veil over right shoulder.

ENG. BY W. BOND.

Inchiquin, Countess of. [Louvre. Sold at Christie's,; February, 1903, as " Mrs. Siddons."]

1795–1800. Half length, facing, looking out. Left arm resting on back of chair. Brown hair bound high over head, with locks over forehead. Large dark eyes. Yellow dress crossed over bosom ; green sash.

Inverness, Duchess of. See Murray, Lady Augusta.

Jebb, Dr. John (1775–1833). Bishop of Limerick. Made Bishop 1822. Defended Irish Establishment in House of Lords, 1824. Pioneer of Oxford Movement.

Painted 1826. At the age of 51. Seated to left, looking left ; natural short hair. Right arm on side of chair. Holding spectacles. In bishop's robes.

MEZ. BY TH. LUPTON, 1830.

Jekyll, Joseph, M.P., F.R.S. (1752–1837). Master in the Court of Chancery. Wit and politician. Whig pasquinader. Restored the Temple Church. Solicitor-General to the Prince of Wales.

R.A. 1817. Half length, to right, stooping and looking out of picture. Old man, with natural grey hair. White cravat, tied in loose knot.

MEZ. BY W. SAY, 1818.

Jennings, Elizabeth. See Locke, Mrs.

Jenner, Edward, M.D., F.R.S. (1749–1823). Discoverer of vaccination. Pupil of John Hunter. First vaccinated with cow-pox 1796. [Ex Miss Baron, of Cheltenham.]

Bust, to right, looking round and out of picture. Natural hair, one lock falling over forehead ; white cravat ; large coat collar.

LITHO. BY J. H. LYNCH.

Jersey, George Child Villiers, 5th Earl of (1773–1859). Succeeded to Earldom 1805; Lord Chamberlain 1830. [Earl of Jersey, Middleton Park. S.B.A. 1831.]

98×57½. " The head by the late Sir Thomas Lawrence." Finished since his death by J. Simpson " (S.B.A. Catalogue). Full length, in a room, almost full face. Earl's robe over black coat. The extended right arm lifts robe and shows the white lining. Folded paper in left hand. White scroll lies on chair.

Jersey, Sarah Sophia, Countess of. Daughter of John, 10th Earl of Westmorland. Granddaughter and heiress of Robert Child, of Osterley Park.

141

SIR THOMAS LAWRENCE, P. R. A.

Married 1804. Died 1867. Intimate friend of George IV. [Earl of Jersey, Middleton Park. O.M. 1895.]

R.A. 1823. 93 × 57. Full length, in landscape, standing to right. Low-cut yellow dress with short puffed sleeves. Red scarf over right arm. In left hand, which holds up skirt, showing left ankle and white satin shoe, she carries a large black hat with feathers. Bracelet on left arm.

Jersey, Julia, Countess of. See Peel, Miss.

Jessop, Mrs. See Siddons, Maria

Johnson, Mr.

Circa 1790. Lawrence received 15gs. for a portrait of this gentleman soon after he came up to London.

Jordan, Mrs. (Dorothy Bland) (1762–1816). Actress. Appeared first in Dublin, and in 1785 at Drury Lane. For many years the mistress of the Duke of Clarence, afterwards William IV, to whom she bore many children. Went to France 1815, and died at St. Cloud. Had some correspondence with Lawrence. [Rev. Jos. Thackeray. S.K. 1868.]

36 × 28. Half length, standing, to right. High dark dress with short slashed sleeves.

Jordan, Mrs. (?). [E. Fischhof, Paris, from the Bentley family, West Bilney Hall, Norfolk.]

Circa 1800. 23 × 20. Bust, facing, looking out. Hair, bound by fillet, falling in short black curls over eyebrows. White dress, crossed over bosom.

Keith, Lady.

Lady Keith, writing to Lawrence (May 16, 1821), complains of the long delay in completing her portrait that was begun fifteen years before.

Kelly, Michael (1764 (?)–1826). Actor and singer. Studied in Italy, and sang at Florence and Venice. Later prepared by Glück and Mozart. Sang in operas at Drury Lane 1787–1808. Musical director at Drury Lane. Wrote settings for Sheridan's plays.

1787. Oval, in feigned frame. Seated, half length, to right, looking round and out. Arms crossed. Powdered hair, fluffed out. High-collared coat. Lawrence received 15gs. for a portrait of " Mr. Kelly " soon after his arrival in London in 1787.

SMALL ENG. BY NEAGLE, " from a painting by Lawrence " (" General Magazine," 1788).

Kemble, Frances, sister of Mrs. Siddons. See Twiss, Mrs.

142

Kemble, Frances Anne (1809–93). " Fanny Kemble," daughter of Charles Kemble. Appeared at Covent Garden in 1829 as " Juliet." Married, 1834, to Pierce Butler, whom she divorced 1848. Lived long in America. Wrote *Recollections of a Long Life.*

F. K. was painted by Lawrence in 1829. At the Blakeslee sale in New York, April 11, 1902, a portrait described as " Fanny Kemble " was sold for £593 15s. A portrait (23½ × 20½) described as " Mrs. Kemble " is in the Wanamaker Collection at Philadelphia. Half length, full face ; large hat with feathers.

Kemble, John Philip (1757–1823). Son of Roger Kemble, manager of an itinerant company of actors. Educated at Douai. First appeared in London, 1783, as " Hamlet." Retired from stage 1817. Brother of Mrs. Siddons and Charles Kemble. [Mr. Blakeslee. Chr. 1895.]

R.A. 1797. No. 188. 55½ × 44. " Portrait of a Gentleman." Seated at a table, nearly full length. Looking up to right. Natural hair, short. Knee-breeches, white cravat.

MEZ. BY W. SAY, 1814.

Kemble, John Philip, as " Rolla," in Sheridan's *Pizarro*. [Ex Sir Robert Peel, Bart. B.I. 1806 and 1844. " Peel Heirlooms " sale, May, 1900.]

R.A. 1800. 132 × 88. Theatrical attitude. Dagger in right hand, child in left. Panther skin over shoulder. (See " Pizarro," Act 5, Scene 2.) Painted over his " Prospero " of 1794. The body of Rolla said to have been painted from Jackson, the prize-fighter, and the child from Sheridan's infant son.

ENG. BY S. W. REYNOLDS, 1803.

Kemble, John Philip. As " Coriolanus " at the hearth of Tullus Aufidius. [Guildhall, presented by Earl of Yarborough. Ex Sir Richard Worsley. B.I. 1845 and 1849.]

R.A. 1798. Full length, standing on steps, wrapped in black toga. Looking up to right. Smoke and flames behind on left. There is a small replica (32 × 17) in the V. and A. Museum (Dyce Collection).

MEZ. BY R. M. MEADOWS, 1805.
.. W. C. BURGESS, 1839.

Kemble, John Philip, as " Hamlet." [National Portrait Gallery, deposited by National Gallery, to which the picture was presented by William IV in 1836.]

R.A. 1801. 117½ × 57½. Graveyard scene. Full length, standing. Skull in left hand. Towers of Elsinore to right.

MEZ. BY S. W. REYNOLDS, 1805.
.. J. BROMLEY, 1834 ; and others.

OIL-PORTRAITS

Kemble, John Philip, as "Hamlet."
[Mrs. Ewart, Guildford.]
To below waist, standing. This is the portrait painted in place of the one with too long legs. (See letter from Miss Day.)

Kemble, John Philip, as "Hamlet."
[Lent by Sir Th. Baring to B.I. 1830.
Chr. 1848, Sir Th. Baring, 50gs.]
Small replica of the large picture.
Another large portrait of J.K. as "Hamlet" was at the R.A. in 1804 and the B.I. in 1806.

Kemble, John Philip, as "Cato," in Addison's play. [Garrick Club (?).
Exd. Dublin, 1829. B.I. 1830.]
R.A. 1812. 132×96 (? including frame). Seated to right, in heavy classical chair. Large scroll open on knees. Left foot on stool. Roman costume.
MEZ. BY W. WARD.
 „ S. W. REYNOLDS, JUNR., 1841.
ENG. IN SMALL BY A. GREATBATCH (" Amulet." 1833).

Kemble, John Philip. [Sir Hugh P.
Lane, Guildhall, 1902. Whitechapel,
1906.]
1790 (?). 30×25. Bust, facing, head three-quarters to right. Powdered hair. Large white cravat.

Kemble, John Philip.
Half length, facing, looking out of picture. Short natural hair. White cravat, tied in bow.
SMALL MEZ. BY CH. TURNER, 1825.

Kemp, Thomas Read (1781(?)-1844).
M.P. for Lewes. Builder (*c.* 1820)
of Kemp Town, Brighton. Founder
of a religious sect. Married daughter
of Sir Francis Baring.
Circa 1810. Nearly to knees, to right. Head turned round, looking out of picture. Young man ; short natural black hair. White cravat.
ENG. BY TH. ILLMAN, 1812.

Kent, Victoria, Duchess of (1786–1861). Daughter of Duke of Saxe-Coburg. Married, first, to Prince of Saxe-Coburg ; second, to the Duke of Kent. Mother of Queen Victoria.
Circa 1825. Half length, standing, three-quarters to left. Huge black hat with white feathers. Black hair over brow. Ear-ring of pearls.
MEZ. BY S. W. AND W. REYNOLDS, as "A German Lady."
A portrait group of a lady with a boy and girl, doubtfully called "The Duchess of Kent, by Lawrence," sold Christie's, April 27, 1901, for 560gs., is more probably by G. H. Harlowe.

Knight, Richard Payne, M.P.
(1750-1824). Visited Sicily in 1777
with the German painter Hackert.
His diary translated and published by

Goethe. M.P. 1780-1806. Wrote on
classical art. Bequeathed his collection of bronzes to British Museum.
R.A. 1794. No. 181. " Portrait of a Gentleman." Of this portrait " Pasquin " said " that it fills one with the idea of an irascible pedagogue explaining Euclid to a dunce."

Knight, Richard Payne, M.P.
[A. R. Boughton Knight, Downton
Castle.]

Knight, Richard Payne, M.P.
[Dilettanti Society. B.I. 1846 ; S.K.
1868.]
Circa 1810. Half length, seated, turning to right. Short hair brushed back. Fur-lined coat. White cravat tied in bow.
ENG. BY E. SCRIVEN, 1811.
MEZ. BY J. BROMLEY.

Knighton, Sir William, Bart., M.D.
(1776-1836). Keeper of Privy Purse
to George IV. Physician to George IV.
when Regent. Assisted George IV. in
business affairs. A man of great ability who acquired much influence at
Court. Showed considerable acumen
as a collector of pictures.
R.A. 1823. Half to three-quarter length, a little to left, looking out of picture. Curly, natural hair. Coat with velvet collar. Black stock. Seen by Waagen at Blendworth Lodge, Hants.
ENG. BY CH. TURNER, 1823.
MEZ. BY S. COUSINS.

Kynnersley, Mrs. Rosamund, daughter
of Sir Wolstan Dixie, Bart., second
wife of Clement Kynnersley, Esq.
[Norman Forbes-Robertson, Esq. Chr.
June 16, 1911. " Property of a Nobleman." 1700gs.]
1798. 29½×24½. To below waist. Facing, head turned to left. Brown hair, powdered ; dark eyes. In white dress, with black sash and grey gauze scarf. Hair bound with white ribbons tied in bow over top of head. Loosely painted.

Labouchere, Henry and John.
Sons of Peter Cæsar Labouchere.
Henry (1798-1869). Became later
1st Lord Taunton. John, the younger
brother, was the father of the late Mr.
Henry Labouchere, M.P. for Northampton. [Formerly at Stoke Park,
Slough.]
R.A. 1811. Two boys of about 12 and 10 years. The elder standing, resting elbow on table ; the younger seated on sofa. Globe to left.
ENG. BY C. W. WASS.

143

Lamb, Lady Caroline (1785–1828). Only daughter of 3rd Earl of Bessborough. Married, 1805, to William Lamb, afterward Lord Melbourne. Separated from husband 1825. Infatuated with Byron. Wrote novels. [Ex Hon. Claude Ponsonby. Chr. March, 1908 ; 310gs.]

1810–15. 21×18½. *Head and neck appearing above clouds. Head inclined a little to right, but full face looking out. Hazel eyes. Brown hair in short, rough curls.*

Lamb, Hon. Amelia, "Emily" (1787–1869). Daughter of the 1st Lord Melbourne. Married first to 5th Earl Cowper (1805); second, to Lord Palmerston (1839). [Countess Cowper. Ex Lady Edith Ashley. B.I. 1830 and 1843.]

R.A. 1803. *" The Hon. Miss Lamb " (R.A. Catalogue). Sketch of head and shoulders, seen from behind left shoulder. Head so turned as to be three-quarters facing. Hair loosely bound. White dress, coral necklace.*

Lamb, Hon. Harriet and Amelia. Children of 1st Viscount Melbourne. Harriet died young, for Amelia see above. [CountessCowper,Panshanger.]

R.A. 1792. *No.* 513. *Little girls in white frocks and pink sashes. Harriet has a cap in her hand. Shortly after his arrival in London, Lawrence received 40gs. for a portrait of Lord Melbourne's children. Lady Palmerston remembered her first sight of the painter as " a young man in black," who came in upon the children as they were romping on the floor and playing with a cap (Panshanger Catalogue).*

Lamb, Hon. William. See Melbourne, 2nd Viscount.

Lambton, Lady Louisa. See Durham, Baroness, and also Grey, Countess.

Lambton, "Master" (1818-31). Charles Wilson, elder son of John George Lambton, M.P., created Earl of Durham (1833). [Earl of Durham. B.I. 1830 ; Manchester 1857 ; S.K. 1868 ; O.M. 1895 and 1904.]

R.A. 1825. 54×44. *Boy of 6 or 7 ; full length, seated on rock, resting his head on his left hand. Crimson velvet dress, open at the neck. Moon to right.* MEZ. BY SAMUEL COUSINS, 1827, and many later prints.

Lambton, Master. [H. Cavendish, Esq. " Fair Children," 1895.] *Original sketch for Lord Durham's picture.*

Lambton, Lady Louisa. See Durham, Countess of.

144

Lansdowne, Henry, 3rd Marquess of (1780–1863). Chancellor of the Exchequer under Grenville, 1806. Marquess, 1809. Married, 1808, daughter of Earl of Ilchester. [Marquess of Lansdowne. B.I. 1830 ; S.K. 1868.]

Circa 1815. 55×43. *Standing, nearly to knees, facing. Head to right, left arm resting on parapet. White waistcoat showing below buttoned swallow-tailed coat with heavy collar.* MEZ. BY J. BROMLEY, 1831.

Lansdowne, Henry, 3rd Marquess of. [Marquess Camden. B.I. 1830.]

Lansdowne, Lady Louisa Fox-Strangways, Marchioness of. Wife of 3rd Marquess of Lansdowne. Fifth daughter of 2nd Earl of Ilchester. Married 1808 ; died 1851. [Marquess of Lansdowne.]

R.A. 1803. 41×32. *Seated, nearly full face. Black curls falling over temples. Crimson silk dress. White shawl over back of chair.*

Lascelles, Lord. See Harewood, Henry, 2nd Earl of.

Lauderdale, Lord. Probably James, 8th Earl of Lauderdale (1759-1839). Succeeded to Earldom 1789.

Circa 1790. *Lawrence received 25gs. for a portrait of this nobleman shortly after his arrival in London.*

Lauther, Sir Charles. [Ex Roussel Collection. Paris, March, 1912, £4640.] *Attribution to Lawrence doubtful.*

Law, Mr. *Lawrence received 30gs. for a portrait of Mr. Law about 1790.*

Lawrence, Rev. Andrew. Elder brother of the painter. *R.A.* 1790. *No.* 260. *" Portrait of a Clergyman."*

Lawrence, Sir Thomas, P.R.A. (1769–1830). [Royal Academy of Arts. S.K. 1868; Guelph, 1891 ; O.M. 1904. Bought at the Lawrence sale, Chr. 1831, by Earl of Chesterfield for 470gs. Lent by him to B.I. 1833, and to Manchester 1857. From him it passed into possession of the R.A.]

35×25. *Half length, facing, looking out of picture. Bald head, high stock, head and neck only finished. A copy of Richard Evans is in the National Portrait Gallery.* MEZ. BY S. COUSINS, 1831 (dedicated to the King, by John Meredith, Lawrence's brother-in-law). Several later engravings.

OIL–PORTRAITS

Lawrence, Sir Thomas. [Royal Collections. Lent by the King to the B.I. 1830.]
Lawrence in a letter to Canova (1816 or 17) promises to send him his portrait. At the same time he says that although his hair is now scant and grey, he has not painted his own portrait or been painted by another artist since he was a boy.

Lawrence, Sir Thomas. [Ex J. Meredith (his brother-in-law). B.I. 1830. Chr. July 5, 1900. C. R. Aston.]
1786. 23 × 19¼. In feigned oval. Bust, to left. Looking round and out, with flowing hair. Dark red coat, white stock. " As a young man, his first attempt at oil painting " (B.I. Catalogue). Writing to his mother. Sept., 1786, he says, " I am now painting a head of myself in oils, and I think it will be a pleasure to my mother to hear it is much approved of."

Lawrence, Sir Thomas.
A portrait of Lawrence, by himself, was lent to the Winter Exhibition of the S.B.A. in 1832.

Lawrence, Sir Thomas.
A cast of Lawrence's face, made at the age of 34, was lithographed in three positions by R. T. Lane.
A portrait of Lawrence, by Jackson, belongs to Mr. Beaumont de Klein.

Layard, Mrs. Brownlow Villiers. [Lieut.-Col. Layard.]
Circa 1800. Bust, three-quarters to right. Head nearly facing and eyes looking out. Dark hair falling over forehead. Dark dress only indicated.

Le Breton, Sir Thomas (1763–1838). Attorney-General 1802, and Bailly of Isle of Jersey 1826. [Oxford, Pembroke College, presented by his granddaughters, 1882. Hist. Portraits, Oxford, 1906.]
Circa 1825. 49 × 39. To knees, standing, facing, head turned a little to left. Right hand resting on book inscribed " Records of Isle of Jersey." Short grey hair. Tight-buttoned dress coat, with full collar. Sea seen through window on right.
MEZ. BY C. TURNER, 1827.

Leeds, Francis Godolphin, 5th Duke of (1751–1799). Married Amelia, daughter of Earl of Holderness. Secretary of State for Foreign Affairs. [Duke of Leeds.]
R.A. 1796. " No. 103, Portrait of a Nobleman," in R.A. Catalogue. Standing, full length, in court dress, with Garter, etc. Hat under right arm. Castle walls to left. Dark background. " A present to the Duchess from the staff of the Foreign Office on the Duke's resignation."
ENG. BY R. M. MEADOWS, 1792.

Leeds, Francis Godolphin, 5th Duke. [Lord Yarborough, Brocklesby Park.]
Full length.

10

Legge, Hon. William (1784–1853). At Eton 1797–1802. Succeeded to his father in 1810 as 4th Earl of Dartmouth. D.C.L., F.R.S. [Provost's Lodge, Eton College.]
1802–3. Oval. 27 × 23. Lad of 16 to 18. To waist, facing; head a little to right, looking to right. Hair low over forehead. Red coat with high collar, loosely buttoned. Large white choker.

Leicester, Earl of. See Coke, Thomas W.

Leicester, Georgiana Maria, Lady (1794–1859). Daughter of Colonel Cottin (?). Married, 1810, to Sir John Leicester, later (1826) Lord de Tabley. [Lord de Tabley. Manchester 1857.]
R.A. 1814 (with quotation from " Faery Queen "). 94 × 56. As " Hope " holding the " Dew-branch " in her hand. Full length, tripping forward, amid clouds. Simple yellow dress, with arms and shoulders bare. Naked Amorini to right and left.
ENG. BY MEYER, 1823 ; BY E. MACINNES ; ETCHED BY YOUNG in the " Leicester Gallery," 1821.

Leitrim, Mary, Countess of, and her daughter. Daughter of William Bermingham. Married to the 2nd Earl of Leitrim. Died 1840. [Lent by Countess of Leitrim to the O.M. 1904.]
Circa 1810. 54½ × 43½. Three-quarter length, seated in red chair, facing. With both hands she holds the child who kneels partly on her lap, partly on chair, with head on mother's shoulder, looking round. Low cut white dress. Black shawl over shoulder.
ENG. BY H. SCOTT BRIDGWATER.

Lennox, Miss. See also Apsley, Lady. [Earl Bathurst ?.]
1788 ? Lawrence received 25gs. for a portrait of " Miss Lennox " about the time of his first settling in London. The sitter was probably the Miss Georgina Lennox whom Lord Apsley married in 1789. The portrait is probably No. 232 in the R.A. of that year.

Lennox, Lady Louisa. Third daughter of 2nd Duke of Richmond ?
1785–90. Lawrence received 15gs. for a portrait of this lady about the time of his first settling in London or earlier.

Lennox, Lady Mary. Eldest daughter of 4th Duke of Richmond. Married, 1820, Sir Charles Fitzroy. Died 1848. [Earl Bathurst. O.M. 1904.]
29 × 24. Half length, less than life-size. Seated to right in landscape, her arms resting on lap. White dress with blue sash.

145

SIR THOMAS LAWRENCE, P.R.A.

Lennox, Lady Mary. [Earl Bathurst.]
Similar to above but with white sash.
Another similar portrait in the possession of Mr.
Windham Baring is unfinished—the hair being only
indicated.

Leopold, Prince, of Saxe-Coburg
(1790–1865). Son of Duke of Saxe-
Saalfeld-Coburg. Married Princess
Charlotte of Wales, 1816; King of the
Belgians, 1831. [H.M. the King of
the Belgians. B.I. 1830.]
1817. *Full length, standing. Plumed hat in left hand.*
In robes. Painted as a birthday present from Princess
Charlotte to the Prince. A studio copy was made for the
Regent, which is probably the picture now in the Waterloo
Gallery, Windsor Castle.

Lethbridge, Sir F. B. [J. T. Blakes-
lee, New York.]
Circa 1810. 30×25. *Half length, facing, looking to*
left. Short rough hair. High black stock. Military coat
with epaulettes.

Lethbridge, Lady. [J. T. Blakeslee,
New York.]
Circa 1810. 30×25. *Half length, facing. Head a*
little to right and looking up. Dark hair falling over
forehead. High waist and short sleeves.

Libromiski, child of Count.
Painted at Aix-la-Chapelle or Vienna in 1818–19.
Oil sketch. " Three-quarter length."

Lieven, Princess. Dorothea von Benc-
kendorf (1785–1857). Married Prince
Lieven, Russian Ambassador to Eng-
land, where, for twenty-one years, she
played an important part in politics and
society. Intimate friend successively
of Lord Grey, Prince Metternich, and
Guizot. [National Gallery, bought
with Peel Collection, in 1871. Chr.
1850.]
18×15. *Head, turned to right. Probably the " Por-*
trait of the Princess Lieven, head only" of the Lawrence
sale, 1831.

Lieven, Princess.
A portrait of this lady, " full length, in a cloak," pre-
sumably an unfinished oil picture, was in the Lawrence
sale, June, 1830.

Limerick, Bishop of (1822–31). See
Jebb, Dr.

Linley, William (1771–1835). Son of
Thomas L., the composer, and brother
of Mrs. Sheridan. Author of "Dra-
matic songs of Shakespeare." [Dul-

146

wich Gallery, Linley Bequest. B.I.
1833; O.M. 1904.]
R.A. 1789 ? 29¼×24¼. *As a youth. Half length,*
head three-quarter to right. Long black hair falling over
shoulders. White cravat. Probably identical with the
" Mr. Linley, brother of Mrs. Sheridan," of the R.A.
Catalogue for 1789.
MEZ. BY T. LUPTON, 1840.

Linley, William. Botanist (?). [Berlin,
Kaiser Friedrich Museum. Presented
by Count Seckendorf, 1905.]
About 1810. Seated, to below waist, nearly facing,
head turned three-quarters to left. Man of about 60 with
spectacles ; greyish whiskers ; roughish thin hair.
High white stock and high-collared black dress coat.
See" Burlington Mag." for April, 1905. Ascription doubt-
ful.

Litchfield, Hon. Mrs. [Chr. July 9,
1904, 230gs.]
29×27. *In white dress with coloured scarf over*
shoulder.

Littleton, Mrs. Hyacinth Mary.
(Died 1849.) Natural daughter of
Marquess Wellesley. Married John
Littleton, M.P., who was created Baron
Hatherton in 1835. [Lord Hatherton.
B.I. 1830.]
R.A. 1822. *In feigned oval. Seated to right, head*
turned to left. Low white dress with full sleeves bound
above elbows by jewelled band. Right arm outstretched
to hold portfolio. Dark hair, loose bound over forehead.
ENG. BY CH. TURNER, 1827.

**Liverpool, Robert Banks Jenkinson,
2nd Earl of** (1770–1828). M.P. for
Appleby 1790; succeeded his father
1808; First Lord of the Treasury
1812–27.
Circa 1795. *Painted when Lord Hawkesbury. Three-*
quarter length, standing. Right hand on hip, left
holding paper. Documents and writing materials on
table to right.
MEZ. BY INIGO YOUNG, 1801.

Liverpool, Robert, 2nd Earl of.
[Windsor Castle, Waterloo Gallery.
B.I. 1830; S.K. 1868.]
1815–20. 55×46. *Three-quarter length, standing*
to left. Hands loosely clasped in front. Looking out of
picture. Black civilian costume, with star of Garter.
White cravat tied in bow.
ENG. BY CH. TURNER, 1827.

Liverpool, Robert, 2nd Earl of.
[Marquess of Bristol, Ickworth. O.M.
1904.]
Circa 1825. 49¼×39¼. *Nearly to knees. Standing,*
to left, hands clasped in front. Black clothes with Garter
star. Curtain background. Packet of letters on table to
right. Similar to Windsor portrait.

OIL–PORTRAITS

Liverpool, Robert, 2nd Earl of. [Sir Robert Peel. B.I. 1830. Graves' Gallery, 1908.]
R.A. 1827. Full length, facing, looking out with half-jaunty expression. Left arm outstretched and hand resting on upright roll of paper (inscribed " Nat. Gallery —R. Academy "). Right arm akimbo, holding gloves. Scanty greyish hair and whiskers. Long black coat.

Liverpool, Robert, 2nd Earl of. [Earl of Liverpool?]

Llandaff, Bishop of (1782–1816). See Watson, Dr. Richard.

Locke, The Rev. George. Vicar of Lee. [Chr., Angerstein Trustees, July 14, 1896.]
35×27. Seated. In black coat.

Locke (or Lock), William (1732–1810), of Norbury Park. Formed a collection of works of art in Rome. Built a house at Norbury 1775. Friend of Reynolds, Fanny Burney, etc. His daughter Amelia married John Angerstein. [Ex Angerstein Collection. Chr. July 14, 1896, also December 4, 1897; 210gs. (? bought in).]
R.A. 1790. No. 19. " Portrait of a Gentleman " in R.A. Catalogue, with MS. note " Mr. Locke the Antiquary." 30×25. In grey coat, with powdered hair. Said to have been painted at a single sitting.

Locke, William (1767–1847). The son of the antiquary.
R.A. 1791. " 140. Young Mr. Locke. The best portrait in the exhibition. The tone of the background is very grand and uncommon " (" St. James' Chronicle ").

Locke, Master William (1804–32). Son of William L. the second. Married Selina, daughter of Admiral Tollemache. Captain in Life Guards, and amateur artist. Drowned in Lake of Como. [Lord Wallscourt. New Gallery, 1897.]
R.A. 1814. 50×39. Full length figure of a little boy with curly hair—wearing shirt only. Playing with St. Bernard dog. Rocky landscape.
ENG. BY W. HUMPHREYS in " Bijou " for 1828.

Locke, Mrs. Elizabeth, daughter of Mr. Jennings Noel. She was a famous beauty. She married the second William Locke of Norbury, and was mother of William L. the third, and of

Lady Wallscourt. [Messrs. P. & D. Colnaghi. Ex Lord Wallscourt.]
R.A. 1799. As Miss Jennings. 93×58. Full length, facing. Right hand under breast. Black dress, coral necklace, landscape background. Much praised by critics of the time, although one complains that " the lady appears to be scratching her arm !" Miss Croft says she first met Lawrence at Dr. Heathcote's, whose niece, Miss Jennings, he was then painting.

Locke, Mrs. Elizabeth Jennings, wife of second William L. [M. Eugène Fischof, Paris. Ex Lord Wallscourt. Chr. May, 1911, 2250gs.]
50×40. To below waist, standing ; full face, arms folded ; brown hair low over forehead. Rose-coloured dress with blue sash, coral necklace, scarf of striped gauze. Apparently a fancy costume, as priestess. Smoke arising from bowl to right. Background of sky and rolling clouds.

Locke, Mrs. (Elizabeth Jennings).
At the Lawrence sale in 1831 a portrait of " Mrs. William Locke, unfinished " sold for £5 10s.

Locke, Mrs. (Elizabeth Jennings). [Lady Walsingham. Fair Women, 1894.]
Oval. Bust, nearly facing ; eyes looking round to left. Pearls round neck. Hair loosely bound up over forehead.

Locke, Mrs. (Elizabeth Jennings). [W. Angerstein. B.I. 1851; O.M.1881. Chr. 1896, Angerstein sale, 1350gs.]
R.A. 1829 ? Panel. 30×24½. Half length, seated in red chair, hands crossed ; black dress, large white cap. White frill round neck. Flowers in front. Perhaps to be identified with the " Mrs. Locke, Senr. (the late)," in the R.A. 1829, No. 455.

Locke, Elizabeth. Daughter of second W. Locke. See Wallscourt, Lady.

London, Bishop of (1813–28). See Howley, William.

Londonderry, Charles Stewart, 3rd Marquess of (1778–1854). Half-brother of 2nd Marquess. Served in the French war as General the Hon. Sir Charles Stewart. As Lord Stewart Ambassador in Vienna during Congress. Marquess, 1832. [Marquess of Londonderry, Londonderry House.]
R.A. 1811 ? 30×25. Nearly in profile, to right.

Londonderry, Charles Stewart, 3rd Marquess of. [Marquess of Londonderry, Londonderry House.]
R.A. 1813. 50×40. Three-quarter length, standing ; slightly to right ; eyes to left. Hussar uniform, holding sword by scabbard over right shoulder. Talavera medal and star.
ENG. BY H. MEYER, 1814.

147

SIR THOMAS LAWRENCE, P.R.A.

Londonderry, Charles Stewart, 3rd Marquess of. [Marquess Camden. B.I. 1833.]
Lawrence painted a "three-quarter length" of Lord Stewart in Vienna, 1818–19.

Londonderry, Henry Robert Stewart, 2nd Marquess of. See Castlereagh, Viscount.

Londonderry, Amelia Anne, wife of 2nd Marquess of. See Castlereagh, Viscountess.

Londonderry, Catherine, wife of 3rd Marquess. See Stewart, Lady Catherine.

Londonderry, Frances Anne, Marchioness of, and her son, Lord Seaham. She was the daughter of Sir Harry Vane Tempest. Married 1819, as second wife, Charles, 3rd Marquess, and died in 1865. [Marquess of Londonderry. B.I. 1830.]
R.A. 1828. About 100×60. Full length, on steps of colonnade. Right hand extended over head of boy who runs in front, looking round. Low dress of black velvet, with long train. Hair high. Landscape to left.
ENG. BY CH. ROLLS for "Amulet" of 1832.

Londonderry, Frances Anne, Marchioness of. [Ex Marquess of Londonderry. B.I. 1830. Chr. 1907.]
1820 ? 30×25. Half length, seated. Hair in short curls on top of head. Low white satin dress with high waist and short sleeves. Left elbow on table, the hand lifting chain with keys.
ENG. BY J. COCHRAN, 1826.
A portrait of "Lady Londonderry" was sold at the Hôtel Drouot in December, 1905, for 29,500fs.

Londonderry, 4th Marquess of. See Stewart, The Hon. Frederick.

Londonderry, 5th Marquess of. See Seaham, Viscount.

Londonderry, Child of 3rd Marquess of. See Seaham, Viscount.

Long, Mr.
1785–90. Lawrence received 20gs. for a portrait of this sitter about the time of his settling in London.

Long, Charles. See Farnborough, Lord.

Long, Mrs. E. [Ex Judge Pitt-Taylor. Chr. June 22, 1901 ; 102gs.]
30×25. Half length, three-quarter face. Seated looking to right. In white dress.

148

Long, Lady Jane.
R.A. 1796. "No. 102, P. of a Lady of quality" in R.A. Catalogue. "Represented in a rural character—very clear and crisp in the touch," says a contemporary critic. Lawrence received 25gs. for a portrait of Lady J. Long about 1793.

Lonsdale, William, 1st Earl of (1757–1844). Sir William Lowther succeeded his third cousin as Viscount Lonsdale in 1802. Raised to Earldom in 1807. Friend of Wordsworth. [Earl of Lonsdale.]
R.A. 1812. Seated, to knees, turning slightly to left. Left elbow on table. Black coat, with ribbon.
MEZ. BY CH. TURNER.

Lonsdale, Augusta, Countess of. Daughter of John, 9th Earl of Westmorland. Married, 1781, to William, 1st Earl of Lonsdale. [Earl of Lonsdale.]

Loudon, Countess of. See Hastings, Flora, Marchioness of.

Lovat, Lady. [Lord Lovat, Beaufort Castle.]

Lovelace, Ada Augusta, Countess. Daughter of Lord Byron and of Anne Isabella Noel, who was the female representative of the extinct Lovelace peerage of Hurley. Married in 1835 to Lord Ockham, who was created Earl Lovelace in 1838.
Circle. Head and shoulder only of child of 7 or 8. Facing, head bent to right. Short, black curly hair.
ENG. IN SMALL BY T. A. DEAN, for "Bijou" of 1829.

Lovell, Miss Mary. See Barrington, Lady.

Lowther, Lady Elizabeth. Eldest daughter of William, 1st Earl of Lonsdale. She died 1867. [Earl of Lonsdale. B.I. 1833.]

Lowther, Col. the Hon. Henry Cecil (1790–1867). Second son of 1st Earl of Lonsdale. In 10th Hussars, afterwards Colonel of the Cumberland Militia. Father of 3rd Earl. [Earl of Lonsdale.]
R.A. 1818. To knees, facing. In Hussar uniform, shako in left hand, right hand holding sabre.
MEZ. BY G. H. PHILLIPS, 1831. ·

Lushington, Mrs. [R. Kay, Esq. O.M. 1881.]
30×24½. Half length, seated, nearly full face. White dress. Sky background. At the Blakeslee sale, New York April 13, 1899, a portrait, entitled "Mrs. Lushington," was sold for £320.

OIL-PORTRAITS

Lyndhurst, Sarah, Lady (1795–1834). Widow of Colonel Thomas, killed at Waterloo, and 1st wife of Lord Chancellor Lyndhurst.

R.A. 1828. Seated, facing. Low-cut black velvet dress. Long sleeves, full at shoulder. Large jewel on breast. Dark hair in rolls and short curls. Hands with fingers intertwined.

MEZ. BY S. COUSINS, 1836.

Lyndsay, Lord and Lady. (? Lindsey, or Lindsay.)

" Let me beg of you, as immediately as possible, to complete, exactly according to its present plan, the picture of Lord and Lady Lyndsay " (Letter of L. to his " coadjutor " from Paris, ? 1815).

Lynedoch, Lord (1748–1843). Sir Thomas Graham, entered army in his 45th year. Won the battle of Barossa, 1811. Created Baron Lynedoch in 1814. Founder of the United Service Clubs (?). [Junior Un. Service Club.]

94 × 57. Full length, standing. Hands crossed in front, holding sword in scabbard.

Lynedoch, Lord. (Sir Thomas Graham.) [United Service Club. S.K. 1868.]

R.A. 1813. 93 × 58. Full length, standing. In uniform of General officer. Right hand grasps hilt of sword, the scabbard of which passes under left arm. Cocked hat to left. Ribbon of Bath. Battle scene (Barossa ?) in background to right.

MEZ. BY S. W. REYNOLDS, 1831.

Lynedoch, Lord. (Sir Thomas Graham.) [Duke of Wellington.]

R.A. 1817. Three-quarter length, facing, head to right. Uniform with medals and stars. Sash round waist. Left hand grasps scabbard ; sabre hanging from right cuff.

MEZ. BY H. MEYER.

Lysons, the Rev. Daniel (1760–1834). Born at Rodmarton, Gloucester, where he later held the family living. Author of *Environs of London* and *Magna Britannia* (with his brother Samuel). [Rev. Daniel Lysons. S.K. 1868.]

30 × 25. Bust, seated. Black coat.
At Chr., Nov. 22, 1912, was a bust portrait of "Daniel Lysons," 19½ × 15 ; facing, looking out ; natural grey hair ; frilled cravat.

Lysons, Samuel (1763–1819). Antiquary and Topographer. Assisted his brother (q.v.) with *Magna Britannia*. Keeper of the records in the Tower. [Rev. Daniel Lysons. B.I. 1830 ; S.K. 1868.]

R.A. 1799. 30 × 25. Bust, full face. Eyes to left. High white cravat. His own hair.

MEZ. BY S. W. REYNOLDS, 1804.

Lysons, Sarah, wife of Daniel L. (1780–1850), and Mrs. Charlotte Savery Price (1782–1850). Daughters of Colonel Thomas Carteret Hardy. [Camillo Roth, Esq. O.M. 1888, as " Daughters of Col. Hardy."]

1805 ? 49 × 39½. Both facing, nearly full length, seated on couch. Mrs. Price to left, in loose white dress. Mrs. Lysons to right, in purple velvet.

MEZ. BY J. B. PRATT, 1901.

Macdonald, Miss Julia. Daughter of General Sir John Macdonald. Married to Sir Roland Errington. Died 1859. [Lent to B.I., 1833, by General Macdonald.]

R.A. 1829. Half length, seated, facing ; left hand raised to face. Black hair in short curls on either side of face. Black velvet dress with short, full sleeves, fastened with jewels. This portrait was intended for the R.A. of 1828, but a portrait of Lord Eldon was at the last moment substituted for it. For this Lawrence apologises in a humorous letter to his friend Mrs. Macdonald.

MEZ. BY SAMUEL COUSINS, 1831.

Mackenzie, Sir Alexander (1755 ?–1820). North American explorer. The first white man to cross the Rocky Mountains and reach the Pacific coast (1793). Published his " Voyages " in 1801. Knighted in 1802.

Circa 1800. Oval. Bust, facing, head a little to left. Short, rough hair. White cravat and frilled shirt-front.

ENG. BY P. CONDÉ, 1801.

Mackenzie, Hon. Mrs. Stewart. See Hood, Hon. Lady.

Mackintosh, Sir James (1765–1832). Born near Inverness. Educated as physician, but called to Bar 1795. Published *Vindiciæ Gallicæ* 1791. Went to India 1804. Wrote many articles for *Edinburgh Review*. Distinguished by his powers of conversation. [National Portrait Gallery. Presented by his son.]

1804. 36½ × 29. To the waist, in the red robes as Recorder of Bombay. Nearly facing, head to left. White cravat loosely tied. Short hair over forehead.

ENG. (bust only) BY C. WILKIN, 1814 . also by ED. SMITH and others later.

Mackintosh, Sir James. [Ex Josiah Wedgwood.]

R.A. 1804. Half length, seated, nearly facing, looking up to left. In Recorder's robes. Right hand on book. Dark hair over forehead.

149

MacLeay, Alexander, F.R.S. (1767–1848.) Entomologist and Colonial Secretary for N.S. Wales 1825–37. Secretary of Linnæan Society. Died at Sydney. [Linnæan Society.]
Late. 30×25. *Half length. Seated, slightly to left. Scanty grey hair. White cravat tied in bow.*
ENG. BY CH. FOX.

MacMahon, Rt. Hon. Sir John (1754–1817). Private physician and friend of the Prince Regent. [H.M. the King.]
R.A. 1814. 36×27. *Seated, facing, looking out of picture. Curly hair over forehead. Buttoned coat, white cravat, frilled shirt. Paper in right hand.*
MEZ. BY C. TURNER, "from the picture in the possession of H.R.H. the Prince Regent."

MacMahon, Rt. Hon. Sir John. [Mrs. Marrable. O.M. 1907.]
1813 ? 36×27½. *Similar to the last.*

Maddon, Miss.
R.A. 1788. *No.* 112, " *Portrait of a Lady.*" " *The sky, the drapery, the background of this little gem* " *highly praised by a contemporary critic.* " *Happy the artist who had such a model, and happy the model that had such an artist* " (" *The Bee* " *on the R.A. of* 1788)..

Maguire, Mrs., and Arthur Fitzjames. The mistress of James, 1st Marquess of Abercorn, and her son. Arthur Fitzjames was afterwards Colonel of the Middlesex Militia. [Duke of Abercorn. O.M. 1904.]
Circle. Diameter 65. *Full-length figures, seated on floor, in an open colonnade. The lady, in dark dress, rests her right arm on a large dog (St. Bernard ?). The boy, in crimson velvet, has his hand on the dog's nose. His hair is thick and curly. Landscape between columns in background. Painted at the Priory, Stanmore, when Lawrence was staying with Lord Abercorn for private theatricals.*
ENG. BY W. GILLER, 1846, as " The Faithful Friends."

Malmesbury, James Harris, 1st Earl of (1746–1820). Diplomatist, Minister at Berlin 1772–6. Ambassador at Petersburg 1777–82. Created Baron Malmesbury 1788. Negotiated alliance with Prussia 1794, and marriage of Prince of Wales. Created Earl 1800. [Earl of Malmesbury.]
R.A. 1806. *To knees, seated, facing. Elderly man, with longish white hair ; in peer's robes, with collar of Bath. Hand on table.*
MEZ. BY W. WARD, 1807.

150

Manby, Captain George (1765–1854). Brother of Admiral Manby. Inventor of rocket apparatus for use in shipwrecks (1808). Was associated with Lawrence in the "Delicate Investigation." [Madame Barrot, "Portraits du Siècle," École des Beaux Arts, 1885.]
Three-quarter length, standing, looking to right. Holds sabre between folded arms. Fur-lined military cloak over red coat. Shipwreck in background.
ANONYMOUS LITHO, inscribed " by Sir Th. Lawrence, P.R.A."

Manners, Lady, or Milner, Lady. [No. 160, "Portrait of a Lady," in the R.A. Catalogue for 1794, has been thus variously identified.]

Manners, Lady John. *Née* Mary Digges (1737–1829). [Mrs. Hamilton Ogilvy, Biel House, Dunbar.]
42×54. *To below knees ; seated. Nearly full face ; grey hair. Satin and lace cap ; lace frill round neck. Dark blue silk dress with white square opening of bodice ; black lace shawl. Crimson leather arm-chair and crimson curtains.*

Manners, Lady Robert. Apparently the wife of Robert William, third son of the 4th Duke of Rutland, a Major-General (1781–1835).
R.A. 1826.

Manners-Sutton, Charles (1755–1828). Archbishop of Canterbury. Bishop of Norwich 1792. Archbishop 1805. Intimate with Royal Family. Active in Church reform. Father of Viscount Canterbury. [Archbishop of Canterbury. S.K. 1868.]
30×25. *Bust, unfinished, looking to left.*

Maria de Gloria, Donna. See Portugal, Queen of.

Markham, Colonel David. [Colonel Markham. Leeds, 1868 ; O.M. 1876.]
R.A. 1796. *No.* 202. *Catalogued as " Portrait of an Officer." MS. note in the B.M. Catalogue, " The late Lieut.-Col. Markam (sic)."* 49×39.

Markham, Admiral Sir John (1761–1827). Commander on *Centaur* at battle off Cape St. Vincent. For twenty years M.P. for Portsmouth. [Colonel Markham. O.M. 1877.]
29½×25. *In naval uniform. Sea in background. Lawrence was paid 25gs for a portrait of Captain Markham within a few years of his settling in London.*

OIL–PORTRAITS

Martin, Admiral Sir George (1764–1847). Present at St. Vincent, 1797, and in action off Cape Finisterre 1805. Rear-Admiral 1805.

Circa 1815. *To waist. Facing, head to right, looking out of picture. Rough short hair. Naval uniform and high black stock. Ribbon, stars, and medals. A copy of Lawrence's portrait, by Charles Landseer, is in the Painted Hall at Greenwich.*

MEZ. BY F. C. LEWIS, 1836.

Martindale, Mrs.

Circa 1790. *Lawrence received 25gs. for a portrait of this lady soon after he came up to London.*

Masters, Mrs. Thomas. *Née* Mary Dutton, sister of 1st Lord Sherborne. [Chr. May, 1911, n.n.; 1250gs.]

Circa 1790. 29¼ × 24¼. *Seated, half length, three-quarters to right. In plain white dress with blue sash, black shawl over left arm, white mob-cap with blue ribbon above. Powdered hair, falling to ruff. Red curtain to left and strip of landscape. Lawrence received 30gs. for this portrait shortly after his arrival in London in 1787.*

May, Mrs.
R.A. 1812.

Mayow, Wynell (1753–1807). "Of Sydenham, Kent. Solicitor of excise."

Circa 1800. *Half length, three-quarters to right. Grey hair tied on bow behind. Coat buttoned nearly to chin.*

ENG. BY W. SHARP.

Meade, Lady Selina, Countess Clam Martinics. Daughter of Richard, 2nd Earl Clanwilliam. Married, 1821, Count Clam-Martinics, General in the Austrian Army. Died 1872. [Earl of Clanwilliam.]

R.A. 1820. *Painted in Vienna, 1818–19. Half length, to left, looking round and out of picture. White satin dress with high waist, frilled at breast. Flowers in left hand. Black hair, high behind, in curls at side. Brought by Lawrence to Rome on top of travelling carriage. Of Lady Selina he writes, "In beauty and interesting character one of the most distinguished persons in Vienna" (Letter to Angerstein from Rome).*

ENG. BY CH. HEATH, 1828 (" Keepsake ").
 GEORGE DOO, 1835.

Melbourne, William Lamb, 2nd Viscount (1779–1848). Married Lady Caroline Ponsonby 1805. Entered Parliament 1806. Prime Minister on resignation of Earl Grey 1834, and again 1835. Acted as secretary and principal adviser to Queen Victoria on her accession. [Earl of Arran. Victorian Exhibition, 1891–2.]

30 × 24. *Half length, facing, head to left.*

Melbourne, William Lamb, 2nd Viscount. [Hon. W. F. D. Smith. Whitechapel Exhib. 1909.]

Half length, facing, looking slightly to right, and upwards. Thick, dark curly hair, slight whiskers. White stock and waistcoat.

Melbourne, 2nd Viscount. [Countess Cowper, Panshanger. S.K. 1868.]

1805–10. 30 × 25. *To below waist, to right, looking round and out of picture. Dark hair over forehead. Black fur-lined coat. Age about 25–30. Lady Caroline Lamb, in letter to Lawrence, speaks of her husband as being " handsomer, thinner, and more interesting out of than in his portrait " (Layard, p. 94).*

STIPPLE BY G. FREEMAN, 1832.
MEZ. BY EDWARD MACINNES, 1839.

Melbourne, Children of 1st Viscount. See Lamb, Hon. Harriet and Emily.

Mellon, Harriet (1777?–1837). Actress. Playing at Drury Lane 1795–1815. In latter year married to Thomas Coutts, the banker, and in 1827, after his death, to the 9th Duke of St. Albans. [W. Burdett-Coutts, Esq.]

1810–15. *Half length, seated. In high-waisted white robe. Head to right. Dark hair over forehead. Left arm over back of chair.*

Melthorpe, Sir J., and Melthorpe, Miss.

Circa 1790. *Lawrence received 50gs. for these portraits soon after he settled in London. He also received 25gs. for the portrait of a niece at the same time.*

Melville, Henry Dundas, 1st Viscount (1742–1811). Son of a Scottish judge. Devoted to Pitt. In office 1783–1801. Created Viscount 1801. Impeached in 1806 for malversation, but acquitted. [National Portrait Gallery.]

R.A. 1810. 29¼ × 24¼. *Bust, facing, three-quarters to left. Brown scratch wig. Reddish coat, high collar, and white cravat. Writing to Farington (May 20, 1809), Lawrence says: " I have finished the Resemblance with great force and truth. . . . Hoppner gave it up after many sittings " (Layard, p. 62).*

Melville, Henry Dundas, 1st Viscount. [Earl of Aberdeen.]

Nearly to knees, standing. Head slightly to left, eyes looking up. Left hand on papers on table. Loose dark hair, frilled shirt and cuffs.

MEZ. BY CH. TURNER, 1810.
ENG. IN STIPPLE (bust only) BY H. MEYER, 1810.

Melville, Robert Dundas, 2nd Viscount (1771–1851). Son of 1st Viscount. First Lord of Admiralty,

151

SIR THOMAS LAWRENCE, P. R. A.

1812–27. Melville Sound was called after him. [Carlton Club?]
R.A. 1826, *but painted earlier. Half length, seated a little to left, but looking to right. Fur-lined buttoned coat, with star.*
MEZ. BY CH. TURNER, 1827.

Melville, Viscountess. Anne Saunders. Married, 1796, to 2nd Viscount Melville. Died 1841.
" Fine late portrait."

Meredith, Sir R., and Lady Meredith.
Circa 1790. *For this portrait Lawrence received 30gs. A picture, entitled " Children of Lady Meredith fishing," was shown at the École des Beaux Arts in 1897.*

Meredith, Mrs. Probably Lucy, sister of Sir Thomas Lawrence. [Messrs. Gimpel and Wildenstein, Paris.]
Oil sketch.

Metternich, Clement Wenceslaus, Prince (1773–1859). Born at Coblentz. Married daughter of Kaunitz. Conducted Marie Louise to Paris. Negotiated coalition against Napoleon, 1813. Visited England 1814. Represented Austria at Congress of Vienna. The chief figure in European politics from 1813 to 1822. [Windsor Castle, Waterloo Gallery.]
R.A. 1815. 51½×41½. *Nearly full length, seated, looking round to right. Black coat with gold lace, red and blue ribbon, with orders. Right arm on chair, left hand holding papers on knee. Painted at York House in 1814.*
MEZ. BY S. COUSINS, 1830.

Metternich, Prince. [Prince Paul von Metternich, Winneburg.]
Commenced at Aix-la-Chapelle; " altered, improved, and almost completed " at Vienna, 1818–19. Seated, nearly full length, facing. Head three-quarters to right. Court dress and ribbon; holding paper in left hand. Order suspended from neck. Similar to Windsor picture.

Metternich, Princess Clementine, as " Hebe." Daughter of Prince Metternich. [Princess Pauline Metternich. " Cent Chefs d'Œuvre," Paris, 1892.]
Painted at Vienna, 1818–19. Arms and left shoulder bare. Lifting a vase. Light drapery over one shoulder. Deep blue sky. Princess Clementine died shortly after this picture was painted. Her father wrote: " I am convinced that Lawrence grieves for her, not on account of her beauty, for he has painted others more beautiful, but because he is devoted to me, and feels what I feel."

152

Metternich, Marie, daughter of Prince. See Esterhazy, Countess (under Drawings).

Mexborough, Countess of. See Pollington, Viscountess, and Child.

Michel, Mrs. Anne, daughter of the Hon. Henry Fane. Married in 1803 to Lieutenant John Michel, of Dewlish, Dorset. [Agnew's Gallery, 1905. Chr. December, 1904, " Property of a Lady"; 2000gs.]
Circa 1820. 55×44. *Seated, full length, resting left arm on red cushion, and holding yellow gauze scarf in right hand. Black velvet dress with short full sleeves. Large hat with white feathers.*

Mildert, William van, Bishop of Durham (1765–1836). Bishop 1826–36. The last of the Prince-Bishops. [Bishop of Durham, Auckland Castle. S.K. 1868.]
Late portrait. 56×44. *Seated, facing, three-quarter length. Lawn sleeves, arms resting on side of chair. Trencher hat in left hand. Bishop's wig. Durham Castle seen through window on right.*
MEZ. BY TH. LUPTON, 1831.

Miller, Mr.
Circa 1790. *Lawrence received 25gs. for a portrait so entitled.*

Milner, Lady. [Messrs. Agnew. Ex Sir Frederick Milner, Bart.]
Lawrence received 25gs. for a portrait of Lady Milner soon after his first settling in London.
The " Portrait of a Lady " in the R.A., 1794, has been identified by some as " Lady Milner," by others as " Lady Manners " (q.v.).

Minto, Earl of. See Elliot, Sir Gilbert.

Mirza Abul Hassan Khan. See Hassan, etc.

Mitford, Sir John. See Redesdale, Lord.

Molyneux, the prizefighter. " The Black " ?
An oil study for a portrait of this gentleman was sold at the Lawrence sale for 2gs.

Moore, Dr. John (1736–1805). Archbishop of Canterbury. [Sir Robert Peel, Bart. B.I. 1848. Graves' Gallery, 1908.]
R.A. 1794. " No. 115. Portrait of a Bishop," in R.A. *Catalogue. Nearly to the knees, standing. In bishop's robes and wig. " It conveys a full idea of the florid, well-fed visage of this fortunate arch-prelate " (Pasquin).*

OIL-PORTRAITS

Moore, Dr. John (1729-1802). Physician and author. Published *Zeluco*, a novel (1786), and a journal of his residence in Paris during the Revolution (1793). A social favourite. Father of Sir John Moore. [T. Carrick Moore. Loan Exhibition of Portraits, Edinburgh, 1884.]

R.A. 1791. No. 375. 28×23½. Bust, head three-quarters to right. Brown eyes and eyebrows. Powdered hair, tied. Blue-black coat, frilled shirt. About 1791 Lawrence received 25gs. for a portrait of " Dr. Moore."
MEZ. BY G. KEATING, 1794.

Moore, Sir John (1761-1809). Born in Glasgow, 3rd son of Dr. John Moore. Served in America and in Corsican Expedition, etc. Commander-in-Chief in Spain 1808. Killed at the Battle of Coruña, 1809. [National Portrait Gallery. Bequeathed 1898 by his grand-niece, Miss Carrick Moore. S.K. 1868 ; Guelph Exhibition 1891.]

Circa 1808. 29½×24½. To waist, full face ; red uniform coat ; greyish hair.
MEZ. BY CH. TURNER, 1809, and many others.

Moore, Sir Graham (1764-1843). Admiral, younger brother of Sir John Moore. In 1804 captured four Spanish treasure ships. Commander-in-Chief in Mediterranean, 1820. [National Portrait Gallery. Presented 1898 by his grand-niece, Miss Carrick Moore. S.K. 1868 ; Guelph Exhibition 1891.]

Circa 1815. 29½×25. To waist, facing ; in naval uniform ; grizzled hair ; white loose stock.

Moore, Sir Graham (?).

R.A. 1792. No. 366. " Portrait of a Naval Officer," is called by a contemporary critic " Captain Moore," and is probably to be identified with Sir Graham.

Moore, Thomas (1779-1852). The Irish Poet. Author of *Translations of Anacreon, Poems of Thomas Little, Lalla Rookh, Irish Melodies, Life of Lord Byron*, etc. [John Murray, Esq. Portrait Exhibition, Dublin, 1872 ; S.K. 1868.]

R.A. 1830. 30×25. Half length, looking up to left. Short black hair brushed over forehead. Black coat and cravat. Painted for John Murray, the publisher ; one of Lawrence's last works.
VIGNETTE BY W. FINDEN, 1836.

Morant, George.
ENG. BY W. SAY.

Morgan, William, F.R.S. (1750-1833). Actuary. Advanced reformer, friend of Tom Paine, Horne Tooke, etc. Pioneer of Life Insurance. Wrote on " Doctrine of Annuities," etc. Opposed to large National Debt.

R.A. 1818. Nearly full length, seated. Left hand on white cravat. Bald head. Knee breeches.
MEZ. BY CH. TURNER, 1830.

Mountjoy, Ch. Gardiner, Viscount (1782-1831). Son of 1st Viscount. Married Mrs. Farmer, *née* Power. He was created Earl of Blessington in 1816.

R.A. 1812. In a letter to Farington, Lawrence says Lord Mountjoy was sitting to him (October, 1811).

Mountjoy, Viscount (died 1798). Created Baron Mountjoy 1789. Killed by the Irish rebels.

Oval. Half length, to right. Long hair. Military coat with star and cross. An early portrait.
ENG. IN STIPPLE BY F. BARTOLOZZI.

Mountstuart, John, Lord (1767-1794). Son of 1st Marquess of Bute (whom he pre-deceased), and of Charlotte, daughter of last Lord Windsor and Mountjoy. Married daughter and sole heiress of Earl of Dumfries. Father of 2nd Marquess of Bute. [Col. J. Crichton Stuart, M.P. B.I. 1855 (lent by Lord James Stuart) ; O.M. 1873.]

R.A. 1795. No. 86 : Portrait of a Nobleman," in R.A. Catalogue. " The late Lord Mountstuart," MS. note in B.M. copy. In a Spanish dress. (Lady Holland, in her Journal, refers to meeting John, Lord Mountstuart, in Spain.) The background is said to be by William Owen, R.A.

Muilman, William Ferdinand Mogge (1778 ——). [Amsterdam, Rijksmuseum. Presented to Mr. H. Muilman, Sen., by J. J. Angerstein. Bequeathed, 1880, to the Dutch Collection by Jhr. J. van de Poll.]

30×25½. Man of about 30. Half length, facing, head to right. Short rough hair, powdered, and slight whiskers. Huge white cravat.

Mulgrave, Constantine John Phipps 2nd Baron (1744-92). Naval captain and politician. Served under Rodney. Succeeded his father as Baron 1775. Commanded *Racehorse* in Expedition to Spitzbergen. Early patron of Lawrence. [Sir Hickman Bacon, Bart.]

Circa 1787. 30×24. To waist, three-quarters to left. Hair long. Dark brown coat with full collar. Loose white cravat. Lawrence received 15gs. for a portrait of Lord Mulgrave about the time of his arrival in London. A head of the same sitter was sold at the Lawrence sale in 1831 for 4½gs.

153

SIR THOMAS LAWRENCE, P.R.A.

Mulgrave, 2nd Baron. [Pinacothec, Munich, presented by Freiherr v. Cramer Klett.]

Circa 1790. *Oval. Head three-quarters to right, looking to right. Powdered hair. White vest and black coat with high collar.*

Mulgrave, Rt. Hon. Henry Phipps (1755–1831). 3rd Baron and 1st Earl of Mulgrave. Military adviser of Pitt. First Lord of the Admiralty, 1807–10. Earl 1812. Patron of Art, befriending Haydon, Jackson, and others. [Chr. May 3, 1902; 190gs.]

1787 ? 30×25. *Half length, facing slightly to left. Short greyish hair. White cravat and frilled shirt.*
MEZ. BY CH. TURNER, 1808.

Munday, Mr. [? Father of Duchess of Newcastle.]

1790 (?) *Lawrence received 25gs. for a portrait of " Mr. Munday " soon after settling in London ; somewhat later he appears to have received 50gs. for another portrait of the same gentleman.*

Munster, Count (1766–1839). Born at Osnabruck. In the Hanoverian service during the great war. Represented Hanover at the Congress, and was head of the reactionary government there after the Peace.

1819 (?). *Black military coat, with blue ribbon. The portrait in the Waterloo Gallery, at Windsor, is " after Lawrence." I have failed to trace the original.*

Murray, Lady Augusta. "Married" 1793 to the Duke of Sussex. Afterwards created Duchess of Inverness. [Musée de Besançon, Jean Gigoux Bequest.]

Ascription to Lawrence doubtful.

Murray, Rt. Hon. Sir George, M.P. (1772–1846). General and statesman. Quarter-Master General of Army in Spain. Served in Waterloo campaign. Colonial Secretary 1828–30. Edited Marlborough's Dispatches, 1845. Married, 1826, to sister of Marquis of Anglesey.

Nearly to waist. Facing, head to right. Short black hair and whiskers. Military coat and black stock.
MEZ. BY H. MEYER, 1841. Also a STIPPLE ENG. BY J. COCKRAN, probably from the same picture.

Murray, Louisa Georgina, only daughter of Rt. Hon. General Sir George Murray. Afterwards Mrs. Boyce. Died 1891. [Wanamaker Collection, Philadelphia (?). Ex Sir

154

G. Murray, B.I. 1830. Major Boyce, B.I. 1848. F. R. Elkington, "Fair Children," 1895. Chr. May, 1905 (Huth sale), 850gs.]

1829. 55×42. *Called " Child with Flowers " in B.I. Catalogue, 1830. A little girl of 6 or 7, in white dress with pink sash and bows. She comes forward as if dancing, holding out with both hands her skirt, which is full of flowers. Loose curls over forehead. Garden background.*
In the Wanamaker Catalogue the size is given as 35½×27½.
ENG. BY G. DOO, 1834.

Napoleon, François Charles Joseph (1811–32). "Napoleon II." Roi de Rome, Duc de Reichstadt. Son of Napoleon and Marie Louise of Austria. [Duc de Bassano. Lent by S. Woodburn to B.I. 1833, as "The Young Napoleon."]

Oval. Oil sketch of a boy of about 8. Head only finished. Facing. Hair over forehead. White collar indicated. Painted at Vienna, 1818–19.

Napoleon, François Charles Joseph. Roi de Rome, etc.

For another portrait of the Young Napoleon, ascribed to Lawrence, see Clément de Ris, " Gaz. des Beaux Arts," 1882. It represents him as a boy of 12 or 13, and was bought in Vienna by the Comte de Flahaut, when Ambassador to the Austrian Emperor.

Nash, John (1752–1835). Architect. Designed the Terraces in Regent's Park, Regent Street, and Waterloo Place. Designed the Marble Arch and enlarged Buckingham Palace. [Jesus College, Oxford: placed there at Nash's own request, instead of "pecuniary recompense for work done on behalf of the College." Exh. of Historical Portraits, Oxford, 1906.]

R.A. 1827. 54½×43½. *Nearly full length, three-quarters to left, seated in leather arm-chair. Bald head. Spectacles in left hand, which rests on papers on table. Sculpture and architectural models in background to left.*

Neave, Mrs.

R.A. 1798. *" A spirited likeness, after Sir Joshua's manner," says a contemporary critic.*

Nelthorp, Miss. [J. H. McFadden, Philadelphia.]

About 1810. *Half length. Facing three-quarters to left. Dark hair in loose curls over forehead. Dark dress, low in front, with tulle-like border. Short sleeves. End of loose glove over right arm ; shawl over right arm ; hands not seen. Landscape and curtain background.*
ENG. BY HENRY WOLF, 1907.

OIL-PORTRAITS

Nesselrode, Karl Robert, Graf von (1780–1862). Born in Livonia, of Hanoverian extraction. Russian Ambassador in Paris 1807. Secretary to Emperor Alexander. Represented Russia at Vienna. Helped to negotiate the Holy Alliance. [Windsor Castle, Waterloo Gallery. B.I. 1830.]

Seated, head facing to right. Red ribbon across breast. Left hand on book.
Painted at Aix-la-Chapelle in 1818.

Newcastle, Henry Pelham, 4th Duke (1785–1851). Succeeded to Dukedom 1795. [Duke of Newcastle. B.I. 1855.]

Full length, standing, in uniform. Head slightly turned to left. Left arm outstretched, hand resting on commission in Nottingham Yeomanry, signed by the Duke. Man of about 40.
MEZ. BY CH. TURNER, 1830.

Newcastle, Georgiana, Duchess of (1789–1822). Daughter of Edward Munday. Married, 1807, to Henry Pelham, 4th Duke of Newcastle.

Full length, standing in large empty room, looking three quarters to right. High waist, ermine robe over shoulders. Dark hair in curls over forehead. Part of large framed picture on wall to right.
ENG. BY S. W. REYNOLDS.

Newdicote (?), Lady.

Circa 1790. Lawrence received £25 for a portrait of this lady soon after settling in London.

Norfolk, Charles, 11th Duke of (1746–1815). Became a Protestant and a Whig. Developed democratic tendencies and dismissed from Lord-Lieutenancy of West Riding 1798. Friend of Prince of Wales. President of Society of Arts 1794. [Duke of Norfolk.]

R.A. 1799. Full length.

Norfolk, Charlotte, Duchess of, when Countess of Surrey (1788–1870). Daughter of 1st Duke of Sutherland. Married, 1814, to Henry Charles, Earl of Surrey, afterwards 13th Duke of Norfolk. [Ex Duke of Sutherland. Chr. February, 1908; 820gs. Again July 12, 1912.]

Circa 1820. 29½×24. Half length, seated, head turned to right. Dark curly hair over forehead. Low dress with frilled border. Gold chain round neck, cameo on breast, with male portrait.
ENG. BY J. THOMSON, 1825.

Norfolk, Charlotte, Duchess of. [Duke of Norfolk, Arundel Castle.]
Similar picture to the last.

Norgate, Rev. Burroughes Thomas. At the age of 23. Died 1855. Fellow of Caius College, Cambridge. [Chr. May 13, 1899; 310gs.]

35×28. In black gown, with stock and band. Seated in red velvet chair.

Normanton, Welbore - Ellis, 2nd Earl of (1778–1868). [Earl of Normanton.]

Standing, nearly to knees, looking round to right. Dark hair and whiskers. Left elbow leaning on parapet. High white stock and fur-lined coat. Thunder-cloud in background. Writing to Lawrence in 1824, Lord Normanton reminds the painter that he has been sitting ever since 1815.

Normanton, Diana, Countess of (died 1841). Daughter of the Earl of Pembroke. Married Lord Normanton in 1816. [Earl of Normanton. B.I. 1830; O.M. 1904.]

R.A. 1827. 93×58. Full length, standing, looking round to left, on steps leading to garden. Right hand on balustrade, left on hip. White muslin dress with particoloured sash. Shawl of purple silk. Landscape back ground. According to Lord Normanton's letter, mentioned above, this picture also was begun in 1815, which accounts for the fashion of the dress.
Plate, "Burl. Mag.," 1903.

Northumberland, Charlotte Florentia, Duchess of (1787–1866). Daughter of 1st Earl of Powis. Married, 1817, to Hugh, 3rd Duke of Northumberland. [Duke of Northumberland. R. Hibernian Acad. 1829.]

Circa 1827. 52½×44½. Half length, seated, head three-quarters to right. Black velvet dress. Rubens hat with large white feather. Pearl necklace with jewel in front. Crimson curtain and sky background.
MEZ. BY O. BURGESS, 1845.

Nouaille, Peter, of Greatness, Sevenoaks (1723–1809).

1809. Seated; to knees, looking out of picture. Whitish hair or wig. Knee-breeches. Frilled cuffs. A man of 86.
ENG. BY T. BLOOD.

Nugent, Right Hon. George Grenville, Lord (1788–1850). Second son of Marquess of Buckingham. Published *Memoirs of John Hampden*, 1832. Lord High Commissioner of the Ionian Islands, 1832–5.

Circa 1820. Full length, facing, standing, on seashore. Lord Nugent wrote to Lawrence, 1818 and 1820, to complain of the delay in finishing the portraits of himself and Lady Nugent (Layard, p. 126).
MEZ. BY W. WARD, 1822.

155

SIR THOMAS LAWRENCE, P. R. A.

Nugent, Anne Lucy, Lady (1790–1848). Daughter of Major-General Vere-Poulett. Married Lord Nugent in 1813.

Circa 1820. Oval. Head and shoulders only. Looking to right. Long dark hair falling over left shoulder. LITHO. BY R. T. LANE, 1830. MEZ. BY McCORMACK, 1890.

Nugent, Lady. Wife of Admiral Sir Charles Nugent. Her daughter married Georges Bankes, of Kingston Lacy. [Mrs. Bankes, Kingston Lacy.]

In Lawrence's early style.

Nugent, Mrs.

Lawrence was paid 15gs. for a portrait of this lady about 1790. This may probably be identified with the preceding.

Offley, Hon. Mrs. See Cunliffe Offley.

Ogilvie, Miss Emily Charlotte. Afterwards Mrs. Charles Beauclerk. [Chr. May, 1906, Woods sale, 3000gs. to Agnew.]

R.A. 1796. " No. 116, Portrait of a Lady," in Catalogue. 30×25. Profile to right. Amber-coloured dress, blue sash, black lace shawl over left arm. Rose-bud in breast. High waist. Brown hair bound with white kerchief. " Brilliant, yet mellow," says a contemporary critic. " the artist should be more occupied with the ladies, he paints them so well."

See also Beauclerk, Mrs.

Oglander, Lady Maria. [Chr. Dec. 12, 1896 ; 550gs.]

R.A. 1817. 94×57. Full length. In white dress, walking by seashore, carrying hat in right hand.

Orford, Earl of. See Walpole, Horace.

Oriel, John Foster, Baron (1740–1828). Last speaker of "Grattan's Parliament." Opposed Roman Catholic Relief Bill 1793. Opposed Union 1799. Created a Baron 1821. [Chr. June 30, 1831. Lawrence's Exors.]

Whole length.

VIGNETTE LITH. BY M. GAUCI, shows only bust, to right.

Orleans, Duke of (Philippe Égalité).

A whole-length copy by Lawrence (presumably an early work) of Sir Joshua's picture of the Duke was in the Lawrence sale, June, 1831. The original was destroyed by fire at Carlton House. A copy, reduced, is at Chantilly, where it is wrongly ascribed to Reynolds. It may possibly be the picture sold in 1831.

Ottley, Mrs. Wife of William Young Ottley, the writer on art, from whom Lawrence purchased so many of his drawings by the Old Masters.

Painted 1822. See letter from Lawrence to Mr. Ottley, dated October 9, 1822.

156

Ouvaroff, General. [Windsor Castle, Waterloo Gallery. B.I. 1830.]

Painted at Vienna, 1818–19. Standing, three-quarter length. Dark uniform with orders. Right hand extended.

Owen, Lady. Daughter of the Rev. John Lawes Philipps. Married, 1800, to Sir J. Owen, Bart., of Pembroke-shire. [Ex Sir Hugh Owen. Chr. July 13, 1895 ; 950gs.]

95×58. Whole length.

Owen, Lady. [C. Sedelmeyer, Paris. Ex Sir Hugh Owen. Chr. May 8, 1897 ; 950gs.]

Circa 1820. 50×40.. At the age of 28. Nearly full length, seated to right. Eyes looking out of picture. Dark curly hair, one lock falling over forehead. Black velvet dress with short sleeves. Large bracelet on wrist. Red curtain background.

Paget, the Hon. Berkeley Thomas (1780–1842). Sixth son of Henry, Earl of Uxbridge. Brother of 1st Marquess of Anglesey. Later M.P. for Anglesea. [Lord Hylton. O.M. 1904.]

R.A. 1807. 29½×24½. Bust, fronting. Head turned to right. Dark coat, frogged, with fur collar. Sky background.

Paisley, Lord. Son of Marquess of Abercorn. See Hamilton, James, Viscount.

Palmer, James. President of Chelsea Hospital.

R.A. 1821.

Palmer, Mrs. Horsley. [Edward Palmer, Esq. O.M. 1879.]

Painted 1810. 29×24. Half length, seated to left; full face. Low white dress and pearl ear-rings. Curtain background.

Palmerston, Henry Temple, 2nd Viscount (1739–1802). Succeeded to title in 1757. Father of the statesman.

Circa 1790. Lawrence received 30gs. for a portrait of this nobleman shortly after his first coming to London.

Palmerston, Lady. See Lamb, Hon. Amelia.

Paoli, General (1726–1807). Born near Bastia, in Corsica. Captain-General of the Corsicans in the War of Liberation from the Genoese 1755–67. Leader, also, against the French, to whom the Genoese had handed over the island, 1768–9 ; finally defeated.

OIL–PORTRAITS

Lived for many years before his death in England. [Lent to B.I. 1857 by Mr. Ewart, M.P.]
R.A. 1799.

Paterson, General (otherwise Patterson, Pattison and Peterson).
R.A. 1790. No. 103. "Portrait of a General Officer." Half length. Lawrence received 40gs. for this work.

Paterson, Mrs. Robert. See Wellesley, Marchioness.

Pattisson, the Masters. William and Jacob, sons of W. H. Pattisson, of Witham, Essex. "Rural Amusements." [John Naylor, Esq. Chr. 1860, Cooper sale, 200gs.]
Begun 1811. R.A. 1817. Two boys of about 8 and 10 years. One leading and the other kneeling and embracing the head of a donkey. Landscape background.
MEZ. BY JOHN BROMLEY, 1831, "Rural Amusements."

Pattisson, the Masters. [F. L. Pattisson, Esq.]
Oval. Two finished studies of boys' heads, made for the "Rural Amusements."
These were found in 1900 at a farmhouse near Witham, Essex, where the Pattisson family lived.

Peel, Julia, Lady. Born in India, 1795. Daughter of General Sir John Floyd, Bart. Married, 1820, to Sir Robert Peel, 2nd Bart. Died 1859. [M. S. Barboc, Paris. Ex Sir Robert Peel, Bart.]
R.A. 1827. 36 × 28. Standing, almost to knees. White dress, fur-lined cloak, huge black hat, with red plumes falling to either side. Left hand raised, showing three jewelled bracelets. Dark curls on both sides of face. This portrait used to hang in Sir Robert's house as pendant to Rubens' "Chapeau de Poil," now in the National Gallery. (See Williams, II, 475, for list of Peel Lawrences.)
ENG. BY C. HEATH, "Keepsake," 1829.
MEZ. BY S. COUSINS, 1831. Many other prints.

Peel, Julia, Lady. [Sir Robert Peel. Graves' Gallery, 1908.]
R.A. 1825. Seated, in park, facing, nearly full length. Head turned to right. Dark hair in elaborate curls. Low white dress ; large jewel with drop-pearl between breasts. Pink shawl over left shoulder. Large hat with pink and white plumes in right hand. Background of wooded park.

Peel, Julia Beatrice. Daughter of Sir Robert Peel, 2nd Bart. Married, 1841, to the 6th Earl of Jersey; secondly, to Charles Brandling. Died 1893. [Sir George Cooper, Bart. Ex Sir Robert Peel, Bart. Robinson and Fisher (Peel Heirlooms sale), 1907.]
R.A. 1828. A smiling child of 7 or 8, sitting on the ground and hugging a spaniel. Hair in short curls over forehead. Wooded background.
MEZ. BY S. COUSINS, 1833.

Peel, Sir Robert (1750–1830). 1st Baronet. Son of the founder of Lancashire calico printing. M.P. for Tamworth 1790. Interested in factory reform. "A Pioneer of commercial greatness in England." Father of the Statesman. [Sir Robert Peel, Bart. Graves' Gallery, 1908.]
1820 (?). Nearly full length, seated. Elderly man, with shrewd smile. Thick, rough, greyish hair. Arms resting on arms of chair. Left hand holding paper addressed to him. Brown coat, white waistcoat and cravat. Green curtain on right.
ENG. BY H. ROBINSON, 1834.

Peel, Sir Robert (1788–1850). Son of 1st Baronet. M.P. for Cashel and Chief Secretary for Ireland, 1812. Home Secretary 1822, and again 1828–30. Established Metropolitan Police. Prime Minister 1834, and again 1841–4. [Sir Robert Peel, Bart. Graves' Gallery, 1908.]
R.A. 1826. 56 × 44. Standing, to knees, facing right, but looking round slightly to left. Right fingers resting on table, left hand on hip. Civil costume. Reddish brown hair, grey-blue eyes.
ENG. BY CH. TURNER, 1828 ; S. COUSINS, 1850 ; and others.

Peel, Sir Robert. [Rev. W. B. Hawkins. S.K. 1868.]
30 × 25. As a young man. To waist, looking to left. Dark brown coat, yellowish waistcoat, white cravat.

Peel, Sir Robert.
Circa 1829. Bust, three-quarters to left. Wavy hair. High collar and black cravat tied in bow.
ENG. BY W. HOLL.

Peel, Sir Robert. [Lord Brassey?]

Pellew, Sir Edward. See Exmouth, Baron.

Pemberton, Christofer Robert (1765–1822). Physician. M.D. Cambridge. Author of works on therapeutics. [Lent to B.I. 1833 by his widow.]

Pembroke, Catherine, Countess of. Daughter of Count Woronzoff (1783–1856). Married 1808, as his second wife, the 11th Earl of Pembroke.
Circa 1810. In an oval. To waist, seated. Full face. Hair in knot on top of head, fillet about forehead. Loose cloak fastened in front with a buckle.
ENG. BY G. S. FACIUS, with French lettering.

SIR THOMAS LAWRENCE, P.R.A.

Pennicott, Rev. William (1726–1811). Rector of Long Ditton. [Metropolitan Museum, New York. Ex Rev. T. S. Streatfield. Chr. July, 1906.]

R.A. 1800. 30×25. Bust, facing slightly to right; seated in red chair. Black, high-collared coat. Clerical wig.

MEZ. BY S. W. REYNOLDS.

A private plate, by S. W. Reynolds, half length, nearly full face, in private dress, is apparently from another picture.

Perry, James (1756–1821). Originally an actor. Editor of *Morning Chronicle*. Friend of Lawrence. Prosecuted more than once for liberal opinions. [In the Lawrence sale at Christie's in June, 1831, was a portrait of "The late Mr. Perry." Also a copy of the same.

A portrait of " The late James Perry, Esq.," was lent to the Winter Exhibition of the Society of British Artists, 1832, by Mr. E. Perry. To the 1833 Exhibition, a " Portrait of a Lady " was lent by the same gentleman.

Phillips, H. [Chr. June, 1831. Lawrence's Exors.]

" The head only—very fine."

Pitt, Right Hon. William (1759–1806). Youngest son of William Pitt, 1st Earl of Chatham. Chancellor of the Exchequer at 23. Prime Minister from 1783 to 1801, and from 1804 to his death. [Earl of Rosebery. Ex Angerstein Coll.]

R.A. 1808. Begun in 1806. 59×48. Standing; to knees. Facing slightly to left, looking round to right. Pointing with left hand to paper inscribed " Redemption of National Debt." Plain black coat, buttoned, with thick collar. White cravat. Pilaster on right. Painted for Mr. Angerstein, and begun immediately after Pitt's death (January 23, 1806). Founded partly on a death mask, partly on an unfinished portrait by Hoppner.

Pitt, Right Hon. William. [Windsor.]

Finished 1828. 59×48. This is a replica of Lord Rosebery's picture, commissioned by Mr. Angerstein, as a present to the Prince Regent.

In a mezzotint of 1837 by S. W. Reynolds, the paper on table to right is replaced by a map of India ; there is no pilaster to right. This print is inscribed " Died 1800 " (sic). In another mezzotint of 1837 by C. Turner, the hand rests on a blank paper.

Pitt, Right Hon. William. [Hanover, Provincial Museum.]

93×56. Full length.

Pitt, Right Hon. William. [Miss Wilbraham. B.I. 1851; Chr. 1852; 100gs. Northwick sale at Thirlstane House 1859 ; 140gs.]

Standing, three-quarter length. Highly praised by Waagen when in possession of Miss Wilbraham. It is probably the original of a rare anonymous mezzotint (perhaps by Ch. Turner), which shows Pitt standing, his right hand on table, back of left hand on hip ; loose collar, frilled cravat.

158

Pius VII. Gregorio Luigi Barnabo Chiaramonti (1742–1823). Cardinal 1785. Elected Pope in succession to Pius VI 1800. With the aid of Cardinal Consalvi arranged concordat with Napoleon. Crowned Napoleon 1804. Carried off later to Fontainebleau by Napoleon and kept a prisoner there until 1814. [Windsor Castle, Waterloo Gallery. B.I. 1830 ; O.M. 1904.]

1819. Painted at Rome. 104×57. Full length, seated. Red robes with skull cap. Through opening to right is seen the Chiaramonti Gallery, with the " Apollo," the " Laocoön," and the " Torso Belvedere."

MEZ. BY S. COUSINS, 1828.

ENG. BY E. MACINNES, 1840.

Planta, Mrs. Charlotte Augusta Papendieck (1783–1854). Married, first, a Mr. Ooms, and secondly (after 1804) the Right Hon. Joseph Planta, M.P. [Mrs. F. C. K. Fleischmann.]

1804. 30×25. To knees, facing. Low white dress, with short sleeves. Gold, lyre-shaped brooch ; two bracelets, one gold, the other coral ; greenish scarf over shoulder. Dark hair low on forehead, bound by fillet. Background, sky and door-jamb (?).

Platoff, Prince. Hetman of the Don Cossacks. Served with the Allies in 1813–14. Visited England with the Emperor Alexander in 1814. [Windsor Castle, Waterloo Gallery. B.I. 1830.]

R.A. 1815. Painted at York House in 1814. Standing, left hand on horse's mane. Dark uniform, with orders.

Platoff, Prince. Hetman of the Don Cossacks.

At the Lawrence sale on June 17, 1830, " four bold studies " for the Windsor portrait of Platoff were sold for 8gs. They were on brown paper.

Plumer, Sir Thomas (1753–1824). Barrister ; defended Warren Hastings (1788), the Princess of Wales (1806), and Lord Melville (1806). Vice-Chancellor 1813 ; Master of the Rolls 1818. [The Plumer family ?]

1813(?). Half length, seated. Vice-Chancellor's robes, with lace cravat and full-bottomed wig. Background, red curtain.

ENG. BY H. ROBINSON, 1832.

Plumer, Sir Thomas. [Oxford, University College; Oxford Hist. Portraits, 1906.]

35½×27½. This appears to be a replica, mainly by Simpson, probably from the portrait engraved by Robinson.

OIL—PORTRAITS

Plumer, William (1737–1822). M.P. for county of Hertford in eight successive Parliaments. [The Plumer family?]

Circa 1795. *Presentation portrait. Standing, facing, looking up to left. White hair or tie-wig, knee-breeches. Left hand resting on volume—" List of Subscribers." Above, to left, a large silver vase.*

ENG. BY CH. TURNER, 1817.

Pole, Miss W.

R.A. 1812.

Pollington, Viscountess, and Child. Later Countess of Mexborough. Anne, eldest daughter of 3rd Earl of Hardwicke; married, 1807, to John, eldest son of 2nd Earl of Mexborough. Died 1870. [Earl of Mexborough, Canazzaro, Wimbledon. B.I. 1862 (lent by Earl of Mexborough).]

R.A. 1821. *Lady Pollington, full length, facing a little to right; in white dress, with red flower on bosom. The child, of about two years, of preternatural size, seated on table to right, grasps a lock of its mother's hair. Red curtain background.*

Pope, Mrs. Actress (1777–1803).

As " Juliet."

ENG. BY H. MEYER (no impression in B.M.).

Portarlington, Countess of. See Vane, Lady Alexandra.

Porter, Dr. John. Bishop of Clogher. Died 1819.

Bust. *Facing and looking round to right. Bishop's wig and robes.*

ENG. BY CH. TURNER, 1825.

Portland, William Henry Cavendish-Bentinck, 3rd Duke of (1738–1809). Succeeded to Dukedom 1762. Prime Minister 1783. Allied with Pitt as Home Secretary 1794–1801. Prime Minister again 1807–9. [Town Hall, Bristol. S.K. 1867.]

1792. 94×55. *Full length, standing. In crimson, ermine-lined robes. This picture was painted for the Bristol Corporation; Lawrence received 100gs. for it.*

Portugal, Donna Maria de Gloria, Queen of (1819–53). Granddaughter of John VI. Her father, Dom Pedro, renounced the throne in her favour. [Windsor Castle. B.I. 1833.]

1829. *A young girl of about 10. Seated, turning to left. Hands crossed on arm of chair. Hair in curls high on head. Parti-coloured sash. A " finished copy " of this picture was in the Lawrence sale, 1831.*

ENG. BY R. GRAVES in " Amulet " for 1833.

MEZ. BY JOHN LUCAS, 1836.

Pratt, Samuel Jackson (1749?–1814). "Courtney Melmoth": Author of *Gleanings*, etc. Failed as an actor. Several of his plays produced at Drury Lane. A letter from Lawrence to Pratt, containing the most extravagant compliments, is to be found in Anderton's grangerized R.A. catalogues.

1800–5. *Bust, seated, looking out of picture. Elderly man with scanty white hair. Left hand on a table.*

ENG. BY CAROLINE WATSON, 1805.

Price, Sir Uvedale, Bart. (1747–1829). Writer on "The Picturesque," and landscape gardening. "Converted the age to his views," says Scott. Carried out his ideas at Foxley, Herefordshire. [Chr. 1893.]

R.A. 1799. *About 1795 Lawrence received 25gs. for a portrait of Mr. Price.*

Raglan, Lady. Harriet, second daughter of 3rd Earl of Mornington. Married, 1814, to Lord Fitzroy Somerset, afterwards 1st Lord Raglan. [In Russia.]

Circa 1815. *Half length, in white, stepping forward. Dark hair curling over forehead.*

MEZ. BY J. B. PRATT.

Raglan, Lady. See also Mornington.

Raikes, Mrs., and Child. A great beauty, wife of Mr. Raikes, of Hull. [C. Sedelmeyer, Paris.]

Circa 1810. *Standing, full length; left arm round waist of child who stands on chair; right hand over left arm of child. Hair in curls over forehead; black velvet dress, red scarf. Landscape to right, column to left.*

Ramus, Mrs.

Circa 1790. *Lawrence received 30gs. for a portrait of this lady soon after his arrival in London.*

Raphoe, Bishop of (1822–34). See Bisset, William.

Rawdon, Lord. See Hastings, Marquess of.

Read, Mr., "of the Old Jewry."

Circa 1787. *Lawrence received 20gs. for a portrait of this gentleman.*

Redesdale, Sir John Mitford, 1st Lord (1748–1830). Barrister. Speaker of the House of Commons 1801. Baron Redesdale 1802. [? Chr. 1897, Thomson Bonar sale, 52gs.]

1804. 30×25. *Seated, looking up to right. In robes and full-bottomed wig. Lord Redesdale was sitting to Lawrence in August, 1804. (Letter to Ch. Burney.)*

MEZ. BY G. CLINT (1814 ?).

159

SIR THOMAS LAWRENCE, P. R. A.

Reichstadt, Duc de. See Napoleon.

Ribblesdale, Thomas Lister, 1st Baron (1752–1826). Created a Baron 1797. [Lord Ribblesdale, Gisbourne Park. O.M. 1904.]
94×57. *Full length, facing, head turned slightly to left. Right arm resting on pedestal, on which a hat. Right hand gloved, left holds cane. Black coat, drab breeches and gaiters. Landscape background.*

Richelieu, Duc de. [Besançon. Town Museum. Jean Gigoux Bequest.]
To waist, facing. Three-quarter face. Plain frockcoat; loose white cravat; star on left breast. Curly short hair. Plain background.
ENG. BY F. LIGNON, 1824.
This is apparently the original of the portrait in the Waterloo Gallery, Windsor.

Richelieu, Duc de.
A portrait of Richelieu, ascribed to Lawrence, was sold in Paris in 1884 for £500 (? francs).

Richmond, Caroline, Duchess of (1796–1874). Eldest daughter of Marquess of Anglesey. Married, 1817, to 5th Duke of Richmond. [Duke of Richmond, Goodwood. B.I. 1830.]
R.A. 1829. Full length, standing, to right. White satin dress with train and full sleeves. Holding flowers. Black hair, bound up high. In open colonnade, with landscape to right.
ENG. BY FINDON AND BY R. GRAVES (in "Amulet," 1833). LATER BY G. R. WARD AND J. COCKRAN.

Riddell, Mrs. *Née* Woodley. She was a younger sister of Mrs. Henry Bankes. [Mrs. Bankes, Kingston Lacy.]
R.A. 1806. Kit-cat.

Ripon, Frederick John Robinson, 1st Earl of (1782–1859). Son of 2nd Baron Grantham. In various posts between 1809 and 1827. Viscount Goderich 1827. Prime Minister 1827–8. Earl of Ripon 1833. [Marquess of Ripon. S.K. 1868 (lent by Earl de Grey and Ripon).]
1815–20. 36×28. To waist, facing, looking round to left. Dark brown coat, glove on left hand.
MEZ. BY CH. TURNER, 1824, as Rt. Hon. F. J. Robinson, Chancellor of the Exchequer.

Ripon, Sarah, Countess of.
ENG. BY W. J. EDWARDS.

Robinson, the Hon. Mr.
R.A. 1793. No. 231. " Portrait of a Gentleman."

Robinson, Rt. Hon. F. J. See Ripon, Earl of.

Robinson, Mrs. Frances, wife of Henry Robinson, and Son. [Blakeslee sale, New York, April 11, 1902; £520 16s.]

Robertson, Mrs. Francis. [National Gallery. Presented to National Gallery by Mr. Francis Robertson, of Brighton, 1837.]
94×58. Painted circa 1804. Full length, facing; left hand rests on harp. White dress; dark hair falling in curls over forehead. Landscape background.

Robinson, Mrs. [Hon. Charles Lawrence.]
Painted 1793. Half length, facing, looking out. In dark red cloak and wide-flanged bonnet. Dark curls on either side of head. Holding a lamb under her left arm.

Rocke, Mrs. Richard. Susanna, daughter of — Pattle, Esq. [Major W. L. Rocke. O.M. 1907.]
Circa 1820. 23½×19½. Bust, to right; looking out. Heavy, fat face. Black hair loose over forehead. Earring with large pearl-drop. White satin dress. Greyish plain background.

Rolle, Baron, of Stevenstone (1750–1842). M.P. 1780–90. Adherent of Pitt. Hero of the "Rolliad." Created Baron 1796. [Lord Rolle?]
Seated, full length, facing. In peer's robes. Head turned to left. Cloak spread over chair. Bald-headed, stout man. Landscape with winding river to left.
ENG. BY CH. TURNER, 1826.

Rome, King of. See Napoleon.

Romilly, Sir Samuel (1757–1818). Born in Westminster of old Huguenot family. Solicitor-General 1806. Made many important reforms in criminal law. [National Portrait Gallery. Bequeathed by Mr. Charles Romilly to National Gallery. S.K. 1868.]
1810. 29½×24½. Seated, to waist, face three-quarters to left, but looking out of picture. Short hair; black coat and white cravat tied in bow. Frilled shirt-front.
MEZ. BY S. W. REYNOLDS.

Rose, Samuel (1767–1804). Barrister. Counsel to the Duke of York. Friend of Cowper, the poet. Took Lawrence to Weston Underwood to paint the poet, in 1793. Defended William Blake at Chichester. His daughter married to Dr. Ch. Burney, the Greek scholar. [Ex the late Mr. Ch. Burney.]
R.A. 1795. No. 168. 30×25. Seated at a table, to right, looking round. Hands folded on knee.
MEZ. BY CH. TURNER, 1810, AND BY H. ROBINSON FOR COWPER'S WORKS, 1836.

OIL–PORTRAITS

Rous, Mr., or Rouse. [Lawrence sale, 1830, "Mr. Rouse."]

1810. *Half length, seated, facing. Elderly man with short hair; white cravat tied in bow; arms on side of chair. Paper on table to right.*

MEZ. BY CH. TURNER, 1815 (lettered Hon. Mr. ROUS).

St. Albans, Louisa, Duchess of. Daughter of John Manners and Louisa, Countess of Dysart. Married, 1802, to Aubrey, 6th Duke of St. Albans. [Ex Lady Charlotte Bruce, Lady Laura Tollemache, and the Marchioness of Ailesbury. Chr. 1901; 1600gs.]

28 × 24.

St. Germans, William, 2nd Earl of (1767–1845). [Earl of St. Germans, Port Eliot.]

29½ × 24. *Half length, full face, body turned slightly to right. Blue cutaway coat with brass buttons, one fastened over chest, showing white waistcoat below. White cravat. Hair very slightly powdered.*

Salisbury, Frances Mary, Marchioness of. Daughter of Bamber Gascoyne, Esq. Married, 1821, to 2nd Marquess of Salisbury. Died 1839. [Marquess of Salisbury, Hatfield.]

R.A. 1829. 96 × 56. *Standing, nearly full length, facing. Resting right elbow on parapet on which red robe is laid. Right hand to curls surrounding face. Low satin dress with full sleeves. Background, park scenery. "The best I have painted," says Lawrence in contemporary letter.*

SMALL ENG. BY W. ENSOM, 1831.

Saltoun, Alexander George Fraser, 16th Lord (1785–1853). Soldier. Served in Spain, France, etc., 1806–14. Led charge against Napoleon's Old Guard at Waterloo. [United Service Club. Presented by Sir John Bayley, 1855. S.K. 1868.]

1809. 94 × 58. *Full length, standing, facing. Guards uniform with star, busby in outstretched left hand, sword in right.*

MEZ. BY G. ZOBEL, 1854.

Sandwich, Louisa, Countess of. Only daughter of 1st Earl of Belmore. Married, 1804, to George, 6th Earl of Sandwich. [Earl of Sandwich, Hinchingbrook.]

Full length, in white dress with brown drapery. Leaning on an anchor.

Sansom, Philip. [National Gallery. Bequeathed, 1894, by his granddaughter, Miss Ellen Sansom.]

53½ × 39½. *Seated, to knees, three-quarter facing, in arm-chair, resting hand on table. Red curtain and open window in background.*

Schwarzenberg, Prince Karl von (died 1820). Commanded the Austrian forces in the Leipsic campaign. [Windsor Castle, Waterloo Gallery. B.I. 1830.]

1818–19. *Painted in Vienna. Full length, standing. Pointing with bâton. Cloak over right arm. To left his horse, held by an orderly. Writing to Mr. Angerstein from Vienna, Lawrence says: "I have given in one sitting, but that a long one, a likeness of Prince Schwartzenburgh that is greatly liked by all who have seen it."*

Scott, Sir Walter (1771–1831). The great writer. [Windsor Castle. B.I. 1833. Scott Centenary Exh. 1872.]

R.A. 1827. 61 × 52½. *Nearly full length. Seated, facing, looking up to left. Long coat. Pen in right hand. Left elbow on circular table, with writing materials, etc., upon it. Landscape seen through opening on right. This portrait was commissioned by the King in 1820, to begin a series of portraits for the Windsor Corridor. The head only was finished from life. Scott wondered " the artist could make so much from an old weather-beaten block."*

ENG. BY J. HORSBURGH.

„ W. HUMPHREY (half length only).

Seaford, Charles Rose Ellis, 1st Baron (1771–1845). Inherited large estates in West Indies, and became principal authority on the plantations, in House of Commons. Baron 1826. Father of Lord Howard de Walden. Personal friend of Lawrence. [Marquess of Bristol, Ickworth.]

1829 and 1880. 50 × 40. *To below knees. Grey hair. Left hand in breeches pocket; right holding stick. In hand when Lawrence died. Lord Seaford was at the painter's studio Dec. 31, 1829.*

Seaforth, Francis Humberston Mackenzie (1754–1815). Chief of Kintail and 1st Baron. Governor of Barbados. Raised the Ross-shire Buffs (78th Regiment; now 1st Battalion Seaforth Highlanders). Baron 1797. An early patron of Lawrence. [Marquess of Northampton. Lent by Louisa, Lady Ashburton (Seaforth's granddaughter), to Grosvenor Gallery, 1888.]

R.A. 1798. 93 × 57. *Full length, standing. Scarlet uniform with yellow facings. Highland bonnet. Seaforth lent Lawrence £1000 in 1796. This portrait was in part payment.*

Seaham, Viscount, George Henry (1821–84). Son of 3rd Marquess of Londonderry by his second marriage with daughter and heiress of Sir Harry

11

161

Vane Tempest. Succeeded his brother as 5th Marquess in 1872. [Marquess of Londonderry. B.I. 1830.]

R.A. 1824. " Portrait of the child of the Marquis and Marchioness of Londonderry," R.A. Catalogue. A boy of 3. Seated on cushion, facing. See also " Londonderry, Marchioness of, and her son, Lord Seaham."

Shaftesbury, Cropley Ashley Cooper, 6th Earl of (1768–1851). Succeeded to Earldom 1811. Chairman of Committees of House of Lords.

R.A. 1811. " The Hon. C. A. Cooper," R.A. Catalogue. Nearly to knees. Standing to left, head facing. Stick and hat in right hand. Fur-lined frogged coat. Short loose hair.

MEZ. BY CH. TURNER, 1812.

Shaftesbury, Countess of. See Cowper, Lady Emily.

Sheepshanks, Mr.

Circa 1790. Lawrence received 25gs. for a portrait of this gentleman soon after his first arrival in London.

Shepherd, Sergeant, Sir Samuel (1760–1840). Lawyer. Created Sergeant-at-Law 1796. Knighted 1814. Attorney-General 1817. Friend of Sir Walter Scott.

R.A. 1796. " No. 183, P. of a Gentleman," R.A. Catalogue. Nearly to knees. Facing, looking out. Powdered hair. White frill below cravat. Papers in right hand.

ENG. BY J. R. JACKSON, 1846.

Sheridan, Richard Brinsley? (1751–1816). Dramatist and Parliamentary orator. Married Miss Eliza Linley in 1773. Manager of Drury Lane Theatre for many years from 1776. [Lord Young. Chr. February, 1908, 540gs.]

1790–3. 49×39¼. Man apparently of 25 to 30. Standing. Slightly powdered hair. Blue coat with huge collar and large white stock. Stick in left hand. The identification of this fine portrait with Sheridan is very doubtful.

Sheridan, Richard Brinsley. [Sir E. P. Stracey (? Strachey).]

1795. Nearly to knees, facing left. Natural hair, powdered. Large loose white cravat. Left hand outstretched and resting on stick. Dark coat buttoned over white waistcoat.

Sheridan, Tom (1775–1817). Son of R. B. Sheridan. Colonial Treasurer at Cape of Good Hope.

The picture exhibited in the R.A. 1792 as " An Etonian" (No. 209) was said by most contemporary critics to be a portrait of " Young Sheridan." But one paper calls it " Mr. Atherley " (q.v.). It is described as " rich and with a spirited head; the background in the manner of Rembrandt. Eton College is well introduced."

162

Siddons, Mrs. (1755–1831). Sarah Kemble, sister of John and Charles Kemble. Born at Brecon. Daughter of Roger Kemble, actor. Married 1773. First appeared in London 1775, with Garrick, as Portia. Retired from stage 1812. [National Portrait Gallery. Deposited by Trustees of National Gallery, to whom it was presented in 1843 by Mrs. Fitzhugh, of Bannister Lodge, Southampton.]

Probably R.A. 1804. 98¼×56¼. Full length, facing. Black robe, with bare arms. Coral necklace. Turning over pages of " Paradise Lost " with left hand. Volume of Otway below. " Shakespeare " inscribed on column.

MEZ. BY W. SAY, 1810.

Siddons, Mrs.

A portrait of Mrs. Siddons, resembling that in the N.P.G., was sold at Robinson and Fisher's in 1901 for 500gs.

Siddons, Mrs.

Two unfinished portraits of Mrs. Siddons were in the Lawrence sale of June, 1831.

Siddons, Mrs. [National Gallery, bequeathed by her daughter, Mrs. Cecilia Combe, in 1868.]

? R.A. 1797. No. 166. 28½×24½. Half length, facing. A replica of this portrait, formerly in possession of a member of the firm of Rundell and Bridge, was sold at Robinson and Fisher's, May 11, 1905.

ETCHED BY FLAMENG.

Siddons, Mrs.

Circa 1800. Half length, nearly identical in arrangement with the N.G. picture—the locks of hair only slightly indicated, the fichu not crossed, no necklace, cloak not over shoulder.

ENG. BY C. TURNER, 1826.

Siddons, Mrs. [Ex James Cowen, Esq., Paisley.]

50×40. Seated to left, nearly to feet. Nearly profile. Left arm outstretched as if beckoning. Short black cape over white dress. Right arm on shawl, which lies on bank.

Siddons, Mrs.

Portrait sold at the Blakeslee sale, in New York, April 11, 1902, for £3541.

Siddons, Mrs. Henry. Wife of Mrs Siddons' elder son. Actress and Theatrical Manageress. [W. Macqueen. Scottish Port. Loan Exhibition, 1884.]

29½×24½. To waist, standing. Dark hair and complexion. Bare arms and neck. Purple dress. Ascription to Lawrence doubtful.

Siddons, Maria (1779–98). Second daughter of Mrs Siddons. Engaged to Lawrence 1797. Died of consump-

OIL-PORTRAITS

tion at Bath. [Ex. Lord Ronald Sutherland Leveson-Gower. O.M. 1904. Chr. Jan., 1911; 190gs. ? Chr. 1830, G. Morant, 52gs.]

1797. 16¼×11¾. *Oil sketch, unfinished. Head only, three-quarters to right, looking out of picture. Chestnut hair falling over forehead, bound high on head by two bands.*

Siddons, Maria (?).

1797. *Oil sketch. Half length, head only finished. Facing; snake-like locks of hair in wild confusion around forehead. Large dark eyes looking out of picture. The bust only indicated by a few strokes.*

Mez. by G. Clint (private plate). Some copies printed in colour. The copy of the print in the Gott Collection is pencilled "Mrs. Jessop."

Siddons, Maria.

A small picture (15×13) belonging to General Henderson and entitled "Maria Siddons" was sold at Christie's Dec. 20, 1902, for 62gs. It reappeared at the Huth sale, May 20, 1905. It represented a black-haired young lady in the costume of 1815-20. Cf. last two entries under Anonymous Portraits.

Siddons, Sarah (1775-1803). "Sally," eldest daughter of Mrs. Siddons.

1797-98. *Half length, seated, facing. Right arm over back of chair. Dark hair in loose locks over forehead. Head only finished. Possibly represents Maria.*

Eng. by J. Thomson for "The Gem," 1832.

Siddons, Sarah (Sally) (?). [Wallace Collection.]

29½×24½. *Feigned oval. To waist; looking to right. Brown dress open below neck. Blue satin. Hair bound high on head by dark band and falling over forehead. The identification with Sally Siddons appears to be doubtful. Cf. "Martima," Anonymous Portraits.*

Siddons, Sarah (Sally). [Duke of Bedford, Woburn. B.I. 1830.]

Circa 1797. *Oval, 28×33. To below waist. Facing, and looking out of picture. Plain white dress with high waists. Short sleeves. Pink and orange scarf round neck. Body inclined to right. Blue sky background.*

Siddons, Sarah (Sally). [Chr. 1863, Bicknell sale; 140gs.]

30×24½. *Waagen praises a portrait of Mrs. Siddons, by Lawrence, in the Bicknell Collection.*

Mr. Robert Rankin lent a portrait of "Sarah, daughter of Mrs. Siddons," by Lawrence, to the Liverpool Art Club in 1881.

Simpson, Miss. Daughter of John Simpson. Married 1796 to Sir Th. Liddell (created Baron Ravensworth 1821). [Major Fisher-Rowe, Thorncombe, Guildford.]

In white muslin.

Simpson, Mrs. [S. R. Avery.]

Sinclair, Rt. Hon. Sir John, Bart., of Ulbster (1754-1835). Politician and agriculturist. Baronet 1786. Drew up "Statistical Account of Scotland" 1791-9. Made many improvements in Scottish agriculture. [Sir J. Sinclair, M.P. Scottish National Portrait Exhib. 1884.]

1787-90. 28½×23. *Seated, nearly half length, looking round to left. Long hair or wig brushed out at side and tied behind. Right arm resting on book—"History of the Revenue." Raeburn painted a famous portrait of this gentleman.*

Eng. by W. Skelton, 1790.

Smirke, Robert, Jun. (1781-1867). Sir Robert Smirke, architect. Son of the painter of the same name (who died in 1845). Designed British Museum and General Post Office. Knighted 1832. [Chr. June, 1831. Lawrence's Exors.]

Smith, Sir Sidney (1765-1840). The hero of Acre. Served in early life with Sweden against Russia. With Lord Hood at surrender of Toulon in 1793. Wounded at battle of Alexandria. Sir Sidney was associated with Lawrence in the "Delicate Investigation." [Lent by Mr. John Anderdon to Manchester, 1857.]

As a young man.

Soane, Sir John, R.A. (1753-1837). Architect. Pupil of George Dance. Architect to the Bank of England. Bequeathed his house in Lincoln's Inn Fields, with its contents, to the nation. [Soane Museum. Lent by Sir John to B.I. 1830.]

R.A. 1829, but perhaps painted somewhat earlier. Seated in arm-chair, nearly full length. Facing, looking out. Short dark curly hair or wig. Left hand, with spectacles, rests on arm of chair. Legs crossed. Knee-breeches and black silk stockings; dark clothes, with loose white necktie. In part unfinished.

Eng. by Ch. Turner, 1830.

Sondes, Lord, Lewis Monson (died 1795). Second son of John, 1st Lord Monson. Created Baron Sondes 1760; or possibly Lewis Thomas Watson, 2nd Lord Sondes (died 1806).

Circa 1790. *Lawrence received 30gs. for a portrait of Lord Sondes not long after his settling in London.*

163

SIR THOMAS LAWRENCE, P.R.A.

Sondes, Lady. Probably Frances, daughter of Rt. Hon. Henry Palham. Married, 1752, to 1st Lord Sondes, who died 1795 ; or possibly Mary Elizabeth Miller, wife of 2nd Lord Sondes, whom she married in 1785.

Circa 1790. Lawrence received 30gs. for a portrait of Lady Sondes soon after his arrival in London.

Sophia, Princess (1777–1848). Daughter of George III. Died unmarried. [Windsor Castle ?]

R.A. 1825. Painted for her brother, George IV.

Sophia, Princess (1777–1848).

A portrait of this lady, ascribed to Lawrence, was sold at Robinson and Fisher's, June 27, 1901, for 245gs.

Sotheby, William (1757–1833). Poet; translator of Virgil and Homer. Friend of Sir Walter Scott. [Colonel Sotheby. S.K. 1868.]

1800–10. 20×16. Bust. Nearly facing, looking round to right. Unfinished. Scanty grey hair. Elaborate collar to coat.

ENG. BY F. C. LEWIS (after a drawing).

Sotheran, Admiral Frank, M.P. (1765 ?–1839).

Circa 1809. To below waist, facing, head a little to left. Naval uniform. Right hand resting on sword.

MEZ. BY CH. TURNER, 1839.

Southey, Robert (1774–1843). The poet and historian. Born at Bristol. Lived at Keswick from 1804 till his death. [Sir Robert Peel, Bart. Graves' Gall. 1908. Chr. 1909 ; 780gs.]

R.A. 1829. Seated, facing, almost full length. One knee over the other. Head and eyes slightly to left. Abundant greyish hair, flying free ; slight dark whiskers, hazel eyes, aquiline nose. Loose brown tie and brown coat. Note-book and pencil on extreme right. Painted for Sir Robert Peel in 1828.

Spencer, George John, 2nd Earl (1758–1834). Succeeded his father in 1783.

Circa 1790. Lawrence received 30gs. for a picture of this nobleman soon after he came up to London. In the Lawrence sale at Christie's, May 18, 1831, a portrait of Earl Spencer. "half-length, unfinished." sold for 21gs.

Stafford, George Granville, 2nd Marquess of (1758–1833). Ambassador to Paris 1790–2. Baron Gower 1798. Obtained Sutherland estates through his wife and Bridgewater estates from his uncle. Succeeded his father as Marquess of Stafford 1803.

164

Duke of Sutherland 1833. [Duke of Sutherland, Stafford House.]

1810–15. Oval, 30×25. Nearly half length, head turned to left. Dark hair over forehead. Frilled shirt.

ENG. BY S. W. REYNOLDS.
„ W. WALKER, 1839.

Stafford, Elizabeth, Marchioness of. Countess of Sutherland in her own right. Later Duchess of Sutherland. Married, 1785, to 2nd Marquess of Stafford. Died 1839. [Duke of Sutherland, Stafford House.]

R.A. 1816. Seated, half length, a little to left, head facing. Black cap with tassels falling to right. Low dress. Jewel on breast fastened over white fur boa.

ENG. BY DEAN, 1831, AND BY H. MEYER.

Standish, Master. [Lord Allendale, Bywell Hall.]

Stanley, Lord. See Derby, Earl of.

Stanley, Edward Smith. See Derby, 13th Earl of.

Stanley, Edward Geoffrey. See Derby, 14th Earl of.

Stanley, Charlotte Margaret, Lady (1776–1817). Daughter of the Rev. Geoffrey Hornby. Married, 1798, to her cousin, Edward Smith Stanley, afterwards 13th Earl of Derby. [Earl of Derby. S.K. 1868.]

30×25. To waist, seated, slightly to right, but head to left. Short sleeves, small frill round neck. Narrow black girdle, edged with gold. Sky background.

Stanley, Lady Mary Margaret. See Wilton, Countess of.

Stephens, Catherine (1794–1882). Singer and actress. Sung at Covent Garden in "Artaxerxes," 1813. Married to 5th Earl of Essex, 1838. [Jean Dollfuss Sale, Paris, May, 1912, £1000.]

Circa 1813. 31×25. Seated, three-quarters to right. Head supported on right hand. Chesnut hair in buckles over forehead. Low cut red satin robe. Holds in left hand MS. of the opera "Artaxerxes."

Stewart, Lady Catherine, with her Son Frederick. Youngest daughter of John, 3rd Earl of Darnley. Married, 1804, to Sir Charles Stewart (later 3rd Marquess of Londonderry). Frederick Stewart became, in 1854, 4th Marquess of Londonderry. [Marquess of Londonderry, Mount Stewart.]

Circa 1807. 92×54. Full length, kneeling with right knee on a stool. Playing on a table organ. White silk or satin dress ; blue and yellow robe over right knee. The child naked, sitting on a parapet behind her.

OIL-PORTRAITS

Stewart, Sir Charles. See Londonderry, 3rd Marquess of.

Stewart, Lord. See Londonderry, 3rd Marquess of.

Stewart, Hon. Frederick (1805-72). Son of Lord Stewart, afterwards 3rd Marquess of Londonderry. Succeeded as 4th Marquess 1854. [R. Hib. Acad. 1902 ; Chr. April 25, 1903 ; 565gs.]

R.A. 1010. Oval, 28 × 22½.' A young lad in red fur-trimmed coat, white collar. Lord Stewart, writing from Vienna, directed that his son should be brought up from Eton to sit to Lawrence.
See also under Londonderry.

Stonestreet, G. Director of Phœnix Assurance. [Phœnix Assurance Company, Lombard Street.]
R.A. 1802. Painted for the Company.

Storr, Miss, of Blackheath. [Chr. May 7, 1904, S. H. Fraser Collection ; 270gs. Again, July 5, 1908, 200gs.]
About 1820. 28½ × 24½. Half length, facing a little to right, but looking a little to left, in elaborate curls. Boa over left shoulder. White dress and pink and yellow cloak over right arm. Ascription doubtful.

Stowell, William Scott, Baron, F.R.S. (1745-1836). Born near Newcastle, elder brother of Lord Eldon. Friend of Dr. Johnson, whom he accompanied during part of his Scotch tour. Held many legal posts. Raised to peerage 1821. [Sir Robert Peel. Graves' Gallery, 1908.]
R.A. 1824. Seated, facing, nearly full length ; head turned to left. Large retreating forehead, with scanty grey hair and loose, hanging cheeks of very old man. Right hand passed under coat and left resting on arm of chair. Red curtain to left.

Strachan, Mrs., or Stratton, Mrs. [Chr. May 13, 1899 ; 290gs.]
29½ × 20½. Small whole length. Seated on arm of crimson chair, with Newfoundland dog at her side. Black dress and white searf. Perhaps to be identified with the Mrs. Stratton engraved by Ch. Turner (q.v.).
" Purchased by W. Hill from Mr. Evans, a pupil of Lawrence," says Sale Catalogue.

Strange, Sir Thomas (1756-1841). Son of the engraver. Recorder, and later Chief Justice of Madras. Wrote on Hindu law. [Government House, Madras.]
Full length, facing, looking round to left. Paper in left hand. In official robes, of clerical character ; bands and tippet over long gown.
MEZ. BY CH. TURNER, 1820.

Stratton, Mrs. G. F., or Strachan. " Lady and Dog."
R.A. 1811. Full length, seated on couch. In black velvet dress bound by sash under bosom. Right arm outstretched with hand resting on Newfoundland dog, who places paw on her knee.
ENG. BY CH. TURNER, 1813 (private plate).

Stuart, General James (1741-1815). Served in the American War. Took Ceylon from the Dutch 1796. Commander-in-Chief at Madras 1801.
R.A. 1801. To below waist, facing, head turned to right. Short rough hair. Military coat. Right hand resting on sword.
MEZ. BY G. CLINT, 1802.

Suffolk, John Howard, 15th Earl of, and 8th Earl of Berkshire (1739-1820). Born at Tralee. General officer in the Army. [Earl of Suffolk, Charlton Park. O.M. 1870.]
R.A. 1818. 50½ × 40. Waagen says that he saw " a good male portrait by Lawrence " at Charlton Park. Henry Bone made an enamel copy of a picture of the Earl of Suffolk by Lawrence.

Surrey, Countess of. See Norfolk, Charlotte, Duchess of.

Sutherland, Duke of. See Stafford, Marquess of.

Sutherland, Elizabeth, Duchess of (wife of 1st Duke). See Stafford, Marchioness of.

Sutherland, Harriet, Duchess of (wife of 2nd Duke). See Gower, Harriet, Countess.

Tabley, Lady de. See Leicester, Lady.

Talbot, the Sons of Lord G.
1792-6. Lawrence received 60gs. for a picture so described.

Tasker, Mr. " Of the East India Company."
R.A. 1790. No. 268, as " Portrait of an Officer."

Taylor, Gen. Sir Henry. [Gimpel and Wildenstein, Paris.]

Taylor, John, F.R.S.
1810-15. Nearly a full length. Seated, a little to left, looking out of picture. One hand grasping the other ; left elbow on table. White cravat, with frilled shirt-front. Nearly bald.
MEZ. BY CH. TURNER, 1831.
LITHO. (head only) BY " W.D."

165

SIR THOMAS LAWRENCE. P. R. A.

Taylor, Thomas (1758–1835). Translator of Plato, Aristotle, etc. Published innumerable essays and translations in support of his mystical, uncritical opinions concerning Orpheus, Pythagoras, the neo-Platonists, etc. He sacrificed a bullock to Zeus in his back parlour! [Chr. May, 1911, n.n.; 460gs.]
R.A. 1812. 49×39¼. In black dress, with white stock, seated on a couch, resting his right hand upon a table, a volume of Plato by his side. Close-cropped black hair. Distant view of Acropolis to left.
[The portrait of Taylor, by Lawrence, in the Academy in 1812 belonged later to Lawrence's relation, William Meredith.]

Tchernichef. See Czernitschef.

Templetown, Lady. Lady Mary Montagu, daughter of the 5th Earl of Sandwich. Married, 1796, John Upton, Baron Templetown, the elder brother of the beautiful Miss Uptons. Died 1824.
R.A. 1802.

Thayer, Miss. [Lent by F. Knight to B.I. 1830.]
R.A. 1813. Seated, a little to left. Head facing. White low dress bound under waist by band. Black spencer with pink lining over shoulders. Dark locks over forehead.
MEZ. BY E. W. WEHRSCHMIDT, 1899.

Thellusson, Mrs. C., and Child.
R.A. 1804. Probably the wife of some member of the famous banking firm " Thellusson Brothers."

Thomond, Marquess of. See Inchiquin, Earl of.

Thomond, Marchioness of. See Inchiquin, Countess of.

Thompson, Mr.
R.A. 1798.

Thompson, Mrs. Sophia. Wife of Robert Thompson, of the Priory, Malvern. [Chr. May 12, 1912, 280gs.]
25¼×27¼. Seated, resting right arm upon crimson cushion. White muslin dress, low at neck, and long sleeves. Gold chain and bracelets. Foliage and sky background.

Thornton, Mrs. Stephen. Mary, daughter of Thomas Littledale, of Rotterdam. Born 1775. Married Stephen Thornton, Director of Bank of England.
About 1810. Seated to left ; turning round and looking out of picture. Hair in short curls over forehead. Right arm resting on rock. Scarf over upper part of arm. Dark dress with high waist. Flowers on bosom. Landscape to left.
MEZ. BY H. SCOTT BRIDGWATER.

166

Thurlow, Edward, 1st Baron (1731–1806). Famous lawyer. Supporter of Constitutional rights and Royal prerogative. Made Chancellor 1778. Presided at trial of Warren Hastings. " No man could be as wise as Lord Thurlow looked."
R.A. 1803. " Painted in 37 hours of continuous work," says Cunningham. At Carlton House in 1824. (See Westmacott, " British Galleries.") A portrait in the Private Apartments at Windsor Castle is probably of later origin. An unfinished portrait of Lord Thurlow was in the Lawrence sale, June, 1831.

Torrens, Major-General Sir Henry, K.C.B. (1779–1828). Served during the Revolutionary Wars and the whole of the Peninsular campaign.
R.A. 1816. Standing, full length, facing, head a little to right. Military uniform, with orders and medals. Plumed cocked hat in right hand. Landscape to right, with castle.
MEZ. BY CH. TURNER.

Towry, Mrs. (or **Dowry**). Wife of Captain Towry (1767–1809). Mother of the 1st Lady Ellenborough. [Chr. Ellenborough sale, May, 1895 ; 525gs.]

Tracy, Rev. John, Viscount, of Rathcode, D.D. (1722–93). Warden of All Souls. Succeeded as 7th Viscount 1792. [Oxford, All Souls College. " Hist. Portraits," 1906.]
Circa 1790. 29×23½. Nearly to waist, seated, facing and looking out. In wig and college gown. Red curtain background. One of the best of Lawrence's early pictures.
ENG. BY CH. KNIGHT (private plate).

Trimleston, Mrs. [Chr. June 4, 1904, Orrock sale, 1500gs.]
88×58. Whole length. In white dress with coloured scarf, walking, in landscape, carrying parasol.

Trimmer, Mrs. Sarah (1741–1810). Daughter of J. J. Kirby. Wrote on educational and religious subjects. Praised by Dr. Johnson. [Christie's, March, 1908 ; 138gs.]
About 1800. 30×25. Elderly lady. Facing ; to waist. In high-topped white muslin mob-cap, and white fichu passing round chin. Dark grey eyes staring out of picture. Brown dress only indicated.

Tritton, Mr.
Circa 1810. To below waist. Standing, left arm on parapet. Tall beaver hat in right hand. Close-buttoned dress coat. Landscape background.
MEZ. BY W. SAY.

Twiss, Mrs. Frances Kemble, sister of Mrs. Siddons, with whom she acted in the *Morning Bride*, etc. Married

OIL-PORTRAITS

Twiss, the Shakespeare scholar. [Mr. A. L. Dowie, Loan Exhibition, Edinburgh, 1883; catalogued as "Fanny Kemble, sister of Mrs. Siddons."]
R.A. 1800.

Tyrell, Mrs. [Sedelmeyer sale, Paris, May, 1907; £255. Catalogued as "In the possession of the Tyrell family since 1803" (?).]
About 1810. 30×25. *Half length, three-quarters to right. One hand folded over the other. Brown hair loose over forehead and bound over top of head by fillet. Red dress with frilled white collar. Landscape background.*

Upton, Hon. Caroline. Daughter of the 1st Baron Templetown. Married, 1804, to James Singleton. Died 1862. [Ex Viscount Templetown. Rutley's, May, 1911; 2700gs.]
R.A. 1801. *Oval, 26½×21½ Profile to left. Black velvet band round head. Plain gold bracelet on upper right arm. Dark brown hair, loosely curled on top of head. After his repulse by Sally Siddons, Lawrence is said to have found consolation in the society of the beautiful Miss Upton.*

Upton, Hon. Sophia. Sister of preceding. [Ex Lord Templetown. Rutley's, May, 1911; 1800gs.]
R.A. 1801. *Oval, 25½×20½. Facing to right; head turned and looking out. High waist. Holly in hair, which is loosely coiled on top of head.*

Upton, Hon. Sophia. [Ex Lord Templetown. Rutley's, May, 1911; 210gs.]
Circa 1800. *Facing; high waist. Hair loosely coiled on top of head. Unfinished background. Probably a study for the last, to which it is very superior in artistic merit.*

Vallecourt, Lady. Perhaps an error for Valletort, Lady, widow of Lord Valletort, eldest son of Earl of Mount Edgcumbe, who died 1818.
"A fine late portrait."

Valletort, Lord. Probably Richard, son of the 1st Earl of Mount Edgcumbe, 1764–1839. Succeeded to Earldom in 1795.
Circa 1790. *Lawrence obtained 25gs. for a portrait of Lord Valletort soon after coming to London.*

Vane, Lady Alexandra. Daughter of 3rd Marquess of Londonderry. Married, 1847, to the 4th Earl of Portarlington; died 1874. [Marquess of Londonderry.]
30×25. *As a child, in white dress.*

Vansittart, Nicholas. See Bexley, Baron.

Vaughan, Rt. Hon. Charles Richard (1774–1849). Traveller. Friend of Sir Charles Stewart. Held diplomatic posts in Switzerland and Spain. Minister at Washington 1825–35. [Oxford, All Souls Coll. "Hist. Portraits," 1906.]
1810–15. 41×31½ (*panel*). *Half length, seated, facing. Hands folded. Frilled shirt; fur-lined coat collar. Short dark hair.*
MEZ. BY S. COUSINS.

Visme, Miss Emily de. Married to General Sir Henry Murray, K.C.B. [Ex Miss G. L. Murray. Chr. June 25, 1904; 1050gs.]
Early. 50×40. *Girl of 8 to 10, full length, facing, sitting on bank. Left arm raised and pushing hat back from head. Hat trimmed with red ribbon. White frock, red sash. Landscape.*
ENG. BY W. BOND, 1794, as "The Woodland Maid." *Printed in colour, with lines from Thomson.*

Vyner, Lady Theodosia. [R. C. Vyner, Esq., Newby Hall.]
R.A. 1791. 50×40 (*about*). "*No. 75. A Lady of Quality,*" *in R.A. Catalogue. Three-quarter length, seated, facing to right. Powdered hair. White dress, black sash. Lawrence received 30gs. for this portrait. This portrait, apparently not quite finished, strongly recalls Romney's work.*

Wall, C. Baring. Grandson of Sir Francis Baring, Bart. [Lent to B.I. 1843 by C. Baring Wall, M.P.]
Probably the same boy is seen in the group of Sir Thomas Baring's family (q.v.).

Wallscourt, Lady (died 1877). Elizabeth, only daughter of William Locke, of Norbury. Married, 1822, 3rd Baron Wallscourt. [Lord Wallscourt.]
R.A. 1826. *Half length, facing, seated, playing guitar. Dark hair in short loose curls.*
ENG. BY W. ENSOM, in "Bijou" of 1829.
MEZ. BY G. H. PHILLIPS, 1839.

Wallscourt, Lady. [C. Sedelmeyer, Paris. École des Beaux Arts, 1897.]

Warde, John, of Squerries (1764–1834). Collector of Customs at Cowes and Dover. [Colonel Warde, Squerries, Westerham.]
Circa 1790. *Seated. Nearly whole length, looking to left. Right elbow on table to right. Right hand holding paper; left arm hanging over side of chair. In wig and knee-breeches.*
MEZ. BY J. GROZER.

167

SIR THOMAS LAWRENCE, P. R. A.

Watson, Dr. Richard. Bishop of Llandaff (1737–1816). Professor of Chemistry at Cambridge. Experimented with thermometers. Made improvements in manufacture of gunpowder. Bishop 1782. Defended Christianity against Gibbon and Payne. *R.A.* 1794.

Watson, Lady. See Copley, Miss Juliana.

Watt, James (1736–1819). Born at Greenock. Mathematical instrument maker at Glasgow. Experimented on properties of steam. Improved Newcomen's steam-engine. First patent for steam-engine 1769. [M. P. W. Boulton. S.K. 1867.]

R.A. 1813. 54×43. *At the age of 76. Seated, nearly full length, to right, looking out of picture. Natural white hair. Knees crossed. Right hand resting on papers on table. Snuff-box in left.* MEZ. BY CH. TURNER, 1815.

Watts, Mr. 1785–90. *Lawrence received 15gs. for a portrait of Mr. Watts about the time of his first arrival in London, in 1787, or perhaps earlier.*

Webster, Lady. Probably the wife of Godfrey Vassall Webster, M.P. for Sussex (died 1836), the son of the Lady Webster who, after her divorce, became Lady Holland. [Sir Augustus Webster, Battle Abbey.]

1810–15. *Head and neck only, appearing in an opening of a mass of clouds. To right, but head facing and eyes turned archly to left. Mass of loose, dark hair over forehead.*

Wellesley, Richard, Marquess (1760–1842). Son of 1st Earl of Mornington. Elder brother of Duke of Wellington. Governor - General of India 1797. Consolidated English supremacy in Southern India. Mahratta War 1803–4. Lord-Lieutenant in Ireland 1821–8, and again 1833–4. [The Castle, Dublin. Dublin Portrait Exhibition, 1872.]

R.A. 1813. *Seated, nearly full length, facing, looking out of picture. Short white hair, dark eyebrows. Frilled shirt-front. Ribbon and Star of Garter.* MEZ. BY CH. TURNER, 1815.
 S. COUSINS, 1842 (bust only).

Wellesley, Richard, Marquess. [Windsor Castle. Presented by the Marquess to Queen Victoria.]

1813. 50½×40½. *Seated, nearly full length; facing. Short white hair; dark, straight eyebrows. White cravat*

168

and frilled shirt-front. Loosely folded coat and overcoat: wears the " George " and the Garter. Hands outstretched on either side, resting on chair-arm and table. Curtain background, with sky to right.

Wellesley, Richard, Marquess. [Provost's Lodge, Eton College.]

Copy or replica of the last. (Lord Wellesley is buried at Eton.)

Wellesley, Hon. Richard (1787–1831). Son of preceding. At Eton 1800–5. Died before his father. [Provost's Lodge, Eton College.]

36×28. *As young man. To waist, facing, looking to left. Hair over forehead. Right arm outstretched. Dark coat and background.*

Wellesley, Marianne, Marchioness (died 1853). Daughter of Richard Caton, of U.S.A. Married (1) to Robert Paterson, whose sister was Jerome Bonaparte's wife; (2) to Richard, Marquess Wellesley. She was a Roman Catholic, and a " woman of wealth, beauty, and refinement." [Duke of Wellington. S.K. 1868.]

30×25. *To waist, seated, turned to right. Low white dress, left hand raised to shoulder. The lady must have been Mrs. Paterson when Lawrence painted this portrait.*

Wellesley, Mrs. Richard. [B. Altman, Esq., New York. Ex Sir W. Dalby.] *Whole length.*

Wellington, Arthur Wellesley, Duke of (1769–1852). 5th son of 1st Earl of Mornington. [Earl Bathurst.]

R.A. 1818. *Equestrian portrait, life-size and full length; in the costume he wore at Waterloo. Mounted on Copenhagen. Painted for third Earl Bathurst. Miss Croft says that the riding-master at Astley's mounted Copenhagen for Lawrence when this picture was being painted.* ENG. BY W. BROMLEY, 1830.

Wellington, Arthur, Duke of. [Ex Angerstein Collection. Chr. 1896; 180gs.]

55×38. *Mounted on Copenhagen ; in the uniform worn at Waterloo. Possibly the small replica of the Bathurst picture which was in the Lawrence sale, 1831.*

Wellington, Arthur, Duke of. [Windsor Castle, Waterloo Gallery. B.I. 1830.]

R.A. 1815. *Standing under archway, holding sword of State wrapped in flag. Red coat with black ribbon and orders. Facing, head a little to left. In background the façade of St. Paul's, in allusion to the public thanksgiving.* ENG. BY W. BROMLEY, 1818.

OIL-PORTRAITS

Wellington, Arthur, Duke of.
Half length, standing, facing. Cloak over right shoulder. Right hand on left elbow. Tents of camp to left.
ENG. BY T. LYALL, "After Lawrence and Evans" (Lodge's Portraits, 1834).

Wellington, Arthur, Duke of. [Duke of Wellington, Strathfieldsaye? S.K. 1868.]
36×28. To waist, nearly full face, standing. Arms folded. Military uniform. Ribbon of Garter.

Wellington, Arthur, Duke of. [Chr. May, 1897; 380gs.]
50×40. Standing, to right, in landscape. In black coat with blue lining and white waistcoat.
"Presented to owner's family by the 2nd Duke about 1832."
This is apparently the portrait bequeathed by the 2nd Duke to the Marchioness Wellesley.
(?) ENG. BY SAMUEL COUSINS.

Wellington, Arthur, Duke of. [Marquess of Londonderry.]
Lawrence, writing in 1827, says: "For Lord Londonderry . . . I painted my first portrait of the Duke of Wellington."

Wellington, Arthur, Duke of. [Wellington College. Robinson and Fisher, Nov., 1909; 2000gs. [Ex Sir Robert Peel, Bart. B.I. 1830; Victorian Exhibition, 1891–2; Graves' Gall., 1908.]
R.A. 1825. 95×55. Full length, facing. Blue military frock. Arms loosely crossed, holding telescope. Black cape, clasped under chin, white lining visible. Low horizon, with sunset effect.
ENG. BY S. COUSINS (?).

Wellington, Arthur, Duke of. [General Arbuthnot. B.I. 1865. Chr. Arbuthnot sale, 1878; 815gs.]
R.A. 1822. Nearly half length, with cloak over shoulder.

Wellington, Arthur, Duke of.
R.A. 1822 (?). Nearly half length, head facing three-quarters left. Right hand free of cloak, which is thrown over shoulder. White stock. This description is taken from the engravings here quoted, which agree with the Arbuthnot portrait.
ENG. BY S. COUSINS (1828), W. DEAN TAYLOR (1827), DAVID LUCAS (1828), and many others.

Wellington, Arthur, Duke of. [Sir George Donaldson.]
Nearly half length. In dark civilian costume. Facing, looking out. Loose white stock and tall thick collar. Short hair in thin greyish locks. Coat, etc., only rubbed in.

Wellington, Arthur, Duke of. [Earl of Rosebery. O.M. 1896.]
29×24. Half length, a little to left, looking out of picture. Black coat and white waistcoat. Dark background.

Wellington, Arthur, Duke of. [Earl of Jersey, Middleton Park.]
1825–30. 38×30. Half length. Nearly full face. Greyish hair. Black collar and white cravat. The figure to the elbows only indicated in brown. This picture was painted for Sarah, Countess of Jersey, who would not allow it to be "finished" after Lawrence's death. It is one of the painter's best works.

Wellington, Arthur, Duke of. [R. Napier, of Shandon. Lawrence sale, 1831.]
Full length, partly painted by J. Simpson.

Wellington, Catherine Pakenham, Duchess of. Daughter of 2nd Lord Longford. Married 1806, having been engaged to Arthur Wellesley ever since 1793. [Chr. July, 1908, n.n.; 240gs. Again, May, 1910; 180gs.]
1814–15. 24½×20½. Bust, facing. Dark hair over forehead, one lock over right eyebrow. Dark purple dress and frilled collar.

West, Benjamin, P.R.A. (1738–1820). Born in Pennsylvania of Quaker parents. After three years in Italy, came to England 1763. Much patronized by George III. P.R.A. on death of Reynolds in 1792. [National Gallery. Presented by William IV, 1836; lent by King to B.I. 1830 and 1833.]
R.A. 1821 (?). Painted 1811. 106×60. As an old man, in his studio, full length. On the easel a sketch of Raphael's cartoon, "The Death of Ananias."
ENG. BY C. ROLLS.

West, Benjamin, P.R.A. [Painted for the American Academy of Fine Arts.]
Full length. "Delivering his last lecture on Colour to the Royal Academy."

West, Benjamin, P.R.A. [Castle Smith, Esq.]
About 1810. Seated, half length, facing, looking out. Left hand, holding spectacles, on table. Wrapped in cloak. Bald head. Window to left.
ENG. BY H. MEYER, 1813, AND BY S. W. REYNOLDS.

West, Benjamin, P.R.A. [J. H. Anderdon, Esq. S.K. 1868; O.M. 1877. Chr. June, 1830, Lawrence's Exors., 21gs.; Nov., 1912, 90gs.]
Panel, oval, 30×24. Head, turned round and looking out, resting on left hand. Unfinished, only head and collar of coat rubbed in.

West, Miss. Married later to William Woodgate, of Somerhill. [Agnew's

169

SIR THOMAS LAWRENCE, P. R. A.

Gallery, 1907. Christie's, February, 1907; 4000gs.]

Circa 1820. 29×24. *Half length, facing, looking out of picture. Black hair in short curls over forehead; dark blue eyes. Long sleeves full at shoulder. White dress with pink scarf loosely tied round neck; blue sash round waist: holding a watch in right hand. Background of foliage and landscape.*
MEZ. BY NORMAN HIRST, 1908.

Westminster, Marchioness of. See Belgrave, Lady Elizabeth.

Westmorland, John Fane, 10th Earl of (1759-1841). Early friend of Pitt. Lord Lieutenant of Ireland 1790. Lord Privy Seal 1798-1827. [Sir Spencer Ponsonby Fane, K.C.B. Guelph Exhibition, 1891.]

1807. 36×28. *Half length, to left, looking out of picture. Brown coat. Landscape background.*
MEZ. BY S. W. REYNOLDS.
„ S. COUSINS, 1825.

Westmorland, Priscilla Anne, Countess of, and Child. Painted when she was Lady Burghersh. Daughter of 4th Earl of Mornington. [Apethorpe, Peterborough? B.I. 1833.]

Circa 1820. *A child of about 2 fills the centre of the canvas. She prances in her mother's lap, with left arm raised. To right, the mother's head only shows, in lace cap tied under chin.*
ENG. BY G. LONGHI, Milan, 1823 (with Italian lettering).

Wheatley, Lady. Wife of Major-General Sir Henry Wheatley. [In New York. Ex Colonel Moreton Wheatley. Lent to Whitechapel 1906.]

1815. 36×28. *Half length, seated, three-quarters to right, but looking out of picture. Brown hair over forehead. Long sleeves full at shoulders. Landscape background.*

Whitbread, Samuel (1758-1815). Politician. Follower of Fox. Supporter of Queen Caroline. Interested in rebuilding of Drury Lane theatre. Died by his own hand.

R.A. 1793. *" Portrait of a Gentleman." Said by contemporary paper to be " Mr. Whitbread, junr."*

Whitbread, Lady Elizabeth. Eldest daughter of 1st Earl Grey. Married to Samuel Whitbread. Died 1846. [Agnew's Gallery, 1906. Chr. July, 1905; 2000gs.]

Circa 1795. 30×25. *Half length, seated, facing, and looking out of picture. In black dress with white muslin trimmings to bodice and sleeve. Powdered hair, bound with white kerchief. Resting chin on right hand. Landscape to left.*

170

Whitworth, Charles, Earl. (1752-1825). Minister in Poland (1785-9), Petersburg (1789-1800), Ambassador to Napoleon (1802), Lord Lieut. of Ireland, 1813-17. [Louvre. Sackville Bale sale, Chr. 1881; 350gs.]

Standing, almost to knees, facing. *Head three-quarters to right. Ribbon and Star of the Bath.*
MEZ. BY CH. TURNER, 1814.

Whitworth, Charles, Earl. [Lent to B.I. 1862 by Sir Ch. Russell, Bart.]

Said in the B.I. Catalogue to have been painted in conjunction with Sir David Wilkie.
A portrait of Lord Whitworth, " in his robes," was in the Lawrence sale, June, 1831.

Wigram, Sir Robert. First Baronet. " M.P. for Wexford in the first Imperial Parliament."

1803 (?). *Nearly to waist: seated at table, a little to right, looking out. Right hand on table, with papers " E.I.D. 1803." Elderly man in knee-breeches and white frilled cravat.*
ENG. BY J. H. WATT, 1833.

Wigram, Lady. Eleanor Watts, second wife of Sir Robert Wigram, 1st Bart. Married 1787; died 1841. [Lent to B.I. 1830 by Sir Thomas Wigram.]

R.A. 1816. *Seated, full length, on couch, three-quarters to left; head facing. Lady of about 45 in white turban. Black velvet dress, cut square in front, with lace collar. Persian shawl over right shoulder, falls down in front. Landscape to left.*
MEZ. BY CH. TURNER.

Wilberforce, William (1759-1833). Born at Hull. Intimate with Pitt at Cambridge. Efforts for social reform from 1787. Associated with Sharpe and Clarkson in abolition of slave trade. [National Portrait Gallery. Presented 1857 by Exors. of Sir Robert Inglis.]

38×43. *Head only finished, facing. Seated, half length. Leaning over chair, head on one side. Spectacles in right hand. Collar of coat and cravat sketched in oil: the rest outlined in black chalk on drab-coloured canvas. A late work.*
An anonymous engraving.

William IV, as Duke of Clarence (1765-1837). Entered Royal Navy 1778, Post Captain 1786. Made Duke of Clarence, etc., 1789; Admiral of the Fleet in 1811; Lord High Admiral 1827. Married, 1818, Adelaide, daughter of Prince of Saxe Meiningen. [Lord de l'Isle and Dudley. B.I. 1846; Guelph Exhibition, 1891.]

R.A. 1793 (No. 63). 50×40. *Standing, to knees; facing. In blue coat and white waistcoat; Star of Garter. Glove and stick in left hand. Hat in right. Sea and rock in background.*

OIL-PORTRAITS

William IV, as Duke of Clarence. [Miss FitzClarence.]
1793. 50×40. Standing, to knees, facing and looking to left; left hand, holding gloves, resting on cane. Hat in right hand. Blue coat with stock on breast. Hair loosely dressed with a little powder. Loose white stock.
Similar to Lord de l'Isle's picture.

William IV, as Duke of Clarence. [W. Burdett-Coutts, Esq., M.P.]
1790–5. To knees, standing. Long hair, slightly powdered. Left arm extended. In naval uniform; star on left breast.

William IV, as Duke of Clarence. [Royal Collections. B.I. 1830 (" Lent by Duke of Clarence"); B.I. 1831 (" Lent by King").]
Full length, standing; in civil costume. Open letter in hand and hat under arm. Landscape background.
MEZ. BY J. E. COOMBS [COMBES ?], 1836.

William IV, as Duke of Clarence.
To waist; facing, but head three-quarters to left. Naval uniform with ribbon and star. Longish, powdered hair. Cambric cravat. Probably a drawing.
ENG. BY E. SCOTT, inscribed " Drawn by T. Lawrence from a bust by J. Locker, 1788."

William IV, as Duke of Clarence. [Ex Duke of Cambridge. Chr. June 11, 1904; 41gs.]
55×43. In dark blue coat, white vest, black breeches and stockings. Seated at table, holding book in left hand.

William IV, as Duke of Clarence. [Chr. June, 1830, " His Majesty," Lawrence's Exors., 105gs.]
Body unfinished.

Williams, Mr. [Colonel Moreton Wheatley.]
R.A. 1789. No. 51. Half length, facing a little to right, looking out of picture. Longish white (powdered ?) hair. High cravat, loosely tied. Blackish coat and white waistcoat. Lawrence received 15gs. for a portrait of Mr. Williams about the time of his first arrival in London.

Williams, Mrs. John (née Currie), as St. Cecilia. [Colonel Moreton Wheatley. Guelph Exhib. 1891. Ex. Inigo Williams, of Gwersyllt Park.]
93×57. Seated to right. Right arm resting on side of organ, the hand being raised to her face. Head raised, looking up. Two amorini in left-hand upper corner. Roll of music in left hand. White dress and golden scarf round high waist.
LITHO. BY R. J. LANE (reversed).
The picture, begun about 1806, was long in the artist's studio. " Finished by W. Hilton," says the engraving.

Williams, Mrs. John. [Mrs. Currie.]
R.A. 1804(?). Half length. This was the picture first painted. It did not satisfy Lawrence, who painted the large " St. Cecilia " picture in place of it.

Williams, Mr. Raby.
1785–90. Lawrence received 15gs. for a portrait of Mr. Raby Williams about the time of his arrival in London, or earlier.

Williamson, Mr., " of Jamaica."
R.A. 1789 (Anderdon).

Willis, Francis, D.D. (1718–1807). Took holy orders, but had early practised medicine. Consulted by Royal Family on the King's madness.
Early. Oval. Half length, facing, head three-quarters left. Bald head and white, natural hair. Waistcoat buttoned to chin.
ENG. BY S. MAY, 1792.

Wills, Rev. Thomas, D.D. (1740–1802). Evangelical preacher. Associated with the Countess of Huntingdon at Bath. Preached in various London chapels.
Early portrait. Nearly to waist, seated to right, eyes looking out of picture. White wig and surplice. Stout, elderly man.
ENG. BY H. R. COOK (" Lawrence ad vivum delt "), and later on a larger scale by FITTLER.

Wilton, Countess of. Lady Mary Stanley, daughter of the 12th Earl of Derby by his 2nd wife, Eliza Farren; married, 1821, to Thomas Grosvenor, 2nd Earl of Wilton. Died 1858. [Ex Earl of Wilton. Manchester, 1857; Roussel sale, Paris, March, 1912; £19,140.]
Circa 1820. 57×45. Seated, nearly full length, a little to right, on arm-chair of green velvet, over which her shawl is thrown. Head facing, looking to left; grey eyes. Dark crimson velvet dress with large sleeves with rich Oriental girdle. Jewel on bosom. Dark brown hair, with diamond ornament. Curls over temples. Landscape background with column, and red curtain.
MEZ. BY G. H. PHILLIPS, 1838.

Windham, Rt. Hon. William (1750–1810). M.P. 1784. Active in impeachment of Warren Hastings. Joined Pitt's administration as Secretary for War in 1797. Opposed to the peace in 1801, and resigned. His diary appeared in 1866. [Oxford, University College. S.K. 1867; Guelph Exhib. 1891. " Hist. Portraits," Oxford, 1906.]
R.A. 1803. 50×40. To knees, standing, facing, looking a little to left. Left arm raised and resting on books. Letter in left hand. Rather bald, with greyish hair powdered (?). White waistcoat and frilled shirt front.
MEZ. BY S. W. REYNOLDS.

171

SIR THOMAS LAWRENCE, P.R.A.

Windham, Rt. Hon. William, M.P. [National Portrait Gallery. Lent to Official Residence of the Chancellor of the Exchequer.]

Winterton, Lady Lucy Louisa. [Ex Comte de Ganay.]

1809. 18×14. Head only finished. Bare shoulders sketched in bluish ground. Three-quarters to left, eyes looking more to left. Black wavy hair over forehead; one short lock falling over left shoulder. Dated on back of canvas.

De Ganay sale, Paris, 1906. Photo in Catalogue.

Wolff, Mrs. Wife of the Danish Consul, who had in his house at Battersea a collection of casts from the antique; a meeting-place of artists and literary men. Lawrence was much attached to Mrs. Wolff, and corresponded with her up to the time of her death in 1829. [Mrs. Kimball, Chicago.]

R.A. 1815. Nearly full length, seated to right. In loose white satin robe, left arm over back of chair. Right elbow rests by open book, showing engraving of prophet by Michelangelo. Turban bound by embroidered band. Above, to right, hangs a classical lamp. Antique busts seen to left.

MEZ. BY SAMUEL COUSINS, 1831.

Wood, Mrs.

R.A. 1794. No. 168. "Portrait of a Lady." "Beautiful and well-coloured head," says a contemporary critic.

Wood, Major-General Sir George A. Colonel of R.A. at Waterloo. [Windsor Castle.]

Half length, in uniform.

Woodburn, Samuel. The most prominent dealer of the day in the drawings of the Old Masters. He ransacked the Continent to obtain these drawings, most of which were bought by Lawrence. [Lent by Mr. Woodburn to B.I. 1830.]

Woodford, Sir Ralph, Bart. (1784–1828). Governor of Trinidad. As "His Excellency the late Sir Ralph Woodford, Bart., Governor of Trinidad. Painted for the Hall of the Illustrious Board of Cabildo of that island." [Government House, Trinidad. Removed to London, 1907, for restoration.]

R.A. 1830. Full length, facing; head turned a little to left. Handsome man of about 40; brown hair. Military

uniform; white breeches; cocked hat under left arm; stick in right hand. Sea in background; column to left and red curtain above.

MEZ. BY CH. TURNER, 1829. Half length only. (From a copy of Lawrence's picture by Howard.)

Woodgate, Miss Maria. Daughter of W. Woodgate, of Somerhill, Kent. [James Woodgate Arbuthnot. O.M. 1904.]

29½×24½. In feigned oval. Half length, facing, head turned a little to left. Dark dress, with ruff.

Woodgate, Mrs. William. See West, Miss.

Wooll, Rev. John (1767–1833). From 1807 to 1828 Head Master at Rugby. Raised the school to great eminence. Lawrence was connected with Rugby, through his brother-in-law, Bloxam.

Circa 1812. Half length, seated to left, looking out of picture. Thin grey hair. In college gown, with bands.

MEZ. BY CH. TURNER, 1813.

Worcester, Georgiana, Marchioness of. Daughter of the Hon. Henry Fitzroy. Born about 1793. Married, 1814, to the Marquess of Worcester. [Duke of Wellington. Lent by the Duke to the B.I. 1833. Presented to the 1st Duke by the Marquess of Worcester.]

1817. Nearly to waist. Seated, facing. Hair in ringlets over temples. White, short-waisted, low-cut gown, yellow ribbon round waist. Short full sleeves. Right hand raised to double row of pearls round neck. This is one of the pictures that Lawrence carried with him to Rome.

Worcester, Marchioness of. [Duke of Beaufort, Badminton?]

Woronzoff, Count Michael (1782–1856). Russian statesman and soldier. Educated in England, where his father was long Ambassador. His sister married the Earl of Pembroke. Wounded at Borodino. Led Russian cavalry at Leipsic.

R.A. 1822. Nearly full length, facing. Head turned to right. In military uniform. Cloak over right shoulder. Hands loosely clasped in front over sabre.

ENG. BY S. W. REYNOLDS, 1823. (Inscription in French and Russian.)

Wyatt, Edward.

Standing, to right, looking out of picture. Right hand resting on table on which stands a large silver vase. Hair or wig in curls over ears. Dress-coat buttoned.

ENG. BY JAMES GODLY, 1810.

172

OIL-PORTRAITS

Wyatville, Sir Jeffrey (1766–1840). Nephew of James Wyatt, the architect. Employed from 1824 in transforming and modernizing Windsor Castle. Assumed name of Wyatville. Knighted 1828. [Windsor Castle. B.I. 1830; S.K. 1868.]

1829. Full length, seated by table on which are the plans for the restoration of the Round Tower. Windsor Castle seen through window to right. Sir J. Wyatville lent a " Portrait of an Artist," by Lawrence, to the B.I. 1833.

ENG. BY H. ROBINSON.

Wynn, Sir Watkin Williams, Bart.
Circa 1790. Lawrence received 30gs. for a portrait of Sir Watkin soon after his arrival in London.

Yarnicheff, General. Aide-de-Camp to the Tzar Alexander.

Painted at Aix-la-Chapelle or Vienna, 1818–19.

York, Archbishop of (1807–47). See Harcourt, Edward Venables Vernon.

York, Frederick, Duke of (1763–1827). Second son of George III. Entered army 1780. Created Duke 1784. Commander-in-Chief in Flanders 1794. Served in Holland 1799. [Windsor Castle, Waterloo Gallery. B.I. 1830.]

R.A. 1816. Full length, three-quarters to right. In Field-Marshal's uniform, with Garter Star. Holding cloak across figure.

York, Duke of.
R.A. 1789. Nearly to knees. Facing three-quarters to right. Arm on parapet. In military uniform, with powdered hair. The first royal portrait exhibited by Lawrence.

ENG. BY E. SCOTT. 1789.

York, Duke of. [Earl Temple, Wotten House, Aylesbury.]

30 × 24. Half length. Nearly bald, with a little grey hair. In black coat with velvet collar, a little bit of red waistcoat showing. Black satin stock. Star of the Garter.

York, Duke of. [Merchant Tailors' Hall, Threadneedle Street.]

Full length.

York, Duke of. [M. Ernest May, Paris.]

Half length, facing; head turned three-quarters to right. Large black stock; black coat with heavy collar. Star on left breast.

ENG. BY G. DOO, 1824.

York, Duke of. [Ex Duke of Cambridge. Chr. June 11, 1904; 45gs.]

35 × 27½. Nearly to waist. Facing, head turned to right. High black stock. Military close-buttoned coat and Star of Garter.

York, Duke of.
Facing, nearly to knees. Head and eyes to right. Cloak with Garter badge over left shoulder.

MEZ. BY CH. TURNER, 1830.

York, Duke of.
Nearly half length, looking round to right. Robes of Garter, with chains, etc., thrown over Field-Marshal's uniform. High black stock.

ENG. BY W. FRY. 1822.

There were portraits of the Duke of York in the R.A. 1789, 1814, 1816, and 1822.

In the Lawrence sale, June, 1831, there was "a head intended for the Duke of York, whole length" (sic).

York, Duchess of.
Painted by private subscription, for presentation to the Duke (see " Greville Memoirs," Vol. I, p. 8).

York, Whittell. Magistrate and merchant of Leeds.

Circa 1800. Nearly to waist, facing, looking out of picture. Longish grey hair or wig, curled over ears. Fur-lined coat.

MEZ. BY CH. TURNER, 1814.

Young, Thomas, M.D. (1773–1829). Of a Quaker family. Wrote on theory of light as early as 1799. Professor at R. Institution 1801. Established undulating theory of light. Anticipated Champollion in suggesting how the Egyptian hieroglyphics could be deciphered. [A copy by Brigstock in St. George's Hospital.]

36 × 28. Half length, seated, facing, head slightly turned to left. Spectacles in right hand. Coat buttoned up, white cravat. Eyeglass in coat.

MEZ. BY CH. TURNER, 1830

SIR THOMAS LAWRENCE, P.R.A.

OIL—ANONYMOUS PORTRAITS

"Age of Innocence, The." [Chr. April, 1905, Gabbitas sale, 250gs.]
Circa 1820. 35½ × 27. Little girl of about 4, seated on couch, facing. Very light hair. Rose in right hand, the left on bare foot. Blue and white sash. Red curtain background.

Boy, Head of. [Chr. March 16, 1908.]
23½ × 17½. Sketch of boy of 5 or 6. Light, loose hair brushed over forehead. Face only finished. "Feigned oval" suggested in background.

Boy, Portrait of. [Chr. Feb. 25, 1905.]
Panel. 19½ × 17. Bust, three-quarters to right; looking out. Dark dress with white frilled collar. Short auburn hair. Holding a crayon. Age about 9 or 10.

Boy, Portrait of. [De Ganay Collection; sold Paris, April, 1906.]
Circa 1810. 24 × 20. Boy of about 10. Nearly to waist, facing, looking round to right. Dark short hair brushed over forehead. Large white collar over shoulders. Small black necktie below open neck. Sky background.

Boy, Portrait of. [Ex J. H. Lane, Esq. Chr. Dec. 13th, 1912; 305gs.]
19 × 15. Head of lad; turning round and looking up. Red coat and white frill. Short brown hair.

Boy, Sleeping.
Circle. Child of 3 or 4. Head, resting on pillow, falls over to right. Black curly hair.
Eng. by Henry A. Ogg, 1835.

"Boys' Heads. A Sketch." [Lent by Lord C. Townshend to B.I. 1853.]

"Charity." [Henry Samuel, Esq. "Fair Women" Exhibition, 1894.]

"Child, Head of." [Lent by David Baillie to B.I. 1833.] In the Lawrence sale, Chr. June 17, 1830, a "Head of a Child, Study," was sold for 16gs.

Child, Portrait of. [Ex Sir James Knowles, O.M. 1904.]
17 × 13½. Unfinished oil sketch. Head to left.

Child, Portrait of.
R.A. 1826. No. 396.

Children, Two heads of. [Sold Amsterdam "Müller et Cie," Nov., 1906.]
Girl of 5, facing left, looking up to child of 2, in corner to left. Heads only loosely sketched in. Perhaps to be identified with one of the following in the Lawrence sale. The girl's head resembles one of the Abercorn children.

Children, Heads of. See also under Calmady. In the Lawrence sale,

June 18, 1831, were the following unfinished oil pictures:
No. 71. "Two children embracing, heads only. The group partly made out in chalk." Bought by Lord Ch. Townshend, 195gs.
No. 76. "Two children on one canvas—beautiful sketch," 15gs.
No. 87. "Two heads of children. Part of a group." Bought by Lord Ch. Townshend, 205gs.
One of these may perhaps be connected with "The Proffered Kiss," engraved by G. Doo.

Children, Two young. [Chr. May 29, 1908, n.n.; 380gs.]
With fruit, in a landscape.

Earl, Portrait of an (?). [A. Imbert, Rome.]
Late portrait. 50 × 40. Seated, nearly full length, three-quarters to right, looking out; forearms resting on arms of chair. Rough hair brushed over forehead. Slight whiskers. Apparently in robes of English earl, but only the head finished.

Gentleman, Portrait of a. [Chr. June 17, 1830, Lawrence's Exors., 18gs.]
? R.A. 1787. Described in the sale catalogue as Lawrence's "Second work in oil and the first exhibited."

Gentleman, Portrait of a. [Brussels Museum, Modern Masters. Presented by Charles L. Cardon.]
1810–15. Man of about 30. Half length. Seated behind table on which are books and papers. Resting left cheek on back of hand and looking up to right. Loose cravat and yellow waistcoat. Painted with much impasto. Ascription doubtful.

Gentleman, Portrait of a. [Paris, Louvre. "Don d'un Ami de Bagatelle."]
1805–10. Bust. Three-quarters to right. Eyes looking out. Greyish, rough short hair. Red coat and high fur collar.

Lady, Head of. [Chr. July 17, 1911, n.n; 200gs.]
About 1810. 25½ × 18½. Bust, facing, to below the breast; nude. Brown hair loosely tied above head; looking out with bold air. Cut off by clouds below breast. Greenish blue graded background.

Lady, Portrait of. [Sir George Beaumont. Grosvenor Gallery, 1888.]
30 × 24. Possibly Lady Beaumont, q.v.

Lady, Portrait of. [Chr. May 7, 1909; 1300gs.]
28½ × 24. Oval. In white dress, with pink ribbons and sash. Lace cap. Red curtain background.

174

OIL—ANONYMOUS PORTRAITS

Lady, Portrait of. [Chr., Lawrence sale, June 18, 1831 ; 45gs.]
Whole length, standing in garden, with landscape.

Lady, Portrait of. [Paris. Collection Chéramy.]
1820-5. Half length, facing : head turned three-quarters to right. Young woman with aquiline nose and black hair in thin wisps over forehead. Large hat with white feathers falling to left. Right hand raised to breast, only indicated. Face only finished.

Lady, Portrait of.
Circa 1810. Half length, seated, facing. Very plain woman of about 30 in dark turban, hanging down to left. White dress with short sleeves. Jewel with drop pearl and flower on breast.
MEZ. BY W. WARD.

Lady, Portrait of. [National Gallery, Budapest. Bought 1904.]
1800-5. Facing, half length. Head a little to right, looking round to right with animated expression. Stout woman of about 40, with high waist and bare arms, over which a shawl is thrown. Plain background.

Lady, Portrait of.
1815-20. Standing, nearly facing. Right elbow resting on parapet, the hand touching curls. Black shawl with scalloped edges, over white satin robe. Long full sleeves. Short black curls over forehead. Landscape to left.
ENG. IN BIJOU STYLE BY W. ENSOM.

Lady, Portrait of. [Rodman Wanamaker, Esq., Philadelphia.]
29½ × 24½. Rather more than half length. Seated, head three-quarters to right. Hair curly, with roses. Left elbow resting on table on which is a book. Low dress with ruffles round edge of bodice. Scarf loosely passed round shoulders. Large brooch at opening of bodice. Glimpse of landscape to right.

Lady, Portrait of. [Chr. March, 1908, n.n.]
About 1825. 35½ × 27½. Lady of about 25, seated, facing. More than half length. Simper on face. Hair in elaborate dark brown curls on top and side of head. Left elbow rests on table. White dress with pink scarf over right shoulder. Cameo bracelet on right wrist. Sapphire on waistband. Perhaps to be identified with the preceding.

Lady, Portrait of. [Chr. March 27, 1909, n.n. ; 240gs.]
26 × 20½. In red velvet dress, trimmed with fur. Lace head-dress.

Lady, Portrait of. [Chr. May 7, 1909, n.n. ; 370gs.]
In black dress, with white scarf and pearl ornaments. Landscape background.

Lady, Portrait of. [Wallace Collection.]
1788-90. 29 × 24½. To below waist ; seated a little to right. Head three-quarters to right. Tall white cap over powdered hair. Left elbow resting on a bank, with arm raised. High white dress with short sleeves. Apparently unfinished.

Lady, Portrait of. [Chr. April, 1902 ; 220gs.]
Oval. 28 × 22. Bust, in yellow dress and red cloak.

Lady, Portrait of. [Chr. Feb. 27, 1904, J. W. Knight, 270gs.]
32 × 26½. In yellow dress and blue sash.

Lady, Portrait of. [Chr. May 18, 1901, Arthur Kay Sale, 230gs.]
30 × 25. In yellow dress.

Lady, Portrait of, with Two Children. [Chr. April 27, 1901 ; 560gs.]
In yellow dress, holding her daughter. A boy in blue dress behind.

"Mariana." Portrait of young Lady.
Circa 1810. Oval. To waist. Facing, head turned to right. Dark hair bound high on head, above a fillet passing several times round. Full sleeves.
This may perhaps be identified with the portrait called " Miss Siddons " in the Wallace Gallery, q.v.
ENG. BY TH. GRAVES, in " Keepsake " style.

"Mother and Child." [Sir Thomas Glen-Coats, Bart. " Fair Children " Exhibition, 1895 ; and Glasgow, 1901.]
About 1826. Circular. Lady in profile on left, embracing child, who sits on pedestal. The mother with black hair bound high on head, and curls. The child has pale brown hair and blue sash. A red shoe on parapet to extreme left.

Old Lady, Head of. [Victoria and Albert Museum. Parsons bequest.]
23 × 19½. Unfinished sketch.

Officer, Portrait of an. [Chr. May 8, 1897, Noel Fenwick sale, 45gs.]
Painted 1785. 29 × 23½.

"Twin Sisters."
Circle. Two girls of 12 to 14. Seated, half length. Short loose locks over forehead. The girl to left facing ; she passes her arm round the neck of her companion, who is seen in profile, and holds flowers in both hands.
ENG. BY W. H. SIMMONS, 1834, in the " Literary Souvenir " for 1835. With lines by Alaric Watts, stating that both girls died young and at the same time.

Young Girl, Head of. [Chr. Dec. 14, 1901 ; 320gs.]
30 × 25. Dark curly hair. Face only finished. Outline of head only indicated. The rest of canvas bare.

Young Girl, Head of a. [Chr. May 18, 1901, Leatham sale, 160gs.]
23½ × 21½. " Dark curly hair."

Young Girl, Head and Shoulders of.
Head three-quarters to right. Hair bound up in kerchief, knotted at top.
Small square anonymous mezzotint. " Lawrence " below to right. Very early and primitive.

175

SIR THOMAS LAWRENCE, P. R. A.

Young Lady, Portrait of. [Victoria and Albert Museum. Ashbee bequest.]
10×7. Circa 1815. *Girl of about 20. Head only finished. Facing; loose curls over forehead.*

Young Lady, Portrait of. [Hon. Charles Lawrence.]
Circa 1825. 36×28. *Half length. To right, looking out. Auburn hair in curls. Large hat with white ostrich feather. Drawing long glove on to left hand. Landscape background.*

Young Lady, Portrait of. [Chr. July, 1907, n.n.; 1800gs. (Agnew.)]
Oval. 21½×18. *Bust, unfinished. Head three-quarters to right, looking to right. Dark eyes, light-coloured hair, perhaps powdered. Light blue ribbons hanging over shoulders from bonnet. The whole very high in tone.*

Young Lady, Portrait of. [Doucet sale, Paris, June, 1912. 200,000fs.

Ex Mrs. Martin Colnaghi. O.M. 1895.]
Oval. 28×22½. 1795-1800. *Bust, facing; head turned to left; looking down. Long neck; brown hair escaping from kerchief knotted on top of head. Simple grey dress with high waist. Nearly to waist, but only head and neck finished. Apparently about 18 years old. This head bears some 'resemblance to Maria Siddons.*

Young Lady, Head of.
Early portrait. Circa 1798. *Bust to left. Head only finished, facing, looking out. Loose, short curls over forehead. Close-fitting cap over head. Possibly Maria Siddons. May perhaps be identified with the preceding.*
ENG. BY B. HOLL, 1831.

Young Lady, Portrait of. [Louis Huth sale, Chr. May 20, 1905.]
15×13. *To waist, facing. Black hair in loose curls over forehead. Hazel eyes. White dress with buff scarf over shoulder. Costume of about 1815.*
(Called Maria Siddons in catalogue; but this is impossible, as she died in 1797.)

OIL—SUBJECT PICTURES

Christ Bearing His Cross.
1786. *Lawrence's first oil picture. 8 feet in height.*

"Fair Villager, The." [M. Bastegui, Paris.]
Lady in fancy dress. To waist facing, head turned to right. Frilled cap or bonnet over dark hair; hands placed one over the other on breast. Long sleeves with frills at waist.

"Fancy Group."
R.A. 1806.

"Gipsy Girl." [Royal Academy, Diploma Gallery. O.M. 1884 and 1904.]
Painted 1794, as Diploma work. 35×27½. *Half length, standing to right, looking out of picture, holding a white hen with both hands. Blue band over bare shoulders. Wooded landscape background. Etty made two copies of this picture, one quite late in life.*
MEZ. BY S. W. REYNOLDS, 1840.

"Homer Reciting His Poems."
R.A. 1791. *Painted for Mr. R. Payne Knight.*
" The touch and execution are equal to Teniers. The background is extremely grand, in the manner of Poussin."
" St. James's Chronicle."

Hound.
Head and neck only.
ENG. BY W. RADDON, 1834. [" Sir T. Lawrence, &c., pinxit."]

"Innocence and Fidelity."
Oblong. Two girls of 7 to 9. The one to right is hugging a spaniel. The girl to left holds out her arm to the dog.
MEZ. BY PORTER, 1830.

Little Red Riding Hood. See Anderson, Miss Emily.

"Morning Walk, The." See Allnutt, Elizabeth, first wife of John Allnutt.

"Nature." See Calmady, Daughters of Mr. Charles.

Orator, The Little. See Boucherette, R., Children of.

"Peasant Girl." [British Institution, 1806. No. 3.]

"Proffered Kiss, The."
Boy of 4 or 5 playing with little girl of 3 or 4 among loose cushions on a couch. Flowers in vase to right. Completed by Lawrence's pupil, H. Wyatt.
LARGE ENG. BY G. DOO, 1836.
Dedicated to Lord Charles Townshend.

"Prospero Raising the Storm."
R.A. 1793. *Painted over later and destroyed.*

"Psyche." See Grantham, Lady.

"Regard." See Storey, Lydia, *née* Baring.

Richard III., Scene from Play of. [Chr. May 15, 1830. Lawrence's Exors.]
Unfinished sketch.

DRAWINGS AND STUDIES—PORTRAITS

"**Rural Amusements.**" See Pattisson, The Masters.

"**Satan Calling His Legions.**" [Royal Academy, on staircase leading to Diploma Gallery. B.I. 1830 (lent by Exors. of Lawrence). Bought in at the Lawrence sale, June, 1831, at 480gs. This picture belonged at one time to the Duke of Norfolk. It was presented to the Academy by Samuel Woodburn.]

R.A. 1797. Satan, a huge nude figure some 12 feet in height, stands with his legs apart and his arms stretched over his head. Beside him to the left another of the chiefs of the fallen angels (Beelzebub ?). The body of

Satan is said to have been studied from Jackson, the prize-fighter. The head has some resemblance to Fuseli. At Satan's feet are some indications of crouching figures that have been painted out.

"**Sophie.**" See Duvausel, Sophie.

"**Vestal Virgin.**"
R.A. 1787. (The first year that Lawrence exhibited.) Perhaps a drawing.

"**Woodland Maid, The.**" See De Visme, Miss Emily.

"**Youngling of the Flock.**" Illustration to one of Watt's "Lyrics of the Heart."
Portrait of child.
Anonymous engraving.

DRAWINGS AND STUDIES—PORTRAITS

Adams, Louisa (1783–1867). Sister of Sir George Adams and W. Dacres Adams. [? Miss Keightley. Amateur Art Exhibition, 1898.]
Chalk drawing, 1800–5. Seated, to right, left arm on side of chair. Looking down and out. Dark curls over forehead. Loose white dress with short sleeves. Age about 18 to 20.
ENG. BY F. C. LEWIS, 1824.

Adams, William Dacres (1775–1862). Commissioner of Woods and Forests.
Chalk drawing, 1810–15. Bust, facing to right. Stooping, eyes looking front. Short hair. Frilled cravat. Large collar to coat.
LITHO. BY W. D. D[RUMMOND]. (Athenæum Portraits, No. 32.)

Adderley, Anna Maria Letitia, d. of C. C. Adderley, Esq., m. 1834 to F. A. McGreachy, M.P. [J. Pierpont Morgan, Esq.]
Oval, 2¼ × 2¼. Miniature. Sketch of a girl's head. Neck and throat bare ; hair brown and curly. Background grey and blue. Attribution doubtful. Probably painted after 1830.

Alexander, Emperor of Russia. [Ex Angerstein Collection.]
Lawrence made a careful coloured drawing of the Tsar for J. J. Angerstein, who was a Russian merchant (see letter to J. J. A., Jan. 1819).

Anglesey, son of Marquess of. [Chr. June, 1830, Lawrence Exors., 31gs.]
Large drawing on canvas in black, white, and red chalk. "Highly finished."

12

Angoulême, Duc d'. Made in Paris, 1825. [Chr. June, 1830, Lawrence Exors., 12gs.]
Large study from life on canvas, in black, white, and red chalk. Head only, turned a little to right ; eyes look to right. Aquiline nose. Side whiskers. High, military collar.
ENG. BY F. C. LEWIS.

Angerstein, Miss, and the Children of Mr. Boucherette.
R.A. 1795. No. 602, in Council Room, " Portraits of a Family." Probably chalk drawing. A contemporary critic calls this a portrait group of Miss Angerstein and Mr. Boucherette's children.

Angerstein, Mrs. John. Amelia, daughter of W. Locke, wife of John Angerstein, M.P. Sister of Lady Wallscourt. [Lord Wallscourt.]
Chalk drawing. Signed " T. L. July 1795." Bust, high waist. Facing a little to right and looking to right. Veil over bonnet ; index of right hand on chin.

Apsley, Georgina, Lady. Later Countess Bathurst. [Miss Ponsonby.]
Drawing.

Arbuthnot, two sons of the Rt. Hon. Charles. [Chr. May 20, 1830, Lawrence Exors., 41gs.]
Black chalk drawing, with a little carmine. Two boys with short hair. The elder half length ; the younger looking over his left shoulder, the head only visible.
"CRAYON" ENG. BY F. C. LEWIS. (Private plate.)

Banks, Rt. Hon. Sir Joseph, Bart., P.R.S. [National Portrait Gallery.]
Black chalk drawing. 9¼ × 8. To waist, face three-quarters to left. Heavy eyebrows. Ribbon of Bath.

177

SIR THOMAS LAWRENCE, P.R.A.

Bannister, Eliz. Harper, wife of Jack B. [Malcolm Wagner, Esq.]
Black and red chalk. Face turned up to the right. Loose curly black hair.

Barton, Miss. [From collection of Lord Northwick.]
Black chalk drawing, touched with white. Head and neck only ; life-size ; facing, looking out. Hair in loose curls over forehead down to eyebrows.
"CRAYON" ENG. BY F. C. LEWIS, 1835.

Barrington, Lady. Mary Lovell, married first to the Hon. Samuel Grimstone ; second, in 1740, to the 2nd Viscount Barrington. [Ex Lord Northwick. Thirlestane House sale, 1859.]
Chalk drawing. Bath period.

Barrington, Samuel, Admiral (1729–1800). Son of first Lord Barrington. Served under Rodney and Keppel.
Chalk drawing. Bath period.

Bathurst, Henry, 3rd Earl. [British Museum, Print Room.]
Chalk drawing, 8¼ × 6I. Bust, facing a little to right. Eyes looking out. Head only finished. Black chalk with a little red.

Bedford, Georgiana, Duchess of. [Jeffery Whitehead, Esq. O.M. 1879.]
Pencil drawing. Oval. Bust to left, profile. three-quarters left. Hair falling in snake-like curls over forehead. Jewel on shoulder. Long neck.
ENG. BY F. C. LEWIS.

Blessington, Marguerite, Countess of. [Lady Arthur Wellesley (Duchess of Wellington). Amateur Art Exhibition, 1898.]
Drawing.

Bloxam, Henry. Nephew of Lawrence. 3rd son of the Rev. Richard Bloxam, Rector of Brincklow, who married Lawrence's sister Anne.
Pencil, stump, and red chalk. Inscribed " T.L. 1800." Profile to right. Fat child of 3 or 4, with curly hair.
ENG. BY F. C. LEWIS. The same in P. G. Patmore's " Cabinet of Gems," 1837.

Bloxam, Mary Isabella. Niece of Lawrence. Daughter of Rev. Richard Bloxam.
Pencil, stump, and red chalk. Profile head, to right, looking up. Hair loosely bound up and curled over forehead.
ENG. BY F. C. LEWIS, 1828. The same, with some colour, in P. G. Patmore's " Cabinet of Gems," 1837.

178

Bloxam, Mary Isabella.
Pencil, stump, and a little red chalk. Dated 1811. Girl of three. Facing, looking out ; in frilled night-cap with green ribbons. Head only finished.
ENG. BY F. C. LEWIS, 1831. Also in P. G. Patmore's " Cabinet of Gems," 1837.

Bloxam, Roland. Nephew of Lawrence. Son of the Rev. Richard Bloxam.
Pencil, stump, and red chalk. Boy of 2 or 3. Head, three-quarters to right. Looking down, sideways.
ENG. BY F. C. LEWIS, 1831. The same in P. G. Patmore's " Cabinet ot Gems," 1837.

Bloxam, Susan (1802–18). Niece of Lawrence. Daughter of the Rev. Richard Bloxam. Died aged 16.
Careful pencil or black chalk drawing. Profile to right, looking down. Shortish hair curled over forehead and cheeks. High waist.
Lawrence, says Williams, was painting Susan Bloxam's portrait shortly before her death in 1818.
ENG. BY F. C. LEWIS, 1820.

Bloxam, Thomas Lawrence. Nephew of Lawrence. 2nd son of the Rev. Richard Bloxam.
Black chalk with a little carmine. Boy of 4 or 5. Half length, facing. Hair over forehead. Right arm uplifted as if beckoning.
ENG. BY F. C. LEWIS (?) in P. G. Patmore's " Cabinet of Gems " 1837.

Blücher, Field Marshal Prince von. [Chr. June, 1831, Lawrence's Exors.]
Drawing in black and white chalk—" very spirited and fine." Facing a little to right. Looking to right with severe expression. Moustache. White collar and high stock.
ENG. BY F. C. LEWIS.

Boucherette, Emily. Daughter of A. Boucherette. Died unmarried. [Ex Angerstein Collection.]
Black chalk and carmine. Head of girl of 7 or 8. Profile to right, relieved against long black locks. Life-size.
ENG. BY F. C. LEWIS.

Boucherette, Julia. Sister of last. [Ex Angerstein Collection.]
Black chalk drawing, with a little yellow and red. Head, life-size. Girl of 4 or 5, with short hair ; resting on pillow.
ENG. BY F. C. LEWIS, 1820.

Bowdler, Jane (1743–84). Authoress, " Poems and Essays, a Selection," 1786.
Very early. Bath period. Half length, in oval. Nearly facing, head a little to left. Streaming black hair, as if blown by wind.
ENG. BY R. M. MEADOWS. Frontispiece to " Poems and Essays," Bath, 1798.

Burdett, Sir Francis. [S. J. Hodgson. Amateur Art Exhibition, 1898.]
Drawing.

DRAWINGS AND STUDIES—PORTRAITS

Calmady, Emily and Laura, daughters of Mr. Ch. Calmady. "The Lovely Sisters." [Presented by Lawrence to Mrs. Calmady.]

1823. *The first study for the famous picture. Careful pencil study of the heads of the two children, nearly facing, smiling and looking out. Younger child, to right, rests her head on the shoulder of elder, who has curly hair over forehead.*
"CRAYON" ENG. F. C. LEWIS, 1837, *as* "The Lovely Children." *An earlier version, 1825, as* "Daughters of Ch. B. Calmady, Esq."
Miss Croft says the first engraving by Lewis was made from the oil sketch on canvas.

Calmady, Emily and Laura. [Ex Sir Robert Loder. Sold Christie's, May, 1908 (to Colnaghi), 560gs.]

1823. *Circle, 21½ diam. Unfinished first study of heads.*

Campbell, Lady Charlotte. [Ex Mrs. Farr.]

Chalk drawing, signed "T.L., May, 1795." *Profile, head to right. Long flowing light hair. Drop ear-ring.*
LITHO. BY R. J. LANE, 1830.

Canning, George. [Lansdowne House. Chr. June, 1830, Lawrence's Exors., 30gs.]

Chalk drawing for the full-length Windsor and Peel portraits.

Canning, George.

Chalk drawing. Facing, looking out. Left hand to side of face. Bald head.
ENG. BY F. C. LEWIS.

Canova, Antonio, Marchese di. [Chr. June, 1830, Lawrence's Exors., 8gs.]

Made in London, 1815. Large study from life in black, white, and red chalk on canvas.
"A *Study of the Picture of Canova,*" *lent by Mr. Hogarth, was in the Water-colour Room of the Winter Exhibition of the Society of British Artists in 1832.*

Carter, Elizabeth (1717 – 1806). Daughter of Dr. Nicholas Carter. Greek and Italian scholar. Translator of Epictetus, etc., and contributor to the "Rambler." [National Portrait Gallery.]

1788 *or* 89 (? *R.A.* 1790). *Oval drawing, 12½ × 10½. Bust, seated, to right, nearly profile. Very old lady, in white frilled cap with black ribbons.*
ENG. BY CAROLINE WATSON, 1806.
An "unfinished head" *of Mrs. Carter was in the Lawrence sale, June, 1831.*

Castlereagh, Viscount (1769–1822), when Marquess of Londonderry.

Chalk drawing. Half length, facing. Short black hair. In peer's robes. Head nearly identical with the 1814 picture.
ENG. BY H. MEYER, 1822. "From an original drawing."

Charles X. [Chr. June, 1830, Lawrence Exors., 11gs.]

Black chalk drawing. Made in Paris, 1825. Life-size head. Nearly facing; hair brushed over high conical forehead. Mouth apparently out of drawing.
ENG. BY F. C. LEWIS.

Charlotte, Princess. Charlotte Augusta (1796–1817), only child of George, Prince of Wales, and Caroline of Brunswick. Married Prince Leopold of Saxe-Coburg (later King of the Belgians) 1816. Died in child-bed, November, 1817. [Chr. June 18, 1831, "The celebrated original drawing engraved by Golding"; 106gs.]

R.A. 1821. *Chalk drawing, made October, 1817. Three-quarter length, facing. Standing by column. One hand on breast. Black velvet dress and flowing veil to left.*
ENG. R. GOLDING, 1822.

Charlotte, Princess. [Chr. June,1831, Lawrence's Exors. Bought by J. Graves for 21gs.]

Miniature, after the large drawing.
ENG. BY GOLDING:

Charlotte, Princess.

Black chalk and carmine. Circa 1815-17. Life-size; head and shoulders only, nearly facing. Hair bound in knot at top of head.
ENG. BY F. C. LEWIS.

Charlotte, Princess. [Lent by Mr. A. Keightley (Lawrence's Executor) to B.I. 1830.]

Chalk drawing. Perhaps identical with foregoing.

Charlotte, Princess, when a baby. [Mrs. Burney.]

A small, lightly-finished drawing of the head.

Charlotte, Princess, when a baby.

Circa 1797. Black chalk drawing. Head of baby in frilled cap, eyes closed. Another head in black and red chalk. Baby in night-cap. (Attributed to Lawrence, but very primitive in style.)
ENG. BY F. C. LEWIS.

Charlotte, Princess. See also under Queen Caroline.

Churchill, Mr., a son of.

Drawing of a boy made at Bath about 1780 (mentioned in letter from Lady Frances Harpur to young Lawrence, Dec., 1780).

Consalvi, Cardinal. [Marquess of Bristol, Ickworth. O.M. 1904. (Probably ex Mr. J. C. Harford, of Blaise Castle.) Amateur Art Exhib., 1898.]

Drawing in black and red chalk, 15½ × 10½. Half figure, seated, fronting, in robes. Head only finished. Dark piercing eyes, and straight eyebrows.
ENG. BY F. C. LEWIS, 1830.

179

SIR THOMAS LAWRENCE, P. R. A.

Cowper, William (1731–1800), the Poet.
R.A. 1795. *Chalk drawing. Kit-cat ; three-quarters to right. In loose white cap, face only finished.*
This drawing was made in 1793, when Rose brought Lawrence to visit the poet. It was much admired by Lady Hesketh. Cowper shortly after this time sank into a state of stupor and insanity.
ENG. BY RIDLEY, 1801 ; by W. Blake, 1802 : by Bartolozzi, 1805 (inscribed "Lawrence delint, ad vivum, 1793 "), and by Finden. Though differing in detail these engravings are all probably from the same drawing.

Cremorne, Viscount. Thomas Dawson, Irish peer 1770 ; Viscount Cremorne 1785. Died 1813. [B.I. 1864. Lent by Granville J. Penn.]
Chalk drawing, about 1790. Standing ; to waist ; facing to left, but looking out. In blond wig. Coat with loose collar, buttoned at top only.
ENG. BY CH. KNIGHT. 1794.

Croft, Miss. Sister of Sir Richard Croft, the *accoucheur* of Royalty, and intimate friend of Lawrence. [Ex Madame de Chanteau (niece of Miss Croft), Dijon.]
1807. *Chalk drawing.*
Lawrence made two drawings of a brother of Miss Croft. One of these is a posthumous one, and represents him lying in his coffin (1818).

Cumberbatch, Mrs. [Christie's, July, 1908, Mr. C. R. Aston. The drawing in an album that came from Mr. Meredith.]
Chalk drawing. Face only finished, turned a little to right, but eyes looking to left. Lock of dark hair over forehead.
LITHO. BY W. SHARP, 1829.

Cumberland, Prince George of. [Chr. June, 1830, Lawrence's Exors., 32gs.]
Large study from life on canvas, in black, white, and red chalk.

Devonshire, Elizabeth, Duchess of, and child. [Duke of Devonshire. B.I. 1830.]
Chalk drawing.

Devonshire, Elizabeth, Duchess of. [Duke of Devonshire.]
Chalk drawing. Half length, seated to right. Head turned and looking out of picture. Narrow-brimmed hat, with feather drooping to left side. Short curls over forehead.
ENG. BY F. C. LEWIS, 1828.

Devonshire, Duchess of (?).
Chalk drawing. Profile to right of young woman with full bosom. Loose veil, fastened by band over forehead, hangs over shoulders. Hair escapes over forehead.
ENG. BY F. C. LEWIS, 1826.

Dottin, Mrs. Dorothy, *née* Jones. Wife of Abel Rous Dottin. [Chr. May, 1908, C. R. Aston. The drawing is in an album that came from Mr. Meredith.]
1800–5. *Chalk drawing. Head only, in profile to right.*
LITHO. BY W. SHARP, 1829.

Douglas, Marquess of, and his sister Lady Susan Hamilton. See Hamilton, Children of Duke of.

Dover, Georgiana, Lady.
Chalk drawing. Bust, nearly facing : with low dress, high waist, and frilled border. Short curls over temples.
ENG. BY F. C. LEWIS, 1831.

Duvausel, Sophie. Daughter of Madame Cuvier, and afterwards Madame Du Crest de Villeneuve. [Louvre : Cabinet des Dessins.]
1825 (?). *Tinted chalk drawing.*
ENG. BY J. THOMSON for "Amulet," 1832 ("Sophie ").

Ebrington, Susan, Lady. At the age of 31. Daughter of the Earl of Harrowby. Married, 1817, to Hugh, Viscount Ebrington ; later to Earl Fortescue. Died 1827.
Pencil drawing, dated July, 1827. Bust, facing. Head a little to left. Curls over temples.
ENG. BY F. C. LEWIS.

Ebrington, Lady.
Chalk drawing. Head nearly in profile to left. Low dress with high waist. Short curls and band over forehead.
Apparently the same lady as the last, but not the same drawing.
ENG. BY F. C. LEWIS.

Ellenborough, Lady (wife of 1st Baron).
An unfinished sketch for a portrait of Lady Ellenborough was given by Lawrence to Miss Locker.

Esterhazy, Count Vincent.
Chalk drawing, executed in Vienna, in winter of 1818–19.

Esterhazy, Countess Vincent. Marie, daughter of Prince Metternich.
Chalk drawing, executed at Vienna in winter of 1818–19. Nearly half length. Seated, a little to left, head facing. High waist, frilled collar, to chin. Short curls on side of head.
ENG. BY F. C. LEWIS, 1828.
Lawrence mentions in a letter that when at Rome he went about everywhere with Metternich and his favourite daughter Marie.

180

DRAWINGS AND STUDIES—PORTRAITS

Fairlie, Louisa (*née* Purves). Wife of John Fairlie. Niece of Lady Blessington. Writer. Died 1843. [Chr. 17 June, 1830, Lawrence's Exors., £14.]
1810–15. *A slight sketch, in chalk. Standing, looking at a picture. Slim figure in a scanty costume, leaning against a wall.*
ENG. BY F. C. LEWIS, 1830.
Ditto. (Sold for £14.) Chalk drawing, slightly tinted. Bust, life-size.
ENG. BY F. C. LEWIS in two sizes, large and small.

Falconer, William, M.D. (1744–1824). Miscellaneous writer. Published essays on Bath waters. Physician to Bath General Hospital. [Lent by J. A. Roebuck, M.P., to S.K. 1868.]
Bath period, circa 1785. Oval, 11¼ × 9¼. Chalk drawing. Bust, to right. Tie-wig.

Farley, Miss. (Perhaps in error for Fairlie, q.v.) [Lady Layard. Amateur Art Exhibition, 1898.]
Drawing.

Farnborough, Charles Long, 1st Baron (1761–1838). M.P. 1789–1820. Created Baron 1820. Assisted George III and IV in decoration of royal palaces.
Circa 1800. Chalk drawing. Seated, nearly front, with legs crossed. Head turned to right. Holds paper in right hand.
ENG. BY PICART AND BY HEATH.

Fielding, Miss Matilda. [Chr. May 5, 1906; 80gs.]
Pencil drawing, tinted.

Fitzgerald, Mary Frances (later Lady Fitzgerald). Probably the wife of John Fitzgerald, Field Marshal, made K.C.B. in 1831. [Royal Collections. Lent by the Queen to Amateur Art Exhibition, 1898.]
Circa 1820. Pencil drawing. Face to left, nearly in profile. Low dress with high waist. Shawl loose over shoulders. Hair, slightly curled, encircles face. Drop ear-ring.
ENG. BY F. C. LEWIS.

Forster, Miss. Granddaughter of Thos. Banks, R.A. She was the mother of Sir Edward Poynter, Bart. (Cf. "Mrs. Forster," under Oil Paintings.) [Mrs. R. Courteney Bell. Amateur Art Exhibition, 1898. O.M., 1904.]
15¼ × 11. Black and red chalk drawing, signed and dated " T. Lawrence, June 1st, 1829." Small half figure, seated. Head turned to right.

Foster, Lady Elizabeth. See Devonshire, Duchess of.

Fownes, Mrs. James Somerville. [A. F. Somerville. Amateur Art Exhibition, 1898.]
Drawing.

Francis I, Emperor of Austria. [Chantilly. Musée Condé.]
20 × 13. Highly-finished water-colour drawing. Apparently identical in composition with the Windsor picture. Perhaps a copy by another hand ; but compare the drawing of the Tsar Alexander made for Mr. Angerstein.

Francis I, Emperor of Austria. [In Paris. Chr. 2 Dec., 1897, Angerstein Trustees' sale, 12gs.]
1818. 30 × 25. Chalk drawing. Bust. Head slightly to left. Scanty hair. Black stock. Writing from Vienna to old Mr. Angerstein, Lawrence says : " I have kept by me the first accurate drawing—a canvas—of the Emperor Francis, to add to the collection of that kind, constant, and revered friend (Angerstein)."
ENG. BY F. C. LEWIS.

Frederick William III, King of Prussia.
Chalk drawing. Bust, life size. Nearly facing, looking round to right. Whiskers and slight moustache. High military collar.
Probably executed at Aix-la-Chapelle in 1818.
ENG. BY F. C. LEWIS.

Frederick William III, King of Prussia. [Chr. June, 1830, Lawrence's Exors., 10gs.]
Large study from life in black chalk on canvas Perhaps identical with preceding.

Fuseli, Henry (or Fuessli), R.A. (1741–1825). Born at Zurich. After much travelling, settled in England 1779. A.R.A. 1788 ; R.A. 1790. Friend of Lawrence. [British Museum. Ex Benoni White.]
Circa 1795. Pencil drawing on pale yellow paper. 10¼ × 7¼. Bust, facing. Longish natural hair, brushed back and tied behind. Head turned to left, nearly in profile. Frilled shirt front. A head of Fuseli, after Lawrence (?), is engraved in Lavater's " Physiognomy."
ENG. BY T. HOLLOWAY, 1796.
„ W. C. EDWARDS (Cunningham's " Lives ").

George III., Three portraits of sons of. [Captain Butts. Amateur Art Exhibition, 1898.]
Drawing.

George IV, as Prince of Wales. Lawrence received 5gs. for a pencil drawing of the Prince of Wales soon after his arrival in London in 1787.

George IV, as Prince Regent.
Chalk drawing. Nearly to waist. Face to left, nearly profile. In armour. Inscribed, " For this drawing (made in the year 1814 and designed for a medal) His Majesty was graciously pleased to sit. Ths. Lawrence."
LITHO. BY R. L. LANE, 1829.

181

SIR THOMAS LAWRENCE, P.R.A.

George IV.
Black chalk and carmine. Head only, in profile to left, life-size. High black stock up to ears. (Close to the Nat. Port. Gallery head.)
A drawing of George IV was lent to the Amateur Art Exhib. 1898, by Messrs. Walker Bros.
ENG. BY F. C. LEWIS.

Gerard, Lady Henry. [Lady Arthur Wellesley (Duchess of Wellington). Amateur Art Exhibition, 1898.]
Drawing.

Glengall, Emily, Countess of, and her sisters. [Countess Stanhope. Amateur Art Exhibition, 1898.]
Drawing. Oval. Group of three girls—the centre one only finished; the face to left only faintly indicated.
Reproduced in Lord Ronald Gower's " Life of Lawrence."

Gloucester, William Frederick, 2nd Duke of. Grandson of Frederick, Prince of Wales. Born 1776. Succeeded his father as 2nd Duke, 1808. Married his cousin Mary, daughter of George III, 1816. Died 1834. [W. Fitz-Norman Ellis. Amateur Art Exhibition, 1898.]
Drawing.

Godwin, William. [British Museum.]
Circa 1800. 8¼ × 7¼. Black and red chalk. Head only finished, turning to right and looking up. Scanty hair.
ENG. BY W. RIDLEY, 1805. (Plate to " Monthly Mirror.")

Gordon, Duchess of. In 1790 Lawrence received 15gs. for a portrait of the Duchess of Gordon, which was probably identical with one sold at the Hogarth sale (Chr. 1859) for the same price.
Probably a pastel.

Gordon, Lady Susan. [Duke of Manchester, Kimbolton.]
Chalk drawing.

Gordon, Duke of, when Marquess of Huntley. [Chr. June, 1830, Lawrence's Exors., 10gs.]
Large study from life in black, white, and red chalk on canvas.

Hamilton, Children of the 10th Duke of. William, born 1811, succeeded his father in 1852; and Susan, married in 1832 to the Earl of Lincoln, after-

182

wards Duke of Newcastle. [Chr. June, 1831, Lawrence's Exors.]
Chalk drawing. Marquess of Douglas, a lad of 17 or 18, dressed in the fashion of George IV's time, standing, facing. Curly hair, loose, frilled cravat. To left a girl of 12 clasps him about the neck and looks out of picture. Her hair in curls over forehead.
ENG. BY F. C. LEWIS.

Hamilton, Master.
R.A. 1789. *No: 459, " Head from Nature," (Graves).*

Hamilton, Mrs.
R.A. 1789. *No. 528. " Portrait of a Lady."*
Probably chalk drawing.

Hamilton, Emma, Lady. [British Museum. Ex Payne Knight.]
Black and red chalk and stump. Oval, 7¼ × 5¾. Profile to right, looking up. Face only finished. White turban covers head, hanging loose behind. Black curls escaping by the ear.
ENG. BY CH. KNIGHT, 1791, but the inscription added later.
By side of plate, " Emma 1791 " ; and in pencil, " Wrote by the Lady " and " Drawn in pencil by Sir Th. L. while in company with Lady Hamilton and engraved for his private use."

Hamilton, Emma, Lady.
Pencil, tinted with carmine. Only face finished. Fronting, head and eyes turned upwards. White drapery over head. Body to waist only indicated.
ENG. BY F. C. LEWIS (?)—P. G. PATMORE'S " Cabinet of Gems," 1837.

Hammer, Joseph, Freiherr von. Born 1774. Oriental scholar. Lawrence mentions that when in Vienna he made a drawing of " Mr. Khammer, the well-known Oriental scholar."
Drawing, made at Vienna, 1818–19. Half length, seated to right. Short hair over forehead. Big coat collar. Frilled shirt front. Arms resting on side of chair.
ENG. BY BENEDETTI. (Published in Vienna.)

Hammond (? Hamond), Miss. A cousin of Lawrence. [British Museum.]
1781. Pencil on vellum. 5¼ × 4. Half length, seated to right.
Made when Lawrence was 12 (companion to the " Miss Lawrence ").

Harpur, Sir Henry. Early patron of Lawrence. When the latter was a boy at Bath, Sir Henry is said to have offered to adopt him as his son. Lawrence, about 1780, made a " picture " of Sir Harry's bald-faced pony. (Letter from Lady Frances Harpur to Lawrence.)
Chalk drawing. Bath period.

Hudson, Rev. Septimus. Lawrence received 5gs. for a drawing of this clergyman about the time of his arrival in London.
Pencil drawing. Circa 1787.

DRAWINGS AND STUDIES—PORTRAITS

Humboldt, Karl Wilhelm, Baron von. [Chr. June, 1830, Lawrence sale, 35gs.; Chr. 1861, Hutchinson sale, 45gs., bought by Mr. Angerstein.]
Large study on canvas in black, white, and red chalk. "Highly finished—Study for the Windsor picture."

Hutchinson, Lieutenant. [British Museum.]
8¼×7¼. Drawing in red and black chalk. Half length, acing, looking to right. Hair worked with stump.

Impey, Sir Elijah (1732-1809). Went out to India in 1773 as Chief Justice of Supreme Court. Summoned home in 1782 to answer charges which were never proceeded with. [National Portrait Gallery. Presented by Hartree family, 1889.]
1786. Chalk drawing. 12×10. Half length, seated, face nearly in profile to left. Tie wig ; blue coat with brass buttons.

James, John. [Maj.-General R. James. Amateur Art Exhibition, 1898.]
Drawing. "Made when the artist was 16 years old " (1785).

Kemble, Charles (1775-1854). Younger brother of John Philip Kemble and Mrs. Siddons. First appearance at Drury Lane, 1794. Joined his brother at Covent Garden, 1803. Manager, 1822. Tour with his daughter Fanny in America, 1832-4. Pre-eminent in Comedy. Finally retired from stage, 1840.
Chalk drawing, dated 1798. Face only finished. Profile to right ; long hair tied in knot behind. Formerly in the possession of Mrs. Siddons.
LITHO. BY R. J. LANE, 1830.

Kemble, Charles.
Chalk drawing, dated 1805. Bust, profile to right. Natural hair, in locks over forehead. Frilled shirt front ; large full coat collar. Formerly in the possession of Mrs. Siddons.
LITHO. BY R. J. LANE, 1830.

Kemble, Mrs. Charles. Wife of the actor.
Chalk drawing. Face only finished. Profile to right. Long hair, tied in knot, falling over forehead.
LITHO. BY R. J. LANE (on same plate with other members of family).

Kemble, Frances (sister of Mrs. Siddons). See Twiss, Mrs.

Kemble, Frances Anne (1809-93), "Fanny Kemble."
Black chalk drawing. Circa 1828. Seated, nearly full length, facing. Full " leg of mutton " sleeves. Dark hair bound on top of head and brushed out at sides. Inscribed " To Mrs. Charles Kemble, with Sir Thos. Lawrence's respects."
LITHO. BY R. J. LANE, 1830.

Kemble, John Philip.
Bust to right, profile. " The last likeness taken of him."
ENG. BY CHEESEMAN, 1817, from a drawing.

Two portraits of J. K. were lent to Manchester in 1857 : (1) Half length, seated, lent by Col. North ; (2) " At the age of 25 " (1782), lent by George Combe, who married Mrs. Siddons' youngest daughter.

Kemble, Priscilla (née Hopkins), wife of John Philip, m. 1st W. Brereton. Actress (1756–1845).
Pencil drawing. Circa 1800. Profile to right, in close-fitting skull cap, turned up at edge, from which short hair escapes over forehead. High waist, short sleeves, pearl necklace. Formerly in the possession of Mrs. Siddons.
LITHO. BY R. J. LANE, 1830.

Kemble, Mrs. Roger. Sarah, mother of Mrs. Siddons and of John and Charles Kemble (1721–1802).
Chalk drawing, 1790–5. In old age. Head only, facing. In close-fitting cap, frilled at edge. Shawl over shoulders.
ENG. BY FREEMAN, 1808.

Kemp, Mrs. Thomas Read. Daughter of Sir Francis Baring, and wife of T. R. Kemp, builder of Kemp Town. [Miss F. Kemp. Amateur Art Exhib., 1898.]
Drawing.

Lawrence, Sir Thomas.
Half length, facing, looking slightly to right. Long hair, to shoulders. Open collar. Book held in both hands. The engraving inscribed " Published June 18, 1783, by T. Lawrence, Alfred Street, Bath. To the nobility and gentry in general, to the University of Oxford in particular, who have liberally countenanced his pencil, this portrait of Master Lawrence is inscribed, etc. . . . by T. Lawrence, Senr."
ENG. BY J. R. SMITH, under the directions of J. K. Sherwin, 1783.

A copper engraving, reversed but otherwise similar to this, was published in 1830.

Lawrence, Sir Thomas. The Cazenove sale, July 14, 1842, included "Lawrence's own portrait as a boy."

Lawrence, Sir Thomas. [Richard C. Jackson, Esq., Amateur Art Exhib., 1898.]
Drawing. As a young man.

SIR THOMAS LAWRENCE, P.R.A.

Lawrence, Sir Thomas.
Circa 1795. *As a young man. Bust, facing, looking out of picture. Natural hair, somewhat long at sides. Coat with large collar loosely buttoned and white cravat.*
ENG. BY J. WORTHINGTON, 1830. Apparently from a chalk drawing.

Lawrence, Sir Thomas.
Chalk drawing, 1804. Small head in circle. Facing. Slight, dark whiskers. White stock.
ENG. BY F. C. LEWIS, 1831. "At the age of 35."

Lawrence, Sir Thomas.
A small portrait in chalk (1804 or 1805); was bought by Mr. Keightley at the Lawrence sale, and presented to Miss Croft.

Lawrence, Sir Thomas.
Drawing in black chalk, made in 1812. Head only finished. Facing, looking out. Thin hair and slight whiskers.
LITHO. BY R. J. LANE, 1830. "Published with the concurrence of the family."

Lawrence, Sir Thomas. [Chr. June, 1830 (Exors. sale), 31gs.]
Large study from life, in black, white, and red chalk, on canvas.

Lawrence, Sir Thomas. [In the Joseph Mayer sale, Chr. July, 1887, a portrait of Lawrence at the age of 8 was sold with other very early drawings.]

Lawrence, Thomas (1725–97). The painter's father.
1797. *Chalk drawing, black touched with red. Nearly full length. Stout man, seated in chair, facing. Wig and knee breeches. The Aston-Meredith album (sold Chr. July, 1908) contained a drawing (9×7) which was either the original or an excellent copy from Lewis' crayon print.*
ENG. BY F. C. LEWIS, 1830.

Lawrence, Mrs. Thomas (died 1797). The painter's mother.
About 1795. *Drawing in red and black chalk. Head in mob-cap. Facing.*
ENG. BY F. C. LEWIS, 1831.

Lawrence, Mrs. Thomas (?). [British Museum.]
A small and slight etching of an old lady's head, classically treated, is said to be by Lawrence, and to be taken from his mother.

Lawrence, Miss. Anne, elder sister of the painter, later Mrs. Bloxam. [British Museum.]
1781. *Oval, 4¼×3¼. Pencil on vellum. Young lady of about 20. Profile to right. Half length, seated. Made when Lawrence was 12. Companion to "Miss Hammond."*

184

Lee, Miss Sophia. Died 1824, aged 74. Novelist and dramatist. Author of "The Recess," etc. Sister of Harriet Lee.
Chalk drawing. Oval, nearly facing. Tall white cap. White dress with wide waistband. Black lace shawl over left shoulder.
ENG. BY W. RIDLEY, 1797.

Lemon, Robert (b. 1730). For 43 years Chief Clerk of Record Office in Tower. His son Robert and his grandson, also Robert, were distinguished archivists.
Chalk drawing. In wig, seated, left arm on table. Looking out. Aged 80 years.
ETCHED BY W. DANIELL, 1810.

Leopold, Prince, of Saxe-Coburg.
Chalk. Bust, three-quarter to right. Head only finished. Hair over forehead. Small moustache.
ENG. BY F. C. LEWIS, 1820.
Ditto. Chalk. Face only. Life-size, three-quarter to left. Short hair, high collar, small moustache.
ENG. BY F. C. LEWIS.

Leopold, Prince, of Saxe-Coburg. [Chr. June, 1830, Lawrence's Exors., 30gs.]
1817. *Large study from life in black, white, and red chalk. "Highly finished."*

Lichnoffsky, Princess.
Chalk drawing, made at Vienna, 1818–19.

Lieven, Princess. [Chr. June, 1830, Lawrence's Exors., 36gs.]
Large study from life in black, white, and red chalk, on canvas. "Highly finished."

Lieven, Princess.
Black chalk and carmine. Life-size. Bust in profile to left. Head three-quarters left. Short curls over forehead. ? Identical with study on canvas of the Lawrence sale.
ENG. BY F. C. LEWIS.

Lieven, Princess. [Now in Petersburg?]
Chalk drawing, 1815–20. Half length to right. Head turned round and looking out of picture. Low white satin dress with short full sleeves. Pearl necklace. Hair in curls over forehead.
ENG. BY W. BROMLEY, 1823.

Linley, the Rev. Ozias Thurston, as a boy (— 1831). He bequeathed the Linley portraits by Gainsborough and Lawrence to Dulwich College. [Dulwich College, Linley bequest.]
Early drawing in coloured chalks. Oval, 12×9. Boy with clear brown eyes, in brown coat, white waistcoat, and cravat. Executed probably at Bath.

Linley, Maria. Later Mrs. Tickell. [Dulwich College, Linley bequest.]
Early drawing in coloured chalks. Oval, 12×9¼. A girl in low, white dress. Blue bow and sash, and blue ribbon in hair. Executed probably at Bath.

DRAWINGS AND STUDIES—PORTRAITS

Livesay, Jane Bell. [Chr. 16 March, 1908.]
1800-10. 8¼×7¼. *Pencil, touched with red. Half length, to right. Seated on sofa, with arms crossed. Hair bound up and confined by a sort of coronet. Old inscription.*

Locke, Charles, infant son of William Locke. [C. T. Arnold. O.M. 1904. Amateur Art Exhibition, 1898.]
6¼×5¼. *Black and red chalk. Head of a child. Full face. The " Portrait of a Lady." No. 237 in the R.A. Catalogue for 1797, is called " Mrs. Charles Locke " by Williams (I. 458), by the contemporary " Times," and in a MS. note to the B.M. copy of the R.A. Catalogue. No other trace of a Charles Locke.*

Locke, Mrs. Charles.
R.A. 1797. No. 237. " Portrait of a Lady."

Locke, William (1767–1847), with his daughter. Probably the 2nd Wm. Locke, amateur artist and pupil of Fuseli. His daughter, Elizabeth, was married later to Lord Wallscourt. Norbury Park was sold by William Locke in 1819. [W. Angerstein, Chr. 4 July, 1896 ; 12gs.]
36¼×26¼. *Charcoal on canvas.*

Locke, Mrs. (Elizabeth Jennings). [C. T. Arnold. O.M. 1904. Amateur Art Exhibition, 1898.]
7¼×6¼. *Pencil and coloured chalks. Half length, facing to left.*
Another drawing, doubtfully identified with "Mrs. Locke," was lent to the Amateur Art Exhibition, 1898, by Mr. George Hensman.

Londonderry, Charles Stewart, 3rd Marquess of. As Sir Charles Stewart.
Chalk drawing. Circa 1805. Head in profile to right. Loose frilled cravat. High collar of braided coat thrown open.
ENG. BY F. C. LEWIS.

Londonderry, Charles Stewart, 3rd Marquess of. As Lord Stewart.
1815-20. *Chalk drawing. Bust. Head to left, nearly in profile. Short curly hair.*
ENG. BY F. C. LEWIS.

Loughborough, Alexander Wedderburn, 1st Lord (1733–1805). Lord Chancellor, 1793–1801. Created Earl of Rosslyn, 1801. [W. Russell, Esq. Grosvenor Gallery, 1877.]
Chalk drawing, with colour.

Malton, Charles. Son of Thomas Malton, the architectural painter.
R.A. 1791. No. 516 (Graves). Chalk drawing. Boy of 6 or 7. Standing, facing, nearly full face. Enormous shock of hair. Signed " T. Lawrence, April, 1790."
ENG. BY F. C. LEWIS. " From a drawing made by Lawrence when 20."

Manners-Sutton, Mrs. Later Lady Canterbury. Ellen, daughter of Edward Power. Sister of Lady Blessington. Married 1828 to Charles Manners-Sutton, Speaker to the House of Commons, who in 1835 was created Viscount Canterbury.
Careful pencil drawing. Life-sized, profile to right. Back of head barely indicated. Smooth hair over forehead.
ENG. BY F. C. LEWIS.

Marshall, Miss. Niece of Mrs. Wolff. [British Museum.]
Chalk drawing. 10¼×8¼. Bust, facing, looking to right. Low dress, coral necklace. Large brown eyes. Inscribed " Parsonage, October, 1815. T. L."

Mathews, Mrs. [W. Doherty, Esq. Grosvenor Gallery, 1877–8.]
Drawing of head.

Maxwell, John. [Miss Maxwell Hogg. Amateur Arts Exhibition, 1898.]
Drawing, dated 1784.

Maxwell, Mrs. [Miss Maxwell Hogg. Amateur Art Exhibition, 1898.]
Drawing. Dated 1784.

Mead, Hon. Anne. (? Lady Anne Meade, d. of 1st Earl of Clanwilliam, married 1788 ; or Anne Meade, his granddaughter, married 1833 to Sir David Conyngham.) [Duchess of Wellington. Amateur Art Exhibition, 1898.]
Drawing.

Meade, Lady Selina. Sister of Earl Clanwilliam. Later Countess Clam-Martinics.
Drawing made in Vienna, 1818–19.

Meredith, Lucy, later Mrs. Aston. Niece of Lawrence. [E. E. Leggatt.]
Pencil, stump, and red chalk. Girl of 10 or 12. Head only finished. Facing, looking out. Short hair over forehead. White dress. Left arm over side of chair. Signed " T. L., Feb. 10, 1813."
ENG. BY F. C. LEWIS. A similar head in P. G. Patmore's " Cabinet of Gems," 1837.

Meredith, Mrs. Lucy, sister of Sir Thomas Lawrence.
Chalk drawing. Lady of about 35. Apparently an invalid. Nearly facing, in frilled white cap, and high collar to chin. Leaning back against pillow. Signed " T. L., Feb. 10, 1813."
ENG. BY F. C. LEWIS, 1831. At the side, " By Sir T. Lawrence, from his sister Lucy."

Methold, Mrs. Alice. [Lt.-Col. J. Inyr Burges. Dublin Portrait Exhibition, 1872.]
Done at Bath, in 1786, when Lawrence was 17.

185

SIR THOMAS LAWRENCE, P.R.A.

Miniature on ivory of a Young Gentleman. [Chr. June 17, 1830, Lawrence's Exors.]
Circa 1793.
For other miniatures by Lawrence, see Charlotte, Princess ; Sotheran, Mrs ; Adderley, Miss.

Molyneux, the pugilist — "The Black"? [Chr. June, 1830, Lawrence's Exors., 2gs.]
Large study from life on canvas, in black and white chalk.
Another of the same, in oil, sold also for 2gs. at the Lawrence sale.

Morgan, Lady (1783–1859). Sidney, daughter of Robert Owenson. Writer of fiction from 1804. Married Sir Th. Morgan in 1812. [Duke of Wellington, Apsley House.]
Drawing.

Mornington, daughters of the 3rd Earl of. "The three lovely sisters." Priscilla Anne, Lady Burghersh (afterwards Countess of Westmorland), Lady Mary Wellesley (afterwards Lady Bagot), and Lady Harriet (afterwards Lady Raglan). [Duke of Wellington. O.M. 1904. Cooke's Exhibition, Soho Square, 1822.]
Black and red chalk. White dresses, girdled under breast. Long sleeves, full at shoulder and wrists. Hair in short curls over head and forehead. The centre girl holds her sandalled foot in left hand.
ENG. BY J. THOMSON, 1827.

Mornington, Anne, Countess of. Mother of the 1st Duke of Wellington. [Duke of Wellington, Apsley House.]
Sketch in water-colour of an old lady.

Murray, Lady Emily, "with another lady and a boy." [Richard C. Jackson. Amateur Art Exhibition, 1898.]
Drawing.

Murveldt, Count von, son of.
Chalk drawing, made at Vienna, 1818–19.

Napoleon, François Charles Joseph, Roi de Rome, Duc de Reichstadt. [Marquise de Valette. See "Gaz. des Beaux Arts," 1882.]
Drawing. Boy of about 8. Life-size, in profile to right. Nearly to waist. Cloak over shoulder. Hair over forehead. Probably made in Vienna, 1818–19.
ENG. BY W. BROMLEY, 1830. The plate (unpublished) sold at the Lawrence sale in 1830.

186

Newdegate, Maria (née Boucherette), wife of Charles N., of Harefield.
1800–5. *Washed pencil drawing, slight. Full-length figure of young lady, seated in chair, bending down to work (sorting wool ?). Legs outstretched to footstool. Short hair. Simple, scanty dress, in style of Flaxman.*
ENG. BY F. C. LEWIS.

Newdegate, Maria.
Circa 1810. *Chalk drawing Careful study of head ; lips and cheek tinted red. Profile to right ; large aquiline nose. Hair plaited and tied in knot. Pearl necklace.*
ENG. BY F. C. LEWIS, 1825.

Normanby, Marquis of. [Hon. Mrs. C. Eliot. Amateur Art Exhibition, 1898.]
Drawing.

Oriel, John Foster, Baron.
1820–5. *Bust, head only finished. Facing slightly to left, but eyes a little to right. Grey, natural hair.*
LITHO. BY M. GAUCI.

Paget, Lord Alfred (died 1816). Second son of 1st Marquess of Anglesey. Later General and Equerry to H.M.
Chalk drawing. Life-size head of a boy with curly hair ; three-quarter to right. The face touched with carmine.
ENG. BY F. C. LEWIS.

Peel, Sir Robert, 2nd Bart.
Chalk. Head and shoulders. Head turned three quarters to left. High, white stock.
LITHO. BY F. C. LEWIS, 1840.

Peel, Sir Robert, 2nd Bart. [Septimus Croft, Esq. Amateur Art Exhibition, 1898.]

Pitt, William.
As a young man. Half length to right, profile, seated.
SOFT GROUND ETCHING BY F. C. LEWIS.

Pius VII. Before leaving Rome, in the autumn of 1819, Lawrence made a drawing of the Pope for the Duchess of Devonshire.

Ponsonby, Lady Emily. Wife of Sir Frederick Ponsonby, Governor of Malta. [Miss Ponsonby, Wilton Terrace.]
Drawing.

Ribblesdale, Thomas Lister, 1st Baron. [Lord Ribblesdale. O.M. 1904.]
Black and red chalk. 14½ × 10.

Ricci, Mademoiselle.
Chalk drawing, made at Vienna, 1818–19.

Ripon, 1st Earl of, when the Right Hon. F. J. Robinson. [Chr. June, 1830, Lawrence's Exors., 10½gs.]
Large study from life on canvas, in black chalk.

DRAWINGS AND STUD I ESPORTRAITS

Robinson, Mrs. Mary (1758-1800). Actress, and mistress of the Prince of Wales. Was generally known as " Perdita " after her appearance in the "Winter's Tale." Received a pension from Fox after her connection with H.R.H. was broken off. Published her memoirs (?).

1798 (?). Chalk. Oval. Half length. Head bent to right, and partly resting on back of right hand. White turban tied by band under chin. Loose white dress.

ENG. BY W. RIDLEY, 1799.

Rogers, Samuel (1763-1855). Banker, and a son of a banker. Poet, conversationalist, and well-known figure in London Society. Left some good pictures to the National Gallery. Chiefly remembered now for his breakfasts in St. James's Place. [National Portrait Gallery ; lent at present to Guildhall Gallery (?). S.K. 1868.]

1820-5. Chalk, tinted. 27 × 22. Half length, seated, body nearly facing. High, buttoned coat, with large collar.

ENG. BY W. FINDEN AND BY F. C. LEWIS.

Rogers, Samuel.

1815-20. Chalk. Half length, seated in arm-chair.

ENG. BY H. MEYER, 1822 (? from same drawing as last).

Rogers, Samuel.

Chalk drawing. Half length. Seated to left in arm-chair ; looking round and out of picture. Chin supported on knuckles of right hand. Thin greyish hair, dark eyes and eyebrows.

ENG. BY ANDERTON, for the 1852 edition of Rogers's Poems.

Rosalie, Countess. [B.I. 1830, lent by J. Meredith, L.'s brother-in-law.]

Chalk. Drawing made in Vienna, 1818-19. In the Lawrence sale, 1831, " Countess Rosalie, drawing in chalk, framed and glazed," sold for 16gs.

Rosamoffsky, Princess.

Chalk drawing, made in Vienna, 1818-19.

Rossmore, Lady. [Christie's, May, 1909. Exors. of G. B. Henderson. Ex. Mrs. Gibbons, 1883.]

Oval, 22½ × 17½. Sketch.

Ryder, Herbert. Nephew of Miss Croft. [Ex. Miss Croft.]

1810. Chalk drawing, made before young Ryder left for India.

Sabloukoff, Madame, and Family. Juliana, dau. of J. J. Angerstein ; married to General Sabloukoff. [Chr.

July 4, 1896, Angerstein sale, 1000gs. (Wertheimer).]

1821, retouched 1823. Chalk. 20 × 16. Family group in landscape. Pillars and red curtain to right. In a letter to J. J. Angerstein, November, 1821, L. says that " young Williams " has made a copy of his " crayon picture " of Madame Sabloukoff.

Sauren, Madame.

Chalk drawing, made at Vienna in 1818-19.

Schwarzenberg, The Young Prince. [Prince Schwarzenberg, Vienna.]

1818-19. Chalk. A drawing made in Vienna

Siddons, Mrs., as the " Grecian Daughter."

1782. Pastel (?). Oval, nearly to waist. Profile to right. Coronet on long curly wig, veil behind. Right hand drawing dagger from waist. " T. Lawrence pinxit."

ENG. BY T. TROTTER. Dedicated to Count de Brühl by T. Lawrence, Oct. 13. Published 1783 by T. Lawrence, Alfred Street, Bath, and by J. R. Smith, Haymarket, London.

Siddons, Mrs., as Zara in the " Mourning Bride."

Bath, 1782. " Painted by T. Lawrence." Pastel (?). Oval. Half length. Face in profile to left. Jewelled turban with aigrette. Left hand pointing to right.

MEZ. BY J. R. SMITH. "Published June 18, 1783, by T. Lawrence, Alfred Street, Bath." Dedicated to the Lady of Sir W. James, Bart., by " T. Lawrence, Oct. 13."

[Lady James, who had been a friend of Sterne, died in 1798.]

Siddons, Mrs., at the age of 29. [Manchester, 1857 ; lent by Mr. George Combe, her son-in-law.]

Bath, 1784.

Siddons, Mrs., as " Sigismunda."

Chalk. 1797-1800. Arms crossed on breast. Lying on couch(?). Veil over head.

LITHO. BY R. J. LANE (on same sheet with other members of family).

Siddons, Mrs. [B.I. 1857 ; lent by W. Ewart, M.P.]

Siddons, Mrs. [Garrick Club ?]

Chalk. Circa 1800. Profile to right ; face only finished. Hat with large rosette of ribbons in front ; band under chin. Tuft of hair over forehead.

ENG. BY W. NICHOLLS, 1810.

Siddons, Mrs. [National Gallery. Bequeathed by Miss. J. E. Gordon.]

1790 – 5. 13 × 10. Water-colour drawing. Oval. To right, nearly in profile. Hair frizzled and hanging in large curl over left shoulder. White dress with blue band over shoulders.

SIR THOMAS LAWRENCE, P.R.A.

Siddons, Mrs.
Black chalk. Half length. Head turned to right, in profile. Loose white cap bound by two ribbons. High collar with vandyked edge. Locket on breast. Inscribed to right, "This drawing is Miss Siddons'"; to left, "T. L., Thursday, 1797"—both in Lawrence's hand-writing.
LITHO. BY R. J. LANE. "From chalk drawing belonging to Mrs. Siddons."

Siddons, Mrs.
Etching. Circa 1795. 9×6. Bust, nearly full face. In high-crowned cap. One arm resting on back of chair. Head only finished.
The impression in the British Museum is inscribed, "N.B. This plate was etched as an experiment which failed. T. L."

Siddons, Cecilia. Youngest daughter of Mrs. Siddons. Born 1794. Married, 1833, to George Combe, phrenologist and author. Died 1868.
Dated 1798. Black chalk. Infant of 3 or 4. Face only finished. Kneeling, facing, in cap, from which lock of hair escapes over forehead. Arms crossed.
LITHO. BY R. J. LANE, 1830. "From a drawing in the possession of Mrs. Siddons."

Siddons, George. 2nd son of Mrs. Siddons (born about 1785). Went out to India in the service of the Company.
Circa 1797. Chalk. Boy of 10 or 12. Bust, profile to right. Hair brushed over forehead.
LITHO. BY R. J. LANE (on same sheet with other members of family).

Siddons, Maria.
Chalk (?). Circa 1797. Half length, seated on chair. The head identical with that in the oil sketch engraved by Clint.
SMALL ENGRAVING by J. DEAN.

Siddons, Maria. [Mr. E. E. Leggatt.]
Circa 1797. Black chalk. Profile to right. Seated. Hair falling over forehead. Veil over head, falling over left shoulder. Head partly supported on right hand. Body only slightly indicated. This drawing is said to have been given by L. to the lady who acted as chaperon to the girls while their mother was at work.
ENG. BY F. C. LEWIS, 1841.

Siddons, Sarah (Sally).
Chalk. Circa 1798. Profile, to left. Face only finished. Hair falls in curve (fringe) over forehead from under cap bound by band under chin. Hat over back of head only indicated.
LITHO. BY R. J. LANE, 1830. "From drawing in possession of Mrs. Siddons." It is unlikely that this drawing can have been executed later than the death of Maria Siddons in 1798, as Lawrence had few opportunities of seeing Sally Siddons after that time.

Siddons, Miss (Sally or Maria?).
Black chalk. 1797-8. Face only finished. Nearly full face, eyes looking to left. Hair high on head, covered by veil or loose cap. Loose locks of hair escaping over forehead.
LITHO. BY R. J. LANE, 1830. "From a drawing in the possession of Mrs. Siddons." Also in P. G. Patmore's "Cabinet of Gems," 1837.

Siddons, Miss. See Lady with Tambourine.

Sidney, Caroline, Viscountess. Second wife of the 2nd Viscount Sidney. [Hon. R. Marsham Townshend. Amateur Art Exhibition, 1898.]
Drawing.

Sinclair, Rt. Hon. Sir John, of Ulbster, Bart. Lawrence received 5gs. for a pencil drawing of this gentleman about 1787.

Sotheran, Caroline Matilda. Wife of Admiral Sotheran (1787-1812). [J. Pierpont Morgan, Esq.]
Oval. 3½×3. Circa 1810. Miniature. Nearly full face. Brown hair in loose curls over forehead. White dress with high waist and blue sash; a yellow cloak edged with blue thrown over left shoulder. Neck and throat bare; the dress fastened in front by gold brooch with ruby. Background dull green.
. A large oil portrait of the same lady, purporting to be by Lawrence, was lately in the market.

Stewart, Miss. [Chr. July 17, 1897; 41gs.]
Chalk drawing. Oval. In white dress and cap. Blue sash. Spaniel at side. Landscape background.

Storey, Lydia, née Baring. Wife of the Rev. P. L. Storey. Youngest daughter of Sir Francis Baring. Married 1806.
Chalk drawing. Circa 1810. Head and bosom. Profile to right. Neck stretched forward with dramatic action. Hair bound up at back of head, with loose curls over forehead. Pearl necklace.
ENG. BY J. THOMSON, 1826, as "Regard."

Thistlewood and Ings. Thistlewood (1770-1820) organized the meeting in Spa Fields, 1816. Head of Cato Street Conspiracy. Hanged 1820. Ings was a cobbler, for whom the post of secretary of the provisional government was reserved.
[Chr. Lawrence sale, May 20, 1830; £2 10s.]
Pencil. Sketch from life. Made at the trial in 1820 on the back of a letter.

Thurskeim, Countess.
Chalk drawing, made at Vienna in 1818-19.

Tickell, Mrs. See Linley, Miss Maria.

Upton, Hon. Sophia. Daughter of the 1st Baron Templetown. Died 1853. [Viscount Templetown. B. I. 1830.]
R.A. 1801. Chalk (?).

DRAWINGS AND STUDIES—PORTRAITS

Valière, Madame la (?), or Valieri.
Chalk drawing. Face only finished. Head thrown back ; eyes with marked eye-lashes, looking up. Drapery over head. Arms outstretched.
ENG. BY F. C. LEWIS.

Wallscourt, Lady.
Chalk drawing. To waist, but the bust only slightly indicated. Leaning forward and smiling. Full face. Loose hair over forehead.
ENG. BY F. C. LEWIS.

Walpole, Horace, Earl of Orford (1717–97). Youngest son of Sir Robert Walpole. Author, letter writer, connoisseur. Succeeded to earldom on his nephew's death in 1791. [Ex Samuel Lysons.]
Chalk. 1796. Bust, head three-quarters to left. Face only finished. Long hair at side of face (a wig ?). Inscribed, " T. Lawrence ad vivum, 1796."
ENG. BY T. EVANS, AND BY H. MYERS, 1811.

Ward, Robert Plumer (1765–1846). Novelist, politician, and writer of diary. [Hon. Mrs. C. Eliot. Amateur Art Exhibition, 1898.]
Drawing.

Ward, Mrs. [Dulwich College. Bequeathed by the Rev. Ozias Linley, 1831.]
Chalk.

Wellesley, Richard, Marquess. [National Portrait Gallery, Dublin. Ex Sir William Knighton.]
Chalk drawing on canvas. 24×20. Sketch for portrait. Head and shoulders ; full face ; life size.
ENG. BY F. C. LEWIS.
In the Lawrence sale June, 1831, a portrait of the Marquess Wellesley was sold to Woodburn for 12gs.

Wellesley, Canon. [Duke of Wellington.]
Drawing.

Wellesley, Marianne, Marchioness, when Mrs. Paterson. [Chr. June, 1830, Lawrence's Exors., 3½gs.]
Large study from life on canvas, in black, white, and red chalk.

Wellington, Arthur, 1st Duke of. Several chalk studies for portraits of the Duke were in the Lawrence sale in June, 1831.

Wellington, Duke of. [Chr. June, 1831, Lawrence sale.]
Black and white chalk. Half length.
LITHO. BY F. C. LEWIS, 1840 (?).
Ditto. Two drawings of the Duke by L. were lent to the Water-colour Room of the B.I. in 1832 by Mr. Harding and Mr. Marshall.
Ditto. There is a drawing ascribed to L. at Apsley House.

Wellington, Arthur Richard, 2nd Duke of. As Lord Douro. Born 1807. Succeeded his father 1852, died 1884. [Duke of Wellington. Amateur Art Exhibition, 1898.]
Drawing, given to the Duchess of Wellington by Lawrence.

Wellington, Catherine Pakenham, Duchess of. [Duke of Wellington. S.K. 1868 ; O.M. 1904 ; Amateur Art Exhibition, 1898.]
Black and red chalk. Half length, nearly facing. Left elbow on arm of chair, hand to throat. High frilled collar. Signed " T. L. 1814."

West, Benjamin, P.R.A. [Chr. June, 1831, Lawrence's Exors.]
Black and white chalk. Half length. " Very fine."

Westmorland, John Fane, 11th Earl of. As Lord Burghersh. Succeeded to the title 1841. Soldier, diplomatist, and musical composer. [Ex Hon. Gerald Ponsonby. Amateur Art Exhibition, 1898.]
Chalk drawing, tinted. Bust ; profile to right. Loose curly hair, slight whiskers. Cloak over shoulders.
ENG. BY J. BULL, 1838.

William IV, as Duke of Clarence.
Chalk drawing. Head and bust, three-quarters to right. Short white hair, brushed up from forehead. Black stock.
ENG. BY F. C. LEWIS, 1831.
A drawing of the King, lent by Mr. Colnaghi, was in the Water-colour Room of the Winter Exhibition of the Society of British Artists in 1832.
Lawrence received 5gs. for a pencil drawing of the Duke about the time of his arrival in London.

William IV, as Duke of Clarence. [Chr. June, 1830, Lawrence's Exors., 9½gs.]
Large study from life in black, white, and red chalk, on canvas.

Williams, "the reputed murderer of the Marr family." Hero of De Quincy's essay, " Murder considered as one of the Fine Arts." [Chr. June, 1830, Lawrence's Exors., £5 10s.]
1813. *Careful crayon drawing, made in Cold Bath Fields prison immediately after the suicide of the presumed murderer. Hair light and curling ; eyes blue and half closed, mouth somewhat distorted.*

Wilton, Countess of. [Chr. June, 1830, Lawrence's Exors., 30gs.]
Large study from life on canvas in black, white, and red chalk. Head, nearly facing, relieved against large circular hat. Low dress ; curls over temples.
ENG. BY F. C. LEWIS.

189

SIR THOMAS LAWRENCE, P.R.A.

Wollaston, William Hyde, M.D.
(1766–1828). Chemist and physicist.
In early life a physician. Invented
method of welding platinum; made
discoveries in optics, and advanced
the theory of electricity.

*Chalk drawing. Bust, facing, looking out. Bald head,
slight hair and whiskers. Coat with high collar.*
ENG. BY F. C. LEWIS, 1830.
The *Dict. Nat. Biog.* mentions a *painting* of Dr.
Wollaston engraved by F. C. Lewis.

Wolff, Hermann, son of Mrs. Wolff.
*Chalk drawing. Circa 1817. Bust, full face. Boy
of 11 or 12. Hair falling over forehead.*
*A drawing of Hermann Wolff was lent to the Amateur
Art Exhibition, 1898, by Lady Nicholson.*
LITHO. BY F. C. LEWIS.

Wolff, Hermann.
*Chalk drawing. Circa 1813. Head only of boy of 8 or 9.
Face in profile to right. Tuft of hair over forehead. Very
slight.*
LITHO. BY F. C. LEWIS. ["Unique." Brit. Mus.
Catalogue.]

Wolff, Mrs., instructing her son Her-
mann. [Lent to O.M., 1879, by Mrs.
Keightley, and to Amateur Art Exhi-
bition, 1898, by Miss Keightley.]
*Pencil drawing, slightly coloured. Circa 1817. Lady
lies on sofa ; her boy of 8 or 9 crouches at her side. She
holds book in hand and points with pencil.
Separate study of feet.*
LITHO. BY F. C. LEWIS.

Wolff, Mrs., and her son Hermann
[Miss Keightley. O.M. 1904.]
*Black and red chalk. 9 × 6½. Seated in classical chair,
leaning over back. Profile to right. Loose white robe and
cap covering hair. A boy of 6 or 7 seated on the floor
embraces the feet of his mother, which rest on a large
footstool, while with one hand he plays with a lap-
dog.*
*This is perhaps the drawing made in 1812 (or earlier)
for Miss Croft, and lent by her to the B.I. in 1830.*
ENG. BY JOHN BROMLEY, 1830.

Wolff, Mrs. [Chr. June, 1830, Law-
rence's Exors., 8gs. ; bought by Miss
Keightley.]
*Large study from life on canvas in black, white, and
red chalk. "With large book." Probably the sketch for
the oil picture.*

Woronzoff, Countess.
*Chalk drawing. Bust, nearly facing, looking out.
Hair elaborately curled over the whole of the head. Cross
on bosom, pearl ear-rings.*
ENG. BY F. C. LEWIS.

Wynn, Master William. [Sir Wat-
kin Williams-Wynn.]
*Chalk drawing. Boy of about 6 or 7. Facing. Short
hair over forehead. Head and neck only.*
ENG. BY W. SHARP, 1830.

York, Duke of. Lawrence received
5gs. for a pencil drawing of the
Duke of York soon after settling in
London.

DRAWINGS AND STUDIES—ANONYMOUS
PORTRAITS AND MISCELLANEOUS

Anatomical Studies. [Victoria and
Albert Museum. Dyce Collection.]
*9½ × 6½ and 10½ × 6½. Black chalk heightened with white,
with wash of Indian ink, on brown paper. Two careful
studies : (1) Nude torso ; (2) Studies of legs.*

Ariel and Ferdinand. [Chr. June 18,
1831, Lawrence's Exors.]
Chalk drawing, highly finished.

Belch, Sir Toby. [Ex Mrs. Charles
Denham.]
Chalk drawing. Head only finished. Pipe in hand.
LITHO. BY R. J. LANE.

Children, Group of three young.
[J. Jaffé, Nice.]
*Chalk drawing. In circle. Girl of about 5 in centre,
her arm over shoulder of younger child to left, who is
playing with spaniel. To right a still younger child in
cap—perhaps a later addition by another hand. Cf.
"Innocence and Fidelity."*
MEZ. BY PORTER.

Children Embracing.
*Two busts of children of about 3 or 4 years, embracing.
Pencil, stump, and red chalk. "The drawing since
finished by another hand" (inscription on engraving).*
ENG. BY F. C. LEWIS. (P. G. Patmore's "Cabinet of
Gems," 1837.)

190

DRAWINGS & STUDIES—ANONYMOUS

Christ, Head of. [Ex Samson Low, Esq.]
Pen drawing. Head crowned with thorns. Stooping, profile. A "Head of Christ"—an unfinished sketch—was in the Lawrence sale, May 15, 1830.
ENG. BY CHARLES HEATH and many others.

"Copenhagen." Studies of Wellington's horse. [Duke of Wellington, Apsley House.]
Made when painting the portrait of the Duke for Lord Bathurst. The horse was taken to Astley's and put through its paces in the presence of Lawrence.

Copies from Old Masters. Early studies. [Chr. May 20, 1830, Lawrence's Exors, 2gs., 8gs., and 8gs.]
Crayon drawings after copies of Guido, P. da Cortona, and Sacchi, made in 1782, when Lawrence was 13 to 14, at the house of the Hon. W. Hamilton, on Lansdowne Hill, Bath. See also under "Transfiguration."

Cupid and Psyche. [Lady Nicholson. Amateur Art Exhibition, 1898.]
Drawing. "Made" ["painted" in catalogue] "when the artist was 16 years old" (1785).

Etchings by Lawrence. See Lawrence, Mrs. Thomas, and Siddons, Mrs. (under Drawings).

Facial Expression, Studies of. [British Museum.]
Pencil tinted with Indian ink. 4¼×3¼. Early work. The lower part of face repeated on overlying slip, with change of expression. (a) Girl with ringlets (b) Face of man.

"Fancy Group."
R.A. 1806.

Female Figure. [Ex Mrs. Farr.]
Chalk drawing. Girl in light dress and white cap, seated on ground, resting on left arm.
LITHO. BY R. J. LANE.

Female Figure.
Chalk drawing. Seated on steps reading sheet of paper. Wrapped in robe with loose folds. Hair bound up with fillet.
ENG. BY R. J. LANE, 1827, with quotation from Cowper.

Female Head with Veil.
Chalk drawing. Three-quarters to right. Careful drawing of head, classically treated. Veil with fringe over forehead, fastened by pin on bosom.
ENG. BY F. C. LEWIS.

Girl, Head of Young. [Paris, Petit Palais, 1901. "Exposition de l'Enfance."]
Crayon sketch.

Girl, Head of. [British Museum. Ex. Maude Collection.]
Black and red chalk. 8¼×6¼. Hair brushed over forehead. Slight and delicate.

"Girl, Study of." [Lent by H. A. J. Munro to B.I. 1833.]

"Golden Age, The." ("Amulet," 1833.) See "Young Girl Lifting up a Baby."

"Hebe."
Drawing (?). Head only seen from above. Resembles the "Iris," but with more vigorous expression and no rainbow.
Cf. the "Iris."
ENG. BY C. KNIGHT, 1808. Published by Edward Orme.

Infant, Legs of. [British Museum.]
1. 10¼×6¼. *Careful study in red chalk. In style of Rubens. On drab-coloured paper.*
2. 10¼×7¼. *Study in black and red chalk. Signed in red chalk. "T. L., June 21st, 1807."*

Infant, Sleeping. [British Museum.]
Black and red chalk. 8¼×6¼. Signed "T. Lawrence, Delint., Feb., 1789." Careful study of head.

"Iris."
Drawing (?). Head only, facing. Ostrich feather round head, droops to left. Clouds below, rainbow above. See also "Hebe" and "Countess Woronzoff," whom this head resembles.
Stipple engraving for Edward Orme's "Essay on Transparent Prints," 1806.

Lady, Portrait of a. [Ex G. B. Windus. Chr. March 16, 1912 ; 200gs.]
1790. *Oval. 9¼×7¼. Black and red chalk. Seated ; hands folded on knees.*

Lady with Tambourine. [Probably in America. Sotherby and Wilkinson's, July 27, 1901. Bgt. by Sabin for 225gs.]
Tinted drawing. Called Miss Siddons. Girl in dancing attitude with tambourine held in both hands above head. A piece of paper added to top to give space for arms.
This is perhaps the same as the "Girl Dancing and Playing Tambourine" which was sold at Christie's in 1869 for 28gs.

Laocoön, Three studies of. [British Museum.]
Black chalk touched with white on light brown paper. Made in Rome, 1819.
(a) 16×9¼. *Right part of group. Signed "From the original statue, Th' Lawrence."*
(b) 10¼×8. *Legs of group. Signed "From the original statue in the Vatican, Th' Lawrence."*
(c) 16¼×12¼. *Head and bust. Signed "Sketch from the original statue in the Vatican, for the background of a portrait of Pius the 7th."*

191

SIR THOMAS LAWRENCE, P.R.A.

"**Mad Girl, The.**"

R.A. 1787. *Probably to be identified with an oval pastel drawing in the possession of Mr. E. Leggatt. The drawing is said to have been taken in 1781 from a well-known character in Bath. On the back is written, " Be pleased to keep this from damp and dust. Thos. Lawrence. 1787."*

"**Maternal Affection.**"

Chalk drawing. Seated female figure ; profile to right. Right hand over head lifts veil. Beside her are three young children : one, nude, stands on table to left. In style of Flaxman.

LITHO. BY W. SHARP.

"**Minerva.**" [Athenæum Club.]

Drawing. Head only in helmet in style of Antique Gem. " Αθηναιον " to left. Design for the seal of the Athenæum Club.

Small anonymous engraving.

"**Minerva,**" or rather Cleopatra.

Profile to left. After Michelangelo's drawing ; with snake-like braided hair.

Anonymous lithograph.

Prize-fighters. [Ex. Benjamin Hick. Bicknell sale, Chr. April, 1863, " Prize-fighter, pen and ink with caricatures."]

Rapid pen sketch.

ENG. BY F. C. LEWIS.

"**Romeo.**" [Chr. May 20, 1830, Lawrence's Exors., 3½gs.]

Black and red chalk.

Satan and Beelzebub. Three studies for the large picture. [Chr. May 20, 1830, Lawrence's Exors. Sold for about 5gs. each.]

Black and white chalk.

"**Satan Calling His Legions.**" The original chalk drawing was sold at Christie's, June 18, 1831 (Lawrence sale), for 15gs.

Sheldon, Tomb of Archbishop.

Full-length effigy.

ENG. BY C. KNIGHT.

"**Selina**" (" Keepsake," 1828). See Meade, Lady Selina.

"**Shipwrecked Mariners, The.**" [Chr. May 20, 1830, Lawrence's Exors., £4 6s. 0d. ; bought by Sir C. Greville.]

Black, red, and white chalk, on brown paper.

"**Transfiguration.**" Copy of Raphael's picture. [Chr. May 20, 1830, Lawrence's Exors., 23gs.]

Crayon study made from a copy in 1782, when Lawrence was 13. This was the study, no doubt, for which the Society of Arts awarded him a silver palette, " gilded all over."

"**Triumph of Mordecai.**" Copy from French Print. [Chr. June 17, 1830, Lawrence's Exors.]

Signed " T. Lawrence, fecit et scr. Aged 10 years " (1779).

Young Girl Lifting up a Baby.

Chalk drawing, vignetted. Head only of girl of 5 or 6, with long black hair. The baby, to left, in white cap.

ENG. BY F. C. LEWIS for " Amulet," 1833, as " The Golden Age."

Young Girl Lifting up a Baby.

Girl of 4 or 5 years, in profile to right, with long hair, lifting up child of 2 years. Pencil, stump, and red chalk.

ENG. BY F. C. LEWIS (P. G. Patmore's " Cabinet of Gems," 1837). Probably another version of the foregoing.

Young Lady, Study of. [British Museum.]

Black and red chalk. 8¼×6¾. Profile, looking down. High waist ; low dress. Very delicately drawn. Possibly the Princess Lieven.

Young Lady, Head of. [Ex S. Catherton Smith.]

Chalk drawing. Head and neck only, nearly front face. Light hair bound on top of head and hanging loosely over forehead and temples.

ENG. BY W. SHARP. 1830.

Young Lady, Portrait of.

R.A. 1823 (*in Ante-room*). *Probably a crayon drawing.*

Young Lady, Bust of.

Chalk drawing. Lady of about 20. Head only finished. three-quarters to right. Rather Jewish features. Loose curls bound by fillet passing over forehead.

ENG. BY F. C. LEWIS.

Young Man, Bust of. [J. Jaffé, Nice.]

Chalk drawing. Signed " T. Lawrence, 1821." Facing, head turned three-quarters to right. High white stock, short curly hair.

LANDSCAPES—IN VARIOUS MATERIALS

LANDSCAPES—IN VARIOUS MATERIALS

Landscapes. Illustrations to " Landscapes in Verse," by the author of "Sympathy," 1785.

Very early work. 1. *Oblong oval composition on title-page. Two figures seated to left.* 2. *A small oval landscape as tail-piece. Fields and hedgerows.*

" Mr. Lawrence, at the age of 13 (now 16), made a drawing of a hermit and a dog for the 1st book of ' Sympathy.' It will appear in the 7th Edition of this poem."—(Extract from advertisement.)

ENG. BY T. BONNOR.

Landscape.

" Study from nature." Woodland glen with deer. Pool in centre of foreground.

ENG. BY TH. LUPTON, 1834.

Landscape.

" Study from nature." Welsh-like mountain landscape. Stream to left. Meadows in the foreground with willows, etc.

MEZ. BY T. LUPTON, 1834.

Landscape. [Chr. May 13, 1830.]

Interior of a wood. " Masterly sketch from nature."

Landscape. [Chr. June 17, 1830; 6gs.]

Oil sketch. View on the Tiber.

Landscape. Meadows opposite Sloane Street. Moonlight. [British Museum.]

Black and white chalk. On grey-blue paper. " Drawn from memory."

Landscapes. A set of twelve. [Messrs. Walker Brothers. Amateur Art Exhibition, 1898.]

Drawings.

Two landscapes by Lawrence were lent to the Winter Exhibition of the Society of British Artists, 1832, by — Pickering, Esq.

INDEX

195

SIR THOMAS LAWRENCE, P.R.A.

D

d'Angoulême, Duchesse, 90
Dawe, George, 67
Devonshire, Duchess of (Lady Betty Foster), 72 ; *portrait* of, 14
—— Georgiana, Duchess of, 96 ; *portrait* of, 14
Dilettanti Society, 27, 33
Dimsdale, Thomas, 81
Dudley, Earl of, 83
Dysart, Countess of, second wife of 4th Earl (*portrait* collection of Colonel D. J. Proby), Plate XIV, 38

E

Eldon, Earl of, 84
Elgin Marbles, 63, 86–9
English Review, quoted, 85

F

Falconer, Dr., of Bath, 19 ; *portrait* of, 14
Fane, Lady Georgiana (*portrait*, "A Child with a Kid," National Gallery), Plate XV, 42
Farington, Joseph, 64, 66, 67, 68
Farren, Miss Eliza (Countess of Derby), letter to Lawrence, 30 ; (*portrait* collection of J. Pierpont Morgan), 29, Plate XVI, 46
Fries, Count de, of Vienna, 81
Frith, J. B., quoted, 47
Fuseli, quoted 8 (note), 38

G

Gainsborough, Earl of, 18
—— Thomas, 13, 22
Garricks, The, 7, 14
Gentz, Baron Friedrich von (*portrait* Fürstlich Metternischen Gemälde Galerie, Vienna), Plate XVII, 48
George III, 27
—— IV, 78, 82, 83, 90 ; (*portrait* Vatican, Rome), Plate XVIII, 50
Gérard, François, Baron (*portrait* Versailles), Plate XIX, 52
Grey, Lord, 79

H

Hamilton, Emma, Lady (*portrait*, chalk drawing, British Museum), Plate XXXIX, 94
—— Hugh (Irish artist), 13
Harpur, Bart., Sir Henry, 16
Hastings, Warren (*portrait* National Portrait Gallery), 56 ; Plate XX, 54
Hayman, Mrs., 94
Heald, K.C., Sir George Trafford (*portrait*), Plate XXI, 56
Hemming, Mrs. Frederick (*portrait* collection of A. Hirsch), Plate XXII, 58
Hoare, P., 18
—— William, 7, 13
Hoppner, John, 22, 49
Hurst and Robinson, 78

I

Impey, Sir Elijah, *portrait* of, 14

J

Jackson, John, 52
Jennings, Elizabeth—Mrs. Locke (*portrait* collection of Eugène Fischof, Paris), Plate XXV, 64
Jersey, Sarah Sophia, Countess of (*portrait* collection of Earl of Jersey), Plate XXIII, 60
Jervis (Lawrence's teacher), 6
Jordan, Mrs., 96

K

Kemble, Fanny, 96 ; quoted 38, 41, 47,
—— John P. (*portrait* as "Hamlet," National Portrait Gallery), 55 ; Plate XXIV, 62
Kenyon, Lady, 4 ; *pencil sketch* of, 5
—— Lord, 4 ; *pencil sketch* of, 5
Knapp, Oswald, E., "An Artist's Love Story," quoted, 41, 46

L

Lavater, 46
Lawrence, Anne (Mrs. Bloxam), 26
—— Thomas (father of the artist), 2, 3, 8, 9, 15, 99 ; death of, 37
—— Mrs. (mother of the artist), 2, 3, 99 ; death of, 36

INDEX

INDEX

West, Benjamin, 25
Wheatley, Lady (*portrait*), Plate XXXIV, 84
Wicar, Jean Baptiste, 81
Wilberforce, William (*portrait* National Portrait Gallery), Plate XXXV, 86
William II (King of Holland), 83
Williams, D. E., quoted 1, 2, 5, 7, 8, 12, 15, 16, 17, 22, 25, 26, 68, 74, 91, 92
Wilton, Lady Mary Stanley, Countess of (*portrait*), Plate XXXVI, 88
Wolcot, Dr. ("Peter Pindar"), 27

Wolff, Mrs., 47; *portrait*, 65; Plate XXXVII, 90; Letter to, 90
Woodburn, Samuel, 81, 83

Y

York, Duke of, *portrait* of, 14

Z

Zanetti Collection (purchased by Lawrence), 81

199